THE GENDER OF DEATH

A CULTURAL HISTORY IN ART AND LITERATURE

Why is it that in some cultures and times, literature, folklore, and art commonly represent death as a man, in others as a woman? Karl S. Guthke shows that these choices, which often contradict the grammatical gender of the word "death" in the language concerned, are neither arbitrary nor accidental. In earlier centuries, the gender of the figure of death contributed to the interpretation of biblical narrative – in particular, whether original sin was that of Adam or Eve; it related to concepts of the devil and also reflected the importance of the classical figure of Thanatos. More recently, the gender of death as angel, lover, or bride – whether terrifying or welcome – has carried powerful psychological and social connotations. Tracing the gender of representations of death in art and literature from medieval times to the present day, Guthke offers astonishing new insights into the nature and perception of the Western self in its cultural, intellectual, and literary context.

Karl S. Guthke is Kuno Francke Professor of German Art and Culture at Harvard University. He is the author of a wide range of books on German and West European and English literature and culture, among them *Modern Tragicomedy* (1966), *The Last Frontier* (1990), *B. Traven: The Life Behind the Legends* (1991), *Last Words* (1992), and *Trails in No-Man's Land* (1993).

THE GENDER OF DEATH

A CULTURAL HISTORY IN ART AND LITERATURE

KARL S. GUTHKE

CAMBRIDGE
UNIVERSITY PRESS

PUBLISHED BY THE PRESS SYNDICATE OF THE UNIVERSITY OF CAMBRIDGE
The Pitt Building, Trumpington Street, Cambridge CB2 1RP, United Kingdom

CAMBRIDGE UNIVERSITY PRESS
The Edinburgh Building, Cambridge CB2 2RU, United Kingdom http://www.cup.cam.ac.uk
40 West 20th Street, New York, NY 10011-4211, USA http://www.cup.org
10 Stamford Road, Oakleigh, Melbourne 3166, Australia

First published 1999

Printed in the United Kingdom at the University Press, Cambridge

Typeset in 11.5 on 15pt Adobe Caslon in QuarkXPress™ [SE]

A catalogue record for this book is available from the British Library

Library of Congress cataloguing in publication data

Guthke, Karl Siegfried, 1933–
 The gender of death: a cultural history in art and literature / Karl S. Guthke.
 p. cm.
 Includes bibliographical references and index.
 ISBN 0 521 59195 3 (hardback)
 ISBN 0 521 64460 7 (paperback)
 1. Death in art. 2. Arts. 3. Gender identity in art. 1. Title.
 NK650.D4G88 1999
 700'.4548 – dc21 98-25141 CIP

ISBN 0 521 59195 3 hardback
ISBN 0 521 64460 7 paperback

To talk at all interestingly about death is inevitably to talk about life.

D. J. ENRIGHT *The Oxford Book of Death*

It is our conception of death which decides our answers to all the questions that life puts to us.

DAG HAMMARSKJÖLD *Markings*

CONTENTS

List of plates ix

Acknowledgments xi

INTRODUCTION 1
Why this book?

1 IMAGINING THE UNIMAGINABLE: DEATH PERSONIFIED 7
Is Death a woman?

2 THE MIDDLE AGES: THE UNFORTUNATE FALL 38
The wages of sin – Adam's sin, or Eve's?

3 RENAISSANCE AND BAROQUE: THE DEVIL INCARNATE 82
Death and the Maiden – and the man

4 THE ROMANTIC AGE: "HOW WONDERFUL IS DEATH" 128
The youth with the downturned torch;
"The last best friend"; Death in the bridal chamber

5 FROM DECADENCE TO POSTMODERNITY:
THE STRANGER AT THE MASKED BALL 173
Angels of death and skeletal coquettes

EPILOGUE 252
Death immortalizing life

Notes 257

Select bibliography 285

Index 290

PLATES

1 Hugo Simberg: Death Listens. Atenumin taidemuseo, Helsinki 2

2 Alfred Kubin: The Best Physician. Artists Rights Society, New York.
Photo: Institut für Geschichte der Medizin, Universität Düsseldorf 25

3 Jean Grandville: *Journey to Eternity,* no. 7. Beinecke Library, Yale University 28

4 Latin Bible (thirteenth century), illustration. From: Alexandre de Laborde, *La Bible
moralisée,* vol. IV (Paris: Pour les membres de la société, 1921), ill. no. 599; detail.
Houghton Library, Harvard University 47

5 Jean Colombe: Death as Knight on Horseback. Art Resource, New York 52

6 Beatus de Liébana: Commentary on the Apocalypse, illustration. Staatsbibliothek zu
Berlin 60

7 Francesco Pesellino: Triumph of Chastity and Death. Isabella Stewart Gardner
Museum, Boston 70

8 Fresco, Campo Santo, Pisa. Art Resource, New York 72–73

9 Charles le Vigoureuz (printer): The Triumph of Death. From: F. P. Weber, *Aspects of
Death...* (London: T. Fisher Unwin, 1918), p. 125 76

10 Hans Baldung, called Grien: Death and Woman. Kunstmuseum Basel 102

11 Niklaus Manuel, called Deutsch: Death and the Maiden. Kunstmuseum Basel 103

12 Niklaus Manuel, called Deutsch: Death and the Canon. Hessisches Landesmuseum
Darmstadt 119

13 Hans Holbein the Younger: *Icones mortis.* The Nun. Institut für Geschichte der
Medizin, Universität Düsseldorf 121

14 Agostino Veneziano: The Skeletons, copper engraving of Rosso Fiorentino: I
squeletti. Institut für Geschichte der Medizin, Universität Düsseldorf 126

15 G. E. Lessing: *How the Ancients Represented Death,* title-page vignette. From:
K. Lachmann and F. Muncker (eds.), Lessing, *Sämtliche Schriften,* vol. XI
(Stuttgart: Göschen, 1895), p. 1 138

16 Philipp Jakob Scheffauer: Genius of Death. Staatsgalerie Stuttgart 145

PLATES

17 D. N. Chodowiecki: Friend Hain. From: Matthias Claudius, *Werke* (Hamburg and Gotha: Perthes, 1844), frontispiece 148

18 J. R. Schellenberg:Frustrated Expectation. Institut für Geschichte der Medizin, Universität Düsseldorf 153

19 Oskar Schwebel: *Der Tod in deutscher Sage und Dichtung* (Berlin: Weile, 1876) title-page vignette 195

20 Carlos Schwabe: The Death of the Gravedigger. Art Resource, New York 197

21 Jacek Malczewski: Thanatos I. Muzeum Narodowe w Poznaniu 199

22 Gustave Moreau: The Young Man and Death. Harvard University Art Museums 207

23 Félicien Rops: Dancing Death. Institut für Geschichte der Medizin, Universität Düsseldorf 217

24 Félicien Rops: Street Corner. From: Ottokar Mascha, *Félicien Rops und sein Werk* (Munich: Langen, 1910). Houghton Library, Harvard University 219

25 Thomas Cooper Gotch: Death the Bride. Alfred East Art Gallery, Kettering Borough Council, Kettering, England 224

26 Klaus Rosanowski: Hairdresser and Death. Institut für Geschichte der Medizin, Universität Düsseldorf 231

27 Andreas Paul Weber: Death and Devil. Artists Rights Society, New York. Photo: Institut für Geschichte der Medizin, Universität Düsseldorf 232

28 Alfred Rethel: Death as Political Orator. From: Rethel, *Auch ein Todtentanz*, 3rd edn. (Leipzig: Weigand, 1849) 241

29 Max Slevogt: Dance of Death. Artists Rights Society, New York. Photo: Germanisches Nationalmuseum, Nuremberg 247

30 Gian Lorenzo Bernini: Tomb of Pope Urban VIII. Art Resource, New York 253

The illustrations are published by permission of the copyright holders indicated.

ACKNOWLEDGMENTS

I am indebted to many friends, colleagues, and students, but above all to Frau Eva Schuster, curator of the collection of graphics on the general subject of death and dying housed in the Medizinhistorisches Institut of the University of Düsseldorf. She made several photos available to me without which this book would be incomplete, and conversations with her during my week-long stay in Düsseldorf were eye-opening. My trip to Düsseldorf was made possible through the generosity of the Committee on Research Support and the Center for European Studies at Harvard University. Ms. Doris Sperber, who word-processed the text with her usual efficiency and attention to detail, contributed sound advice and helpful suggestions. I am grateful to Ms. Mary Clare Altenhofen for helping me use the holdings of the Fogg Art Museum at Harvard, and to Professors Joseph Koerner, Eckehard Simon, and Jan Ziolkowski for their critical reading of individual chapters.

The Gender of Death is my own version (with some additions, deletions, and corrections) of *Ist der Tod eine Frau?* (Munich: Beck, 1997; 2nd edn. 1998). I am deeply indebted to Robert Sprung for devoting many hours of his busy life to reviewing my text with his unfailing eye for stylistic infelicities.

The argument was fine-tuned here and there and accommodated to the interests of English-speaking readers by greater reliance on examples from the arts and literatures of the Anglo-Saxon world as well as by occasional modifications of my commentary. Unless indicated otherwise, English renderings of quotations are my own; I have no fear that my translations of poetry will be thought to imply any poetic ambitions. In many cases there is no standard English title of a work of literary or pictorial art originating outside the English-speaking world; this should be no problem, however, as the notes invariably (even when an illustration is provided) refer the reader to illustrations and further discussion, wherever possible in English-language publications, though the German catalogue of the Düsseldorf collection, Eva Schuster's

Mensch und Tod (Düsseldorf: Triltsch, 1989), remains the most indispensable handbook in this field. In providing foreign language titles and/or English equivalents, I have been guided by common sense, adding or omitting translations or original titles with a view to what most readers would find necessary or desirable. (So I refer simply to the *Aeneid* on the one hand, and to Malraux's *Antimémoires*, on the other; in the overwhelming number of cases, both original title and English translation are given.) The period labels of the individual chapters are flags of convenience; thus, for better or probably worse, "The Romantic Age" includes the later eighteenth-century Enlightenment as well as the Classical Revival around 1800.

Speakers of English will take it for granted that the Grim Reaper is male, but, then, they are apparently not expected to be taken aback when, in the *Times Literary Supplement* of August 14, 1998, they come across a poem by Edwin Morgan which quite matter-of-factly casts Death in the role of a ghastly "she." Or are they?

Interest in the subject of this essay seems esoteric until one discovers that it is universal – which might explain why it has never resulted in a book-length study, or why, perhaps, it shouldn't be taken to such an extreme. Be this as it may, I was not disconcerted to find out that even British TV culture has been infested by the "bug." One fine day on ITV (on July 9, 1997 at 8 p.m., to be scholarly about it), Inspector Morse got into a mildly philosophical discussion of death with the usual suspects; one of them, a young woman disappointed in matters of the heart, offered the opinion that Death is a "he" because all things "ugly" are male, while all things beautiful are female. She turned out to be innocent of murder, but not of oversimplification.

Is Death a woman? How does one come upon such a question? Through an error. Some years ago, in a slide lecture at Harvard University, Finnish Symbolist Hugo Simberg's watercolor "Death Listens" (Kuolema kuuntelee, 1897) was shown. The painting, which has recently met with intense interest in various quarters,[1] takes us into a simple room in a peasant's wooden house. Under the wall clock in the background an old woman lies in bed while a barefoot boy in the foreground sits on a stool, playing the violin; Death, leaning on a chair opposite him and listening thoughtfully, is the familiar skeleton. But one thing was striking about this unpretentious yet riveting composition (which, curiously, reverses the conventional constellation of Death the fiddler and his victim): this Death, of whom only the skull, hands, shins, and feet are visible, is a woman – dressed in a cape and a skirt. Why a woman? A matter of grammatical gender, I was told: while the word for death is masculine in German, it is feminine in other languages, e.g., "la mort," "la muerte." But then, Finnish has no grammatical gender. Before finding that out, however, I had looked into Sakari Saarikivi's richly illustrated *Hugo Simberg*[2] and discovered – Simberg's Death is a man! Since the mid-nineties, Simberg had repeatedly featured a unique personification of death in his paintings, as a sort of private mythology: a skeleton dressed in the jacket and knickerbocker trousers of the Finnish peasant of his day. What in the lateral view of "Death Listens" appears to be the skirt of a woman are in fact widely cut and more than knee-length culotte-like breeches, as several others of Simberg's representations of Death make unmistakably clear.[3] In his watercolor "Dance on the Bridge" (Tanssi sillalla), for example, two such Death figures dance with women wearing Finnish country outfits, while three men stand by somewhat disconsolately.

With this discovery, the "case" was closed, but the question "Is Death a man or a woman?" posed itself all the more insistently. The instinctive answer, that the gender of Death would be determined by the grammatical gender of the word for death in the language involved, was not con-

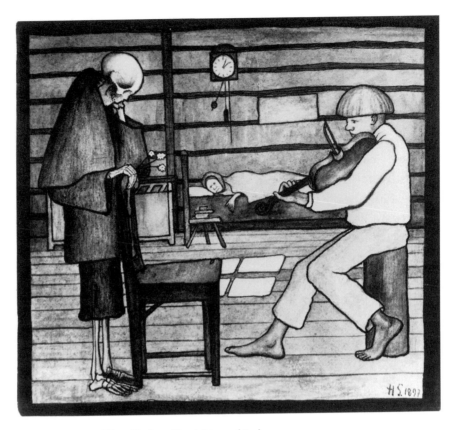

PLATE I Hugo Simberg: Death Listens (1897)

vincing. Why should Dalí, in his color etching "Death and the Maiden" (1967), represent "la muerte" as a faintly quixotic cavalier and guitar player on horseback?[4] Why should Stefano della Bella, the most promi-nent seventeenth-century Italian etcher, in the first image of his cycle "The Five Dead" (Les cinq morts), have Death gallop over the battlefield in the shape of a supreme commander clutching a flag and a trumpet?[5] Why is "la mort" in Anouilh's *Eurydice* (1958) and in Ionesco's *Massacre Games* (*Jeux de massacre*, 1970) a man? Nor did French linguistic sensibil-ities, it appears, rebel in the eighteenth or in the twentieth century, when French satirists personified death as a man in their graphics, be it as a political orator in the aftermath of the Revolution, as the gambling part-ner of a miser, or as the waiter presenting the bill to Adolf Hitler.[6] On the other hand, why is Death, "der Tod," in Klaus Drechsler's aluminum

2

print "Death with a Child" (Tod mit Kind, 1991) a woman dressed in a billowing skirt, a nurse perhaps, who hurriedly carries away the baby in her bony arms?[7] In Paul Celan's poetry, Death makes its appearance not only as "a master from Germany" but also, less famously, in a poem in *Thread Suns* (*Fadensonnen*, 1968), as "die Tödin," the Death-Woman. The graphics of Félicien Rops have it both ways as well: Death is presented sometimes as a man, sometimes as a woman – as a female dancer in a seedy night club in the etching "Dancing Death" (La Mort qui danse, 1865?), but as a skeleton in tails, with a monocle in his eye-socket, in the etching "Le Vice suprême" (1884).[8] Why is it, finally, that in Rilke's fifth *Duino Elegy*, it is "Madame Lamort" who sells "the paltry winter hats of fate" and that in George Tabori's play *Mein Kampf* (1987) it is "Frau Tod" (Frau Death in Tabori's own English version) who picks Adolf Hitler as her tool? If grammatical gender did indeed determine the gender of our personifications of death, these examples would all point to some sort of incongruity, and yet they are not exceptional cases; they can easily be multiplied, leaving us wondering: what is the rule and what is the exception?

Observations of a different kind call attention to the problem that seems to be announcing itself here. In Edvard Munch's well known lithograph "Kiss of Death," the skull kisses the cheek of a young woman whose flowing tresses identify her as a representative of a type quite common in Munch's oeuvre – clearly, this is the familiar death eroticism of the *fin de siècle*, what else?[9] But this picture was first published as an illustration for Strindberg's short play *Simoom* (*Samum*, in the journal *Quickborn*, 1899) – and there, surprisingly, the situation is entirely different. In the play, set in colonial Africa, a folkloric local witch holds a skull up to a captive Frenchman, telling him that he is seeing his own death's head in a mirror. (The shock deprives him of his sanity and his life.) So in "Kiss of Death," the long-haired figure, visible only as head and shoulders, would be a man; he, and not a woman, would be receiving the kiss of Death?[10] Our thoughts are getting lost in the psycho-labyrinth of those sexual confusions of the turn of the century which are re-emerging today in the widespread fascination with androgyny.

Gustave Moreau's celebrated painting "The Young Man and Death" (Le Jeune Homme et la Mort, 1865) presents a similar challenge.[11] In the

densely allegorical world of this picture, Death, an unequivocally female angel of death with hourglass and sword, appears behind the half-nude young man in the foreground. An entirely unthreatening, oddly absent expression is on her face. In two preparatory sketches, however, Death was not a woman but a winged greybeard.[12] How are we to explain this change from one image of death to another, from the male to the female?

Surely, such observations cry out for further inquiry. Yet curiously, it turns out that while there is indeed some writing on the general subject, hardly any of it proves illuminating. As so often, the older studies are richer in information than in judgment, while it is the other way round with more recent ones. Still, patient collecting of "evidence," sometimes trying, sometimes fascinating, occasionally helped by serendipity that played "pertinent things . . . into one's hands virtually in the manner of a procurer" (as Thomas Mann has it in *The Story of a Novel: The Genesis of "Doctor Faustus"*), was eventually rewarded, I think, by insights into thematic and iconologic contexts of male or female personifications of Death and into the factors in intellectual and cultural history that gave rise to them and endowed them with specific meaning.

The classical mythological tradition, it turned out, was not alone in playing a role in the determination of the gender of Death in art and literature. The Bible had a powerful impact as well. If, for example, the Middle Ages believed that death was the wages of sin, then the question arose: was it Adam's sin or Eve's which brought death into the world? And, according to an alchemy of the imagination widespread at the time, the answer to this question then suggested that death had to be visualized as male or female, respectively. The Renaissance and Baroque periods, on the other hand, tended to identify Death and the devil. This makes sense if we remember that, according to the Book of Wisdom (2:24), it is the devil, rather than Adam or Eve, who brought death into the world. And just as the devil may appear in male or female shape in folklore and in art, so may Death; and as he or she does so, Death comes to be eroticized in an unprecedented manner, creating new tensions and relationships between the Grim Reaper figures and their victims. Instead of fearful and gruesome biblical Death, the skeleton, it was the Death of Antiquity, Thanatos, stylized as the gentle, friendly youth with a still

smoldering downturned torch, that fascinated the Romantic Age, revealing its radically changed attitude to death, or rather life. This attitude then also allowed artists and writers to "domesticate" Death as a friend, indeed "the last best friend" (Robert Southey), but as a bridegroom as well (not without a secularizing reminder of Jesus as the bridegroom of the truly Christian soul) or, more rarely, as a bride – both of them fervently desired. In a later period, extending from what is loosely called decadence all the way to our own days, the eroticism implied in the bridegroom or bride metaphor has an impact in yet another personification rampant in art and literature: Death as the dangerous, yet irresistible, sexual seductress, be it in the raucous ambiance of a floorshow or in the austere aura of quasi-religion. (The Italian Blackshirts, by the way, marched to "Life, thou art my friend; death, thou art my mistress.") In turn, the seductress in this period calls forth the complementary image of the seducer at the masked ball of life.

These remarks can, of course, no more than hint at the wealth of images that the creative impulse has produced over hundreds of years of imagining the unimaginable in the Western world. At any given time, related and contrary images of death naturally cluster around the dominant ones. Different cultural contexts, different group-specific views as well as different individual attitudes create different images of death. They are male and female images that each comprise a wide variety of further differentiations: old and young, beautiful and ugly, fatherly and motherly, terrifying and seductive, contemptible and venerable, and so on.

Such images may or may not reveal something about the "nature" of death (a topic of great interest in popular theology today); they may or may not contribute something to the ideologies of feminism or its opponents – or to the loosening up of these ideologies. There is no doubt, however, that they open our eyes for aspects of "the world as interpretation," that is, for humans, individuals and groups, orienting themselves in their world by making such images and thereby, ultimately, defining themselves. The history of such images in literature and art might offer a variation on the cultural history of the West that may appear eccentric at first glance but does not lose its fascination on closer inspection. To preserve and arouse this fascination, the following pages, in spite of their

bookish footnotes, have been written in the manner of an essay: as an initial foray into extensive and multifarious uncharted territory.

The first chapter is systematic in orientation; it touches upon a number of works that will be discussed in context and in greater detail in the subsequent, historically oriented chapters. In those chapters the intention is, as it has to be in a pioneering study of this kind, to present as great and varied a wealth of examples as is compatible with a sensible overview.

I

IMAGINING THE UNIMAGINABLE: DEATH PERSONIFIED

IS DEATH A WOMAN?

Why is the Grim Reaper a man? True, the noun ending would theoretically allow us to visualize the reaper as a woman as well, but we don't. German word formation is more explicit: "There is a reaper, Death by name," the folksong has it – "ein Schnitter," not "eine Schnitterin." Yet the female reaper is not at all uncommon in the art and literature of the French-, Spanish-, and Italian-speaking countries, ranging all the way from the late medieval fresco in the Campo Santo in Pisa, via an anonymous seventeenth-century Italian etching of a woman wielding a scythe, through Félicien Rops's "Mors syphilitica" and a Spanish broadside from the early twentieth century.[1] Why is it "Mister Death" in E. E. Cummings's poem "Buffalo Bill's Defunct," but "Madame Lamort" in Rilke's fifth *Duino Elegy*, or, for that matter, in Rachilde's play *Madame La Mort* at the turn of the century? Why is Death "Freund Hein" (friend Henry) in the popular parlance of the German-speaking countries, but "La tía Sebastiana" (aunt Sebastiana) in the folklore of Mexico?

In some cultures – Spanish, French, and Polish, for example – art, literature, and conventional thought almost regularly personify death as a woman: beautiful or ugly, old or young, motherly, seductive, or dangerous. In others – English and German, for instance – Death more often than not appears as a man, and again in a large number of variations: violent or friendly, inexorable or weak, horrifying or alluring. But in both sets of cultures there are significant, substantive exceptions, real alterna-

7

tives such as the "Schnitterin" in German, for example, that occurs at the end of Sacher-Masoch's short novel *Raphael the Jew* (*Der Judenraphael*), and the (male) reaper ("segador") in *Don Quixote* (pt. 2, ch. 20).

Or *are* they exceptions? The "exceptions" and the "rule" reflect rivaling conventions of the imagination which are arguably of anthropological interest. How do we account for this twofold discrepancy – between cultures and within a given culture? What does this twofold image-making, this visualizing of death as a man and as a woman, as this *kind* of man and that *kind* of woman, tell us, if not about "human nature," then at least about creative individuals and their historical and cultural milieu? In what follows, a wealth of "cases" from the Middle Ages to the present will be examined with a view to discovering the meaning of such questions and, with luck, some insight into the multiform functioning of the literary and artistic imagination in its various cultural, intellectual, and historical contexts.

I

Image-making is one of those urges that define humans. The fact that some religions try to curb it only shows that it is basic to our orientation in the world. This urge to make an image is activated most dramatically whenever we experience situations that baffle or overwhelm us because familiar patterns of thought cannot cope with them, cannot give them shape and order that make them familiar. Death is such an experience – our own death and that of others. Neither the sun nor death can be looked in the eye, says one of La Rochefoucauld's *Maximes* (Nr. 26: "Le soleil ni la mort se peuvent regarder fixement").

But that is only a half-truth. The theologian's or the philosopher's conclusion that death is imageless and therefore cannot be visualized as a person is not really tenable, as every historian knows.[2] It is refuted time and again by the imaginative and sometimes very concrete representations of the imageless that abound in art and in literature and indeed in language. Imagination, being the elementary urge to visualize, does not stop short of the "unimaginable." It gives shape to the shapeless by approximating it to the familiar, thereby endowing it with meaning. At the border of intelligibility, the imagination, according to Goethe's observation about the nature of the symbol,[3] transforms the unin-

telligible into an image that clarifies, elucidates, and thereby renders accessible to understanding what seemed to elude it. The German dramatist Gerhart Hauptmann sketched this process in poetic language, and with a faint touch of Jungian psychology, in his play *The White Savior* (*Der weiße Heiland*):

> All believe what I declare,
> If not all, at least, the many:
> Yet what we know is but little.
> We stand at all knowing's frontiers,
> And we gaze with pious eyes,
> As 'twere from a little islet,
> Deep into the first sea's night.
> That is more than knowledge, brothers.
> For now faces rise before us,
> Images fearful and sublime, –
> Rise out of our very self.
> And the ancient peak of knowledge
> Seems to open out in silence,
> And from its abyss of fire
> It spouts o'er us the sacred flames.

> Manche glauben, was wir wissen,
> sei das meiste, wenn nicht alles,
> und doch ist's das ganz Geringe.
> Stehn wir an des Wissens Grenze,
> blicken wir mit Götteraugen
> wie von einer schmalen Insel
> in des Urmeers Nacht hinein.
> Das ist mehr als alles Wissen.
> Denn dann heben sich Gesichte,
> Bilder, furchtbar und erhaben,
> aus dem eignen Selbst empor.
> Und der alte Berg der Rede
> scheint sich lautlos aufzuschließen
> und aus seinem Feuerabgrund
> heiliges Leuchten auszuspein.[4]

"Strange are these creatures, strange indeed, / Who what's unfathomable, fathom,"[5] Hofmannsthal might have objected: isn't this an all-too-human escape into myth and illusion? And yet it is more and something quite different. For, to return to La Rochefoucauld's metaphor, an image produced in this manner can be looked in the eye; it can be given a name that creates distance, orientation, understanding. What seemed overwhelming in its namelessness and unimaginability has been "domesticated" through interpretation.

In this manner, death, too, rather than remaining shapeless and chaotically threatening, is made concrete and visible by our creative imagination. Such image-making, such interpretation through personification, occurs on all levels of consciousness, in all cultures, in all times that have left records. Many mythologies, including the fall of Adam and Eve that brought death into the world, all but define humans by their knowledge of death, their awareness that they are destined to die. Where there is life, there is its opposite, demarcating the border that circumscribes and, literally, defines it. Thus every reflection about human nature must begin with the end of life. "La mort c'est encore elle seule, qu'il faut consulter sur la vie" – this quotation from Marie Lenéru's play *The Liberated* (*Les Affranchis*, 1911) opens Maeterlinck's ruminations on *La Mort* (1913) – it is death alone that one should ask about life. To speak about life and its possible significance is to speak about death: about our image of death, since we define and understand and shape our life with a view to its ultimate "other." "No doubt every civilization," André Malraux remarked in his *Antimémoires* (1967), "is haunted, visibly or invisibly, by what it thinks about death."[6] Quite apart from all philosophy in the narrower sense (which, to be sure, Montaigne understood to be a matter of teaching how to die and, therefore, to live),[7] what we "think" about death emerges in the image we form of death as the radical opposite of our being and hence the focal point of our search for ourselves.

No single image can capture death in all its allure and horror.[8] Not surprisingly, not one but *many* images come to mind spontaneously or with some reflexion. Mythologies, folklore, religions, turns of phrase, art and literature, and even our daily lives are full of such visually realized or realizable personifications of that which is largely taboo in industrialized societies today – unthinkable and therefore unimaginable. The most

familiar is perhaps the Grim Reaper with his sickle; he makes his appearance early, in the Hebrew Bible (Job 5:26; Jer. 9:21), and again in the Revelation of St. John (14:15–16) but also in the German folksong and hymn mentioned above, "Es ist ein Schnitter, der heißt Tod." Longfellow features him in a much-quoted line of his poem "The Reaper and the Flowers" (1839): "There is a Reaper whose name is Death." The skeleton with the hourglass comes to mind just as easily. Equally commonplace in the eighteenth century was Thanatos, twin brother of Hypnos, god of sleep, familiar from the Sarpedon episode in the *Iliad* (xvi, 688 ff.) or the *Aeneid* (vi, 278); in visual art he appears as a youth with a torch turned to the ground, as in Jean Simon Berthélemy's painting "Apollon et Sarpédon" (1781)[9] or any number of statues and reliefs in our cemeteries. The rider on the pale horse, from Revelation 6:8, has become a household image as well, not least through Dürer's woodcut of the four apocalyptic horsemen. Akin to the rider is Death the hunter – with a lasso in Egyptian mythology,[10] with a sling and a rope in the Bible (2 Sam. 22:6; Ps. 116:3), with bow and arrow everywhere: in the folksong "The Old Archer, Death by Name" (Der alte Schütz, der Tod genannt), in a woodcut in an early edition of *The Plowman from Bohemia* (*Der Ackermann aus Böhmen*, Bamberg: Pfister, 1461), and in many paintings and graphics of the Renaissance, inspired to some extent, no doubt, by the apocalyptic horseman (Rev. 6:2).[11] As late as the seventeenth century William Drummond of Hawthornden chose Death the hunter as *the* allegory of human life: "This world a Hunting is, / The pray, poore Man, the Nimrod fierce is Death."[12]

This series of death images can easily be continued. The biblical angel of death as the messenger of God may come to mind, as may "King Death" of the Middle Ages (with its faint echo in Dürer's 1505 charcoal drawing of the crowned skeleton riding, scythe in hand, on an emaciated nag [see below, p. 88] and even in Shelley's *Adonais* [vii: "kingly Death"]). Death has also made an appearance as dancer, judge, or bailiff (Hamlet's "fell sergeant" [v, 2]), as grave-digger, gardener, and fisherman or fowler with his net (Eccl. 9:12 and still a powerful image in J. R. Schellenberg's Dance of Death *Freund Heins Erscheinungen in Holbeins Manier* of 1785, where, in the copper engraving "Love Disturbed," the skeleton sets up his net for the lovers). Other commonplace personifications include Death as fiddler in the Dances of Death of the early modern

period, as treecutter or forester, as army commander or general (as in the German folksong "Der Tod reit' oft als General")[13] or simply as warrior or mercenary with spear or lance. Peculiar to the German-speaking countries is the proverbial "Freund Hein" or "Hain" who became widely known through Matthias Claudius's dedication of this collected works (1775) to the "boneman" featured in the frontispiece ("a good sort"). The Dutch equivalent is "de magere Hein" (apparently undermining the widespread assumption that Claudius immortalized his physician, Dr. Anton Hein of Hamburg, in his "Freund Hain").[14] A similar personification that may be remembered in this context is "Godfather Death" (Gevatter Tod) of the Grimms' and Ludwig Bechstein's fairy-tales, a death figure, incidentally, that re-emerged in Indian garb in B. Traven's adaptation of a Mexican folktale, *Macario* (1950).

Death the lover is an even more common motif the world over. It gained unprecedented popularity with Gottfried August Bürger's horror ballad "Lenore" (1773) and with Schubert's setting of Matthias Claudius's poem "Death and the Maiden" (Der Tod und das Mädchen, 1824) and it was still going strong in Hofmannsthal's poem on the transience of beauty ("Vergänglichkeit der Schönheit").[15] It had in fact been current as early as the sixteenth century in the crassly sexual variations introduced by Niklaus Manuel, Hans Sebald Beham, and Hans Baldung Grien. The motif lends itself to a whole range of emotions: Death may be the terrifying seducer as in Baldung Grien's paintings, or a "friendly" savior as in Claudius's verses; he may be the fervently desired bridegroom of the soul as in Schiller's *Intrigue and Love* (*Kabale und Liebe*, act v, sc. 1); he may be the lover whose sexual advances are explicitly welcomed as in Edvard Munch's etching "The Maiden and Death" (Pigen og døden, 1894), or he may be the elegant and gallant heart-throb of Ferdinand Barth's lithograph "Death and Young Woman" in his Dance of Death sequence entitled, oddly, *Death at Work* (*Die Arbeit des Todes*, 1867). In the Age of Reason, Death the lover may even be trivialized in pure rococo manner, as in Gleim's "To Death" (An den Tod) in his *Versuch in scherzhaften Liedern* (1744):

> Death, can you fall in love, too?
> Why, then, are you fetching my girl? . . .
> Death, what are you going to do to my girl?

With teeth and no lips
You cannot kiss her, can you?

Tod, kannst du dich auch verlieben?
Warum holst du denn mein Mädchen? . . .
Tod! was willst du mit dem Mädchen?
Mit den Zähnen ohne Lippen
Kannst du es ja doch nicht küssen.

In Herder's poem "Death: A Dialogue at Lessing's Grave" (Der Tod: Ein Gespräch an Lessings Grabe, 1785) the classical Thanatos figure actually becomes Love personified: "Heavenly youth, why are you standing here? Your smoldering torch, turned earthward . . . / Are you Amor? – / I am!"[16]

It would not be difficult to add to this list many more images of death from literature, the arts, and film, images which vary the conventional or traditional notions in an often highly original manner without, however, offering a new paradigm.

All of these personifications, in spite of their differences, visualize death not as an animal or half-animal being or a monstrous demon (death personifications not unknown in mythology) but as a human figure, more exactly: a male figure. "And come he slow, or come he fast, / It is but Death who comes at last" (Scott, *Marmion*, II, 30). Likewise, Longfellow's reaper "with his sickle keen, / He reaps the bearded grain." Death is the male, not the female reaper, the man, not the woman with the scythe, the male, not the female skeleton. Folksongs, both English and German, present Death as a man – powerful, terrifying, grim, and inexorable.[17] In German and in French "leaving for the grand army" is, or used to be, a euphemism for dying which would seem to require us to picture the commander of that army as male.[18] In the landmark dialogue of Death and the plowman, *Der Ackermann aus Böhmen* (ca. 1400), Death is repeatedly addressed as "herre tod" – just as (to compare the seemingly incomparable) "Mr. Death" is ubiquitous in the folklore of sub-Saharan Africa.[19] To return to more well-trodden ground: Schiller dedicated his starkly disillusioned lyrical *Anthologie auf das Jahr 1782* to his "master, Death", addressing him further in equally masculine terms as "tsar of all flesh," "devastator of the Empire," and an "insatiable glutton." From Ingmar

Bergman's film *The Seventh Seal* one remembers Death as a male, not a female chess player (a motif dating back to the Middle Ages),[20] and no less male, finally, is the death figure in White Zombie's video "Thunderkiss."

Surely, this deliberately mixed bag of "cases" of male death personifications gives one pause. We tend to think of Death as male, it seems; and yet Death may be female, and indeed, gender is one criterion which allows us to perceive some order in the multitude of personifications of death prevalent in a variety of cultures – a criterion, of course, that would not seem to be far-fetched these days. Rebelling against examples such as those cited, Jeanne Hyvrard provocatively entitles her appraisal of present-day feminist awareness *Mère la Mort*, Mother Death (1976). But the longing for death as a return to maternal love is by no means a sentiment that only women may claim for themselves; staying in the same culture, one need only think of the power that Mother Death exerted over French historian Jules Michelet. (It is not for nothing that Edward K. Kaplan called his selection from Michelet's diaries *Mother Death* [1984].)

Personifying death as male is anything but a universal habit of the imagination, prevalent at all times in all cultures, nations, and languages; it is not even consistent within such communities. Some contrasting pairs of examples may remind us of this. To Death the bridegroom, common in German and English folksongs (to which Bürger's "Lenore" owes its inspiration), there corresponds in several cultures the image of Death the bride: the Germanic goddess Hel, Persephone in Greek mythology, Ishtar in the *Gilgamesh* epic; in Euripides' *Heracles* (verses 481–482) the Kers are apostrophized as "the brides of the dead"; and Death the bride functions as a counterpoint to the "Death and the Maiden" motif, in Ukrainian folksongs as well as in a Latvian Lament of the Dead,[21] not to mention Shakespeare's plays, *King Lear*, for example (IV, 6, 203). Death bringing the plague (or should one say, the plague bringing death?) survives as male in the game of German and Swiss children "Who's afraid of the black man?" (Wer hat Angst vorm schwarzen Mann?) and in French Dances of Death; but in Scandinavian folklore and in Italian pictorial representations, in the *Trionfi della morte* – murals, miniatures, cassoni, and poetry such as Petrarch's – this particular Death is normally a woman dressed in black, reminiscent of the furies

or harpies of Antiquity, as she still is in Arnold Böcklin's Symbolist painting "Die Pest" (1898).[22] Also ambivalent is the angel of death, wreaking destruction as the messenger of the Lord.[23] In Jewish tradition as well as in early Christian and medieval iconography, angels of death and angels generally are male, sons of God, the youths or bearded men of Rembrandt's etching "Abraham Entertaining the Angels" (1656), of Milton's *Paradise Lost* (1667), of Blake's *The Marriage of Heaven and Hell* (1790), of Goethe's *Faust* (11.794ff.), and of Byron's poem "The Destruction of Sennacherib" (ca. 1815), where "the Angel of Death spread his wings on the blast." By this time, however, indeed since the Renaissance at the latest, angels are often female, though of course not always (Caravaggio comes to mind). This female personification keeps gaining ground and becomes clearly dominant in the late nineteenth and earlier twentieth century – one thinks of the angel of death in the American sculptor Daniel Chester French's relief "Death Staying the Hand of the Sculptor" (1893) in the Metropolitan Museum of Art in New York, of Carlos Schwabe's watercolor "Death of the Gravedigger" (La Mort du fossoyeur, 1900) as well as of a number of turn-of-the-century paintings by Polish Symbolist Jacek Malczewski and even of Balanchine's ballet *Serenade* of 1934.[24] Still, works such as Jacob Epstein's scandal-prone monument for Oscar Wilde in Père Lachaise (1912) and Wim Wenders' film *Wings of Desire* (1987) remind us that the male angel is not entirely a matter of the past.[25] Another case history illustrating the male/female ambivalence of death figures: There is hardly an anthology of last words that fails to list the dying remark of St. Francis as "Welcome, Sister Death." Why not Brother Death as in Goethe's *Faust* or in Ernst Wolfhagen's 1962 woodcut "Brother Death" (whom Rimbaud, too, seems to ignore in his poetic exclamation: "O mort mysterieuse, ô sœur de charité!")?[26] Yet Robert Schneider's startlingly successful novel *Schlafes Bruder* (1992) revives the once well-known Protestant hymn that claims Death as the "Brother of Sleep," and without the slightest allusion to the classical twins Hypnos and Thanatos at that.

Elsewhere in life and literature Death is unambiguously female. Only a few, deliberately varied examples need be cited. In Cocteau's play *Orphée* of 1927, made into a film in 1949 and more recently turned into a postmodern opera by Philip Glass, Death figures as "Madame," much as

in Camus's *Etat de Siège* (1948), where Death is the secretary-bureaucrat who registers the victims of the plague in her ledger. In the Mediterranean countries, female Death is not all that unusual, though by no means *de rigueur*. Already mentioned was Petrarch's black-dressed "donna" of furious mien. Variations range from Ronsard's "Hynne de la mort" (1555), where Death is apostrophized as "great goddess" (grand' Déesse), all the way to Baudelaire's "Danse macabre" in the *Fleurs du mal*, where she is a "maigre coquette." Among painters, Gauguin stands in this tradition with his frontispiece to Rachilde's (Marguérite Vallette's) play *Madame La Mort* (1891), where Death appears as a ghost or a specter in the shape of a "femme voilée." Even Rilke was receptive to this tradition, in the fifth *Duino Elegy*:

> Squares, o square in Paris, endless showplace,
> where the *modiste*, Madame Lamort,
> twists and winds the restless ways of the world,
> those endless ribbons, and from them designs
> new bows, frills, flowers, cockades, artificial
> fruit – all cheaply dyed – for the paltry
> winter hats of fate.
>
> Plätze, o Platz in Paris, unendlicher Schauplatz,
> wo die Modistin, Madame Lamort,
> die ruhlosen Wege der Erde, endlose Bänder,
> schlingt und windet und neue aus ihnen
> Schleifen erfindet, Rüschen, Blumen, Kokarden, künstliche
> Früchte –, alle
> unwahr gefärbt, – für die billigen
> Winterhüte des Schicksals.[27]

In Spanish culture Death tends to be a woman as well. It is not for nothing that Tomi Ungerer's color lithograph of 1973 featuring an elegantly dressed woman dancing with a tambourine in her hand, with her bright red lips showing that she is anything but a skeleton, is entitled "La Mort en espagnol."[28] In Mexico, easily one of the most death-obsessed countries in the world, as Octavio Paz demonstrated in his famous essay on All Souls' Day in *The Labyrinth of Solitude*, it is "Aunt Sebastiana" or

"doña Sebastiana," who to this day represents Death on the highest of Mexican holidays. As a tourist souvenir or a toy, as a piece of candy or a puppet decorating the altar set up on All Souls' Day in honor of the family's dead – this Death is always a woman, a skeleton, to be sure, but invariably identified as a woman through her dress or other attributes such as her long hair ("la pelosa" is another name by which Sebastiana is known, referring to her tresses). And this folklore informs art: present-day Mexican and Mexican-American painters and writers still portray Death as a woman, as could be seen in the Mexican Fine Arts Center Museum in Chicago in 1991[29] and (to give another random example) in Eduardo Rodríguez-Solís's "comedy" *Las Ondas de la Catrina*, performed in New York in 1994 as *The Fickle Finger of Lady Death*. The Mexican conceptualization of death as female may hearken back to the personification as Empress approved by the Catholic Church during Mexico's colonial period.[30] Or does the tradition go back further, beyond colonial conventions, to preconquistadorial times? It is well known that Mexican Catholicism today preserves prehispanic symbolism even in its church service; and the ceremonies associated with All Souls' Day in particular have their links with pre-Columbian rituals honoring the dead.[31] Is it a coincidence that the Aztecs (the tribe with which the conquerors were in closest touch) as well as other peoples, believed that not only a god but also a goddess, his spouse, both carved in monumental sculptures, presided over the realm of the dead? And superior to both of these deities was the goddess Tlaltecuhtli, a terrifying monster representing, much like the goddess Coatlicue, both maternal fertility and death.[32]

In the Slavic world, too, Death is a woman more often than not. In Russian folklore and fairy tales Death is the witch-like Baba Yaga (who evokes other associations as well); in Czech folksong she is Smrt; in the popular superstition of other Slavic countries she may be a white woman with green eyes known in mythology as Giltine, goddess of death.[33] And further east, too, death is not infrequently personified as a woman. The apocryphal gospel of Bartholomew contains a remarkable example of the imaginative realization of the unimaginable in its account of Christ's descent into hell (a variant of which is also to be found in the *Golden Legend*): Death, who is "our queen" (regina nostra) and the wife of the devil, is bound with fiery chains.[34] The Indian mythological epic *Mahab-*

harata (200 BC – AD 200) tells the story of the creation of Death by Brahma, who had originally created humans to be immortal; a beautiful woman emanates from Brahma's body, bedecked with jewels and crowned with lotus flowers – a goddess by the name of Death. She is to terminate the lives of men and women, the wise and the foolish, the old and the young, in order to prevent overpopulation; and after first trying to avoid this terrible duty out of pity for mankind, she eventually consents.[35]

Germanic mythology and folklore are equally hospitable to female Death. Their deity that wields power over the dead, though she herself does not kill, is the above-mentioned Hel (Halja), who was still alive in nineteenth-century superstition as Jacob Grimm noted; at the same time she is the deity of fertility, indeed the Earth Mother[36] – a conjunction and identification of beginning and end, life and death, procreation and destruction, maternity and deadliness which is at home in many mythologies the world over. (The Fates of Antiquity spin the thread of life *and* cut it; their name, Parcae – the name of the deity of death – is derived from *parere* [to give birth]. Persephone stands for death and ever-renewed life; the Great Mother of several mythologies is the goddess of death. The deadly Baba Yaga is also Mother Nature. Kali symbolizes fertility and death, as does the Aztec Tlaltecuhtli.[37]) To return to the Germanic imagination: in the Gísli saga a woman appears to the outlaw hero in his dream to announce his imminent death; she has been identified as one of the *dísir*, the goddesses of fertility that are at the same time goddesses of death,[38] as are the Norns, the Fates, most closely resembling the Parcae. Even the nameless elf in the folk ballad "Erlking's Daughter," a Scandinavian variant of "la belle dame sans merci," may be seen as a personification of death: in the ballad, which was included in the *Heroic Ballads* (*Kjaempeviser*) and then in Herder's *Folksongs*, she strikes the young rider Oluf on his heart, and "there lay Sir Oluf, and he was dead."

Even in our own century death, normally the Grim Reaper, may make its appearance in female shape in the superstition, fairy tales, and folklore of German lands. "Sometimes it is a couple, Death and his wife, who come into the country with a scythe and a rake," according to popular belief.[39] Local legends, too, are familiar not only with Death as a bony

man (Knochenmann), but also as his wife: a folk story from Uri, Switzer-
land, begins: "One day Death and his wife (die Tötin), came hiking up
the valley of the Reuß";[40] and especially the folklore of the southeastern
corner of the German-speaking region of Europe held on to the Death-
Woman (die Tödin) into the twentieth century. She is a white figure, a
misty shape stalking field and forest by night – old or young, ugly or
beautiful and usually alone, though the couple, Mr. and Mrs. Death, is
not unheard of in this superstition either.[41] (The death-as-couple motif
can be found in the Austrian Adolf von Tschabuschnigg's folksong-like
poem "Tod und Tödin" [1841], set to music by Carl Loewe: theirs is a
petit-bourgeois household – *he* has so much to do with the burial of the
dead that it interferes with his love of domestic *Gemütlichkeit*; *she* is up
late washing the funeral shirts of the dead in the nearby brook and plant-
ing flowers on the graves.[42]) And as already mentioned, this female death
figure of folk belief can be encountered under the same name even in a
highly literary poem by Paul Celan, included in his *Thread Suns* (*Faden-
sonnen*, 1968). Finally, the identification of motherhood and death, ubiq-
uitous in folklore and mythology, appears in literature in such far-flung
works as Whitman's *Leaves of Grass* (see below, pp. 201–203) and Anna
Croissant-Rust's story "The Corn Mother" (Die Kornmutter), in her nar-
rative cycle *Death* (*Der Tod*, 1914): the archaic and the everyday, motherli-
ness and deadliness, the joy of living and the horror of death are
combined here in a literary myth inspired by folklore. Much the same is
true of the paintings of George Frederick Watts (see below, pp.
203–205). Like other archaic images, these ancient embodiments of
death live on to this day in literary and pictorial art.

II

Death a man, Death a woman – if imaginative personification of the
unknown is one of the characteristic features of our species, why does it
operate in such contradictory ways? If it defines "human nature," why
does it not define it in a more uniform manner? Why, instead, this polar-
ity of images, chosen deliberately from bafflingly heterogeneous sources
– a polarity of images that, on the one hand, unites cultures and historical
periods with apparently little else in common and, on the other hand,
splits up otherwise homogeneous cultural and linguistic communities?

One explanation relies on the distribution of power in a given community, contrasting matriarchal (normally agricultural) and patriarchal (normally hunting and warring) societies:

> Death will be seen as masculine or feminine according to whether it typically occurs in a phallic-penetrating or vaginal-enveloping form. Thus in a hunting society, or a martial one, death is most likely to occur in the form of some kind of wounding or tearing, whether by the goring, clawing, or trampling of beasts, or by the weapons of man. Such events will tend to be associated with masculinity, and with paternal strength and power ... In an agricultural or peasant society ... death is more apt to come from starvation and disease and hence to be experienced as an envelopment and associated with maternal deprivation. It is no coincidence that human sacrifice to blood-thirsty goddesses is typically found in highly developed and stable agricultural societies with considerable specialization and interdependence, such that crop failures cannot be compensated for by branching out into other modes of subsistence, but simply cause mass starvation.[43]

Such thinking assumes, however, that primitive mindsets of this kind continue to be virulent in much later, industrial communities. But these societies are so complex that one cannot *a priori* expect that they are dominated by just *one* concept or image of death, as Malraux still seemed to imply. Moreover, this explanation fails to account for the image of female Death with destructive weapons like lance and scythe in her hands, as, for instance, in the Pisa fresco of the "Triumph of Death," which according to such thinking would have to be associated with masculine violence instead.

No less simplistic is the explanation derived from psychoclinical observations of the dying that posits that Death is welcomed as a lover, hence it is male or female in accordance with the thoughts of the dying person.[44] Also, present-day readers would find unacceptable the conviction of philologists as late as the first half of the twentieth century that grammatical gender (where it exists) – widely believed to condition our

imaginative personification of death – is in its turn determined by "psychological factors"[45] in the sense that everything great, strong, intimidating is genderized as male, everything endearing and "reminiscent of the destiny and functions of woman" as female. Such dominant figures as Jacob Grimm and Wilhelm von Humboldt did indeed believe that some sort of imaginative "extension of natural gender to all manner of objects"[46] played a role, if not the only one, in the formation of grammatical gender. But this, of course, begs the question. *Why* is death masculine in some languages and feminine in others? Why should "psychological factors" vary in this manner from one language and culture to the next? Is it not, rather, a matter of the influence of fundamental cultural, perhaps mythological views that vary from one community to another? – which in turn poses the question of the reason for this variability.

The most recent attempt to explain the duality of male and female personifications of death, Gert Kaiser's observations in his book on the theme of Death and the Maiden, *Der Tod und die schönen Frauen* (Frankfurt: Campus 1995), takes its cue from the Dances of Death of the late Middle Ages and the early modern period. In them, female death figures are seen as "mocking figures" fulfilling "the same function as the abbot's mitre that Death wears in the Basle Dance of Death or the knight's armor or fool's cap donned by Death – a scornful mask" demonstrating Death's "ability to change to conform to his victims" (p. 123). Coming from a study of male death figures in art and literature though it is, this is an intriguing line of reasoning. It would, however, need to be tested against the long and rich history of death personification before and after the Dances of Death; after all, they constitute only one chapter in the art history of death. And indeed, even in the Dances of Death themselves, Death is not by any means always presented as a sort of mirror image of the victim. Not all women are approached by Death in the guise of a woman, nor are all knights summoned by him in the shape of an armored knight. In Dürer's woodcut "Death and the Fool" the fool wears the fool's cap, but Death does not. And vice versa: Death may accost a man in the shape of a woman, for example the priest or canon in Niklaus Manuel's Dance of Death in Berne; dressed as a fool, Death may come to fetch a person who is by no means identified as a fool, as in Holbein's

Dance of Death, in Hans Sebald Beham's engraving "The Lady and Death," or in Chodowiecki's "Dance of Death" where Death, the court jester, summons the queen. We may conclude that an artist's choice of female Death is determined by factors other than the supposed need for a female mask or mirror image. But which factors?

The explanation for the male/female dichotomy of death images most frequently heard and indeed often considered self-evident is the grammatical gender of the word for death in a given language, though the just-mentioned "psychological" explanation of grammatical gender in its turn, so dear to generations of philologists, has by now been abandoned, of course. (The designation of grammatical gender as "masculine" and "feminine" originated with early Greek grammarians.)[47] According to such grammatical gender "theorists," *der Tod* would mandate that death be personified as male, just as *la mort, la morte, la muerte,* as well as variations of *smrt* in the Slavic languages, would make female anthropomorphism inevitable.[48] The contemporary German poet Karl Krolow even wrote a poem establishing this connection between grammatical gender and mythopoetic imagination.[49]

Exceptions may easily come to mind – examples from art and literature indicating that death may be visualized as male in Romance or Slavic language cultures or as female by speakers of Germanic languages. But before turning to such cases, some general linguistic reflexions on grammatical gender and its supposed determination of our perception of reality are in order. Few, if any, cultures do not form images of death. But apart from languages that order their nouns (and their perception of reality?) in only two categories, namely masculine and feminine, as does French for instance, there are also languages such as Finnish and Hungarian or postmedieval English, that do not have grammatical gender at all. So, why would turn-of-the-century Finnish painter Hugo Simberg consistently portray death as male, just as Finns today visualize death as the "bone*man*" (to translate the epithet into English literally)? And why do Hungarians ordinarily personify death as male, though an artist like Ilona Bizcó Fábiánné portrays death as a female reaper holding a scythe, in a copper engraving of ca. 1920?[50] What principles (if that is the right word) does the imaginative personification of impersonal nouns or concepts follow in languages that have no grammatical gender? When

Shakespeare, writing some 300 years after the extinction of grammatical gender in English, personifies or anthropomorphizes abstract nouns, he sometimes differs in his choice of gender from his contemporaries. Moreover, in such Shakespearean personifications the Old English gender of a given word "is irrelevant: Old English feminine and masculine nouns may assume the opposite gender when they are personified."[51] The same is true when Shakespeare poetically personifies English words derived from French, dubbing them as "he" or "she."[52] On the other hand, when Shakespeare and his contemporaries deviate from Old English grammatical gender in their genderizing of a word, the influence of French (or Latin) may play a role, as in *sun* (feminine in Old English, male in poetic language to this day) or *moon* (masculine in Old English, feminine in poetic usage).[53]

Other languages that do not have masculine/feminine grammatical gender order their nouns according to different semantic categories such as animate/inanimate, human/nonhuman, rational/nonrational, strong/ weak, big/small, concrete/abstract – or a combination of such categories. Four such grammatical "genders" or rather noun classes are not infrequent, twenty are possible (not considering nonsemantic, that is formal, morphological or phonological criteria for classification).[54] How do speakers of such languages personify death? As male or female? And why?

But even if a language has grammatical gender in the strict sense, its nouns being either masculine or feminine (or neutral), the relationship between grammatical gender and imaginative representation or indeed reality is by no means consistent and predictable. In Old Norse the word for the hero or brave man is grammatically feminine (*hetja*), the word for a haughty woman is masculine (*svarri*); Latin *nauta* (sailor) is morphologically feminine but of course any adjective will take the masculine ending (*nauta bonus*). Turning to the grammatical gender of words that do *not* designate a man or a woman, we find again that the relationship between grammatical gender and imaginative personification (male/female) is highly complex and not at all self-evident. For example: are *la maison* and *die Uhr* visualized as somehow female? Clearly not. In other words, grammatical gender exerts no normative power over imaginative visualization. Ships are female in English, but not necessarily

visualized as women.[55] The pope is "sa Sainteté" in French, with any adjective and the personal pronoun requiring the feminine form, even though a speaker of French does not visualize the pope as a woman (Pope Joan notwithstanding). Also, the grammatical gender of some nouns has changed in the course of time, certain words can have different gender depending upon circumstances (for example, *baby* and *doctor*),[56] and grammatical gender may vary in a given period, indeed with one and the same author, even in the same work.[57] In closely related languages identical words, when personified, take on different genders: before the collapse of masculine and feminine gender into one, the moon was female in Dutch, male in Swedish. When words migrate from one language to the other, from Gothic into Old High German, for example, or from Latin or French into German, their grammatical gender may change: *murus* becomes *die Mauer, le courage* emerges as *die Courage,* etc.[58] There are even regional variations of grammatical gender, as in present-day German.

Such general considerations render the connection between grammatical gender and imaginative personification unreliable, or tenuous at best. This is particularly true in the case at issue here, as some earlier examples suggest. What do we make of the fact that in German folklore there is a male as well as female Death, though grammatically there is only masculine death? In the Germanic languages of Scandinavia, the home of female death figures, the word for death was grammatically masculine until the Middle Ages, when the masculine/feminine distinction disappeared from their grammar.

The disconnection between grammatical gender and visualization of death is readily illustrated in the art and literature of a number of cultures. (What follows are really only *examples*; the subsequent chapters will introduce others cases and place them into a wider frame of cultural reference.) Jacob Grimm, at the dawn of modern philology, found it curious that Roman art, in spite of the feminine gender of *mors*, "never" represented death as a woman.[59] Instead, "mors imperator," Emperor death, was the standard phrase, which is still echoed in Ernst Barlach's woodcut of this title (1919). In the Uta codex, the early eleventh-century gospel of abbess Uta of the Niedermünster nunnery near Regensburg, a much-reproduced miniature of the crucifixion represents death ("Mors")

at the foot of the cross in the shape of a man – he is overcome by Christ, the sickle drops from his hand, and the point of a lance hits and kills him.[60] A similar incongruity between grammatical and natural gender confronts a speaker of German in Alfred Kubin's pen-and-ink drawing "The Best Physician" (Der beste Arzt, 1901–02) which presents Death as a lady in evening dress, or in one of the drawings of Kubin's *Dance of Death* (*Totentanz*) sequence, *Die Blätter mit dem Tod* (1918), where Death is a solicitous old woman (no. 8), or finally in Klaus Drechsler's aluminum print of Death as a nurse, "Death with a Child" (Tod mit Kind, 1991).[61] Earlier instances from the German-speaking areas include Franz von Pocci's *Todtentanz* (1862: Death as an old woman with a basket on her back), Schellenberg's *Appearances of Freund Hein* (*Freund Heins Erscheinungen*, 1785, no. 35: Death as a rococo lady welcoming her suitor) and Hans Holbein the Younger's sequence of woodcuts known as *Großer Totentanz* (ca. 1525) in which Death summons members of the various classes in the shape of a man, but wears female garb when he confronts the empress and the nun (nos. 29 and 30).[62]

The situation is no different in the anglophone world. If in the English-speaking countries death is thought of and portrayed as male "almost without exception," typically as "the old man with the scythe" as the *Times Literary Supplement* reminds us on January 12, 1996 (p. 7), then one

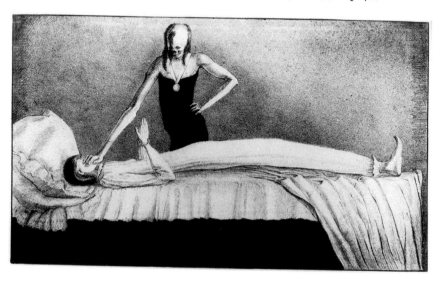

PLATE 2 Alfred Kubin: The Best Physician (1901–02)

wonders how the English reader reacted to the unusual appearance of a female death figure in the works of prominent Middle-English authors such as Occleve and Lydgate in the first half of the fifteenth century.[63] One would also like to know whether English readers were perplexed when in Florio's perfectly idiomatic translation of the *Essais* of Montaigne (1603) they found Death referred to as "shee" – in essays that are among Montaigne's most frequently quoted. Would it have been helpful to have remembered Geffrey Whitney's poem "While furious Mors, from place, to place did flie" (in his *Emblemes* of 1586) where death is personified as a "leane virago" (p. 132)? Edward, Lord Herbert of Cherbury continued bucking the trend in his well-known poem "To his Mistress for her True Picture," which apostrophizes Death as "my lifes Mistress and the sovereign Queen / Of all that ever breath'd" (1665 in his *Verses*).

To be fair, English literature has never been overly hospitable to the female death icon, nor has American literature. It is all the more noteworthy, therefore, that countless anthologies of American poetry include Whitman's elegy on the death of Abraham Lincoln, "When Lilacs Last in the Dooryard Bloom'd," with its haunting "Come lovely and soothing death, / . . . Dark mother always gliding near with soft feet." And one of the more widely read American novels of the twentieth century, John O'Hara's *Appointment in Samarra* (1934), unapologetically chooses as its epitaph a fable (borrowed from Somerset Maugham's play *Sheppey*) about Death as a woman encountered in a market-place. It is this fable that gives the book, a present-day New England family tragedy, its title and allegorizes its plot with the exoticism of the Near East:

> Death speaks: There was a merchant in Bagdad who sent his servant to market to buy provisions and in a little while the servant came back, white and trembling, and said, Master, just now when I was in the market-place I was jostled by a woman in the crowd and when I turned I saw it was Death that jostled me. She looked at me and made a threatening gesture; now, lend me your horse, and I will ride away from this city and avoid my fate. I will go to Samarra and there Death will not find me. The merchant lent him his horse, and the servant mounted it, and he dug his spurs in

its flanks and as fast as the horse could gallop he went. Then the merchant went down to the market-place and he saw me standing in the crowd and he came to me and said, Why did you make a threatening gesture to my servant when you saw him this morning? That was not a threatening gesture, I said, it was only a start of surprise. I was astonished to see him in Bagdad, for I had an appointment with him tonight in Samarra.

Nor are the pictorial arts of the English-speaking countries strangers to female death figures. At the turn of the century George Frederick Watts's work prominently features the motherly death image, most conspicuously in his painting "The Court of Death," while the late Pre-Raphaelite Thomas Cooper Gotch, in his turn-of-the-century painting "Death the Bride," evokes reminiscences of Ophelia or Persephone with the "bride" emerging from a lush field of poppies. And as late as 1922 John Singer Sargent, in a mural in the library of Harvard University, represented Death as a shrouded woman embracing a soldier fallen in World War I.

An interesting French example of the conflict of natural and grammatical gender is van Gogh's self-interpretation of a late painting depicting a male reaper in a sun-drenched wheat field, wielding a scythe. Van Gogh wrote to his brother Theo in September 1889: "I see in this reaper – a vague figure toiling away for all he's worth in the midst of the heat to finish his task – I see in him the image of death, in the sense that humanity might be the wheat he is reaping . . . But there is no sadness in this death . . ." (J'y vis alors dans ce faucheur – vague figure qui lutte comme un diable en pleine chaleur pour venir à bout de sa besogne – j'y vis alors l'image de la mort, dans ce sens que l'humanité serait le blé qu'on fauche . . . Mais dans cette mort rien de triste . . .).[64] Van Gogh speaks of "la mort" but he sees a male figure, the "faucheur" he has painted. Much the same is true of Jean Anouilh when in his "pièce noire" *Eurydice* (1958) he does not introduce Death, as did Cocteau in his revival of the myth, as an elegant lady in evening dress, accompanied by two surgery assistants, but instead as "Monsieur Henri," a cigarette-smoking young man wearing a rain coat whom we encounter in the railroad station and a hotel of a provincial town in France. Ionesco follows the same pattern: the stage

PLATE 3 Jean Grandville: *Journey to Eternity*, no. 7 (1830)

directions for *Jeux de massacre* (1970) require that the dumb role of La Mort be performed by a man who resembles a monk in his black cowl. Likewise, in Baudelaire's *Fleurs du mal* (1857, 1861) Death is not always female as in "Danse macabre"; in the concluding poem of the volume we read "O Death, old captain, it is time! Let's weigh anchor!" (O Mort, vieux capitaine, il est temps! levons l'ancre!). Jean Grandville in his sequence of Dance of Death graphics *Journey to Eternity* (*Voyage pour l'éternité*, 1830) only rarely introduces Death as a woman; most personifications are male: coachman, postilion, waiter, dandy, etc., and, most grippingly, a bearded skeletal officer with a sword, epaulettes, and towering bearskin cap sporting a tassel fluttering in the wind; this is how Death marches ahead of a band of volunteers under a banner inscribed "Immortalité" – straight into the battlefield from which they will not return, as one of the well-wishing bystanders seems to sense as she wipes her tears away with a handkerchief.[65] This incongruity of grammatical

gender and visual representation of death does in fact go back to the Middle Ages in the French-speaking territories. In a fifteenth-century book of hours preserved in the Bibliothèque Nationale one comes across a miniature presenting Death as a crowned cadaver sitting on a grave that is described as "King" Death in the Latin text ("regem cui omnia vivunt").[66] Contemporaneous with it is the much-noted Dance of Death poem taking its title from the eating of the apple in Paradise *Le Mors de la pomme* in which "La Mort" describes itself as God's "sergant criminel," God's bailiff, foreshadowing Hamlet's metaphor.[67] And in a miniature by Jean Colombe in the famous book of hours of Duke Jean de Berry (1485–89), Death (*la mort*, of course), a knight on a white steed, in courtly dress, charges with drawn sword over graves into a band of armed soldiers separated from him by a long procession of the dead wrapped in their shrouds.[68] Similarly, in the Italian Middle Ages Death appears, in a marble relief in the church of San Pietro Martire in Naples (1361), as an unmistakably male falconer holding a falcon on his raised hand, surrounded by his real quarry: the human dead of all ranks and classes. The inscription, of course, cannot reverse the convention of grammatical gender, "Eo sono la Morte."[69]

In Spanish art and literature, too, personifications of death are independent of the grammatical gender of "muerte." Cervantes and Calderón immediately come to mind. In the second part of *Don Quixote* the knight of the mournful countenance runs into a company of strolling actors; among them is a young man who plays the role of Death in their performances – even though (as an Elizabethan or Jacobean would be surprised to hear) there are women in the troupe (ch. 11). In Calderón's Corpus Christi play *King Balthasar's Feast* (*La Cena del rey Baltasar*) Death makes his appearance in the shape of a nobleman with a sword and courtly dress, identifying himself as the son of sin. Similarly, Spanish pictorial art, from the sixteenth century to the present, has been featuring male death figures along with female ones, though only the latter correspond with the grammatical gender of *muerte*.[70] Thus, Dalí's color etching "Death and the Maiden" in *Apollinaire: Poèmes secrets* (1967) confronts a fleshy young woman with a Quixotic knight on horseback swinging his guitar.[71] A particularly telling example is the woodcut "Song of Stalingrad" (Corrido de Stalingrado) by Mexican artist

Leopoldo Méndez: it shows a uniformed Russian commissar on horse-back, sabre in hand, riding across a battlefield strewn with dead soldiers – his head is a skull.[72] In case one wonders whether the foreign socio-political situation might have determined the gender of Death in this image – assuming that Soviet commissars were usually male – one might turn to José Guadalupe Posada's rather similar leadcut "Calavera Zapatista"; it presents the Mexican peasant leader Emiliano Zapata as a "skeleton in Mexican dress riding on an almost skeletal nag, wearing a huge sombrero on his oversized skull, carrying a rifle over his shoulder and holding a banner with skull and crossbones in his hand."[73] And in our own days Mexican painter Francisco Toledo still stuns the viewer with his fresco "Death Descending Stairs" (La muerte bajando la escalera, 1988): it features a skeleton with more than just a hint of male genitals.[74]

These few cases, chosen from diverse cultures and languages, are enough to suggest that grammatical gender is not necessarily the determining factor when death is personified and, inevitably, genderized. Would it not be more logical to inquire how and why words signifying nothing specifically male or female (such as "death") are endowed with masculine or feminine grammatical gender in the first place? Why *la mort* but *der Tod*? When literary scholars turn their attention to personification as a stylistic device, they too, much like psychologists and linguists, postulate a prelinguistic realm as the locus in which such determinations are made. "The origins of personification lie deep in the past and are related to primitive animism," notes the literary historian and philologist Morton W. Bloomfield in a much-cited study on "A Grammatical Approach to Personification Allegory."[75] Such prelinguistic factors of imaginative visualization, then, may have inspired English authors to ascribe a male or female connotation to words not signifying either gender, long after grammatical gender disappeared from the language. "A writer of English," says Bloomfield, "after about 1300, unlike his German or French counterparts, had more or less freedom in choosing masculine or feminine gender for his personal figures" representing abstract nouns such as *victory* or *life* (p. 244). In other words: the grammatical gender of Old English exercised no influence on this decision. On the contrary, the new situation was comparable to that of lan-

guages that had never had grammatical gender. Instead of the lingering effect of defunct or obsolescent grammatical gender, quasi-mythical, archaic images ("primitive animism") indigenous to the culture in question were and are more likely responsible for determining the gender of abstractions like *death* – which may confirm or contradict the visualizations possibly implied in this or that erstwhile grammatical gender. To return to Gustave Moreau's densely symbolic "The Young Man and Death," whose genesis showed that an original male death figure was replaced by a sumptuous female one:[76] mythological, archaic images may well have stirred the artistic imagination, not French grammar.

An analogous conclusion is suggested by the observation of a Jungian psychologist that "archaic representations of the demon of death" recur in male *and* in female shape in the dreams of individuals who are at home in only *one* language and, as it happens, one that *does* have grammatical gender.[77] Of similar interest is the experiment of psychologists Aisenberg and Kastenbaum who around 1970 interviewed a broad spectrum of English-speaking Americans about their instinctive or habitual personification of death: If Death were a person, what sort of a person would it be? The subjects were asked to think about this question until an "image" of death as a human person would emerge. The result was that not one image but many, and very different ones, presented themselves to the imagination of men and women who in their daily lives did not have any particular exposure to visual or literary personifications of death. The differences in these images had to do primarily with the gender of Death. While several respondents saw Death as possibly male *or* female, most conceived of it as a man exclusively, and some saw it as a woman exclusively: young woman, old man, comforting woman, terrifying man, female lover, male lover, etc. Clearly, cultural and/or psychic factors were playing a role here, quite independently of grammatical gender, which is (largely) absent in English in any case.[78]

Recent anthropological research into grammar reinforces these findings. Synthesizing over a century of theorizing about grammatical gender, Greville Corbett concludes that skepticism about the formative influence of the grammatical gender on our visualization of abstract words such as *death* is indeed widespread. Grammatical gender (which, to repeat, may change over periods of time) does not by any means

predispose the speaker of a given language to form a male or female "image": *table* is grammatically feminine in French, Corbett reminds us, adding that it does not follow that a speaker of French thinks of a table as female. Grammatical gender in turn appears to be determined by semantic factors, i.e., quasi-mythical, folkloric concepts and images current in a linguistic or, more important, cultural community.[79] This is how Jacob Grimm had explained the origin of grammatical gender.[80] We hear an echo of this view in modern linguistics: "The world view of the speakers determines the categories involved" in grammatical classification of nouns (masculine/feminine or animate/inanimate or whatever); as a result, a high degree of complexity, even contradictoriness in the relationship of grammar and meaning, of language and image has to be expected.[81] And as far as literature and the arts are concerned, recent linguistic investigations even concede the possibility and legitimacy of individual variation, indeed of artistic deviation from whatever the pertinent "rule" may be.[82]

If linguistics gives rise to strong doubts, at the very least, about the assumed correlation of grammatical gender of a word and the corresponding mental image realized in art and literature, then the specific question for the historian of art and literature is: what does a deliberately male or female personification of death reveal about artists' or authors' perception of reality and, further, about their cultural community and its religious, mythological, or historical perceptions or preconceptions? What light is shed on their creative and imaginative transformation of the world, on their self-understanding and their image-making that gives order and meaning to their experience? Such image-making invariably springs from an encounter with the incomprehensible, baffling "other" in that moment of astonishment or wonder that is at the root of all culture. For it is this wonder that challenges the image-making, name-giving, and hence interpreting propensity to meaning that defines our species. One of the most significant aspects of this propensity is our imaginative coming to terms with death.

III

As one approaches this question with a view to Western art and literature, it is reasonable to expect that the mythologies dominating this cul-

tural domain, the biblical and the classical, should have left their marks. Thanatos comes to mind: the Greek personification of death as a graceful, gentle youth turning a still-burning torch earthwards, symbolically intimating the extinction of life. This icon did indeed have an intensive afterlife in European art and literature, especially since its rediscovery by Lessing in the 1760s – or rather, since its "creation" by Lessing through a productive misunderstanding (see below, p. 137). Thanatos naturally appealed to the enlightened mind, or more specifically, to its animosity against Christianity with its intimidating allegory of death as a skeleton or decomposing cadaver. Schiller's polemical juxtaposition of the two could not be more pointed (he also implies the synthesis, mentioned above, of death and love, Thanatos and Eros):

> None but a howling sinner could have called death a skeleton; it is a lovely, charming youth, in the flower of life, the way they paint the god of love, only not so mischievous, a quiet, ministering spirit who lends his arm to the exhausted pilgrim soul to help her across the ditch of time, opens up the fairy castle of everlasting splendor, nods in a friendly fashion, and disappears.

> Nur ein heulender Sünder konnte den Tod ein Gerippe schelten; es ist ein holder niedlicher Knabe, blühend, wie sie den Liebesgott malen, aber so tückisch nicht – ein stiller dienstbarer Genius, der der erschöpften Pilgerin Seele den Arm bietet über den Graben der Zeit, das Feenschloß der ewigen Herrlichkeit aufschließt, freundlich nickt, und verschwindet.[83]

Thanatos is not threatening; he certainly does not kill. The Sarpedon episode in the sixteenth book of the *Iliad* introduces him in a typical role: there he joins his twin brother Hypnos in carrying the Lykian prince slain by Patroklos from the battlefield so he can be buried in his homeland – no suggestion of a torch turned earthwards.

Despite Lessing's partisanship for Thanatos in the shape of the gentle youth with the downturned torch, there is no denying, as classical philologists have not tired of reminding us ever since Lessing, that the popular culture of ancient Greece visualized Thanatos as a terrifying

(male) demon (personified to the point of grotesqueness in Euripides' *Alcestis*). Classicists have also long been aware that Greek artworks, in particular fifth-century miniatures on Attic funerary vases (*lekythoi*), portray Thanatos not as a handsome youth but as a somber bearded man who carries the dead from the battlefield.[84] And finally, research has established that Greek representations of death *do* indicate the fusion of Thanatos and Eros that Lessing so vigorously denied,[85] only to be ignored by the hellenophiles of subsequent generations, the Romantics in particular.[86] Still, even in these many (related) shapes, Thanatos was not the sole death image in Greek antiquity. Rivaling male personifications include Hades (Pluto) as the god of the underworld and later Charon as the god of the dead (who lives on in Michelangelo's fresco of the Last Judgment in the Sistine Chapel).[87] A monstrous yet still human variation of Charon is the bloodthirsty Charun of the Etruscans who is regularly portrayed as a terrifying bearded old man with animal ears, wielding a hammer as his preferred instrument of slaughter.[88]

Side by side with these male personifications of death, female death figures also populate classical mythology. Their identities and functions overlapped at times, though each essentially preserved its own meaning over the centuries of Graeco-Roman civilization. The Kers are the rapacious servants of Hades; unlike Thanatos, who does not kill, they are demons bringing death; in the *Iliad* they work havoc on the battlefield, eventually dragging their victims away (Book 18).[89] Equally vivid creations of the mythopoetic imagination are the Parcae or Fates – the single goddess Moira in Homer and then, ever since Hesiod, the trio of Clotho, Lachesis, and Atropos who spin the threads of individual lives *and* cut them off with scissors, thus becoming synonymous with Death, especially in early Greek times.[90] (Atropos still appears as an allegory of death in fifteenth- and sixteenth-century French books of hours and in illustrations of the "Triumph of Death" theme; and, conversely, the more familiar Christian skeleton may be represented with a pair of scissors, as in the 1625 etching "Dordrecht in Holland," attributed to Sebastian Furck.[91]) Closely related to the Fates are the Erinyes, the Furies in Roman mythology.[92] They, too, wield power over life and death, as does the grim, scythe-swinging woman in the famous fresco in the Campo Santo in Pisa (unless this "Morte" is closer to another classical archetype,

the Harpy). This list may conclude with the goddess of dawn: Eos (Aurora) abducted her beloved Tithonos from the world of humans – a female variation of the fusion of love and death, Eros and Thanatos.[93] "Aurora the abductress," Herder noted, was "the Greek image of early, gentle death."[94]

These death images of Antiquity had a powerful impact on the imagination of later generations. So too did the biblical representations of death, especially those of the Old Testament. The angel of death appears as the servant of Jahweh (Gen. 19:2; 2 Sam. 24:15–16; Is. 37:36), identified later in Jewish thought and folklore with Satan under the name of Sammael.[95] There is also Nimrod, the hunter Death (2 Sam. 22:6), the shepherd (Ps. 49:15), and the reaper (Jer. 9:21; his scythe or sickle, by the way, is also the attribute of Chronos). The most concrete personification of death of pre-medieval times, however, in the Coptic *History of Joseph the Carpenter* (late fourth century), has remained rather marginal in subsequent iconology: here Death (*moy*), summoning the father of Christ, comes across as a coward; he is moreover visually reminiscent, it has been suggested, of Set, the murderer of Osiris in Egyptian mythology, and thus of a Death seen partly in human and partly in monstrously animal shape.[96]

Such classical and biblical images of death were surely instrumental in the fashioning of male and female personifications of death in post-classical art and literature, even when not expressly evoked. But these images were not alone. True, when one looks at the history of European art and literature with an eye for the recurrence and appropriation of traditional icons of death current in formative earlier cultures, a wealth of such reprises comes into view: the rich afterlife of Thanatos, for example.[97] More interesting and more telling, however, is originality in the sense of non-conformity to the heritage of formative images and ciphers, be they the mythological constructs of Antiquity and the Bible or the symbols developed independently since then, such as the "bone-man," Freund Hein, Madame La Mort, Aunt Sebastiana, etc. Of course, one would not see the forest for the trees if in this pursuit one were to amass a "complete" iconology of death, with all its untold ramifications, not to mention repetitions. The more promising question to ask would seem to be: which images of death dominate in a given period of art and

literature? What are the significant deviations from such a pattern, e.g., female images in a period or culture favoring male personifications, and vice versa? What conclusions can be drawn from the mainstream *and* from the exceptional cases – conclusions concerning the encounter of a time, culture, or individual with the *tremendum* and *fascinosum* that everyday language so baldly calls "death"? For male Death and female Death are of course only the roughest of categories; within them more telling variations are possible: woman as the object of fear, or fulfillment of erotic desire; man as a terrifying power, or as the eagerly welcomed partner – quite apart from further modifications suggested by keywords such as young and old, beautiful and ugly, motherly and fatherly.

Tracing the interplay of such images, one might delineate a cultural history of death in the Western world. Such a history, ranging across national boundaries, would seem to promise a more multifaceted panorama than conventional "intellectual history," even conventional "history of death," was able to provide, from Walther Rehm to Philippe Ariès. Trends might come into view that run counter to those sweeping currents of intellectual life charted by traditional historiography intent on discerning lines of manifest development of the European "mind," *conscience*, or *Geist* (entities that, in practice, were usually thought of as largely monolingual and monocultural, which enhanced the generalizing and simplifying bent of this approach). A more nuanced and differentiated comparative approach such as will be attempted here is likely to come closer to the rich and complex life of the products of our creative imagination than did the all too schematic abstractions of intellectual history pioneered in the 1920s in Germany and still popular.[98]

Such a cultural history may be worth attempting. "Whether we know it or not, whether we abandon ourselves to them or resist them, our thinking is informed by many concepts and images from the past . . . Our understanding . . . endeavors to share the experiences that have taken such shapes. But why? Aren't there more urgent questions than the one concerning the image of death in literature? . . . Just as it is a legitimate form of self-preservation not to live in constant anticipation of death, so it is another to do so now and then. What was possible? What is no longer possible? What is still possible?"[99] If, as the observation quoted from Marie Lenéru and Maeterlinck has it, it is death that should be con-

sulted about life; if, as Dag Hammarskjöld noted in his diary, "it is our conception of death which decides our answers to all the questions that life puts to us,"[100] then the past and present images of death prevalent in the Western world (and I regret this geographical limitation) may heighten our understanding of those who shaped them – and ultimately of ourselves.

2

THE MIDDLE AGES: THE UNFORTUNATE FALL

THE WAGES OF SIN – ADAM'S SIN, OR EVE'S?

I

The Pardoner of the *Canterbury Tales* tells of the three young men whose drinking and gambling are interrupted by the message that one of their friends has suddenly died. They set out to take their revenge on Death, the "privee theef" and "false traytour": "He shal be slayn, he that so manye sleeth."[1] Their idea of their enemy is nothing if not concrete and historically well informed. For the words they choose to describe and vilify Death follow a medieval polemical tradition of denouncing Death as uncourtly: "morte" is "villana" as Dante had it in his *Vita nuova* (VIII). Looking for this unknightly villain, the three young men encounter an old man who tells them where they can find Death. But what they discover in the designated place is a pile of gold, and they promptly forget what brought them there in the first place: "No lenger thanne after Deeth they soughte" (772). They decide it would be best to secure the treasure under cover of darkness, and as they are waiting for night to fall, one of them goes to the village to get some food and drink. In the meantime the other two hatch a plan to slay their crony on his return. In this they succeed, but the third man had had the same idea: two of the bottles of wine he brought are poisoned and so the other two also meet a sudden end.

This is clearly a moral exemplum illustrating the root of all evil, just as the prologue had promised: "radix malorum est Cupiditas." Beyond

that, however, the story has been read, in the context of intellectual his-
tory, as a rejection of the mythmaking prevalent at the time, in particular
as a rejection of the customary anthropomorphic visualization of death.
Death, the story suggests in this reading, is not something or someone
approaching us from outside, an active inimical power with recognizable
intentions and a definite shape, but, instead, a force or quality in man
himself that can make itself felt at any time; the danger is in us, it cannot
and should not be personified as another – as the three youths do when
they set out to slay Death the thief and traitor while they are the actual
thieves and traitors. Habits of the imagination still widespread at the
time, the Pardoner implies in this interpretation, should yield to a new,
more humanistic attitude to death, which would seem to mark the end of
the Middle Ages.[2]

Needless to say, personifying death did not cease with the end of the
Middle Ages, which in any case would not occur until a century after
Chaucer. Nevertheless, the Pardoner's Tale does confront us with the
question of how the Middle Ages did "fashion" or visualize death in
anthropomorphic shape. When Lessing famously answered this ques-
tion in 1769, he simply and rather vaguely referred his readers back to the
horrifying skeleton, the Grim Reaper, leaving all specifics and implica-
tions to their own imagination while he himself turned his full attention
to the Thanatos of Antiquity whom he found so much more appealing.

Lessing was fixated on the skeleton as a palpable object, rather than
on the Christian thought or even dogma providing the framework for
understanding it. Yet hardly any intellectual or artistic problem in the
Middle Ages could be addressed outside this theological framework, and
as far as death was concerned, Scripture, the ultimate source of dogma,
spoke loud and clear. But to what anthropomorphic concepts of death
did the relevant biblical passages give rise in the visual or literary arts?
Specifically, do they favor a male or a female personification of death?
And precisely what sort of personification? And how do the scriptural *loci*
make it plausible that *both* personifications of death occur, as indeed they
do, in the products of the artistic imagination of the time?

For the literary and visual creativity of the Middle Ages, the theolog-
ical horizon in which death was to be seen was provided by the biblical
account of the fall and expulsion from paradise, as amplified by St. Paul's

commentary in his Letter to the Romans and First Letter to the Corinthians. The basic premise was that death is the wages of sin (Rom. 6:23).[3] The original sin was Adam and Eve's disobedience to God. God had warned Adam, before the creation of Eve, that the punishment for eating from the tree of the knowledge of good and evil would be death (Gen. 2:17). So Adam and Eve, as medieval art never tired of recalling, are expelled from Eden after tasting the apple – before it occurs to them to eat from the tree of life, which would have made them immortal (Gen. 3:22). Expelled from Eden, they will die at the end of their days and return to the earth of which they were made (Gen. 3:19). Adam *and* Eve – yet Paulinian Christianity holds only one of them, Adam, responsible for mankind's mortality. Indeed after the fall, God told Adam – not Eve – that mankind would be mortal, while he apprised Eve, in a speech not half as long, merely of the penalty of having to bear children and obey Adam (Gen. 3:16). Only *one*, then, "one man" ("anthropos") brought death into the world through his sin (Rom. 5:12); it is in Adam, or because of Adam, that we all die (1 Cor. 15:21–22): "per unum," as the Vulgate has it, not "per unam" (Rom. 5:17). Death reigned not from Eve but "from Adam to Moses" (Rom. 5:14). St. Augustine, while by no means absolving Eve, made this an article of orthodox faith in *The City of God* (XIII, 14 and 23). Now, in medieval modes of thought the implication is that Adam, bringing death upon "all men" (Rom. 5:12), killed *himself*, indeed, that he *is* Death or, at any rate, has become Death. Accordingly, Gregory the Great asked rhetorically what death, "primogenita mors," could be if not sin, which kills the soul from within: "quid autem mors nisi peccatum est, quod ab interiore vita animam occidit?"[4]

Sin and dying, sinner and death become identical. It is not surprising, therefore, that late medieval and early modern Dances of Death, for example Holbein's (ca. 1525), Nikolaus Manuel's (1516–19) and Heinrich Aldegrever's (1541), but also the fresco in the Benedictine Abbey of La Chaise-Dieu in Auvergne (1460–70), chose the fall and expulsion from paradise as their opening scene, thus reminding the viewers of the origin and nature of death.[5] Accordingly, the Dances of Death themselves not infrequently point out that Death summons his victims *media in vita*, in the midst of their sins. That the original sin that accounts for our sinfulness is Adam's alone is demonstrated signally by the medieval icono-

graphic convention of placing the cadaver or the skeleton or at least the skull of Adam at the foot of the cross of Christ, in consonance with the ancient belief that Adam was buried at Golgotha. A familiar example is the tympanon of the western facade of Strasbourg Cathedral (ca. 1280): beneath the cross we see the skeleton of Adam in his grave. The message is that Christ, as the new Adam, grants eternal life through his martyrdom on the cross and overcomes death in this world as represented by Adam.[6] This interpretation is confirmed by some crucifixions that place "Mors" instead of Adam at the foot of the cross, as for example the ivory cross in the National Museum in Copenhagen (late eleventh century) where "Mors" is seen in an open coffin below Christ. "Adam, sinful man given over to death, is identified with death itself."[7] An art historian has cogently demonstrated the truth of this equation by pointing out that Hans Baldung Grien's depictions of "Death and the Maiden" simultaneously suggest the fall: Adam's sinking his teeth into the apple is evoked by Death literally "biting" into the maiden's cheek; Adam equals Death[8] – medieval modes of thought still prevail in the early sixteenth century. In this connection one might also think of an illustrated Dance of Death poem from the fifteenth century called *Le Mors de la pomme* (introduced, significantly, by a miniature of the fall in Eden). Here "La Mort"'s killing of a large number of typical representatives of the time, from townspeople to the queen, gives rise to theological wordplay (encountered elsewhere as well) with *mors* and *mort* (*bite* and *death*), and there can be no doubt that it is *Adam's* bite into the apple that brought death into the world; for next to the miniature of the crucifixion we read that Christ on the cross takes back death that came into the world through Adam's bite into the apple ("En croix fais reparation / Du mors q adam fist en la pomme)."[9] Also telling in this context is that in a fourteenth-century (?) illustration of a French translation of St. Augustine's *City of God*, Death appears as a naked bearded man in the foreground of a scene that features Adam and Eve under the tree of knowledge – Death as "the old Adam."[10]

In the light of these observations we see: the predominantly male representation of death in medieval art and literature (by contrast, in the first millennium of the Christian era, personification of death had been the exception)[11] has little, if anything, to do with the grammatical gender

of the word for death (masculine in St. Paul's Greek and in the Germanic languages, feminine in the Latin of the Vulgate and in the Romance languages). It is more significantly related to a widespread theological view which predisposed the believer to think of Death as male, Adamic.

Before considering further medieval examples of male personification of death, one might pause to wonder about the role of Eve in this scenario. Why is Adam the guilty party (as he clearly is, to cite one more "case" here, at the end of the twelfth century in the first stanza of the *Vers* of Thibaud de Marly, to be discussed presently)? Why is it still self-evident in the fifteenth-century *Everyman* play, also to be commented on below, that "each living creature / For Adam's sin must die of nature" (144–145)? Is Adam generically guilty because only he had been warned by God? Or because he alone was created in the original creation while Eve came into being in a secondary creation, arising from the rib of Adam? But, then, was it not Eve who led Adam into temptation, giving him the apple after tasting it first herself? Genesis is clear on this point: the serpent first led Eve to disregard the Lord's injunction, which to be sure had not been announced to her (Gen. 3:6,12). So why, throughout the Middle Ages, the theological and representational privileging or rather incrimination of Adam, following the teaching of St. Paul and St. Augustine? After all, Milton, as one of the more significant champions of Judeo-Christian mythology, saw it differently: in *Paradise Lost* (1667) he made great play of Eve's, rather than Adam's, bite into the apple, presenting it as that swallowing of death which, in accordance with archaic modes of thought, would identify *her* with death: "Greedily, she engorged without restraint / And knew not eating death" (IX, 791–792). And speaking of Eve's sin, one must keep in mind (as St. Augustine did in the *City of God* [XIII, 13–14]) that it was not only death that came into the world as a result of the transgression of God's injunction but also the "sin of the flesh," "lust," sexuality. Only after the fall are Adam and Eve aware and ashamed of their nudity; only then do they sew fig-leaves together and make themselves aprons; only then does the Lord make coats of skin to clothe them with (Gen. 3:7,21). Given the notorious misogyny of medieval, particularly Augustinian Christianity, the implied association of Eve and lust provided an excuse for animosity against the "rib," branding woman as the seductress to sinful lust. So if Eve's sinfulness in paradise is fore-

grounded, the medieval lapsarian "logic" of identifying the sinner and death would seem to require that Eve, rather than Adam, should be identified with death. It has even been suggested that the feminine grammatical gender that the Middle-English word for death is given occasionally, in Lydgate and Occleve, for example, might be seen in the context of the clerically authorized, quasi-official misogyny of the time.[12] Be that as it may, it is nevertheless striking that in late medieval literature, in the climate of fear and hatred of the daughters of Eve, death is personified as a woman precisely in those works that pointedly base their theology and anthropology not on the fall of Adam but on the transgression of Eve, relating the origin of death, lust, and all evils to her seductive disobedience. These include, to mention the most significant, the *Dança general de la muerte* and the dialogue *Death and Liffe*, both dating from the fifteenth century. And apparently the habit died slowly. As late as the mid-eighteenth century we find a work of theological didacticism still following in the footsteps of this tradition of attributing the responsibility for death to Eve, and with the approval of the Catholic censor at that: in the anonymous *Spiritual Thoughts about Death* (*Geistliche Todts-Gedancken*, Passau: Mangold, 1753) we read: "The question is where this great evil [death] originated. The woman you gave me as a helpmate gave me [the apple] from the tree and I ate it, Adam says in his defense. So Eve, who was to be the mother of all the living, gave us all over to death" (Fragen wir woher dises grosse Unheyl den Ursprung genohmen? Mulier quam dedisti mihi sociam, dedit mihi de ligno, & comedi, sagt Adam zu seiner Entschuldigung. Hat also Eva, die eine Mutter aller lebendigen seyn sollen, uns alle dem Todt überantwortet, p. 7). The discussion of Eve's guilt will be resumed in the context of female personifications of death (pp. 58–68 below). First, the male image of death, suggesting Adam's guilt, needs to be examined more closely.

II

As Lessing and the Enlightenment saw it, not without antipathy, the standard icon of death throughout the Middle Ages was the skeleton (which in Antiquity had symbolized not death but the dead person or rather his *larva* or lemure, his ghost). In fact, however, the iconography of death as skeleton did not develop until the thirteenth century, and it

was only in the fourteenth century, if not later, that the skeleton was firmly established as the shape of death personified.[13] A skeleton could be male or female, and it did not take a physical anthropologist to see the difference: it could be designated as one or the other by the attributes chosen for it, such as the scissors alluding to Atropos, a trumpet, a drum, or the gravedigger's shovel; in later times it could even be an arquebus as, for example, in the Dance of Death on the outer wall of the Chiesa dei Disciplini in Clusone near Bergamo (late fifteenth century). Or a skeleton could be endowed with a beard (as in the emperor scene in the Basle Dance of Death) or with a pendulous bosom (as when the Basle Death fetches the queen) or with long waving hair (as in the late fourteenth-century "Triumph of Death" fresco in the Benedictine monastery of Sacro Speco in Subiaco near Rome[14] and in several other illustrations of that theme at the time). We shall return to death as a skeleton. First, what about the representation of death in religious art of the *earlier* Middle Ages, up to the thirteenth and fourteenth centuries – insofar as one can speak at all of images of death in the first millennium of the Christian era? In this period death appears not as a skeleton but as a "living" human figure or as a more or less decomposed body, with its stomach slit open and the intestines removed, as a sort of mummy (the technical term is *transi*). Its gender is ordinarily obvious: the death that dominates in those centuries is male.

In the miniatures of various Byzantine manuscripts of the *Topography* of Kosmas Indikopleustes (sixth century), this male Death is still somewhat, if quite remotely, reminiscent of Greek visualizations of Thanatos. The Vatican's eighth- or ninth-century manuscript of the *Topography* contains an illustration of the Old Testament story of Enoch, whom God rewarded for his steadfastness in his belief by excepting him from death, the common curse of mankind (Gen. 5:24; Hebr. 11:5). It shows Enoch "draped in a kind of antique attire . . . tall and imposing, calm and deep in thought. His right hand is raised as in a blessing; in his left hand he . . . holds a scroll. By his side, sitting on a coffin, there is the much smaller figure of a young man [Death]. The color of his skin is dark green, his dark red tousled hair stands on end. His upper torso is naked, only his hips are covered with a greenish cloth. He sits with his legs crossed, bent and waiting, not like someone who is about to

act. His right hand makes a gesture that clearly expresses an awareness of his powerlessness as he faces this righteous man."[15] Powerlessness is the key word.

Death is similarly powerless in early medieval representations of Christ's conquest of death through his descent into hell,[16] which was familiar at the time primarily through the apocryphal gospel of Nicodemus. The illustrated Utrecht manuscript of the psalter from the earlier ninth century shows such a Death, pointedly male on account of his beard. But perhaps the best known example is a late Byzantine one: the right front column of the ciborium (the arched canopy over the altar) in Venice's San Marco Cathedral (thirteenth century): somewhat grotesquely, Death, a bearded man at the feet of Christ, bites his fingers in despair over his defeat.[17] In other Byzantine representations, Death again crouches at the feet of the Savior – a small ugly hairy figure, described in the critical literature as silen- or faun-like or even as Hades,[18] a male figure in any case. Outside the Byzantine sphere of influence we find a somewhat similar male death figure in the Worms missal of the eleventh century: bound hand and foot, Death cowers on its back beneath Christ the victor, who holds him down with his feet and rams his crozier into his mouth.[19] In all these images, then, there is no suggestion of the *power* Death will wield in the later Middle Ages when the skeleton becomes the ever-present cruel enemy of man. This is equally true of a miniature in the gospel manuscript owned by Uta, the abbess of the Niedermünster nunnery near Regensburg, which dates from the very early eleventh century. It features the other – the first – victory of Christ over death, the victory at the cross that gives back (eternal) life: "Crux est reparatio vitae" and "Crux est destructor mortis," the commentary explains:

> The crucifixus is presented in strictly archaic form: a high golden cross with the crucified not hanging from it but standing on a footboard, identified as king by his purple mantle and his crown. At the foot of the cross, where Mary and John are usually placed, there are . . . on either side the figures of Life and Death, designated as "Vita" and "Mors." Vita on the right, attired like a queen and wearing the crown of life, raises her hands in prayer in the

posture of the worshipper of the old Christian church. While
Life looks up victoriously and gratefully to the Savior, Death, to
the left of the cross, collapses as from a heavy blow. The artist ren-
ders him with dishevelled hair and in the clothes of the poor man.
His power is completely broken, he is conquered and fatally
wounded . . . His own weapons are broken, the point of his splin-
tered lance turning against his own head. The sickle in his left
hand, too, is broken and useless.[20]

The pictorial contrast with Life emphasizes the maleness of this
Death. He is equally male in a miniature in the Stammheim missal from
St. Michael's monastery in Hildesheim (late twelfth century). Again the
crucifixion is seen to signify the victory of Christ over Death, who is
introduced here as a dark-skinned bearded figure with a hooked nose, his
teeth bared in a vain threat.[21] Also similar to the portrait in the Uta codex
was the confrontation of "Vita" and "Mors" as a young woman and an
ugly man in the now destroyed mosaic on the floor of the East choir of
Hildesheim Cathedral (twelfth century).[22] Through the pathetic appear-
ance and the inferior position of Death opposite Christ, all of these
images convey the idea that Death is anything but a presence inspiring
horror, fear, or even respect. Even compared to humans he cuts a miser-
able figure when he is shown, in an illustration of Rev. 9:6 in a mid-thir-
teenth century Bible preserved in the British Library, escaping from men
who anxiously implore him to let them die: Death is a dark-skinned
bearded demon holding a sickle and a sword, casting fearful glances
behind himself.[23] Clearly, any anxiety about the end of earthly life as pre-
ordained by Adam's fall is overshadowed here by an awareness of the
glorious self-sacrifice of Christ that conquered Death – not only on the
cross, but again by his descent into hell and finally at the Last Judgment:
condemned to death on earth, man may be certain of eternal life; bodily
death cannot harm him as spiritual death has been shown its limits. The
Christian believer already sees himself saved.

In this context it is significant that death is visualized as male. (His
beard may or may not refer back to Thanatos.) "Pictures show Death in
the shape of a man with a scythe" (Mors in specie hominis cum falce in
picturis repraesentatur), states Caesarius von Heisterbach (1170–1240), a

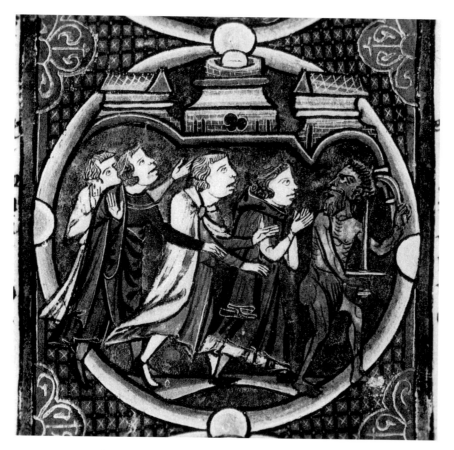

PLATE 4 Latin Bible, illustration (thirteenth century)

much-read Cistercian author of ecclesiastical and ascetic writings, in a passage where "homo" can only mean man as the opposite of woman.[24] If, then, the personifying imagination persists in visualizing death as male even though it is referred to with the feminine noun *mors*, it is plausible to assume that Death's archetype is none other than Adam who brought death into the world. Just as in some medieval works of art Adam (and sometimes "Mors") lies at the foot of the cross at Golgotha, so Death, in the cases just cited, is prostrate at the feet of Christ the victor. Death, as the text explicating the miniature in the Uta codex has it, is destroyed by the cross just as Adam's sin, that brought death upon us, is extinguished by Christ's sacrifice. Death and Adam are fused into one when "mors" is personified as male.

This image of death as the incarnation of powerlessness is superseded in the later Middle Ages (when the skeleton becomes its icon) by a – male – personification that is the paragon of power. As soon as death emancipates itself from the narrow frame of dogma, the subordinate position dictated by theology gives way to an enhancement which quite literally places on his skull the crown that earlier, in the Uta codex, had been the insignium of Christ, his antagonist. Endowed with such power, Death becomes comparable, in the poetry of Hélinant, for example (to be discussed presently), to the Lord himself who granted him his might in the first place, whereas the weakling Death had often been identified with the devil who, in this view, was not "the lord of this world" after all. "King Death" – the term became a cliché – makes its appearance in the early fourteenth century at the very latest. The earliest iconographic representation of King Death is believed to be a fresco in the Basilica of San Francesco in Assisi, dating back to the first decade of the fourteenth century: Death as a skeleton with a crown on his skull that identifies him as Death rather than a dead person.[25] But this is not necessarily the earliest indication that we have of the change from impotence to power. Events in natural history and demography no doubt played their role in this transformation. Since the early thirteenth century at the latest, long before the onset of the plague epidemics in the mid-fourteenth (which decimated the population of Europe by a quarter to one half, according to varying estimates), famines and war, diseases and economic crises, natural catastrophes and crop failures had driven home to survivors the power of the Grim Reaper.[26]

Significantly, in one of the earliest literary personifications of death, *Les Vers* by the Cistercian monk Thibaud de Montmorency de Marly (late twelfth century), death is introduced as wielding this awesome power to which all mankind, the old and the young, the mighty and the humble, are subject. Although French can only present this as the power of "La Morz," Death is nonetheless conceived in Thibaud's poem as an unmistakably male overlord ("un homme"):

> Lord, we are here not in our patrimony;
> we are, rather, subject indefinitely to a man
> who has great power over all men;

48

he is holding his sword over everyone, ready to strike:
he will certainly not spare the young for the old,
the poor for the rich, the fool for the wise man,
the humble for the great, the layman for the scholar.
We all must die, that is how it is ordained.

Seignor, ne sommes pas ci en nostre herité,
Ainz sommes a un homme sanz terme commandé
Qui desor toz les autres a la grant poësté;
Sor chascun tient s'espee, si a son cop levé:
Ja ne refusera le geune por l'ainz né,
Le povre por le riche, le fol por le sené,
Le petit por le grant, le lay por le letré.
Touz nos covient morir, einsi est esgardé.[27]

In Thibaud's theologically far-ranging work, this apotheosis of death is just a marginal vignette. It was left to Hélinant, a Cistercian monk at Froidmont and a former troubadour, to elaborate on it with plenty of detail, and with his index finger raised throughout, in *Les Vers de la mort* (ca. 1195). Eager as only a recent convert can be, the cloistered monk sends Death as a warning messenger to all the typical, and typically corrupt and sinful, representatives of his time and his world: the courtly world in particular, including the princes, kings, and even the pope. Much like a mirror held up to their soul, Hélinant reminds them of their shortcomings, which he then takes as his cue for an almost satirical admonition that they mend their ways and, ideally, turn away from this world in monastic fashion. To be sure, Death, invoked as a person at the beginning of many of the stanzas – "Morz," grammatically feminine – is nowhere called a "man" *expressis verbis* or given an unmistakably male epithet as was the case in Thibaud's *Vers*; nevertheless it is correct to describe him, in terms of the sensibilities of the time, as "male according to his powers and actions."[28] His aura is overpowering, indeed godlike in its power and omnipresence. Depending on the nature of the sins and the social position of his victims, Death appears to them as a royal figure or as the apocalyptic horseman, as a knight or hunter, an avenger or thief in the night; armed with his bow and arrow, sickle, net, club, or knife; on foot, on horseback, in battle, or at the sickbed. The apostrophe "Morz, tu

defies et guerroies" (XLI, I), which summarizes all these antagonistic modes of action, is the strongest linguistic suggestion that this all-powerful and violent Death is masculine – Death as the challenger and warrior, with no hint of Amazonian warfare. As such, this Death seems to foreshadow in his way a miniature in a fifteenth-century French book of hours where, contrary to all expectations that might be derived from *mors* or *la mort*, Death presents himself as an "homme robuste," clutching a scythe with both hands and riding on an ox.[29] Indeed, it has been suggested that Hélinant's male Death is, more specifically, a "courtly" figure.[30] That, however, would seem to be too narrow an identification since Death here makes his entry in many guises, ranging from the peasant to the knight and warlord.

No courtly Death, then, in Hélinant's poem, but it was easy to foresee that the new image of death, the metamorphosis of the early medieval humbled and deprived Death into a figure of power and authority, was destined to be given a courtly air – as indeed happened long before Hans Burgkmair presented an eminently knightly (and crowned) Death in his woodcut "The Horsemen of the Apocalypse" (1524). It is yet another indication of the commanding greatness and respectability of (male) Death that he is accepted as an equal into the ranks of the dominant stratum of society by the late Middle Ages, when he is widely anthropomorphized as a courtly knight. Where *this* Death comes into his own, there is no longer any trace of the degradation of Death, familiar from Dante and even Chaucer, as "vilain," as failing to live up to the knightly code of courtly highmindedness.[31] At the same time the theological-dogmatic frame of reference, tracing the origin of death to the garden of Eden, fades away, though the maleness of death may still point back to Adam. As an embodiment of the ideal social form of life of the time, then, knightly and courtly Death can assume a variety of individual shapes. He may be the drummer Death as so often in the Dances of Death, as on the title-page of *La Grande Danse macabre des hommes et des femmes* (after the now destroyed fresco on the cemetery wall of the monastery Aux Saints Innocents in Paris, published in Troyes in 1486).[32] Or Death may present himself as the herald with his fanfare as he does in his confrontation with the pope in the South German Dance of Death of the late fifteenth century.[33] Or, as indicated, he may be placed at the very

apex of feudal society as "King Death." This happens even where Latin and its derivatives rule supreme (with their feminine noun for death). A Latin book of hours in the Bibliothèque Nationale from the second half of the fifteenth century contains a miniature representing death as the king (not queen) for whom everything living exists: "regem cui omnia vivunt."[34] The image shows a skin-covered skeleton, with a crown on its skull, sitting on a grave instead of a throne, holding in his right hand his lance as a scepter and in his left hand a skull – much as Christ may hold a globe or a secular ruler an orb. Akin to this image is the representation of knightly, courtly Death as a falconer – interestingly, an image created in Italy: in a marble relief in the San Pietro Martire church in Naples (mid-fourteenth century) we see a doubly crowned death figure, a heavily decomposed *transi*, in the role of a hunter with a falcon on his hand; at his feet lies his quarry in the shape of several human cadavers, over whom he towers triumphantly. The inscription designates him as Death, the hunter chasing the sick and the healthy:

> Eo sono la Morte, che chaccio
> sopera voi iente mondana,
> la malata e la sana . . .[35]

However, the noblest representation of death as a medieval knight is without doubt Jean Colombe's miniature in Duke Jean de Berry's justly famous book of hours, *Les Très Riches Heures* of the late fifteenth century.[36] It illustrates the passage in Revelation describing the opening of the fourth seal: "And I looked, and behold a pale horse: and his name that sat on him was Death, and Hell followed with him. And power was given unto them over the fourth part of the earth, to kill with sword, and with hunger, and with death, and with the beasts of the earth" (Rev. 6:8). A knight in the prime of life, dressed in courtly fashion, his drawn sword in his right hand, bearing himself with pride on his elegantly white steed, is seen charging over the gravestones of the foreground; before him and to his side is his retinue: an army of the dead wrapped in funeral shrouds and carrying lances; they march toward the castle in the background while a crowd of armed mercenaries retreats to the town on the horizon with gestures of horror. The triumph of Death is visualized as the

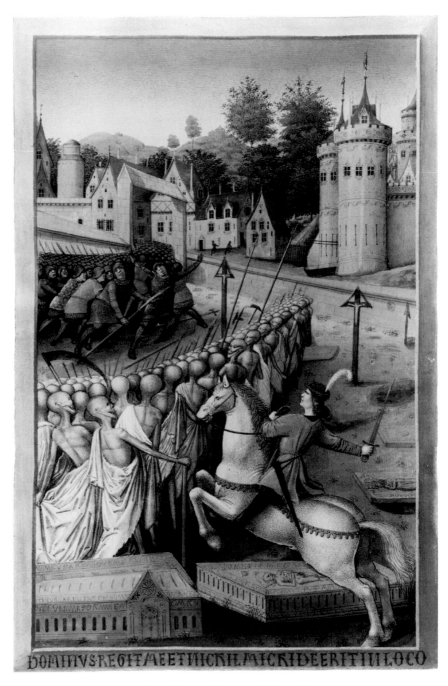

PLATE 5 Jean Colombe: Death as Knight on Horseback
(*Les Très Riches Heures du Duc de Berry*, fifteenth century)

triumph of the courtly knight. He who has been given the greatest might on earth presents himself as the exemplar of that social class which, apart from the monastic orders, is considered the highest and most beloved of God.

Suggestions of this knightly conception of Death may also be found here and there in literary works of the later Middle Ages. To be sure, in the typical dramatic forms of the fifteenth century, the allegorical Every-man plays ("moralities") and dramatizations of biblical subjects from both testaments ("mysteries"), it is not always verbally explicit whether the death figure appearing on the stage is to be thought of as male or female. Nor is this clear in the familiar English *Everyman* where the pro-tagonist is eventually fetched by Death, or in the so-called *Ludus Coven-triae* where, in the Herod scene, Death enters as the gruesome guest who makes the seemingly omnipotent lord of life, surrounded by his "knyghtys," his "thrall" as he runs him through with his lance.[37] Never-theless, given his power, authority, and actions that spare no one, this Death is no doubt meant to be male in the context not only of the dra-matic plot but also of the conventional mind-set of the age. If this Death had been meant to be female, it would have been incumbent on the dramatist to signify such unexpected identity. We can be all the more confident of this as the specifically knightly ambience and the corre-sponding male and courtly nature of Death are hard to miss in such prominent moralities as *The Pride of Life* and *The Castle of Perseverance*, both dating from the first half of the fifteenth century and highly repre-sentative of the genre as a whole.[38] In *The Pride of Life*, the "King of Life" extols his own power and greatness so self-confidently that he does not hesitate to challenge Death, referred to as "he," to a courtly duel. The play as we have it breaks off before this tournament can take place, but we gather from the prologue that none other than Death was to be victorious in it. Similarly, in *The Castle of Perseverance*, where, incidentally, "vetus Adam" is mentioned as the theologically relevant sinner who made our salvation through Christ necessary (3338–3339), "Mors" plays a role that would have been considered knightly and male according to the courtly mind-set of the time: with his lance he unfailingly pierces "lordys" and "dukys," "knytys" and "kyngys" (2804–2808).

Above all, however, Death appears as a knight in a major work of the

English Middle Ages, second only to the *Canterbury Tales*, William Langland's late fourteenth-century *Piers Plowman*, the exemplary allegorical epic that uniquely combines "mystery" and "morality." The narrator's dream visions, constituting the bulk of this alliterative poem, introduce allegorical figures and events to convey a vivid idea of contemporaneous England in all her vitality and corruption; highlights of biblical history follow, culminating in the stormy events of the apocalypse at the end of time. Death is prominently personified in two episodes. The crucifixion of Christ at the beginning of "passus" XVIII (18–45) is seen as a knightly duel between Jesus and Death; the Savior loses the first "bout" at the cross, yet ultimately he wins through his resurrection and triumphant descent into hell, the abode of Death. The final vision of *Piers Plowman* dramatizes the attack of the Antichrist and his retinue of renegades against "Unity," that is, against the Christian community of "Holy Church." In the full-fledged battle that ensues with all the usual banner-carriers, heralds, and knights, the knight named "Kynde" (representing good and divine Nature) leads the way against the enemy. Among his followers, besides personified diseases and old age, Death takes the shape of a courtly knight, fighting on the side of God and the just cause:

> There was 'Harrow!' and 'Help! Here cometh Kynde,
> With Deeth that is dredful, to undo us alle!'
> The lord that lyved after lust tho aloud cryde
> After Confort, a knyght, to come and bere his baner.
> 'Alarme! Alarme!' quod that lord, 'ech lif kepe his owene!'
>
> Thanne mette thise men, er mynstrals myghte pipe,
> And er heraudes of armes hadden discryved lordes,
> Elde the hoore; he was in the vauntwarde,
> And bar the baner bifore Deeth – bi right he it cleymede.
> Kynde cam after hym, with many kene soores,
> As pokkes and pestilences – and muche peple shente;
> So Kynde thorugh corrupcions kilde ful manye.
>
> Deeth cam dryvynge after and al to duste passhed
> Kynges and knyghtes, kaysers and popes.
> Lered ne lewed, he lefte no man stonde

That he hitte evene, that evere stired after.
Manye a lovely lady and [hir] lemmans knyghtes
Swowned and swelted for sorwe of Dethes dyntes.[39]

Knightly Death is by definition a noble figure. As a result, the fear
and horror of the Grim Reaper, the arch-enemy of mankind since the
expulsion of Adam and Eve from paradise, tend to be forgotten (just as
they are when, from an entirely different premise, the mystics reinter-
pret "Mors" as the almost erotically "sweet" or "dear Death," as a
"friend" or even "douce mère").[40] When Death becomes a knight, he
seems to lose his "sting." No wonder, then, that under the noble and
courtly image of Death on horseback in Duke de Berry's book of hours,
we find a quotation from the twenty-third psalm: "The Lord is my shep-
herd; I shall not want. He maketh me to lie down in green pastures; he
leadeth me beside the still waters. He restoreth my soul; he leadeth me
in the paths of righteousness for his name's sake. Yea, though I walk
through the valley of the shadow of death, I will fear no evil; for thou
art with me." Death, powerful as ever in the later Middle Ages, is to
offer consolation and give confidence to those who labor and are heavy
laden, like a Christian knight as it were – after all, Langland's Death
fights the Antichrist.

By contrast, another literary genre typical of the Middle Ages once
again throws into relief the horror of death as the all-powerful lord of this
world. That is the popular "dispute" which features Death as the unshak-
ably steadfast interlocutor of Life or a person desperately clinging to life
or extolling its value.[41] The most poignant example is Johann von Tepl's
prose dialogue *The Plowman from Bohemia* (*Der Ackermann aus Böhmen*,
ca. 1400; the "plowman" is actually a clerk, as his plow is a metaphor for
his pen). Here the vilification of Death, familiar from the time of Dante,
is intensified to a degree which is paralleled, if at all, only in some
contemporaneous French lamentations of the dead;[42] and obviously the
intensity implies a correspondingly increased power of Death which can
only be visualized as male. The plowman, whose wife died in childbirth,
is indefatigable in inventing ever new tirades of curses against "the grim
destroyer" and "horrid murderer of all" (ch. 1; the endings of the German
nouns are masculine). And Death himself is far from denying his power

over the good and the evil, the great and the humble, the young and the old, the sick and the healthy; even kings and emperors lose their crowns and scepters to him. To be sure, he sees himself as "the hand of God" (gotes hant) and views his power as God-given, but even this he says in the plural of majesty, and not for a moment does he let his opponent forget that he and none other is the "lord and strongman on earth" (herre und gewaltiger auf erden), "Lord Death, a mighty reaper" with his devastating scythe (herre Tot, ein rechte wurkender meder, ch. 16).

No less omnipotent is "La Mort" in the most significant French death poem of the waning Middle Ages, *Le Mors de la pomme*, dating from the early or mid-fifteenth century. The Dance of Death, ubiquitous at the time, here combines text and image, verse and miniature, giving each equal weight. Within the frame of reference provided by the Christian concept of history as ranging from the Fall to the Last Judgment, Death is a terrifying presence. Inexorably he approaches representatives of all estates and classes, hauling them out of life after a brief dialogue or dispute, without ever granting a reprieve. And this Death appears as a man in both the illustrations, which present him as a bony corpse (though not as a rattling skeleton), and the verses, overwhelmingly dialogues with the victims who run the gamut from child to king. The miniatures clearly distinguish his gender from that of the women, ranging from Eve to "pucelle" and "mère," while in the text Death identifies himself, not without a faint echo of knightly conventions and anticipating Hamlet's famous phrase, as the "sergant criminel" of the "Roy eternel"[43] – an indication that, much like the *Plowman from Bohemia* and the English *Everyman* play, where Death is God's "myghty messengere," *Le Mors de la pomme* defines the power and authority of Death as a mandate from the Almighty.

This is generally the view of the Dances of Death of the waning Middle Ages and early modern period whose mindset largely mirrors that of the English "moralities," *Everyman* included, and that of the doctrinal passages of "mysteries" such as the *Ludus Conventriae*. For ever since James M. Clark's critical analysis of 1950 there can no longer be any doubt that the typical Dance of Death, frequently both pictorial and literary, presents not a dance of the dead, but a dance of Death with the living, with the sinners to whom he addresses, much as he did in *Le Mors*

de la pomme, his stern summons (a constellation that almost inevitably gives rise to a critical review of all segments of society).[44] As for the gender of this mummified or skeletal Death, the Dances of Death (the majority of which date from the fifteenth century)[45] do not normally care to be explicit. But even when gender-specific anatomical details such as beard, chest, or sexual organs are missing,[46] Death would, in accordance with the conventions of the age, have to be visualized as male because of its power and severity.[47] Gender-specific attributes such as a drum often confirm this male image. Or the text may make the male gender explicit as in the Lübeck Dance of Death (1463) where Death is addressed as "master" (here, 77) or in the South German Dance of Death of the Heidelberg blockbook of ca. 1465. Here Death takes a baby from his mother's breast, unmoved by the lamentations of mother and child:

> Even if you were sucking at the breast,
> That would not help you in this hour[.]

> Hettistu den totten yn dem munde
> Is hilft dich nicht an desir stunde[.]

This is Death speaking, of course, and the child gives the reader a vivid impression of this allegorical construct when it comments: "A black man is dragging me away" (Eyn swarczer man zeut mich do hyn); and it is the Dance of Death that he drags the child to: "Now I must dance and cannot yet walk" (Nw mus ich tanczen vnd kan noch nicht gan).[48] By this time, Death fetching a small child seems to have been a popular motif, possibly because it encapsulated his arbitrariness. The lines quoted sound much like an echo of the legend under an English illustration of the theme from the fourteenth century:

> Alas! O dearest mother dear!
> A black man drags me away from here;
> Why wilt thou let me go from thee,
> I cannot walk, no dance for me.[49]

Such violence of death turns our thoughts to the pictorial and literary genre known as "The Triumph of Death" which makes its appearance in

the fourteenth century in Italy, specifically, though not exclusively, in the wake of the plague. But there death, especially when riding roughshod in a chariot over large crowds, takes on female shape, recalling the harpies and furies of Antiquity (see below, pp. 68–81). Interestingly, however, one also encounters a "Triumph of Death," a somewhat different one, in the cultural context of masculine images of death. For that is indeed the title commonly given to the fresco on the outer wall of the Chiesa dei Disciplini in Clusone in the province of Bergamo dating from the late fifteenth century. Here skeletal Death, triumphantly victorious over all mankind, including the clergy represented by a pope, cardinals, and monks, is implicitly identified as male – even though the Italian text explicating the painting speaks of "la morte." It is not so much his crown that signifies that this Death is male (another "King Death," standing on a pope's and an emperor's grave, his hands raised as if responding to the crowd's homage) but rather his soldierly "double" on his left: a skeleton that, like a typical mercenary of the time, aims his arquebus at the sea of human figures surging up to him; flanking King Death on his right we see a similar skeleton using the more traditional bow and arrow – Death's militant "assistants" doing their warlord's work.[50]

III

The throng in the Clusone fresco is a cross-section of mankind that, as Adam's progeny, is sinful by definition. This sinfulness surfaces here in the attempt of some of Adam's descendants to bribe Death with gifts and money. The Clusone Death and the original sinner in the garden of Eden are linked by the gender they share, accentuated in the case of Death by the eminently modern destructive weapon that is his attribute. Yet evidently medieval thought, lay and theological, was not of one mind concerning the question of the original sinner: was it Adam or was it Eve? Biblical and theological *loci* implicating Adam have guided the discussion thus far. But what was Eve's role in the fall and in the subsequent emergence of death? It now remains to be added: certain biblical passages did indeed put the onus of original sin on Eve, making her, rather than Adam, responsible for the origin of death. In the context of medieval allegorical thinking, this in turn would suggest or even require that Death

would be visualized as female, quite apart from the possible contributory influence of medieval misogyny (itself unthinkable without the biblical sentiments that support it).

While the New Testament says somewhat ambiguously, in the pseudo-Paulinian First Epistle to Timothy: "Adam was not deceived, but the woman being deceived was in the transgression" (2:14), the Old Testament is more explicit: "From a woman sin had its beginning, and because of her we all die" (Jes. Sirach 25:24). From there it is only a small step to a passage like Ecclesiastes 7:26 which gives firm footing to medieval Christian misogyny: "And I find more bitter than death the woman, whose heart is snares and nets, and her hands as bands." In Christian times it became common to contrast Eve's role as instigator of sin with Mary's role (it was convenient to point out that Ave is Eva spelled backward) – a contrast that made the identification of Eve and death all but self-evident. For while Eve, at the inception of Christian history, set us on the path from Eden to death, Mary, in the fullness of time, would lead us back to life eternal. As a pseudo-Augustinian sermon put it, "Eve is the originator of sin, Mary the originator of salvation. Eve did us harm through the fall, Mary restored us, giving us life. One killed, the other healed" (Auctrix peccati Eva; auctrix meriti Maria. Eva occidendo obfuit, Maria vivificando profuit. Illa percussit, ista sanavit).[51] "Eva occidendo obfuit" – the originator of sin (the Church Fathers kept repeating it) harmed us by making us subject to death as its wages. The identification of Eve and death could not be more plausible – not in those quarters, at any rate, where Eve's, rather than Adam's, guilt was taken for granted, whether out of scholarly conviction or out of prejudice in the search for a scapegoat. For believers of this persuasion, that search was simplified by considering that original sin had brought not only death into the world but also, according to medieval moral theology, sexuality or *luxuria* as the source of all evil – which was usually blamed on women. As a result death, sin, carnal desire, and Eve were fused to the point where one could allegorically stand for the other.[52] In particular "Luxuria," represented as a woman with long waving hair (much like Death in medieval images to be discussed presently), frequently appears in close association with death in the Middle Ages, so that one becomes the equivalent of the other.[53] Aldegrever's *memento mori* engraving of 1529 sums up this view: it shows Eve

holding an apple and hourglass in her hands. The sentence from Ecclesiastes 7 quoted at the beginning of this paragraph had given the cue: the metaphorical snares and nets associated with women were more commonly the attributes of Death, in the Bible and elsewhere.

It thus comes as no surprise that Death appears in the shape of a woman in the Middle Ages, though not as frequently as in the shape of a man. Even a cardinal biblical motif, commonly viewed in male terms, may be reinterpreted along these lines: the fourth apocalyptic horseman, Death, may be represented as a woman. A manuscript of Italian provenance of Beatus de Liébana's famous Latin commentary on the Revelation of St. John (late twelfth century) contains a miniature showing Death as a long-haired woman, riding side-saddle over naked men and women, dead or alive, piercing one with her lance.[54] More familiar perhaps is the representation of the fourth horseman of the Apocalypse as a

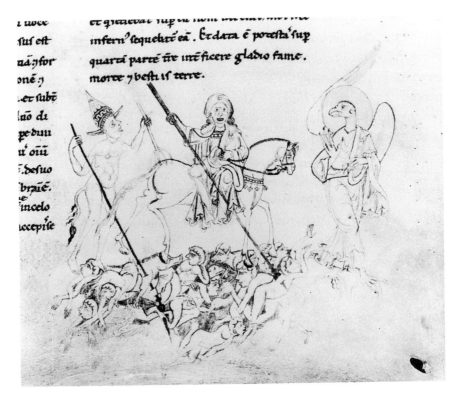

PLATE 6 Beatus de Liébana: Commentary on the Apocalypse, illustration (twelfth century)

naked woman with long hair on the Last Judgment portal of Notre Dame in Paris (early thirteenth century). Impetuously bent forward on her galloping horse, a dagger in her hand, she has just found another victim – a dead body sinks to the ground behind her.[55] This apocalyptic scene is echoed in the Last Judgment portal of Amiens Cathedral, erected not long after Notre Dame. It appears as well in an illustrated Florentine manuscript of Brunetto Latini's *Il Tesoretto* from the early fourteenth century: where the text has "Natura" holding forth on the omnipotence of Death, a miniature shows a fully dressed female rider, sword in hand, trampling over a body.[56]

In these cases an originally male biblical motif is feminized. Unencumbered by such scriptural analogues, the literary and artistic imagination was capable of representing female Death in rather different terms: not only as the impetuous murderess or mass murderess that indulges in veritable orgies of destruction in the later fourteenth century in the "Triumph of Death" motif (see below, pp. 68–81), but as the entirely unthreatening, indeed gentle and peaceful female figure that appears at the foot of the sickbed, perhaps as a vision of the dying person – an old woman with a coffin, scythe, or gravedigger's shovel. This is the Death we find in a gilded miniature in a thirteenth-century Brussels manuscript of Hélinant's *Vers de la mort*[57] as well as in Guillaume de Deguileville's *Pilgrimage of Human Life* (*Pèlerinage de vie humaine*). In this longwinded epic poem from the early fourteenth century the pilgrim lying in his bed (the monk who describes the dream vision of his pilgrimage to Jerusalem which constitutes the bulk of the work) is accosted by a female figure carrying a coffin and scythe.[58] An illustration of this passage in a Brussels manuscript of ca. 1395 corresponds faithfully to the text: a crone places her right foot on the bed of the *moriturus*.[59] This reassuring, peaceful image of death – a remarkably autonomous creation of the artistic imagination – failed, however, to hold its own beside the more aggressive and threatening conception of death, as did the images of death as gentle "friend" or "mother."

The same is true of literary articulations of the motif; they, too, tend to present female Death as a powerful menace and terrifying enemy rather than as a friend. Italo Siciliano, in his book *François Villon et les thèmes poétiques du Moyen Age*, quotes from a "Balade de la Mort" preserved in the Bibliothèque Nationale (twelfth/thirteenth century):

> I, Death to all humans that I am,
> Make it known as their goddess,
> That I hold their lives in my hands.
>
> Moy, qui suis mort a tous humains,
> Fais assavoir comme deesse
> Que je tieng leur vie en mes mains.[60]

While these lines with their goddess metaphor recall classical Antiquity, Robert de l'Omme's allegorical poem *The Mirror of Life and Death* (*Le Miroir de vie et de mort*, 1266) remains within the confines of medieval Christian concepts in its prominent description of a highly allegorical dream: in a tree whose roots are the seven deadly sins sits a "dame" representing Life; Death, "une feme," holding a shroud under her arm, climbs up a ladder leaning against the tree which none other than the devil holds for her, and after a brief exchange of words, she destroys both the "dame" and the Tree of Life, which is indeed the tree of the *joys* of life as the poet specifies with allegorical precision. And it was the devil who urged Death on with a reminder of the sins from which the Tree of Life grows.[61]

Death, sin, and woman are closely associated here, not least through the female personification of death; indeed, they are all but identified. And yet the theological basis for this fusion is not stated in so many words. Such theological awareness becomes more explicit, however, in two major fifteenth-century literary works, one Spanish, one English, which both conspicuously introduce female Death. The eminently comparable *Le Mors de la pomme*, discussed above, had Jesus say that on the cross he is redeeming mankind from the evil that Adam, not Adam and Eve, brought about when he bit into the apple:

> I am suffering death and Passion
> Out of the true love with which I love mankind.
> On the cross I make reparation
> For death which Adam brought into the world with the apple.
>
> Je sueffre mort et passion
> Pour vraye amor dont jaime lomme.
> En croix fais reparation
> Du mors q adam fist en la pomme.[62]

Accordingly, *Le Mors de la pomme* personified death as male, as God's "sergant criminel." By contrast, the Dance of Death poem *La Dança general de la muerte* and the dialogue *Death and Liffe* pointedly speak of Eve as the source of all evil including, of course, death. As "La muerte" ambushes the unsuspecting patriarch in *La Dança general*, she explains that this sudden blow is ultimately due to Eve's eating the forbidden fruit: "Esto vos ganó vuestra madre Eva / por querer gostar fructa devedada."[63] And in the English poem Death – "Dame daughter of the devill," who should know – declares that it was Eve who violated God's command by plucking the apple that "poisoned" both of them:

> Yett his bidding they brake, as the booke recordeth
> When Eue ffell to the ffruite with ffingars white
> And plucked them of the plant and poysoned them both.[64]

What follows from this for the literary articulation of the theme of death as the common lot of mankind? In the seventy-nine stanzas of the Spanish poem Death, much as in *Le Mors de la pomme* and a host of narrated or painted Dances of Death, confronts typical representatives of all social (and particularly ecclesiastical) ranks one by one; a brief exchange of arguments ends predictably with Death getting the upper hand over the reluctant *moriturus*. What is unusual in this poem, though, is that the death figure is conceived as masculine early on, indeed as the bridegroom, when he addresses his first dancing partners, two young ladies ("dos donzellas") as his wives ("mis esposas," p. 29), but that the same figure then transforms itself into a female persona as it encounters the pope, emperor, cardinal, and other men. Inviting the abbot to dance with her, Death even calls him her husband ("mi esposo"), offering to be his lover ("vuestra conpaña," p. 53). Apparently, this Death adjusts its role to the sexual identity of his partners according to the conventional heterosexual pattern. This is also the case in the *Dança general*'s fifteenth-century Italian counterpart, the likewise anonymous sequence of poetic dialogues entitled *El Ballo della morte*, where a monk, when summoned to depart from this world, addresses Death as "dolce amica."[65] In both of these Dances of Death, a female Death encounters a man, and not without erotic overtones – the exact opposite of some fifteenth- and sixteenth-cen-

tury pictorial Dances of Death where a *woman*, though not each and every woman of the cycle, is approached by a death figure clearly identified as female by her pendulous breasts, e.g., the queen in the Basle Dance of Death of ca. 1440 or the empress and the nun in Holbein's of about 1525. While in these instances the female death figure summoning women may conceivably be intended to point to a specifically female sin whose wages come due as the *ultima hora* approaches,[66] the change of Death's gender in *La Dança general* and in *El Ballo della morte* may be seen as an anticipation of the eroticization of death which will become widespread in later ages. In particular, the Spanish death figure as would-be seducer of two "donzellas" strikes the historian as a prelude to the "Death and the Maiden" motif that became prevalent in the early sixteenth century with Hans Baldung Grien, Hans Sebald Beham, Niklaus Manuel, and others, and which is still echoed as late as 1967 by Dalí. Complementarily, the seductive female death figure who in the *Dança general* asks the abbot to dance and about whom the monk in *El Ballo della morte* fantasizes not only recalls Eve's role in Eden, but also vaguely anticipates the much later erotic diabolization of woman as deadly seductress as we see her in the works of Félicien Rops and other artists of the turn of the century.

Interestingly, however, in fifteenth-, sixteenth-, and seventeenth-century Spain there are also exceptions to the female death figure encountered in the *Dança general*. Spanish Death can now and then be a man even when not confronting a "donzella." Cervantes' *Don Quixote* and Calderón's *La Cena de Baltasar* come to mind most readily. But even at the time of the *Dança general* or shortly thereafter, at least three Iberian poems, similar to the *Dança*, present Death as a man. One is Juan del Encina's *Verses on Death* (*Las Coplas de la muerte*, 1530) where Death, an "hombre oculto," knocks on the door of one of the high and mighty of this world and is addressed and treated with all the respect due to a "cavallero" and "señor", though such deferential hospitality fails to sway him. The second is the Catalan *Venturos Pelegrí* (fifteenth century or earlier) where the "fortunate pilgrim" tells of meeting a soul from purgatory on his pilgrimage to Rome; the soul reveals that it had an encounter with a wild, black man, "un hom ferest," "com negre," who turned out to be none other than Death. Finally, there are the famous *Verses on the Death of his Father* (*Coplas por la muerte de su padre*) written by Jorge

Manrique in 1476; here Death, summoning Don Rodrigo to his final duel, appears as a man who is without question his victim's knightly equal.[67] In these Spanish works, then, the male personification of death is conditioned not by a male–female erotic constellation but by formative mytho-folkloric concepts that command attention in the pantheon of the intellectual life of a culture.

Turning from *La Dança general* to the other fifteenth-century long poem prominently featuring a female death figure, one is struck by the complete absence of even the slightest suggestion of an eroticization of death. Instead, *Death and Liffe* revives that hostile opposition of life and death images which we encountered in the Uta codex and in the Hildes-heim mosaic and which may still be found in fifteenth-century works such as the Low German *Dialogue of Life and Death* (*Zwiegespräch zwischen dem Leben und dem Tod*), printed in 1484.[68] The persons giving the Middle English dialogue its title are described as female, and at great length: Death is a horrid witch, Life a beautiful lady. One cannot help suspecting that behind this confrontation of Death and Life there is the archetypical theological constellation of Eve and Mary as icons of Death and Life in the Christian scheme of thought. The passage quoted above from *Death and Liffe* incriminating Eve as the author of sin and death suggested that the female death figure associates herself with Eve as her *raison d'être*. Life, on the other hand, presented in a rhetorical but also somewhat fishwifely power-struggle with Death, where Life eventually gets the upper hand, is introduced as the consummation of womanhood: Life is "worthy and wise, the welder of ioye" (125) – so much so that she comes close to outranking Mary as the Christian icon of female virtue. Is it a coincidence that, like the Mother of God herself, Life is consistently distinguished by the title of "Lady"? And is it not telling that she is "grounded in God" (289), whereas Death is the "daughter of the devill" (235)? In any case, the author uses the licence granted by the dream conceit to endow the stark contrast of the two allegorical figures with poetic, if not realistic plausibility. "Dame Death," unintimidated by the high and mighty in her pursuit of victims, is the leader of "one of the vglyest osts that on the earth gone; / . . . soe grislye and great and grim to behold" (152, 154). Poetic fantasy indulges in grotesque capers: while Life is beauty and perfection personified, Death is not:

With a carued crowne on her head all of pure gold,
And shee the ffoulest ffreake that formed was euer,
Both of hide and hew and heare alsoe.
Shee was naked as my nayle, both aboue and belowe;
Shee was lapped about in linenn breeches;
A more fearffull face no freake might behold,
For shee was long and leane and lodlye to see;
There was noe man on the mold soe mightye of strenght,
But a looke of that lady and his liffe passed.
H[er] eyes farden as the fyer that in the furnace burnes;
They were hollow in her head, with full heauye browes;
Her cheekes were leane with lipps full side,
With a maruelous mouth full of long tushes;
And the nebb of her nose to her navell hanged,
And her lere like the lead that latelye was beaten.
Shee bare in her right hand [an] vnrid weapon,
A bright burnisht blade, all bloody beronen;
And the left hand like the legg of a grype,
With the talents that were t[a]chinge and teenfull enoughe.
(156–174)

The rhetorical altercation of the two makes up the substance of the poem. At stake is their relative power. Death prides herself on conquests dating back to Adam and Eve, Jesus included, whom she claims to have overcome at Golgotha. Life counters with the well-rehearsed idea that Christ's triumphant harrowing of hell signifies nothing short of "euer-lasting liffe" (394) and, therefore, the defeat of death. And she identifies herself with eternal life when she adds that after his descent into hell Christ had granted her "that neuer danger of death shold me deere after" (426). What is at least hinted at in this confrontation of Life and Death is nothing less than the grandiose drama of Christian salvation in which Mary and Eve are the ultimate allegorical antagonists. In spite of all her arrogant words, Death, Life assures her princely retinue, no longer has any power over the Christian soul (432). She, Life, will look after mankind, protect it and serve as its guide from earth to heaven. Death will have no sting for them *if* they love the Lord "that light in the

mayden" – who was born by the Virgin. At this point, the association of Life and Mary can hardly be overlooked: Life is eternal life, promised by Mary after Eve's fall brought death into the world: "euerlasting liffe, that ladye soe true":

> I shall looke you ffull l[e]uelye and latche ffull well,
> And keere yee ffurthe of this kithe aboue the cleare skyes.
> If yee [loue] well the L[ord] that light in the mayden
> And be christened with creame and in your creede beleeue,
> Haue no doubt of yonder Death, my deare children,
> For yonder is damned with devills to dwell,
> Where is wond[red] and woe and wayling ffor sorrow;
> Death was damned that day, daring ffull still;
> Shee hath no might n[e] no maine to meddle with yonder ost,
> Against euerlasting liffe, that ladye soe true. (434–443)

Thereupon "lady Dame Liffe" blesses her retinue with the sign of the cross, revives the dead who are now twice as beautiful as they had been in real life, and with this enlarged host makes her way over the hills, leaving Death to her shame. The dreamer awakens and "amen" is the last word of the long poem.

With the plague still ravaging Europe, this dialogue surprises us with its supreme confidence in the conquest of death, and a conquest at that which could only have been reinforced through the allegorical subtext contrasting Mary and Eve. While the Black Death rages, "Dame Liffe" has the last word against "Dame daughter of the devill," much as *Piers Plowman* had Christ lose his knightly duel with Death at the cross, but not without the promise of ultimate victory through his descent into hell. Langland had chosen a male death figure, of course. This throws into relief the real surprise of *Death and Liffe*. For as it presents Death in *female* shape as *conquered*, it flies in the face of tradition: when female Death made her debut in Christian art – as the apocalyptic horsewoman – she symbolized the devastating omnipotence and the self-glorious authority of death, suggesting a violent death and massive harvest of lives (a full quarter of the population, as Revelation had predicted [6:8]). Moreover, this tradition of powerful female Death, which *Death and*

Liffe contradicts, had in its turn been transformed and thereby strength-
ened as early as the mid-fourteenth century – which makes *Death and
Liffe* all the more remarkable. The tradition was transformed with the
development of a motif which historians of art and literature, following
Petrarch's *Trionfo della morte*, call "The Triumph of Death." It features a
female reaper and female charioteer driving over human bodies. The
intensity of this transformation, which appropriates notions of classical
art and literature rather than biblical precedent, was of course hardly
thinkable without the devastations the Black Death had wrought ever
since the mid-fourteenth century.

IV

In the opening lines of the *Decameron*, written soon after Florence was
struck by the plague in 1348, Boccaccio summons all the forces of his liter-
ary eloquence to describe its horrors. Although the aristocrats manage to
escape to the country where they pass the time with story-telling, the
Black Death remains a vivid presence throughout, in the text as well as in
its illustrations. A miniature in a *Decameron* manuscript preserved in the
Bibliothèque Nationale (1427) chillingly renders Death as a rider gallop-
ing away over three dead bodies – waving hair and dress identify this
Death as a woman, though she carries the traditional reaper's scythe over
her shoulder.[69] Her almost ladylike appearance notwithstanding, she
reminds us of the fourteenth-century long-haired skeleton in the fresco of
the Benedictine monastery of Sacro Speco in Subiaco near Rome –
another female Death charging on a white horse over bodies sprawled on
the ground, whose target, true to the cliché, is not the paupers who beg to
be killed, but two young men, one of whom carries a falcon on his hand.[70]
In both images, the Boccaccio illustration and the fresco, the memory of
the apocalyptic rider of earlier centuries is evidently still alive, although
in the age of the plague it gains new immediacy.

However, more conspicuous than this female apocalyptic Death as
triumphant rider is the scythe-wielding Death approaching on a classical
chariot of triumph, drawn by oxen over bodies scattered on the ground.
Yet significantly, in both this image of the "Triumph of Death" and the
just cited examples of the apocalyptic rider it is a woman that personifies
this violent Death riding roughshod over humanity. Strangely enough,

none other than Petrarch was instrumental in introducing the more prominent of the two images.

It was in the shape of a woman that death took Petrarch's Laura, perhaps the most prominent victim of the plague, in 1348 in Avignon. The poet describes Donna La Morte memorably in the first canto of his poem *Trionfo della morte* (which, however, is only one of six Petrarchan *trionfi* and as such does not have the last word: while Death overcomes the World and Love and Chastity, Death is outlasted by Fame, Time overcomes Fame and Eternity will conquer Time):

> When I beheld a banner dark and sad,
> And a woman shrouded in a dress of black,
> With fury such as had perchance been seen
> When giants raged in the Phlegraean vale . . .

> Quando vidi un'insegna oscura e trista:
> et una donna involta in veste negra,
> con un furor qual io non so se mai
> al tempo de' giganti fusse a Flegra . . .(30–33)[71]

In numerous illustrations of the *Trionfo della morte*, this Death celebrates her victory in all her demonic glory. But how? Curiously, as the pictorial imagination lets itself be inspired by the lines just quoted, more often than not it chooses the chariot of triumph, known from Antiquity, as the dominant attribute of this devastating female Death. Petrarch himself had been content to have Death engage in a verbal dispute in which Laura, like all the beautiful, wise, and powerful humans before her, could only lose; in the end Death cut a lock from Laura's head as a token of her victory – an allusion to Antiquity, to the death goddess Proserpina in the *Aeneid* (IV, 698) and to Thanatos in Euripides' *Alcestis* (74–76). Of course, Petrarch was familiar with the classical chariot of triumph but he used it only for Love triumphing over the World, not for the Triumph of Death. Nonetheless, countless[72] miniatures, frescos, cassoni, ceramics, engravings, fayences, gobelins, and stained-glass windows presented Petrarch's Triumph of Death in this manner: as a long-haired woman, usually wielding a scythe (rather than carrying a banner as in the poem), standing triumphantly on her chariot whose wheels crush the

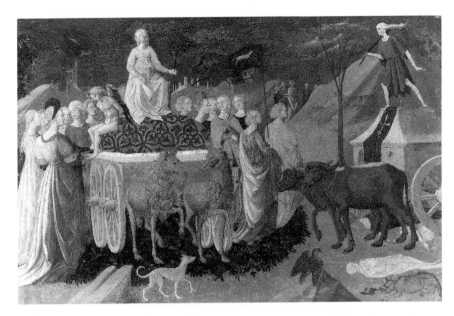

PLATE 7 Francesco Pesellino: Triumph of Chastity and Death (fifteenth century)

bodies of the living and the dead. The chariot is often hung with black cloth and decorated with skulls and bones; its pedestal-like upper part is sometimes reminiscent of a huge urn or a catafalque. Though no longer the devastating apocalyptic rider, female Death, a skeleton or a cadaver, still remains the awe-inspiring charioteer in control of mighty animals and surrounded by the symbols of her power.[73] The traditional horror of the end of life, a violent end in particular, is held in balance by the glory of omnipotence appearing in unfamiliar shape. "The end of life is the beginning of glory" (vitae finis principium est gloriae), Petrarch wrote elsewhere.[74] In many of the illustrations of the *Trionfo della morte* we do indeed find an ambivalent fusion of horror and glory.

These pictorial renderings of the Triumph of Death tend to repeat themselves down to the smallest details; so it may suffice to mention just a few of the more memorable ones: Lorenzo Costa's fresco in the San Giacomo Maggiore church in Bologna (ca. 1489),[75] Francesco Pesellino's (d. 1457) Florentine cassone painting in the Isabella Stewart Gardner Museum in Boston,[76] the cassone painting in the Horne Museum in Florence, attributed to Matteo de Pasti (mid-fifteenth century),[77] and above all the terrifying fifteenth-century painting "Il trionfo della morte"

in the Siena Accademia di Belle Arti attributed to Piero della Francesca.[78] But this particular Triumph of Death may also be found in more modest illustrations, as for instance, with surprisingly rich detail, in a Petrarch manuscript in the Bibliothèque Nationale (1457)[79] and in Girolamo Savonarola's *Sermon on the Art of Dying Well* (*Predica dell'arte del bene morire*, Florence: A. Tubini, ca. 1500).[80]

It is customary in art history to apply the designation "Triumph of Death" also to a rather different presentation of Death prevalent at this time: to a woman who is likewise long-haired, scythe-wielding, and of furious mien, but presented now as a *flying* fury-like shape, often endowed with claws and bat's wings. The most famous example is the fresco from the arcades of the Campo Santo in Pisa. Formerly attributed to Francesco Traini, but more recently to Buonamico, known as Buffalmacco, it predates Petrarch's poem; indeed, it is now believed to have been painted even before the arrival of the plague in Europe in 1347. The "similarity"[81] of the two "Triumphs of Death" is not overwhelming, but of course both do hark back to classical mythology (see below, pp. 75–76).

The painting presents a landscape panorama divided in half vertically by a massive, steep mountain. At its foot in the foreground lies a pile of dead bodies. Around them and also above the mountain, winged angels and devils hover, competing for the souls of the dead, some of which are conducted to heaven while others are thrown into the ravines that represent the gates of hell. The division of the fresco into two halves is more than merely compositional. It marks also a watershed in intellectual history. For the mountain separates the contemplative renunciation of the world in the left half, which features a variation on the popular medieval motif of the encounter of the three living and the three dead, from the joyful this-worldliness of a festive gathering in a bosky bower on the right. But it is these carefree young men and women who are threatened by death: swinging a scythe, Death is already hovering above them, ready to strike. What holds both sides of the fresco together is, therefore, the theme of death, of death triumphant – the composition as a whole clearly deserves the "Trionfo della morte" label that art historians have given it. But that should not obscure the difference in the concept of death in the two sections. The hunting party on horseback on the left, coming to a halt in front of three open coffins with snakes slithering all over them,

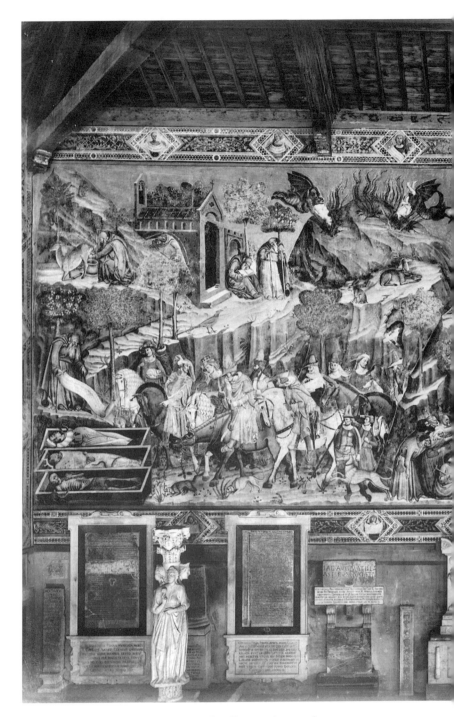

PLATE 8 Fresco, Campo Santo, Pisa (fourteenth century)

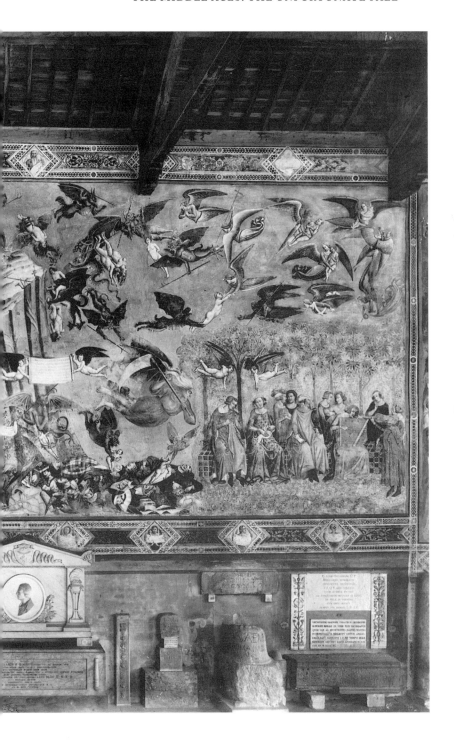

contemplates death with evident horror (one of the riders holds his nose). A monk unrolls for them a scroll whose verses, in *memento mori* fashion, warn against arrogance and self-confidence – a lesson that has already been learned by the friars further up on the left side of the picture; they are deep in contemplation and reading. On the right side of the fresco, on the other hand, the figures have no inkling at all that death is ever-present. These elegant and cheerily dressed young people converse and make music in a well-designed garden – the *Decameron* comes to mind – while disaster approaches from the sky. There, a woman wearing a nondescript dress, with wings like a bat, long blond hair fluttering in the wind and claws on her feet, holds a huge scythe in her clawed hands; her facial expression – open mouth and Medusa mien – suggests anger: she is "the horrid woman" as art history's terminology had it in a bygone age. Any moment now she will mow down all these happy young men and women and send them to hell. For that is where, according to theological tradition, all those ended up who died suddenly, unprepared, without the required formula "Commendo spiritum meum in manus tuas, domine" or an equivalent deemed acceptable by the clergy in attendance at the deathbed. Of course, in the middle foreground, there are those who *are* prepared to die: they beg Death for release from their miserable lives; but Death does not give them so much as a glance. Two putti or genii hovering near her in mid-air hold a scroll that explains what is going on and gives at least a hint of the moral and theological significance of the entire fresco, painted, we recall, on a cemetery wall:

> Using a screen of wisdom or wealth,
> of nobility or kindness,
> is of no help if you are the aim of her blows.
> Are you really unable, my dear reader,
> To find a way of opposing her?
> I urge you to keep your mind well awake,
> To be in a state of permanent readiness
> in order not to be surprised by her in a state of mortal sin.

> Schermo di sapere e di recheça
> di nobiltà e ancor di gentiliça
> Vaglian niente a'colpi di costei;

Dè, che non trovi dunque contra lei,
O tu lector, niuno argomento?
Or non haver il tuo intellecto spento
Di starci sempre in apparecchiato
che non ti giunga nel mortal peccato.[82]

The Pisa "Triumph of Death" has an iconographical post-history that takes many forms, though few are as memorable. Andrea Orcagna, to whom the Pisa fresco was formerly attributed by some authorities, created an imitation, now mostly destroyed, for the Santa Croce Church in Florence which Vasari, in the first Book of his *Lives* (*Vite*) describes as more or less identical with the Pisa original; the same winged female figure symbolizing Death makes her appearance again in a painting called "Allegory of Sin and Redemption," ascribed to Pietro Lorenzetti, who is believed to have collaborated on the Pisa fresco.[83] Here Death hovers above Christ crucified, apparently leaving open the controversial question, touched upon earlier, whether the crucifixion implied Christ's victory over death or, instead, his defeat, to be followed by the ultimate triumph over death in the harrowing of hell. A flying female death figure is also conspicuous, in the first decade of the fifteenth century, in an illumination of what is probably the earliest manuscript of Christine de Pisan's textbook of the history and mythology of Antiquity, the *Epître d'Othéa* in the Bibliothèque Nationale: holding three spears or arrows in one hand and another, ready to throw, in the other, a deeply décolleté wingless female figure, her hair and dress fluttering, flies over a varied group of people, among them a pope and a king or queen, some apparently already hit by earlier arrows.[84] And finally we encounter the motif, at the end of the fifteenth century, in the engraved frontispiece of another Florentine edition of Girolamo Savonarola's *Sermon on the Art of Dying Well* (ca. 1497): a wingless skeleton dressed in a woman's garment, with the usual tresses and a scythe on her shoulder, holds a scroll in her hand which reads "I am" (ego sum); below her are four dead bodies in a desolate landscape.[85]

To return to the surprise that both the motif of female Death on the chariot of triumph and the motif of Death as a flying, sometimes bat-winged woman are traditionally called "Triumph of Death": both of them share, at least in some instances, the more or less clearly articulated

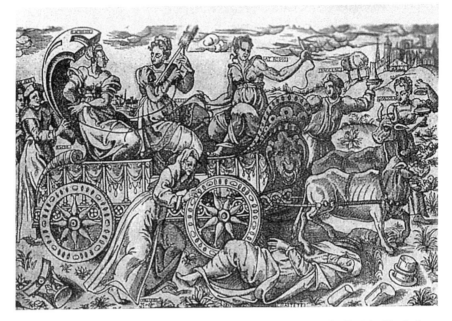

PLATE 9 Triumph of Death, French copper engraving, printed in Paris by Charles le
Vigoureuz (sixteenth century)

allusion to the Fates, the Parcae or Moira, or to at least to one of them,
Atropos, who cuts the thread of life. It is this reminiscence of Greek and
Latin mythology, rather than the grammatical gender of "morte" that
accounts for the conception of death as female in these images.

That the female death figure driving the chariot of triumph is sug-
gested to be Atropos is apparently a development not documented in art
and literature before 1500.[86] Only from the sixteenth century on is the
charioteer not just any female figure, as earlier, but Atropos, though some-
times all three Parcae – Clotho, Lachesis, and Atropos – may be seen on
the chariot of Death, usually drawn by oxen. This is the case, for instance,
in a painting formerly attributed to Titian, but now believed to be the
work of Bonifacio Veronese (d. 1553), where the three Parcae, rather than
mythologically anonymous skeletons or female figures, are enthroned on a
chariot, apparently unconcerned that it plods its way over dead bodies[87] –
a motif that is reported to be commonplace on sixteenth-century gobelins
and illustrations of Petrarch's *Trionfo della morte*.[88] The female gender of
death is confirmed and defined through the metamorphosis of the

"anonymous" woman into Antiquity's female personification of fate: Mors appears as Moira, as the Parcae, specifically as Atropos, often identified by their traditional attributes; see for example, a French sixteenth-century copper engraving discovered by F. P. Weber (Plate 9).

The *Epître d'Othéa* explicitly links Death and Atropos. In chapter 24 it instructs the reader that the poets call Death Atropos and that her arrow or spear will spare no one:

> Ayes a toute heure regard
> A Atropos et a son dart
> Qui fiert et nespargne nul ame...
> Les poetes appellerent la mort Atropos.[89]

The poets – perhaps Christine de Pisan had Boccaccio in mind who, in the first book of his *De genealogia deorum* (ca. 1359), had listed "Atropos" as an alternate designation for Death (s.v. "mors") or maybe she was even thinking of the thirteenth-century *Roman de la Rose*, "the most widely read, imitated and admired work of the French Middle Ages," which states apodictically: "atropos ce est la mort."[90] A later example may be found in Pierre de Michault's poem *The Dance of the Blind* (*La Dance aux aveugles*), written in 1464; here Atropos, riding on an ox, says of herself: "Je suis la Mort."[91] The Renaissance savant Jean Lemaire's verse narrative about Cupid and Atropos (1525) may come to mind as well (see below, p. 106), just as in English Renaissance literature the "three sisters," and Atropos in particular, frequently do double duty as personifications of death, as in Shakespeare's *Henry IV* (pt. 1, II, 4, 212) and in *The Merchant of Venice* (II, 2, 65), to cite but two.

Interestingly, the lines just quoted from the *Epître d'Othéa*, with their identification of Death and Atropos, are illustrated in the Bibliothèque Nationale's manuscript not by a miniature of the triumphal procession of an ox-drawn chariot driven by Atropos, but by the illustration described above, featuring that spear- or arrow-throwing female figure hovering above her human victims which, at a distance of more than half a century, is so unmistakably reminiscent of the Pisa "Triumph of Death" (see note 84). It would therefore not be far-fetched to suspect that the classical archetype dominating the chariot of death motif, Atropos, is also

embodied or hinted at in the terrifying female angel of death seen hover-
ing in the air in the Campo Santo fresco, the more so as it is surrounded
by pictorial echoes of Greek and Roman Antiquity. Once one sees this
connection it is hard to believe that the Pisa personification of death is
really without "any direct trace of classical or pagan inspiration," but
rather, "entirely Italian-inspired."[92] In fact, art historians have for a long
time perceived Greek and Roman mythological prototypes in the female
Death in the Pisa wall painting. The only surprise is that so many differ-
ent such archetypes have been identified: they include not only Atropos
but also one of the Kers or Furies or Harpies. The Kers[93] are fearsome
female figures associated with violent and treacherous death. Their
descriptions in literature, according to the *Oxford Classical Dictionary*,
suggest predatory birds; however, when they appear in the visual arts,
they do not have wings. And it is of course the wings that make the Pisa
Death so conspicuous and distinct. Horace, in a well-known though
surely not original passage, and Seneca in his *Oedipus*, depicted Death
with such wings, but of course they did not specifically have the Kers in
mind.[94] Like the Kers, the Furies or Erinyes, too, are rarely, if ever, repre-
sented in the visual arts as winged; they are visualized as bare-breasted
women with long hair, much as *mors triumphans* is so often.[95]

On balance, the most convincing view is that the mythological arche-
type evoked by the flying Pisa Death is the Greek Harpy.[96] What they
have in common is not only the female features but also wings and claws.
The Harpies abduct the living in the shape of supernatural predatory
birds, while in the earliest Greek times they were also storm goddesses;
and does not the Pisa Death approach its victims from the air much like a
roaring storm? "The horrid woman, too," writes a late nineteenth-century
art historian, "comes rushing in on the wings of a storm, eager to descend
on the merry company. One may think of those winged dressed female
figures on Greek vases, interpreted as Harpies, who pursue youths who are
holding a book or a lyre or trying to escape. And among the many winged
creatures in Etruscan art that have exerted an influence on the medieval art
of Tuscany, there are a number of bird figures with female heads, similar
to the bearers of the soul on the Xanthos monument, which have recently
been interpreted as Harpies."[97] The most incisive description of the
Harpies, eerily reminiscent of the Pisa fresco, may be found in the *Aeneid*:

Monsters grimmer than any, the worst epidemic
hauled up by angry Gods from Stygian water,
Harpies have girls' faces but guts of the foulest
droppings, hands with claws, and permanently whitened
mouths from hunger.

Tristius haud illis monstrum nec saevior ulla
Pestis et ira deum Stygiis sese extulit undis:
Virginei volucrum vultus, foedissima ventris
Proluvies uncaeque manus et pallida semper
Ora fame.
(III, 214–218; *The Aeneid*, tr. Edward McCrorie,
Ann Arbor: University of Michigan Press, 1995)

Medieval pictorial representations correspond to this image; one may assume that the Pisa muralist was particularly familiar with Dante's description of the Harpies:

Here nest the odious Harpies of whom my Master
wrote how they drove Aeneas and his companions
from the Strophades with prophecies of disaster.

Their wings are wide, their feet clawed, their huge bellies
covered with feathers, their necks and faces human.

Quivi le brutte Arpíe lor nidi fanno,
Che cacciar' de le Strofade i Troiani
Con tristo annunzio di futuro danno.

Ali hanno late, e colli e visi umani,
Piè con artigli, e pennuto il gran ventre[.]
(*Inferno*, XIII, 10–14; *The Divine Comedy*, tr. John Ciardi,
New York: Norton, 1977)

In summary: just as the devastating female rider with her scythe or spear is not fully understood unless we associate her with the fourth horseman of the Apocalypse, so the flying female death figure of the "tri-onfo della morte" motif cannot be adequately appreciated unless it is seen

to reveal its classical archetype. Conversely, it is highly improbable that the feminine grammatical gender of the word for death in the languages derived from Latin should have determined the gender of the anthropomorphic vision of death in this and similar motifs, all the more improbable as the rediscovery of classical art, literature, and mythology was just then getting under way in Italy.

Of course one may wonder why, in the case of the Pisa Death and elsewhere, the artist's imagination, in its recourse to classical archetypes, chose a female death figure. Why not Thanatos, the brother of sleep? (There is some uncertainty, by the way, whether the genii hovering over the *fête champètre* on the right side of the Pisa fresco are meant to be Thanatos figures or amoretti;[98] the deteriorated condition of the painting may be to blame, but then, the confusion of Thanatos and Eros has been commonplace since Lessing at the latest.) Thanatos, to return to our question, stands for a beautiful and gentle death, for a desirable death in Greek mythology – death reconciled with life as life takes its leave. This is certainly the primary reason for the fascination of the Enlightenment with the peaceful brother of Hypnos. The female death personifications of Antiquity, on the other hand – Ker, Fury/Erinys, Harpy, Atropos – suggest violent and painful death, death arousing fear and horror, and above all death wreaking mass destruction, as on the battlefield.

Clearly, then, among images handed down from Antiquity, only these *female* anthropomorphic ones were suitable props for an artistic imagination trying to come to grips with that massive presence of gruesome death that severely decimated the population of the fourteenth and fifteenth centuries through the plague, after it had already reaped a grim harvest in the preceding century through famines and natural catastrophes.[99] However, side by side with these female death figures (that bear witness to an impact of Antiquity more powerful than the conventional view of male authority), the male death figure – "King Death" even, as the Lord of the plague[100] – held sway in the visual and literary arts. This long-established male Death, untouched by the classical heritage, but demonstrating instead the vitality of the native tradition or traditions, reveals in its turn an affinity with the imagery of the Bible (the apocalyptic horseman, the angel of death) as well as with Christian

moral theology based on the Book of Genesis (Adam's sin as the cause of death). But as some of the examples from medieval literature and the arts indicate, even this biblical tradition could develop female personifications of death analogous to the male ones such as the female apocalyptic rider – again without apparent inspiration from Greek imagery but rather on the basis of a variant reading of the biblical theme of death as the wages of sin (Eve's sin as the cause of death).

Such manifold historical, intellectual, and theological frames of reference, which are clearly relevant to the emergence of the concrete, bodily images of death that literature and the arts luxuriate in, lend richness and variety to the total picture. The notion, dear to intellectual historians obsessed with neatness, that each age or culture is fixated on, or "haunted" by, just one collective guiding image is wishful thinking. "The image of death in the Middle Ages" does not exist. The reality was different, more confusing perhaps, but also a challenge to us to reflect on the reasons for and contexts of the multifarious images of death produced in these turbulent centuries. For these images still speak to us.

3

RENAISSANCE AND BAROQUE: THE DEVIL INCARNATE

DEATH AND THE MAIDEN – AND THE MAN

I

The most famous early-modern encyclopedia of symbolism and allegory, Cesare Ripa's *Iconology or Description of Universal Images Drawn from Antiquity and other Sources (Iconologia overo descrittione dell'imagini universali cavate dall'antiquità et da altri luoghi*, Rome: Gigliotti, 1593), highly influential among artists and writers throughout Europe for centuries,[1] defines "Mors" as "a woman, pale, with closed eyes, dressed in black, according to the poets" (Donna, pallida, con gli Occhi serrati, vestita dinero, secondo il parlare de' Poeti). This is reminiscent of Petrarch's Death ("donna involta in veste negra," the woman wrapped in a black garment) and, beyond that, of Horace's "pale Death" (pallida mors), "knocking with impartial foot at the cottages of the poor and the palaces of kings" (aequo pulsat pede pauperum tabernas, / Regumque turres, *Odes*, I, 4). Ripa's uncompromising designation of the gender of Death as female had previously been the preference of only a minority; it was bound to jolt more than a few readers, especially north of Italy – all the more so because the *Iconologia* claimed to summarize a long and respectable tradition.

Such consternation and confusion surface in translations of Ripa's work. True, the Dutch versions of 1644 and 1743 reproduce Ripa's wording without apparent qualms, and the French translation, Jean Baudouin's *Iconologie* of 1636, 1644, and 1677, illustrates the text with a copper

engraving of a woman wearing a dress and hat (fig. CIII in the 1644 edition). Georg Greflinger's German translation, on the other hand, *Zwo Hundert Außbildungen von Tugenden, Lastern* . . . (Hamburg: Pfeiffer, 1659), omits the entire entry on "Death" – evidently a smart move since Death is normally the male reaper in German, familiar from the folksong "There is a reaper, Death by name." Another German translation or, more accurately, adaptation, *Iconologia oder Bilder-Sprach* (Frankfurt: Serlin, 1669; by "L.S.D."), likewise fails to include "Death," offering in its place a short entry on the "Chariot of Death" (p. 146), studded with quotations from the classics. Similarly, a third German translation, *Der Kunst-Göttin Minerva liebreiche Entdeckung* (Augsburg: Kroniger u. Göbels Erben, 1704), replaces Ripa's text with a "Reflexion on Death" which studiously avoids the gender issue by not personifying death at all, though it features an engraving of a woman sitting on a grave, contemplating a skull (p. 273). Finally, Johann Georg Hertel's much-used German edition, *Ripae . . . Sinnbilder und Gedanken* (Augsburg: Hertel, 1758–60), which conveniently substitutes copper engravings for all text entries, presents Death in a gender-neutral shape. One cannot help concluding that, Ripa's authority notwithstanding, German translators and adaptors were uncomfortable with the female image of death that the *Iconologia* mandated so magisterially. At any rate, they did not dare to discomfit the readership. On the other hand, the popular German preacher Geiler von Kaisersberg (d. 1510), in one of the sermons collected in his *Book about the Tree of Human Life* (*Buoch arbore humana*, 1521), did not hesitate to describe Death in terms that foreshadow Ripa: "as it has been painted in a number of places: as a black old woman, with wings and a gaping mouth, pale-faced and cross-eyed" (als er in etlichen orten gemalet ist: wie ein schwartz alt weib, mit fetichen, mit einem offnen maul, bleich under dem antlitt, mit krumen augen).[2] This may, however, merely indicate that Geiler was conversant with Petrarchan iconology, and significantly, he felt the need to explain this image of death to his listeners; for them the pale woman was clearly not a household icon. Still, unlike the German translators, P. Tempest, the first translator of Ripa's work into English (which, like German, favors the male reaper), was apparently unfazed by the female image of death provided; his *Iconologia* (London: Motte, 1709) blithely refers to Death as "she" without

bothering with an explanation, and the text is illustrated by a female figure meant to represent Death (fig. 211, opp. p. 53). But something was not quite right with this sort of appropriation. The adaptation of Ripa's *Iconologia* that made the greatest impact in England, George Richardson's *Iconology* (London: Scott, 1779), more than just suggested as much. Its engraving of "Death" shows a winged, bearded angel of a certain age, draped in a long shroudlike garment, holding the scythe in one hand and a hook in the other (vol. II, opp. p. 96). The text explains that Death is allegorized as "the figure of a mean looking man," pale, with a grim expression on his face, dressed in black, winged, with a scythe, a hook, and an hourglass (pp.96–97). The death image of Mediterranean provenance seems to be adapted completely to more northern iconological conventions. Surprisingly, however, Richardson follows this statement immediately with a description of the female death figure that for Ripa was the only acceptable or even conceivable one – without explaining away the resulting incongruity or even commenting on the female death figure (which Milton, for one, had unequivocally rejected in his early poem "In Obitum Praesulis Eliensis": "Non est . . . / Mors atra Noctis filia"):

> Death is called by the poets the daughter of Night, and described as ravenous, treacherous and furious. They speak of her roving about open-mouthed, and ready to swallow up all that comes in her way. She may be represented with a sword in one hand, and a flame in the other, to signify destruction and extinction of life. The Greeks and Latins reckoned Death one of their Gods. (II, 97)

One wonders how a contemporary of Ripa or indeed of Richardson might have reacted to this iconographic conflict – the bearded patriarchal angel doing double duty as the daughter of night. An answer of sorts may be found in the history of art and literature of the sixteenth and seventeenth centuries. On the one hand, the traditional male Death survives in these centuries and beyond (though the more or less mummified or decomposed body representing Death now increasingly gives way to the skeleton, Shakespeare's "bare-ribb'd death" [*King John*, v, 2, 177]). But a

new constellation arises from this conventional male icon, one that Ripa and his followers and adaptors, championing female Death exclusively, had of course not been able to conceive of at all. That is the erotic motif of "Death and the Maiden" which, thanks to Schubert, Munch, and others, has maintained its vitality to the present day. On the other hand, the female death figure, which definitely holds its own in these centuries, develops new variations in its turn, which are quite distinct from the Petrarchan icon and from the influential flying Harpy of the Pisa Campo Santo painting, to say nothing of the female apocalyptic rider of the Middle Ages. They even include the beloved and the seductress.

The Renaissance and Baroque periods are in fact a time of increased preoccupation with death. In the age that is believed to have rediscovered the joys of life, the traditional confrontation of humans with death becomes so widespread in the arts that death, paradoxically, runs the risk of becoming trivialized, especially in comparison with the threatening earnestness of the death figure at the threshold of the post-medieval age, as for example in *The Plowman from Bohemia* (ca. 1400). This confrontation with death takes many forms. Still flourishing, or flourishing once again, are the "dispute" in the manner of Innocenzio Ringhieri's *Dialogues of Life and Death* (*Dialoghi della vita et della morte*, 1550) or Jörg Wickram's introduction to his verse epic *The Lost Pilgrim* (*Der irr reittend Bilger*, 1556) and the more subdued "dialogue" as in Hans Sachs's *Death, an End to all Earthly Things* (*Der Todt ein Endt aller irdischen ding*, 1550?). There is the eloquence of Everyman plays and Dances of Death as well as the mute, pensive encounter with Death as Dürer captured it in his highly evocative woodcut "Death and the Mercenary" (1510). As a result of such omnipresence, death in the sixteenth century becomes "a figure of everyday life," especially in Lutheran lands; the figure of death "has completely taken over the role of the minister" and his *memento mori*.[3] For better or worse, Death becomes everybody's neighbor.

II

The familiarity of this ubiquitous death is heightened by the familiar male roles it adopts, some of them biblical: he appears as the reaper with his scythe, the fiddler, the hunter with his bow and arrow, the fowler, the gravedigger with his shovel, the apocalyptic horseman, King Death, the

warrior or knight engaging a victim in a duel with his sword and lance, the drummer or herald with his fanfare, the fool identified by his pointed cap, and of course, the ever-popular skeleton raising an hourglass in a warning gesture, as for instance in Lucas van Leyden's copper engraving "A Family Surprised by Death" (1523).[4] Often a beard is added to the skull indicating that we are indeed confronted with a male Death, as in the soldier Death in Niklaus Manuel's Dance of Death fresco in the Dominican monastery in Berne(1516–19) which survives in a water-color copy of 1649 by Albrecht Kauw. A few, perhaps less well-known examples of these male roles familiar from theMiddle Ages will illustrate the broad range of death personifications that takes shape during the first post-medieval centuries.

The *fiddler* commonly takes the lead in the Dance of Death; a good example is the Basle Dance of Death, originally painted on the cemetery wall of the Prediger monastery and preserved in Merian's copper engraving of 1621.[5] Death the *hunter* was the icon of choice in William Drummond of Hawthornden's 1623 madrigal "This world a Hunting is, / The pray, poore Man, the Nimrod fierce is Death."[6] It survives in literature as late as Young's *Night Thoughts* (1740s): "Till *Death*, that mighty Hunter, earths them all" (IV, 96). Death the *warrior* is an unsettling presence in Jakob Binck's mid-sixteenth-century copper engraving "Death and the Mercenary": Death is not a skeleton, but a bearded muscular athlete, breaking the lance of the prostrate mercenary with his left hand and with his right hand raising a sword to pierce his opponent while he puts his foot on the chest of the vanquished in a grimly victorious pose – the very opposite of the "boneman" in Dürer's woodcut of 1510 who holds his hour glass up to the mercenary leaning on his halberd, urging him with his penetrating glance to contemplate the end of life.[7] No less vigorous than Binck's warlike Death, indeed flexing his fully developed muscles, is Death in Hans Baldung Grien's drawing "Death with an Inverted Banner" (1505–07); it is surely no coincidence that, as an art historian has pointed out, this athletic, sportsmanlike Renaissance man is modeled on Adam in Dürer's copper engraving of "The Fall of Man" (or "Adam and Eve," 1504), where Adam embodies manly perfection in the state of sinlessness before the fall, which in its turn refers back to the Belvedere Apollo as the very icon of that vigorous and handsome manliness the

Renaissance prized.[8] An interesting example of Death the *drummer* is the sixteenth-century ivory statuette in the Victoria and Albert Museum, already mentioned in passing, unusual in that it is demonstratively endowed with male genitalia.[9] Remarkable also – because of its French origin which, if grammar had the last word, would mandate a female death figure – is the male personification of death in a 1531 Troyes print-ing of the *Danse macabre*: carrying a lance and sounding a fanfare, a *herald* stands on the ramparts of a castle; the legend explains: "message de la mort." This Death, incidentally, is also another example of the "black man" that appeared occasionally in the Dances of Death and elsewhere, but unlike that illustrated in the Heidelberg blockbook of 1465, this black Death is unmistakably negroid and dressed in an exotic garment.[10] More common is Death the *fool*, who in Holbein's Dance of Death woodcut (ca. 1525, printed 1538) summons the queen (see below, p. 120). Most familiar of all, of course, is Death *on horseback*, often but not always as Revelation's fourth horseman, e.g., "Death . . . on his pale horse" from *Paradise Lost* (x, 588–590). Pieter Brueghel's painting "The Triumph of Death" (ca. 1562) springs to mind, which in its title alludes to another well-rehearsed iconographic tradition; yet the distance from the noble knightly appearance of medieval Death – as in Jean Colombe's miniature in the Duke of Berry's book of hours – could not be greater: Brueghel's Death is a skeleton galloping, scythe in hand, on an emaciated nag through a desolate landscape strewn with the dead, the dying, and the executed, leaving more such victims under the hoofs of his horse.[11] Dürer's woodcut "The Four Horsemen of the Apocalypse" (1497–98) may come to mind as well: Death as a gaunt old man on his hack, with a long beard and fluttering hair, rolling his eyes furiously, draped in a shroud; clutching a pitchfork, he rides roughshod over his human vic-tims.[12] And one cannot help remembering, in this context, Dürer's copper engraving "Knight, Death, and the Devil" (1513): Death is a bearded, mummified horseman, raising an hourglass in a warning ges-ture – his own crowned head, hair dishevelled, crawls with worms.[13] Of course, the focal point of the work is not Death but the knight, steadfast in his Lutheran faith, who rides past the equally revolting death and devil figures without a glance at them. And yet Death's crown, though barely visible, reminds us of the secular power of this less than princely Death.

The same is true of the crowned skeleton, clearly come down in the world, that is seen riding a tottering nag in Dürer's charcoal drawing "Death on Horseback" (1505).[14]

His fortunes waning, perhaps, *King Death* has by no means abdicated in Western art of this period. He still appears in all his majesty in Hans Burgkmair's 1524 woodcut of the four apocalyptic horsemen, preceding the other three: cutting a dignified figure with his patriarchal beard and his commanding crown, he gallops over the clouds on a noble steed, aiming his arrow at an invisible target.[15] Nicolaes de Bruyn's untitled copper engraving of 1618, obviously inspired by Dürer's "Knight, Death, and the Devil," also presents Death – unlike Dürer's – as an imposing, indeed royal figure alongside the devil and the knight, with a long white beard, scepter, and crown around which worms or snakes crawl. This King Death, Marlowe's "monarch of the earth" (2 *Tamburlaine*, V, 3, 217), may formally hold court; Shakespeare describes the scene in famous lines:

> And nothing can we call our own but death,
> And that small model of the barren earth
> Which serves as paste and cover to our bones.
> For God's sake, let us sit upon the ground,
> And tell sad stories of the death of kings –
> How some have been deposed, some slain in war,
> Some haunted by the ghosts they have deposed,
> Some poisoned by their wives, some sleeping killed,
> All murdered. For within the hollow crown
> That rounds the mortal temples of a king
> Keeps Death his court; and there the antic sits,
> Scoffing his state and grinning at his pomp,
> Allowing him a breath, a little scene,
> To monarchize, be feared, and kill with looks,
> Infusing him with self and vain conceit,
> As if this flesh which walls about our life
> Were brass impregnable, and humoured thus
> Comes at the last, and with a little pin
> Bores through his castle wall; and farewell, king.
> (*Richard II*, III, 2, 148–166)

At about the same time, Cervantes depicts Death's court in a memorable passage from *Don Quixote* (1605). He speaks of Spain's equivalent of the (earlier) English "moralities," the *autos sacramentales* in the manner of Calderón's *Gran teatro del mundo* – allegorical plays extolling the virtues of Christian life, they were performed by strolling players at the end of the traditional Corpus Christi processions. Don Quixote runs into such a troupe as it travels to its next performance (part 2, ch. 11); its specialty is a play, *Las Cortes de la muerte*, on the power and inexorability of King Death holding court among representatives of all walks of life:

> Don Quixote was about to reply to Sancho Panza, but he was prevented by a cart crossing the road full of the most diverse and strange personages and figures that could be imagined. He who led the mules and acted as carter was a hideous demon; the cart was open to the sky, without a tilt or cane roof, and the first figure that presented itself to Don Quixote's eyes was that of Death itself with a human face; next to it was an angel with large painted wings, and at one side an emperor, with a crown, to all appearance of gold, on his head. At the feet of Death was the god called Cupid, without his bandage, but with his bow, quiver, and arrows; there was also a knight in full armour, except that he had no morion or helmet, but only a hat decked with plumes of divers colours; and along with these there were others with a variety of costumes and faces. All this, unexpectedly encountered, took Don Quixote somewhat aback, and struck terror into the heart of Sancho; but the next instant Don Quixote was glad of it, believing that some new perilous adventure was presenting itself to him, and under this impression, and with a spirit prepared to face any danger, he planted himself in front of the cart, and in a loud and menacing tone, exclaimed, "Carter, or coachman, or devil, or whatever thou art, tell me at once who thou art, whither thou art going, and who these folk are thou carriest in thy wagon, which looks more like Charon's boat than an ordinary cart."
>
> To which the devil, stopping the cart, answered quietly, "Señor, we are players of Angulo el Malo's company; we have been acting the play of 'The Cortes of Death' this morning,

which is the octave of Corpus Christi, in a village behind that hill, and we have to act it this afternoon in that village which you can see from this; and as it is so near, and to save the trouble of undressing and dressing again, we go in the costumes in which we perform. That lad there appears as Death, that other as an angel, that woman, the manager's wife, plays the queen, this one the soldier, that the emperor, and I the devil; and I am one of the principal characters of the play, for in this company I take the leading parts. If you want to know anything more about us, ask me and I will answer with the utmost exactitude, for as I am a devil I am up to everything."[16]

Cervantes probably had no particular play in mind here. The *Auto de las cortes de la muerte*, formerly erroneously attributed to Lope de Vega, has been suggested as a model, but that work has now been shown to be a patchwork of a number of Corpus Christi plays and other dramas that was possibly inspired by Cervantes's passage in the first place;[17] furthermore, in this *auto* Death, carrying the usual scythe, is not a man, but "señora Muerte."[18] The other *auto* contemplated as a model for the novel's *Cortes de la muerte*, the play of the same title by Micael de Carvajal and Luis Hurtado de Toledo (1557), is also an unlikely candidate: while it does feature Death's summons to representatives of many walks of life as does Cervantes's fictional *auto*, here again Death appears a woman.[19] The most interesting thing about the *Don Quixote* passage is, of course, that Death is a man: he is played by a young man, a "joven." True, a widespread convention of the time routinely assigned female roles to men. But that is not the case here; for at least one of the cast mentioned in the passage is a woman, the wife of the director, who plays the queen. So in this play, a product of Spanish language and culture, "la muerte" is clearly personified as a man, as King Death holding court.

That may come as a surprise, the more so as the supposed models feature death as a woman. Yet in sixteenth- and seventeenth-century Spain male Death was not particularly uncommon. *Don Quixote* itself refers to male death again (II, ch. 20), and this time Death is the *reaper*, the "segador," with its distinctly masculine ending, even though "segadora" would have been entirely possible linguistically as well as culturally; and a

little later Cervantes introduces the conceit that a female death figure is really a metamorphosis of Merlin the magician, "el señor Merlín" (II, ch. 35). Two generations earlier Juan González de la Torre had engraved an allegorical image (1555) presenting Adam and Eve both holding an apple in their hands (an equitable idea that does not seem to have occurred to the Middle Ages agonizing over whose sin was original); at their feet kneels the figure of "Natura humana," while opposite them a hollow-eyed skeleton rises up threateningly, raising the sword of "divine justice"; the sash wrapped around it identifies this wages-of-sin Death as the *executioner* of the disobedient (verdugo de inobedencia).[20]

To continue with male Death in seventeenth-century Spanish literature: at least one well-known *auto sacramental* puts Death on the stage as a *noble-man* and a courtier. That is Calderón's *King Balthasar's Feast (La Cena del rey Baltasar*, 1634). Much as in the Coventry cycle of "mysteries", it is again the blasphemous feast of one of the high and mighty of this world that calls Death on the scene; Death gives the pagan king a taste of his greater power by dispatching him from this world with a poisoned draught. And remarkably, this Death, who obviously plays the lead here, is male not just by implication or vague hints; the wording and staging repeatedly identify him as a man, and a man of power and authority at that. "La muerte" enters the stage with the dagger and the sword of the courtier (galán); reminiscent of González de la Torre's engraving, he is addressed as the "severe and just executor of the wrath of God" (severo y justo ministro / de las cóleras de Dios); he refers to himself with grammatically masculine endings (e.g., "Pues en esta cena estoy / escondido y encubierto, entre loscriados suyos") and calls himself "father of the shadows" and "son of sin" (padre de las sombras, hijo del pecado).[21] This choice of words is as unmistakable as his self-assured attitude throughout: this "galán" knows no mercy; even the most powerful of this earth will not be reprieved. Another Spanish play of the Golden Age that brings Death on the stage as a male figure in the wake of the *Don Quixote* passage is Luis Quiñones de Benevente's *Sung Interlude, Death (Entremés cantado La Muerte)* of about 1625 – a Dance of Death in which Bezón, as Death is called here, titles himself "ruler of the world" (alguacil de la tierra). He peremptorily fetches all "representantes del mundo," paying particular attention to a fifteen-year-old girl, a "lusty beauty" (hermosura

liviana) whom he approaches with erotic overtures, asking her to dance with him.[22]

King or hunter, horseman or fiddler, courtly knight or "black man" – all are conventional images of male Death which, side by side with others, live on in the sixteenth and seventeenth centuries as a heritage common to virtually all linguistic and cultural communities of Europe. Those mentioned in this section, while not unusual in principle, may stand out because of certain interesting nuances that were described above. More original or eccentric male personifications that may be found here and there, in English Renaissance drama in particular, do not really imply a radically novel vision of death, let alone a paradigm shift. One might think, if not of Hamlet's "fell sergeant Death" (v, 2, 288), then perhaps of Romeo's *pilot* Death:

> Come, bitter conduct, come unsavoury guide,
> Thou desperate pilot, now at once run on
> The dashing rocks thy seasick weary barque! (v, 3, 116–118)

Even such extravagantly concrete personifications of death as *gambler, tobacconist, trencherman, groom* (Donne) or *chamberlain* (Milton), as *actor, wrestler,* and *butcher,* will on occasion occur in Elizabethan and post-Elizabethan English drama and poetry.[23] German Jesuit drama adds a few curiosities, one or the other of which can be encountered sporadically as much as three centuries later: in an Ingolstadt Balthasar play (1678), the Babylonian reveler comes to a Lucullan end arranged by "Tod" in the shape of a *cook* and wine-steward, while in an anonymous play called *Eternity* (*Aeternitas*), performed in Freiburg in 1639, Death makes his debut as "*General Money-Eater*" (General Geltfresser).[24] But, in principle, these images are still well within the familiar frame of reference; they are only slight variations on those male roles that are routine at the time in the repertoire of Death.

III

But the winds of change are already astir. Above all, the popular *memento mori* idea that makes Death an almost intimately familiar figure can be emotionally heightened to the point where the ever-present

awareness of death may change into longing for death. For if the *memento mori* is observed day in, day out, death can no longer be conceived of as a disastrous assault out of the blue that would send the unprepared straight to hell; instead, being on the mind of the true believer at all times, Death may indeed be welcomed as the redeemer, as a neighbor and friend, or even as lover or beloved – all of them everyday roles for an everyday Death. To be sure, some slight suggestions of such love of death did occur briefly here and there at an earlier time.[25] But it is in the literature of the Baroque period that we find this attitude fully developed. If Christian dying, according to the ideology of martyrdom revived at the time, is nothing but "entering heaven" as one of Andreas Gryphius's sonnets has it (in den Himmel schreiten, *Sonnets*, 1, 24), then the approach of death may be greeted not just with equanimity but even with fervor. This is the case in Gryphius's martyr play *Katharina von Georgien* (1657):

> Welcome, sweet death!...
> We have overcome.
> Through death we have found life itself.
> Oh, Jesus, come!

> Willkommen süsser Tod!...
> Wir haben überwunden.
> Wir haben durch den Tod das Leben selbst gefunden.
> Ach JEsu kom! (v, 119–122)

The opposites have changed into each other, death is real life, "life itself" can only be found in death. Death himself says in this play:

> Whoever rightly sees through this earth
> Hopes only for me...
> You who are kept in bonds,
> Turn to me.
> I break open the strongest dungeon,
> I open stocks and door...
> If you loathe this vale of tears,
> Offer me your hand:

I shall lead you from the torture chamber
Into your Father's land.

Wer die Erden recht durchschaut
Wündscht nicht mehr als mich . . .
Die jhr in den Banden schmacht
Wendet euch zu mir
Ich brech auff der Kercker Macht /
Öffne Block und Thür . . .
Hass't ihr dises Thränenthal:
Bitet mir die Hand:
Ich führ auß dem Folter-Sal /
In das Vaterland. (IV, 469–502)[26]

Where such thinking prevails, in the Baroque age and then in the Romantic cenacles around 1800 and after, for example, Lessing's reproach, in the *Hamburg Dramaturgy* (ch. 1), that such easing of death would make it comparable to drinking a glass of water, would not have been understood. Instead, eroticism appears in the wings: death as bridegroom or bride. Such death eroticism may be, but is not necessarily, paired with sultry religious sentiments as was sporadically the case in medieval mysticism and again in German Romanticism or even in Schiller's *Intrigue and Love* (*Kabale und Liebe*), where Luise thinks of death and dying as a "bridal bed" (Brautbette, V, 1). In the mid-seventeenth century, the Latin poetry of Jacob Balde comes at least close to such overheated mystical sensuality, with perhaps too much of a flair for words. This is still obvious in a contemporaneous German translation or adaptation of Balde's "Genevieve" poem by Georg Philip Harsdörffer, a leading critical and creative writer, in his *Dialogue Games for the Fair Sex* (*Frauenzimmer-Gesprächspiele*, 1649):

Are you tarrying, sweet death, are you tarrying, dear life?
Won't you give your bride what you promised her?
My wedding dress is illness now and pain,
And you, my bridegroom, have not wed me yet.
I am burning in the fire of love and no floods
Can extinguish the hot glowing love in my body.

Verweilst du trauder Tod/verweilst du liebes Leben?
Wilst du nicht deiner Braut/was du versprochen/geben?
Die Krankheit und der Schmertz ist nun mein Hochzeitkleid/
und du/mein Bräutigam/hast mich noch nicht gefreyt.
Ich brenn/ in Feuer-Lieb/ich brenn/und keine Fluten
erlöscht in meinem Leib so heisse Liebesgluten[.][27]

Death, then, no longer inspiring fear and terror, has become the eagerly awaited lover. It almost seems as if the confusion of the classical personifications of death and love, Mors and Amor, Thanatos and Eros, that was a subject of acrimonious scholarly controversy even before Winckelmann and Lessing,[28] has a basis in "fact." To be sure, in a picture like Lucas van Leyden's above-mentioned copper engraving "A Family Surprised by Death" (1523), there was no reason for mistaking one for the other: while Cupid hovers above the family, arrow at the ready, Death, a bearded skeleton, sits with the family around the table.[29] But, to return for a moment to the putto-like figures hovering above the festive company in the Pisa "Triumph of Death" fresco: the question whether they are amoretti or spirits of death has agitated art historians well into the twentieth century. And much like Lessing's controversy with Winckelmann about the identity of the winged youths of classical iconology, this controversy reflects a confusion that was not limited to art historians. In a popular literary motif dating back at least to the sixteenth century, Thanatos and Eros, Mors, or even Atropos and Amor or Cupid exchange their roles, as for example in the *Three Tales of Cupid and Atropos* (*Trois Contes de Cupido et de Atropos*, 1525) by prominent Renaissance poet Jean Lemaire and in Geffrey Whitney's *A Choice of Emblemes* (1586). Both exploit the comic potential of the mistaken identity of Death and Love.[30] This is of course a far cry from Balde's intensely religious erotic mysticism of death and dying, as it is from the more lascivious "Death and the Maiden" motif that is the most characteristic variation of the fusion of Love and Death in Renaissance art and literature – though a basic thematic similarity links them all.

Turning to "Death and the Maiden," perhaps it comes as no surprise that during the Renaissance this constellation can still be viewed within the horizon of Christian history conceived as mankind's progress from

Eden to Heaven or Hell. In fact, the image of Death as lover, especially
the crassly sensual lover (Death's persona in the sixteenth-century pictor-
ial renderings of the "Death and the Maiden" motif) may be seen to
combine, in a sort of iconological personal union, the two consequences
of the fall: death and sexuality. For not only can Adam and Eve count on
death as the wages of their sin of disobedience (as is often made clear in
pictorial representations of the fall where a death figure leads Adam and
Eve out of paradise, as in Aldegrever's 1541 copper engraving); also,
immediately after the fall, Adam and Eve discover their nakedness and
cover themselves (Gen. 3:7). Both sexuality and death came into the
world with the fall; they are therefore to be seen in conjunction. This is
more than just suggested in a passage of the *City of God*, discussing the
consequences of the fall: "Human nature was in his [the first man's]
person vitiated and altered to such an extent that he suffered in his mem-
bers the warring disobedient lust, and became subject to the necessity of
dying."[31]

The idea is familiar from the medieval iconography of death, but
there is a difference now. When in the Middle Ages Eve was blamed for
the fall, and death was accordingly personified as a woman, this death
figure could on occasion be cast in the role of the seductress to sensual
pleasure (*luxuria*); but when, as was more frequently the case, Death was
modelled on Adam as the guilty party, the corresponding male death
figure was not normally seen as the seducer. It is only in the Renaissance,
in its literary and pictorial articulation of the "Death and the Maiden"
motif, that the roles are reversed: death as the incorporation of the erotic,
even of lust, now makes his entry as a man – the "boneman" becomes the
seducer, suitor, lover, and, if his love is requited, the bridegroom (for an
apparently unique medieval anticipation of this motif, see ch. 2, n. 40, p.
267 below). And he will retain that role conspicuously throughout the
eighteenth century and beyond in well-known works by Bürger, Schu-
bert, and others. The rebirth of the converse constellation – female
Death as seductress – was not far behind, but it did not have a compar-
able impact in the early modern period. (It became highly conspicuous
only in the second half of the nineteenth and in the early twentieth cen-
tury.) On balance, what signally distinguishes the imagery of death in the
periods we loosely call Renaissance and Baroque from the iconology of

previous centuries is this consistent eroticization of dying and, hence, of death personified, whether as male or female.

Turning first to the male personifications, a crude and drastically playful variety of this transformation of Death into the seducer may be found in a drama by Wolfhart Spangenberg, one of the major German playwrights of the earlier seventeenth century. The theme had been rehearsed, as it were, in an episode of the fifteenth-century *Dança general de la muerte*. For just as in that work Death had approached the two "donzellas" as their would-be lover, so does Death in Spangenberg's "tragic" drama *The Wages of Mammon* (*Mammons Sold*, 1613). As in the *Dança general*, death is personified here as a man as well as a woman, depending on the sexual constellations that make up this didactic play on the theme of lust and greed. At the outset Satan reduces "Mrs. Riches" to her real self by magically transforming her into a skeleton, into Death in fact, complete with bow and arrow (in gestalt deß Todes) – Death is a woman. However, no sooner has this female Death ended the lives of three *dramatis personae*, who are stylized as allegories of moral shortcomings – namely the mercenary, the usurer, and the peasant – than Death slips into his main role, which is male. Instigated by Satan, he presents himself as the "bridegroom" or rather bridegroom-to-be of the widows of the recently departed men. He approaches each as an elegantly attired seducer, whose appeal Satan has enhanced by presenting him as a man of means, and one by one Death marries them all. The dance to which the gallant invites them is, naturally, a Dance of Death. For this suitor is really after their life: the lover, whose professed feelings are more or less reciprocated, is not merely a messenger of Death but Death in person – and this is not without comedy as in the hour of death each of the three newlyweds attempts to give precedence to the other two, and they even talk of killing Death. In the event, of course, Death's arrows pierce each one of them, and the "revolting bloody bridegroom" becomes a widower three times over. As there are no more women available, Death exits, but not until he has given the audience a quick all-purpose *memento mori*, including a warning about dying unprepared and about greed.[32] Lust and Death are intimately related in this play, even though he arouses erotic desire only in conjunction with desire for possessions and money (Gut und Gelt).

When Shakespeare picks up the motif of Death the bridegroom, one may be sure that he does so with better taste and more human appeal than his German contemporary, who proudly called his rather farcical didactic effort "tragoedisch" in the subtitle. True, when confronted with the subject of death, even Shakespeare's imagery may grow overripe, as when in *The Merchant of Venice*, Portia, beleaguered by her suitors, says: "I had rather be married to a death's-head with a bone in his mouth than to either of these" (I, 2,49–51). *Antony and Cleopatra*, on the other hand, presents a different world. When the queen of Egypt, ready to follow her lover in death, sees her attendant Iras sink to the ground, breathing her last, she gives expression to the motivation that drives her to her suicide:

> If thou and nature can so gently part,
> The stroke of death is as a lover's pinch
> Which hurts, and is desired. (v, 2, 289–291)

Equally familiar with this notion are Romeo and Juliet. Juliet:

> I'll to my wedding bed,
> And death, not Romeo, take my maidenhead! (III, 2, 136–137)

And Romeo:

> Shall I believe
> That unsubstantial death is amorous,
> and that the lean abhorred monster keeps
> Thee here in dark to be his paramour? (v, 3, 102–105)

There is more erotic sultriness when Shakespeare returns to the motif in *Measure for Measure*, which, unlike *Antony and Cleopatra*, introduces it in the context of the denial of eros. In the famous dialogue of Isabella and Angelo in the third act, Angelo promises that he will annul her brother's death sentence if she will give herself to him. When Isabella finally understands what Angelo has in mind, she chooses Death as her lover instead, in words that are remarkable for a novice in a nunnery:

> Were I under the terms of death,
> Th'impression of keen whips I'd wear as rubies,
> And strip myself to death as to a bed
> That longing have been sick for, ere I'd yield
> My body up to shame. (II, 4, 100–104)

The excess of this death eroticism is shaded into the grotesque when Richard Crashaw, the "metaphysical" poet, turns to the theme of amor-ous male Death in "An Elegy upon the Death of Mr. Stanninow" (1635):

> 'Twas old doting Death, who, stealing by,
> Dragging his crooked burthen, look't awry,
> And streight his amorous syth (greedy of blisse)
> Murdred the earth's just pride with a rude kisse. (45–48)

Death as lover, tempting with the pleasures of this world rather than the blessings of the next – this motif, while virulent throughout the sixteenth and seventeenth centuries, comes into its own most conspicu-ously not in literature, but in the visual arts. This is particularly the case north of the Alps where eros, especially in the sense of sex, and crude sex at that, becomes the cachet of death personified as male. The "Death and the Maiden" constellation flourishes there not only in the form of Death sur-prising the maiden, alone or with her lover, in an erotically charged scene as in Hans Sebald Beham's copper engraving "Death and the Sleeping woman" (1548), where a winged skeleton places the hourglass on the shoul-der of a naked woman voluptuously sprawling on her bed: "O, the hour has come" (O die Stund ist aus), or in a woodcut by Urs Graf (1524), where Death, holding an hourglass, sits in a tree while a dressed-up beauty is trying to impress two mercenaries.[33] More characteristically, Renaissance art presents the "Death and the Maiden" motif with Death himself as the lover. Almost all the great names felt the attraction of this conceit. In Dürer's early copper engraving "The Woman and Death" (ca. 1495), the erotic nature of the assault of the grim-looking man on the properly dressed woman is at most merely hinted at, as is the case in his pen and ink drawing "Death and the Young Woman," where the "boneman," as Dürer would have called him, holds out an hourglass to the burgher woman in a gesture

more pensive than seductive.[34] There is no such uncertainty about the nature of the assault in Beham's variation of the same motif in his copper engraving "The Lady and Death" of 1541; here Death, identified by a grinning skull wearing a fool's cap reminiscent of Holbein's fool Death summoning the queen, clearly makes erotic advances to the respectable matron – hourglass in hand; the epitaph says: "All human beauty is ended by death" (omnem in homine venustatem mors abolet).[35] The most gripping and also best-known pictorial representations of "Death and the Maiden" prior to Bürger and Schubert, however, are those by two artists of the age of Dürer who carry Death's sensuous brutality and hence the shocking nature of the encounter to the extreme – Hans Baldung, called Grien, and Niklaus Manuel, called Deutsch. Both were attracted to the motif more than once.

Lingering on the threshold of eroticism is Baldung's earliest version of the motif, in his oil painting "The Three Stages of Life and Death" or "Death and the Maiden" (1509–10). It is, more exactly, a *memento mori* suggesting a touch of lewdness. A young woman, nude except for a veil around her hips, views her face and hair in a hand mirror; though outdoors, in an exotically allegorical landscape, she seems to be carrying out her everyday morning toilette. She cannot help seeing in the mirror what is behind her: Death as a decomposing male cadaver holding her veil with one hand and raising his hourglass over her head with the other. No doubt this Death is about to fetch the woman; the expression on his face is rigid, startling with its clenched white teeth and penetrating blue eyes. Nonetheless there is an undeniable suggestion of lewdness: will he pull the veil away any moment now and expose the woman's pudenda? Her facial expression indicates neither horror nor surprise, she is not yet aware of what awaits her or what is already happening. But dismay can be seen on the face of an older woman opposite her who props up the mirror with her hand: with her other hand she tries to push aside Death's arm holding the hourglass, while her glance is fixed on the penetrating eyes of the intruder – who does not so much as notice her.[36]

In Baldung's painting "Death and Woman" (1518–20), the advances of Death, now almost entirely skeletal, have become rather more aggressive and sexually explicit. Once again, an almost nude woman of voluptuous shape is not so much surprised as assaulted by Death from behind, this time in a cemetery. Her face expresses horror and confusion – and

none of that erotic response to Death that will modify the motif later, as in Edvard Munch's etching "The Maiden and Death" (Pigen og døden), for example (while the traditional articulation of the motif, suggesting sheer horror, will live on in Käthe Kollwitz's lithograph "Death Seizes a Woman" of 1934). Baldung's Death – a skull with deep eye sockets, hollow cheeks, and sparse hair is about all we see of him – grabs the woman by the chest and is about to kiss or rather bite her full cheek. Interestingly, this encounter is strongly reminiscent of the constellation Baldung chose for his presentations of the fall, where Adam lasciviously approaches Eve from behind, just as Death's hearty bite into the woman's cheek evokes Adam's bite into the apple – the sin that brought death and sexuality into the world.[37] In Baldung's "Death and Woman," death and sexuality are graphically united in the macabre intruder; as the cloth is about to fall from the woman's virtually naked body, Death's aggressive stance is sexually explicit. The picture captures the moment in which sensuous arousal and dying, eros or rather sex and death become one. In what is literally the toothy kiss of death, the life of the full cheek is joined with the bare bone of the skull, the emblem of the extinction of life. And yet, taken at face value, the scene also amounts to an ordinary scene of seduction. Within it, however, the perspective of a whole intel-lectual tradition opens up: It suggests not only the theological symbolism of the primal bite into the apple (Gen. 2:17), which gave rise to the play on the words *mors/morsus, mort/mors* (Luther, too, spoke of the "bite" of death and even Ronsard, more attuned to classical iconology, knew of all-devouring death, "Mort mangetout" in his "Ode à Michel Pierre de Mauléon");[38] beyond that, Baldung's image of literally biting Death sug-gests (and this is what Ronsard may have had in mind as well) an allusion to the classical topos of devouring time, personified as Chronos who eats his children; significantly, the scythe is his attribute as it is Death's.

Niklaus Manuel goes even further in making the erotic implications of the "Death and the Maiden" motif explicit in two of his works: in a pen and ink drawing "Death and the Maiden" (1517) and in the encounter of Death with the "Daughter" in his Dance of Death fresco on the ceme-tery wall of the Dominican monastery in Berne (1516–19), preserved in Albrecht Kauw's watercolor copy of 1649.[39] In the episode from the Dance of Death, the skeleton once again approaches from behind,

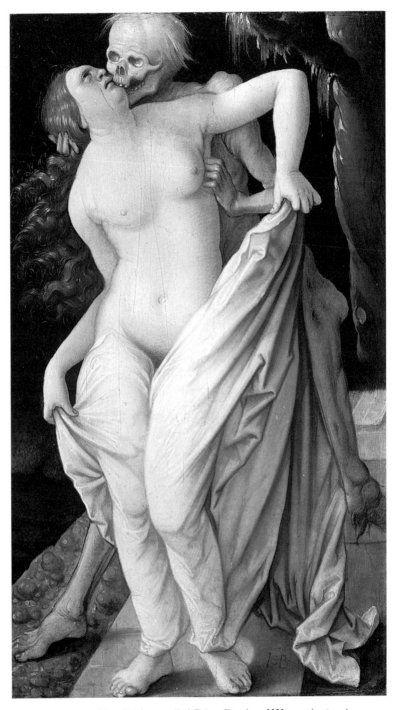

PLATE 10 Hans Baldung, called Grien: Death and Woman (1518–20)

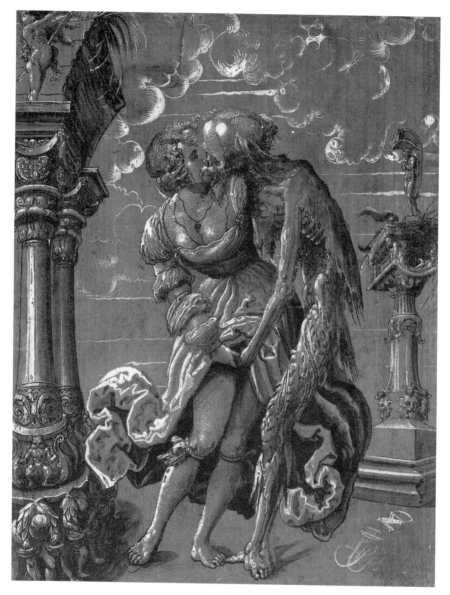

PLATE 11 Niklaus Manuel, called Deutsch: Death and the Maiden (1517)

placing his bony hands and arms around the woman's shoulders, lewdly uncovering her breast while his fleshless mouth is at his victim's cheek, ready to kiss. The accompanying text has Death assure the young woman that her hour has come, her red mouth will turn pale and her body, face, hair, and breasts will all become a rotten heap of muck:

Tochter ietz ist schon hie die stund,
bleich wirt werden dein rohter mund:
dein leib, dein angesicht, dein haar und brüst,
mus alles werden ein fauler mist.[40]

The woman's reaction is interesting: she wrings her hands somewhat theatrically, apparently playing coy; she is bent back a little as if recoiling from the advance, yet her face exhibits no horror or rejection but rather pensiveness, if with pursed lips, undecided, it seems, whether she should respond erotically – although her verbal response to the words of Death clearly suggests fear about the "horrid assault" that is about to "break her heart" (Todt wie greuwlich greiffst mich an, / mir wil mein hertz im leib zergan). Still, the faint suggestion of the woman's erotic willingness, departing from Baldung's "Death and Woman," heralds a new phase of "Death and the Maiden" that foreshadows the macabre eroticism at the turn of the twentieth century. This suggestion is even more obvious in Manuel's tempera painting of 1517. Surrounded by classically inspired columns, Death here makes his entry as a decomposing body, still vigorous enough to "grab a full-bosomed soldier's wench under her skirt," in the language of an older school of scholarship.[41] This formulation, though possibly clairvoyant about the identity of the woman, overlooks what matters most: the attitude of the woman, draped in a billowing, deeply décolleté dress. With her right hand, she seizes Death's groping hand at her pulled-up dress. This may leave us in the dark about who is taking the initiative here, but the woman, who is sometimes described as a prostitute, does turn her full-cheeked curly head as if asking for a kiss. Death, in the shape of revoltingly decomposed flesh, and radiantly healthy life are united in an obscene union. Once again the constellation is not so much that of Eros and Thanatos as of sex and death: drastic sensuality at the very moment it is extinguished for ever, with Death as the brutal seducer of a not entirely unwilling victim.

IV

Death and the Maiden – but what about the man? Can the roles of this erotic relationship be reversed? Can Death seduce a man? Can Death

be a man's beloved? After all, Death could appear as a woman during the Renaissance and the Baroque periods. One of the most memorable representations of the seventeenth century is an anonymous Italian etching labelled "Death the Reaper, Blindfolded" in *Das Bild vom Tod*, the catalogue of the Düsseldorf collection of death images (p. 104); but the figure's long waving hair, typical of female death images, more likely suggests the rear view of a nude "reaperess" wielding her scythe in a partly mowed wheatfield, with a bow and arrows slung around her waist in a quiver. To be sure, this female Death is not a seductress, nor is she the object of a man's love. But the motif of female Death as beloved and lover, indeed as seductress, is not exactly rare in these centuries. In the same Shakespeare plays where women personify death as their bridegroom or lover, men will envision Death as their bride or beloved. This is by no means an anticipation of the *Liebestod* motif of a later day, in which lovers consummate their union by seeking a common death. For in spite of overtones of this notion in *Romeo and Juliet* and *Antony and Cleopatra*, the wording suggests without a doubt that the erotic encounter is with death personified. In counterpoint to the device of male Death as lover, cited earlier, this female Death makes her appearance as the beloved in *Antony and Cleopatra* when Antony says:

> The next time I do fight
> I'll make death love me, for I will contend
> Even with his pestilent scythe. (III, 13, 194–196)

Here the personification of death is not yet fully realized grammatically since the possessive pronoun "his" functioning as a common variant of the neutral "its"[42] has not given way to the "her" required by the constellation. But a few scenes further on in the text, Antony's language is more explicit; he is eager to follow Cleopatra in death, having been led to believe that she killed herself out of love for him:

> I will be
> A bridegroom in my death, and run into't
> As to a lover's bed. (IV, 15, 99–101)

The hints of *Liebestod* observable here are entirely absent in the scene in *Measure for Measure* where Claudio, thinking that he will be put to death, confesses:

> If I must die,
> I will encounter darkness as a bride,
> And hug it in mine arms. (III, 1, 81–83)

Death the bride was evidently a widespread notion in the Elizabethan era. Thomas More, reportedly witty to his very last breath, even applied it to those for whom, according to the doctrine of the Church, a "bride-groom of the soul" might have been more appropriate. His son-in-law and biographer William Roper tells us that through the barred windows of his cell in the Tower, More watched some Carthusian monks being led to their execution and remarked to his daughter: "Loe, doest thow not see, Megge, that these blessed fathers be nowe as chearefully goinge to their deathes as bridegromes to their Mariage?"[43]

The conceit of Death as bride or beloved is fleshed out into an entire drama in Fabio Glissenti's allegorical five-act play *Death in Love* (*La Morte innamorata*, 1608) – with the crucial difference that here Death plays the active role; Death is a seductress. La Morte falls in love with Man, who promptly takes flight with his family to the land of Long Life. La Morte eagerly follows him there, where she finds him living in the house of World. But she soon tires of him; so she makes him ill with the help of Infirmity, and Man dies, not without the good offices of Time. Ironically he dies not in the house of World, but under the care of For-tune, to whom World had introduced him – Fortune, however, is none other than La Morte in disguise.[44]

The doings of Death the lover are earnestly designed for maximum didactic yield here; but the comic potential of the Eros–Thanatos equa-tion is hard to ignore. Authors explored it as early as the sixteenth cen-tury by identifying Death and Cupid to the point where one is mistaken for the other (see above, p. 95). Jean Lemaire, the well-traveled Renais-sance courtier and versatile Humanist poet, fully exploits the farcical potential of the motif in the (Italian-inspired) first of his *Trois Contes de Cupido et de Atropos* (1525): Cupido and Atropos, L'Amour and La Mort,

get drunk one day in an inn and mistakenly pick up each other's weapons – bow and arrow, "belle dame" Atropos apparently having outgrown her scissors. They do not notice their error but shoot each other's arrows, which explains why the *morituri*, hit by Cupid's arrow, revive to new love, whereas others succumb to Atropos's arrows in the flower of youth. Lemaire was by no means the only one to sense the comedy of this constellation. It makes a brief appearance in one of Death's speeches in the Corpus Christi play *Cortes de la Muerte* (1557) by Carvajal and Hurtado de Toledo, mentioned above and to be returned to presently, and in Alciati's *Emblemata* (1531), as well as in graphics of the sixteenth and seventeenth centuries.[45] The motif also inspired the emblematist Geffrey Whitney to the amusing poem he included in his 1586 anthology *A Choice of Emblemes*. It is introduced there by a vignette presenting both winged genii, Mors and Cupido, as archers hovering in the clouds above all mankind:

> While furious Mors, from place, to place did flie,
>> And here, and there, her fatall dartes did throwe:
>> At lengthe shee mette, with Cupid passing by,
> Who likewise had, bene busie with his bowe:
>> Within one Inne, they bothe togeather stay'd,
>> And for one nighte, awaie theire shooting lay'd.
> The morrowe next, they bothe awaie doe haste,
> And eache by chaunce, the others quiuer takes:
> The frozen dartes, on Cupiddes backe weare plac'd,
> The fierie dartes, the leane virago shakes:
>> Whereby ensued, suche alteration straunge,
>> As all the worlde, did wonder at the chaunge.
> For gallant youthes, whome Cupid thoughte to wounde,
> Of loue, and life, did make an ende at once.
> And aged men, whome deathe woulde bringe to grounde:
> Beganne againe to loue, with sighes, and grones;
>> Thus natures lawes, this chaunce infringed soe:
>> That age did loue, and youthe to graue did goe.
> Till at the laste, as Cupid drewe his bowe,
> Before he shotte: a younglinge thus did crye,

Oh Venus sonne, thy dartes thou doste not knowe,
They pierce too deepe: for all thou hittes, doe die:
 Oh spare our age, who honored thee of oulde,
 Theise dartes are bone, take thou the dartes of goulde.
Which beinge saide, a while did Cupid staye,
And sawe, how youthe was almoste cleane extinct:
And age did doate, with garlandes freshe, and gaye,
And heades all balde, weare newe in wedlocke linckt:
 Wherefore he shewed, this error vnto Mors,
 Who miscontent, did chaunge againe perforce.
Yet so, as bothe some dartes awaie conuay'd,
Which weare not theirs: yet unto neither knowne,
Some bonie dartes, in Cupiddes quiuer stay'd,
Some goulden dartes, had Mors amongst her owne.
 Then, when wee see, vntimelie deathe appeare:
 Or wanton age: it was this chaunce you heare.[46]

Another burlesque *jeu d'esprit* with the conceit of female death is a longpoem "To his Mistress for her True Picture" by Edward, Lord Herbert of Cherbury, the brother of the more famous Renaissance poet George Herbert. It appeared posthumously in 1665, in the collected Verses of the historian and philosopher, courtier and diplomat in the service of James I.[47] At issue is the true image of death, and the main thing of which the speaker of the poem is certain is that Death is female. The conventional image of the skeleton no longer carries conviction:

Death, my lifes Mistress, and the soveraign Queen
Of all that ever breath'd, though yet unseen,
My heart doth love you best, yet I confess,
Your picture I beheld, which doth express
No such eye-taking beauty, you seem lean,
Unless you'r mended since. (1–6)

Nor does the speaker trust "the picture, Nature drew," which is an image of sleep. Hence the request:

> To end this strife,
> Sweet Mistress come, and shew your self to me,
> In your true form, while then I think to see
> Some beauty Angelick, that comes t' unlock
> My bodies prison, and from life unyoke
> My well divorced soul, and set it free,
> To liberty eternal: Thus you see,
> I find the Painters error, and protect
> Your absent beauties, ill drawn, by th' effect[.] (16–24)

What follows is an eccentric paean to his love, Death. It applies the traditional *topoi* of courtly love lyrics to this less traditional addressee, hoping to gain a "picture" of his invisible mistress. As it does so it strays, not unintentionally, into the realm of the grotesque. There is no doubt, in the words of the laudator, of the "majesty" of the woman apostrophized or of her worthiness to wear the crown of immortality (36, 39). As such, she deserves his unceasing praise as the liberator of man from the prison of this world and of his body in particular. Next to her, all other women are mere parodies of her beauty, which he describes lavishly while at the same time luxuriating in visions of the decomposition of the flesh. He hopes that she will dispatch armies of worms to her enemies and detractors so that their bodies will be gnawed into a horrid sight – "unless your beauty they confess" (105). Death, then, is the warlike commander of armies of worms – a far cry indeed from Jean Colombe's knightly Death with his army of human skeletons. They are "noble Worms," to be sure (107), and they will eat everything, except the paper on which the poet expresses his praise of his mistress Death. They are "brave Legions then, sprung from the mighty race / Of Man corrupted" and "heirs of all the earth" (111–112, 123). Needless to add, all the more glorious the commander of such worthy worms! And no greater happiness than seeing a picture of her. That, however, can be neither the "meagre" Christian one, ugly and repulsive as it is, nor the classical one of Sleep or the brother of Sleep. So what kind of a picture will it be?

> Mean while, Great Mistress, whom my soul admires,
> Grant me your true picture, who it desires,

> That he your matchless beauty might maintain
> 'Gainst all men that will quarrels entertain
> For a Flesh-Mistress; the worst I can do,
> Is but to keep the way that leads to you,
> And howsoever the event doth prove,
> To have Revenge below, Reward above;
> Hear, from my bodies prison, this my Call,
> Who from my mouth-grate, and eye-window bawl. (133–142)

This is how "the father of English Deism" ends his bizarre extravaganza on the theme of death personified.

Two of the most important French Renaissance poets, Clément Marot and Pierre de Ronsard, are likewise engaged in the quest for the true image of death, though eroticism is far from their thoughts, nor are they tempted to see elements of farce or grotesque in their austere pursuit. Yet theirs is a female "picture" as well. Marot, in his "Déploration de Messire Florimond Robertet" (1527), tries to sketch the history of personification of death, thus depriving himself of the option of introducing anything unconventional. Death is accordingly a terrifying power that has all mankind, from the highest dignitaries on down, trembling – yet, contrary to many traditional images, Marot's Death is a woman. A Dance of Death *en féminin* seems to be in the offing, but Marot ultimately gives the nod not to this image but to the traditional "Triumph of Death" in its principally Italian version of the woman driving the chariot of victory over human bodies:

> I see hideous and formidable Death
> On a chariot of triumph,
> Under her feet a human body
> Crushed to death, a spear in her hand . . .
> Proud Death on the chariot,
> Turning her pale face to me[.]

> Je viz la mort hydeuse et redoubtée
> Dessus ung char en triumphe montée,
> Dessoubz ses piedz ayant ung corps humain
> Mort à l'envers, et ung dard en la main . . .

110

La fiere mort, sur le char sejournée,
Sa face palle a devers moy tournée[.][48]

Ronsard, the brightest star in the Pléiade, develops a comparable, yet quite different image of female Death. For unlike his contemporary, who transferred a medieval image of horrifying, violent death to the Renaissance, Ronsard, true to his Humanist education, returns to Antiquity's gentle and liberating Death. But his Death is not the Greek youth or man Thanatos but a woman, as was Marot's: not the beloved or the lover, to be sure, as in other personifications at this time, but lovable nonetheless, in crass contrast with Marot's fury. Opting for this unthreatening and attractively female image of death, the French Renaissance courtier may be seen joining ranks with the English Renaissance courtier and Humanist Edward Herbert writing nearly a century later. Herbert's *jeu d'esprit*, however – not to mention his eroticism – is entirely absent from Ronsard's "Hymn of Death" (Hynne de la Mort, 1555); a certain confident calm prevails. It is true, though, that the fearful female Death of the Middle Ages, Petrarch's "donna pallida" in particular, does appear sporadically and episodically elsewhere in Ronsard's poetry, where she is described in terms similar to or even identical with Marot's.[49] In those lyrics, death is also mythologized as Proserpina and Atropos,[50] figures associated with bloody and murderous death, which remind us that classical mythology was one of Ronsard's most important sources of inspiration. In the "Hymn of Death," however, his most significant treatment of the theme, the suggestion of horrid and violent death, classical or otherwise,[51] has in effect disappeared in spite of a few remaining vestiges. In fact, this fearful image is expressly rejected; for "the last hour arrives without pain," as Ronsard puts it elsewhere (l'heure derniere / . . . arrive sans douleur, 1, 425). Instead, the "Hymn"'s reflexions on life and death, on the art and wisdom of living and dying, replete with classical allusions as they are, return time and again to the quasi-mythical image of female death kindly inclined toward mankind. Nonetheless, Ronsard, though intimately familiar with the mythological pantheon of Antiquity, does not seize upon one specific classical conception of death, but instead metamorphoses Thanatos into the mother lovingly welcoming the dead and dying. Not unexpectedly, this liberating and endearing "La Mort" is a "goddess":

That is a great goddess and she well deserves
My verses, for she does men so much good.
Even if she did no more than ease our pains
And the evils of which our lives are full,
Without reuniting us with God, our sovereign Lord,
She still gives us an abundance of blessings and honor
And we must call her our loving mother.
Where is the man on this earth, who, even if not very miserable
And slow of understanding, would not want to be
Out of the human prison of this earthly body?

C'est une grand' Déesse, et qui merite bien
Mes vers, puis qu'elle fait aux hommes tant de bien.
Quand elle ne feroit que nous oster des peines,
Et hors de tant de maux dont nos vies sont pleines,
Sans nous rejoindre à Dieu nostre souv'rain Seigneur,
Encore elle nous fait trop de bien et d'honneur,
Et la devons nommer nostre mere amiable.
Où est l'homme Ça-bas, s'il n'est bien miserable,
Et lourd d'entendement, qui ne vueille estre hors
De l'humaine prison de ce terrestre corps? (11, 602)

The last lines should, however, not be read to mean that Death sets the Christian soul free to join God in heaven. In that case the very term "Déesse" would border on blasphemy, occurring as it does in a poem teeming with classical, rather than Christian allusions. Rather, the idea of the liberation of the soul from the prison of the body is modeled on classical lines of thought. So too is the narrative myth that Ronsard creates to explain further his conception of death, though it is by no means taken over intact from classical mythology: the men and women to whom Prometheus gave the flame of eternal life that he had stolen from the gods are bored with their immortality; to relieve their ennui, Jupiter created Death whom he sent into the world in the shape of the goddess wielding the scythe:

He made her two arms as big as the earth,
Carrying a big scythe, and her feet

He wrapped with wool so that no living soul
Could hear the sound of her approaching.
He made her no eyes, no ears, and no heart,
So that she would feel no pity at the sight of the boredom
Of men and would always be deaf, arrogant,
Inexorable, and aloof to their sad entreaties.
For she is the only one among the immortals
Who does not want a temple and altars
And who responds to no prayer or sacrifice.

Aussi grans que la terre il luy fist les deux bras
Armez d'une grand' faulx, et les pieds par à-bas
Luy calfeutra de laine, à fin qu'ame vivante
Ne peust ouir le bruit de sa trace suivante.
Il ne luy fist point d'yeux, d'oreilles ny de coeur,
Pour n'estre pitoyable en voyant la langueur
Des hommes, et pour estre à leur triste priere
Tousjours sourde arrogante inexorable et fiere:
Pource elle est toute seule entre les immortels,
Qui ne veut point avoir de temple ny d'autels,
Et qui ne se flechist d'oraison ny d'offrande. (II, 607–608)

To the extent that the last lines suggest a strict and fearful figure of death, analogous to the Christian reaper, Ronsard corrects this impression in what follows; if severity remains, it is the severity of kindness. And so the "Hymn of Death" culminates in the praise of the "benignité" of "gracieuse Mort" who liberates man from his earthly prison and leads his soul to never-ending happiness "in heaven," "with his God on high" (dans le Ciel, avec son Dieu là-haut, II, 608). What may sound Christian is in fact classical in thought and expression. Accordingly, the grandiose final salute to the goddess, voicing hope for sudden death, is entirely un-Christian. For sudden death was the death preferred in Antiquity – a death favored by Montaigne as well, who hoped to die while planting his cabbages, without, however, counting on Ronsard's Elysian beyond. But sudden death was definitely not what ordinary Christians hoped for at the time; for them it was the greatest of evils, to be feared more than

anything else as an unprepared demise that would send the soul straight
to hell:

> I salute you, wished-for and beneficent Death,
> Healer and alleviator of the utmost pain.
> When my hour comes, Goddess, I entreat you . . .
> Grant me that I may encounter you suddenly.

> Je te salue heureuse et profitable Mort,
> Des extremes douleurs medecin et confort:
> Quand mon heure viendra, Déesse, je te prie . . .
> Donne moy que soudain je te puisse encourir[.] (II, 609)

V

The fascination of the Renaissance and Baroque with the female figure of
Death takes many forms, notably the Dances of Death and related works,
both literary and pictorial. As suggested earlier, however, Death is male in
this genre, either by implication (the stereotypical mind-set of the time
would associate his power, violence, and authority with maleness) or
because of physical characteristics, such as the beard, or forms of address
or attributes. To cite just one example of such clear-cut specification of the
gender of death: in Valentin Boltz's allegorical fusion of literary Dance of
Death, social satire, and moralizing sermon on the theme of *memento
mori*, entitled *The Mirror of the World* (*Der Welt Spiegel*, 1550), Death, who
uses his bow and arrow to dispatch a wide variety of immoral contempo-
raries from this world, is addressed as "Herr Todt," much as was the case
in *The Plowman from Bohemia* a century and a half earlier.[52] At the same
time, this example highlights a feature shared by most Dances of Death:
recalling the "Death and the Maiden" motif, one notes with surprise that
erotic overtones are avoided here even in those encounters that strongly
suggest them, as for instance when Death approaches a young woman,
asking her to dance with him. Eroticism is absent for the simple reason
that the dance with death personified is punishment for a sinful way of
life: "You gave your favors to young men and boys," the maiden is told in
The Mirror of the World, and Death, austere Helvetic moralist that he is
throughout the Protestant minister's work, has no intention of becoming

their successor (p. 219). More than a century later, this has not changed, in a similarly stern Protestant allegory: the idea of eros does not even occur to author or reader when at the end of part 2 of *Pilgrim's Progress* (1684) Christian's wife is summoned by the messenger of Death: "Hail, Good Woman, I bring Thee Tidings that the Master calleth for thee."

Even those Spanish works which are essentially Dances of Death present a male death figure, as noted above (pp. 90–92). With this in mind, one finds it all the more remarkable that three mid-sixteenth-century Spanish Corpus Christi plays (*autos sacramentales*) on the general theme of the Dance of Death introduce Death as a woman, though again, without the slightest suggestion of erotic overtones. The two earlier ones still adhere rather strictly to the medieval frame of reference. In Juan de Pedraza's *Farsa llamada dança de la muerte* (1551) we are treated to the familiar social "review" – the pope, the king, the lady, and the rest encountering Death, who invariably prevails. But when it is the shepherd's turn, he is given to understand that mankind is saved nonetheless by virtue of the sacraments that are celebrated on Corpus Christi day. The femaleness of this Death, whose power, then, is ultimately limited because temporary, is suggested only in the most casual way, e.g., in that "la muerte" is called "victoriosa" for example.[53] This may or may not suffice to establish a palpable female presence on the stage, and it cannot, in any case, be claimed that the female nature of Death gives this *auto sacramental* any special nuance, sexual or otherwise. That, however, is no longer the case in Diego Sánchez de Bajadoz's Corpus Christi play *Farsa de la muerte*, published only three years later. Here, in the dialogues of the shepherd, the old man, and the "galán" with Death (who, as always, summons everyone without reprieve or mercy), the female nature of Death is expressly thematized in theological terms:

> Your birth is nothing,
> Of your creation one cannot
> Read anywhere . . .
> You were born from guilt,
> And your father was sin,
> And he is therefore called *nihil*,
> And you are the daughter of Nothing.

> Nada es tu generación,
> no se halla tu creación
> en todo quanto leyeres . . .
> De culpa fueste engendrada
> y tu padre fue el pecado,
> y pues es nihil llamado,
> tú quedas hija de nada.[54]

The fall as the birth of death may be a veiled reference to Eve which lends plausibility to the female personification of death, as it did in the Middle Ages. But this does not imply any significant empowerment of woman over man. For though this female Death does kill the "galán" (in counterpoint to the "Death and the Maiden" motif, deprived of its eroticism), the last word is that this woman, like her counterparts in the culture of the time, is shown her place, so to speak: Death's triumph is only apparent and temporary. Symbolically, she falls to the ground along with her final victim, the old man ("Cayeron el Viejo y la Muerte juntos," p. 511). For Christ was victorious over death and what death gives us is in truth life everlasting:

> Death gives us life,
> And so, whoever forgets death
> Has forgotten life.

> La vida nos da la muerte,
> y por eso quien la oluida
> tiene oluido de la vida. (p. 512)

The third of this group of *autos sacramentales*, the *Cortes de la muerte* by Micael de Carvajal and Luis Hurtado de Toledo (1557) ends on a similarly consoling note: the prospect of the soul's ascent to heaven. Here, Death – addressed as "Señora," "reina," "gran monarca," and "emperadora" – does not so much try to impress her victims with her rank and power, as he or she did in most Dances of Death when approaching representatives of all walks of life whose hour had come. Rather, she appeals for understanding and assent, and endeavors to give her victims an insight into the errors of their ways – surely a gentler, less fear-inspir-

ing, though incessantly "preaching" Death, who subordinates herself to God with pronounced modesty: "everything is in his hands" (todo está en sus manos). But this friendliness of Death indicates no "classical conception" of death, as has been argued.[55] For the heaven that will open up to the soul is by no means comparable to Ronsard's classical "ciel"; on the contrary, it is pointedly a "heaven with Jesus Christ" (cielo con Jesu-Cristo), in accordance with the Christian frame of reference that is a *sine qua non* of the genre. All the same, even though this Death still wields the scythe, she is no longer the terrifying figure of the medieval Triumphs of Death; a more "philosophical" image of death prevails, in which more sophisticated theological expectations are met, as this *auto* introduces, among other *dramatis personae*, heathens (converted Indians) as well as Jews and St. Augustine (who bedevilled himself with the question of the salvation of non-Christians). Yet why is this Death so expressly visualized as a woman? And why is this still the case in Quevedo's *Dreams* (*Sueños*), published in 1627, specifically in the vision entitled "El sueño de la muerte" which amounts to a Dance of Death with Death as "a very handsome woman" (una mujer muy galana) – why, considering that Spanish was also remarkably hospitable to male death figures at this time?

Pictorial Dances of Death may point the way to an answer. Oddly enough, or perhaps not, death may appear in male and in female shape in one and the same sequence of images, much as in the late medieval *Dança general de la muerte* death was personified as both the would-be seducer of the young women and the "wife" of the abbot. The Basle Dance of Death of ca. 1440, for example, presents death as male in some scenes but as female in others, with the decisive difference, however, that it avoids consistently the death eroticism of its Spanish counterpart. The Death that comes to fetch the queen and the empress is a woman with waving hair (and pendulous bosom, in the former case). But not all women are summoned by female Death in the Basle fresco. The Death that confronts the others is either a neutral skeleton or one identified as male by attribute or physical feature – the same that approaches the men: the knight is summoned by Death wearing knightly armor, the blind man is led away by a bearded "boneman," etc. What is the principle behind this difference? The Basle Dance of Death simply leaves us baffled. Some of the

later cases complicate matters even further – before some clarification emerges.

A masterwork of early book design is the alphabet of decorative initials, each about 1 inch square, that first appeared around 1530 with the Basle printers Bebelius and Cratander, and was subsequently used by other printers. The background of most of these initials is a Dance of Death episode so that the entire alphabet amounts to a somewhat eccentric *Totentanz*. Death is male, for example, in the episode featured in the background of the letter F: assisted by a colleague (a striking, though not a unique idea), he lifts up the empress's dress with drastic eroticism that leaves little to the imagination. Even more explicit is the illustration around the letter S which, in the words of a late Victorian, shows male Death "in a very licentious action with a female."[56] On the other hand, Death is metamorphosed into a female in the image surrounding the letter I, where a hand-wringing duke is ambushed by death in the guise of a grotesque old woman. Even the most prurient imagination would not read a counterpart to the eroticism of "Death and the Maiden" into this "action." (The old crone is, rather, distantly related to Death in a copper engraving by Jacob de Gheyn II [1565–1629], "Old Woman Offering a Young Man Money": an old woman appeals for the favor of a robust young man by spreading coins on the table while the object of her attention exchanges glances with a young woman; Death, long-haired and dressed as an older woman, rises up behind the aging nymphomaniac, raising an hourglass over her skull.)[57] Why is Death a woman in these images that present her in an entirely unerotic situation, and one that is in no way reminiscent of the various "Triumphs of Death," or of Eve, for that matter, or any classical death figures?

The same question suggests itself in Niklaus Manuel's Berne Dance of Death (1516–19). It has, on the one hand, its unmistakably male death personae such as the skeleton sporting an elegant sword, who fetches the empress, or the armored Death with a halberd in his bony hand, who announces to the warrior that his last hour has come. But when Death summons the canon or priest, not only in the Dance of Death itself, but also in Manuel's preparatory drawing, we see a female Death, indeed an ugly old woman with long hair and long dangling breasts, while the

Death fetching the fool is suggested to be female by long waving hair only.[58] How can this juxtaposition of male and female Death be explained? It is one thing to say, apropos of the overly conspicuous breasts of female death, that male sexual organs are not normally represented for reasons of propriety and because they are not really necessary to remind the viewer that Death is male, as that is taken for granted anyway. Thus it is "not surprising," says a recent critic, Sarah Webster

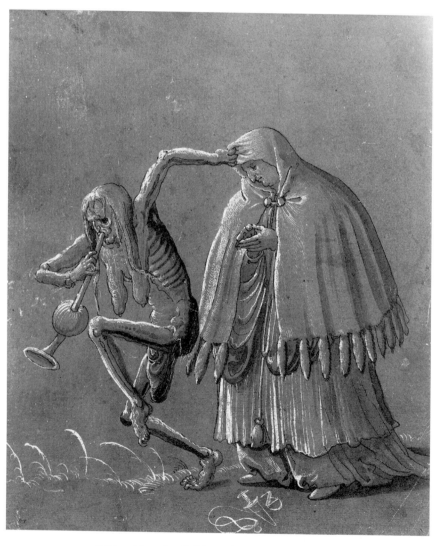

PLATE 12 Niklaus Manuel, called Deutsch: Death and the Canon, drawing (1516–19)

Goodwin, that only the "second sex," as the exception to the rule, had to be signalled with anatomical detail.[59] But it is quite another thing to explain *why*, in the Berne and the Basle Dances of Death as well as in the Basle alphabet, death is sometimes allegorized as male and sometimes as female. Why are not all women taken from this life by a male Death and not all men by a female Death, or vice versa?

A glance at yet another famous Dance of Death, Holbein's of ca. 1525 (which was the occasion of the just quoted explanation), does not simplify matters. Death, in the usual rendezvous with representatives of all classes, here turns up twice as a woman, so identified by unmistakable breasts, and summons women (the empress and the nun)[60] – in contrast to Manuel's Dance of Death where she fetched men, but in agreement with the Basle fresco. Holbein's Death takes the shape of a withered old woman who, with an imperious gesture, points to a freshly dug grave in a splendid city square as the crowned empress approaches in state, with ladies-in-waiting holding her train. More dramatic and suggestive, even mysterious, are the goings-on in the apartment of the nun, which is definitely not a cell, but rather an opulently furnished Renaissance room with an alcove. The nun is seen kneeling before an altar; her glance, however, is intently fixed on a young man sitting on the bed, playing the lute; in the background skeletal Death materializes, with her trademark ugly pendulous breasts, to extinguish the candle, the life-light, with her bony fingers, as might a chambermaid; clearly, this female Death, too, is not there because of any erotic appeal she might have.

But why? The question is complicated in that, just as in the Basle Dance of Death, not all women are fetched by female Death; the old woman, for instance, is not, nor is the queen whom Death summons in the guise of the fool; and none of the men encounters a female Death, some of them being approached by a skeleton with pointedly male attributes, the count for example, who is slain by a peasant figure with his own armor. If one goes on the assumption, as did the older interpretations, that the skeleton or *transi*, in Holbein's or any other Dance of Death, is meant to be not Death but a dead person, then the problem does not come up in the first place, of course.[61] If, on the other hand, one takes the skeleton in the Dances of Death to signify Death, as has been common for some time, then the question of the reason for and the meaning of the

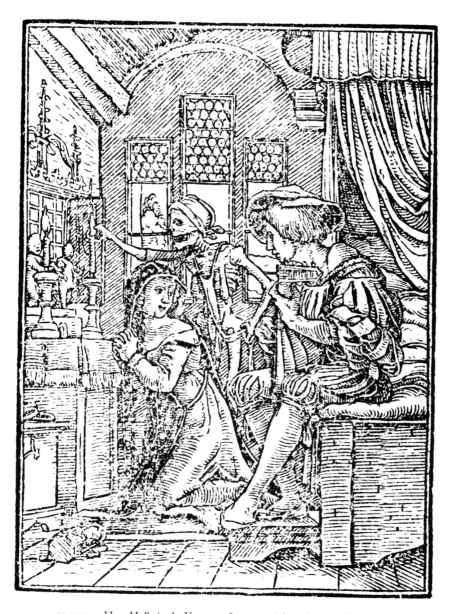

PLATE 13 Hans Holbein the Younger: *Icones mortis* (woodcuts by Hans Lützelburger).
The Nun (1554)

feminity or masculinity of death personified becomes real, and crucial.
To return to the specific case of Holbein's nun: is the femaleness of
Death in this image meant to be read as a hint that the nun is guilty of an
erotic offense? Sarah Webster Goodwin comments:

The exact center of the image lies between Death's grotesquely sagging breasts and its concealed pelvis, and Death's left arm sketches an arc that then moves into a spiral form. Here the macabre visually echoes the Nun's spiritual corruption; Death's body is an emblem of illicit female sexuality. To read the image this way we have to follow our eye into it and seek, pruriently, the details that will reveal its meaning: Death's first breast is barely detectable, and the second, behind it, is even more dimly sketched. If our eye travels beyond Death it encounters a tripar-tite window, with open spaces visible: yet another threshold – this time, subtly, to the freedom from corruption promised by the trinity (or, with different, complementary connotations, by the Crucifixion: the windows form a cross shape directly behind Death). In one image, then, we have not only the Fall, its conse-quences, and redemption; we also have the psychology of sin and our own implication in it.[62]

This interpretation is as ingenious as it is far-fetched; it surely expects too much of the contemporaneous viewer and, above all, such a reading would hardly seem to be transferable to other "cases." And this common-sense objection would also hold good for the more sociological explana-tion offered recently to the effect that maleness and femaleness of Death are to be seen as adaptations of Death's role to the social identity of the victim claimed.[63] This would of course fit a case like the chambermaid Death in the countess episode in Kaspar Scheit's *Dance of Death* (*Der Todten Dantz*, 1557), a volume of woodcuts after Holbein's Dance of Death: Holbein's gender-neutral skeleton is transformed by Scheit's explanatory verses into a chambermaid who says to the countess: "You no longer need all your chambermaids. Here is a bony woman," namely Death, who plays that role now.[64] The sociological explanation would also fit a case like Jakob von Wyl's Lucerne Dance of Death painting of the early seventeenth century, where Death is actually identified through her dress and function as a chambermaid.[65] But only a small fraction of female or male death figures could possibly be interpreted along the lines of this sociological model; there are simply too many counter-examples that cannot be passed off as mere exceptions. To mention just one

instance: there is no conceivable sociological reason why in Rudolf and Conrad Meyer's *Mirror of Dying* (*Sterbensspiegel*, 1650) the maid is fetched by a female death but the stable-boy by a male, or at least not female, Death (copper engraving, no. 35).

VI

A different explanation for the occasional choice, at this time, of a female rather than male or simply gender-neutral death persona may be suggested by a theological consideration. Just as in the Middle Ages there were indications that a male or a female personification of death might become plausible if seen against the background of the archetypical significance of Adam or Eve in the theology of sin and salvation, so a different, yet related theological mindset, more germane to the time of Holbein and Dürer, might be helpful in an endeavor to understand why male and female images of death can be found side by side, so to speak, or why Death is not necessarily male even in cultures whose language has a grammatically masculine word for death. The argument might go like this: When the Middle Ages traced the origin of sin (whose wages was death in such a direct and irrevocable way that death and the sinner could be identified) to Adam's or to Eve's eating from the forbidden fruit, then the understanding of the origin of sin and death went only half-way. The popular pun about the bite and death, *mors/morsus* or *mort/mors*, did not go far enough. For ringed around the apple-tree in the garden of Eden, there was, after all, the original instigator of the transgression of God's command. The eloquent reptile, however, is Satan, according to a common reading of Scripture, sanctioned by the church fathers. So it was ultimately the devil, not Adam or Eve, who brought sin into the world, and it was the devil that could be identified with death in that curious alchemy of the imagination that fused the sinner and the consequence of sin into one. The Book of Wisdom (of Solomon) makes no bones about it: "Through envy of the devil came death into the world" (2:24). Once this is accepted, there seems to be no more urgent need to argue, as theologians did in the Middle Ages, whether Adam was culpable or Eve. And is that not the "Solomonic" wisdom of González de la Torre who presented Adam and Eve *each* holding an apple in their hands (see above, p. 91), or the wisdom of Lucas Cranach who repeatedly painted Adam and

Eve, together or separately, each with a freshly picked apple, or the wisdom of Aldegrever who around 1533, in a matching pair of engravings, portrayed Adam and Eve, each holding an apple?[66] It helped, of course, that the incrimination of Satan, rather than Adam or Eve, could also be found in non-apocryphal biblical passages, in the gospel of St. John, for instance, where the devil is "a murderer from the beginning . . . He speaketh a lie . . . for he is a liar, and the father of it" (8:44), and has been ever since Eden. The first Epistle of John could be read in this light as well: "He that committeth sin is of the devil; for the devil sinneth from the beginning" (3:8).

But why was it, by and large, not until the sixteenth century that the conclusion was drawn that ultimately and originally it was the devil, not the first humans, that subjected mankind to death as the wages of sin? The reason may be found in the rejection of St. Augustine's essentially antimanichean understanding of sin, based on St. Paul's, which predominated throughout the early Christian period and the Middle Ages. St. Augustine held that the fall and its consequences were due primarily not to some evil cosmic power, whether independently coeval with God or created by God. Instead, he believed sin to be grounded in the soul, in the actions of men and women: evil springs from sin, not sin from evil, as Mani taught. No wonder that St. Augustine was so notoriously troubled by the biblical references to the devil as the murderer and instigator of sin "from the beginning," forever leading us into fatal temptation, following us like "a roaring lion" on the look-out for "whom he may devour" (Ep. of Peter 5:8). St. Augustine tried to interpret such references away in keeping with his basic conviction that not the devil but human nature, fallible and sinful from the beginning, was responsible for the fall and for death.[67]

As the Middle Ages drew to a close, this understanding of sin (and of death, as its consequence) lost ground. By and large, the Renaissance and Baroque are not persuaded that human nature is sinful by definition, prone to sin though it is. On the contrary, it was a time "when the development of Christian thought had polarized the human and the supernatural worlds into a conflict between good and evil, and had given their struggle a new intensity and rigor. This inevitably gave the devil and his hierarchy unprecedented theological and psychological importance . . . The fairly relaxed coexistence of a benevolent God and his malevolent

double was brought to an end."[68] In an age rife with persecution of pre-sumed pacters with the power of darkness, such as Faust, and of witches presumed "possessed" by the devil, the idea gained ground that it is the Father of Lies, the devil as the instigator of the fall, who is accountable for sin and hence for death – rather than Adam and Eve, which is to say, human nature. In Northern and Central Europe, Lutheranism (which, to be sure, does not share many aspects of the Renaissance and Humanist "image of man") contributed powerfully to this view. Lutheranism met the rejection of Augustinian moral theology at least half-way in that, in an almost paranoid manner, it saw the devil plotting our downfall every-where and at all times. Goethe blamed Luther for this in his *Theory of Color* in words not easily brushed off: "How easy Luther makes it for him-self by pressing the devil into service everywhere to explain away the most important phenomena of nature in general and human nature in particu-lar in a superficial and barbaric manner."[69] One of these most important phenomena was death. Lutherans "diabolized" death,[70] not without logic. "Your power and might you owe to me," the devil says to Death in Hans Sachs's *Play of the Rich Man Dying* (*Comedi von dem reichen sterben-den menschen*, 1549).[71] It is not death and Adam, not death and Eve, that are virtually identified here, but death and the devil as the ultimate author of sin.[72] And this accords well with the fact that in the sixteenth century, as the Grimms' authoritative German dictionary documents, the name Hein was current for both death and the devil.

Death equals Satan. The devil is a fallen angel, and Death, too, is often represented with wings – as the angel of death (Beham's engraving may come to mind [see above, p. 99]). In the Revelation of St. John, death and hell, the domain of Satan, are closely associated (6:8). When Christ descended into hell, he overcame none other than death, that other Prince of Hell, "principem mortis" as the apocryphal Ascension of Isaiah has it (9:16), in agreement with the Gospel of Nicodemus and the Passion of Bartholomew. A woodcut from an Italian *Ars moriendi* (ca. 1500) says it in the language of allegory, still widely understood at the time: Death, a skeleton riding roughshod over a crowned skeleton, has two ox-horns growing out of its skull– the insignia of the devil.[73]

These theological and creative identifications of death and the devil as the author of sin are relevant to our inquiry into the reasons for the

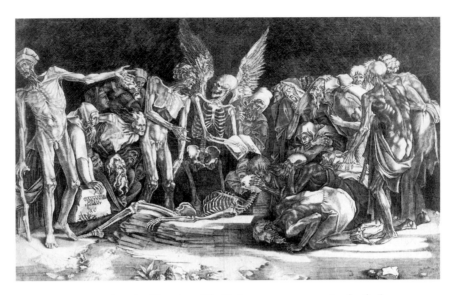

PLATE 14 Agostino Veneziano: The Skeletons, copper engraving (1518) of
Rosso Fiorentino: I squeletti (1517)

genderization of death as both male and female for the following reason.
Always associated with sex and the sin related to it, the devil (as one of
the fallen angels whose gender varies notoriously in the Judeo-Christian
world) may adopt one or the other gender in the myth-making imagina-
tion of the church fathers, the Middle Ages, and subsequent centuries.
As a woman or succubus, it was believed, Satan would lead monks and
hermits into temptation, St. Dunstan for example and St. Anthony, a
notion that lived on all the way to "Black Romanticism" as Mario Praz
has taught us to see it, if not beyond. As a youth or a man, or incubus,
Satan would seduce women and girls[74] – in Goethe's *Faust*, in the garden
scene where Mephistopheles makes advances to Marthe, we still hear an
echo of this. "For spirits when they please / Can either Sex assume, or
both," *Paradise Lost* tells us (1, 423–424) – or both: it is Mephistopheles's
bisexuality, specifically his homosexuality, that will cost him the soul of
Faust in the end, in the grotesque scene called "Entombment." The
equivalent in the pictorial arts of the Renaissance and the Baroque is, as
Panofsky has observed,[75] that the devil is often represented with female
and male sexual organs, with breasts and penis, as for example in Rosso
Fiorentino's drawing "The Skeletons" (I squeletti, 1517), or, when the

126

hips are not visible, with breasts only, as for instance in the *Art de bien vivre et de bien mourir* (1492), printed by Antoine Vérard in Paris, or in Dürer's woodcut "Descent into Hell" (1510).[76]

To repeat: Satan equals death. The fact that in the Dances of Death, Death is introduced, contrary to all physiological probability, as a skeleton with overly conspicuous pendulous breasts in some scenes, but in others is signalled by a beard to be male, may reflect the then widely accepted ambisexuality of the devil – who in turn, viewed now *as the originator of sin*, was identified with death. This understanding of the (or one) source of the genderization of death gains conviction if we remember that in pictorial representations of death as female, that is, with pronounced breasts, the genital area is often covered or made invisible as a result of the composition of the image – which would not exclude that endowment of death with sexual characteristics of both sexes that is familiar at the time from the iconography of Death's alter ego, the devil. But not only that: the male–female changeability of the devil, as it occurs in the art and literature of a period that liberated sexuality from the taboo imposed by the church, is likely to help account for the fact that Death can be male and then again female in one and the same sixteenth-century Dance of Death. And in retrospect, the idea of this changeability of the devil (as Death's alter ego) might also throw some light on the ambivalence of the Renaissance and the Baroque about the sexual identity of Death as represented in other genres of literature and art. In them, Death was portrayed, as we saw, sometimes as a man and sometimes as a woman, sometimes in the same work, whereas the devil could be not only one or the other, but both at the same time. Given the conceptual identity of death and the devil, might not the unequivocally male and the unequivocally female death figures be perceived to be simplifications that fail to do justice to the full reality of the phenomenon that the artist tries to come to grips with? Hence, time and again, the spectacle of one such personification calling, so to speak, for its opposite to appear on the scene. And would this, then, not be the (or one) reason for our finding that in this period Death (like the devil, Death's alter ego and the instigator of the transgression whose wages is death) appears in art and literature as a man as well as a woman, in a wide variety of metamorphoses and imaginative innovations?

4

THE ROMANTIC AGE: "HOW WONDERFUL IS DEATH"

THE YOUTH WITH THE DOWNTURNED TORCH
"THE LAST BEST FRIEND"
DEATH IN THE BRIDAL CHAMBER

I

When Schiller dedicated the 1782 *Anthologie* of his poetry to his "master, Death" he did so with "devoutest shivers" running down his spine. For this Death, the dedication claimed, was the "most powerful tsar of all flesh," an "insatiable glutton everywhere in Nature."[1] This Death is clearly inherited from the age of the Dances of Death, the age that indeed cowered in fear at the thought of death. So overpowering was this horror during the late medieval and early-modern periods that, wherever religious orthodoxy held sway, erotic overtones were quite unthinkable even when Death encountered a young woman, as he routinely did in the Dances of Death. On the contrary, the "maiden" was stunned and terrified by the assault of an unrelentingly severe "boneman." It was only in the (wide) *margins* of the domain of religious orthodoxy that the encounter with Death became an erotically charged theme in the centuries before Schiller – overt and aggressive in Niklaus Manuel's images, gentle and "romantic" in Shakespeare's plays, passionately mystical in Jacob Balde's poetry.

Despite Schiller's nod to the grim "master" of earlier times, Death becomes a gentler presence in art and literature, a "friend" in fact, in Schiller's own age. Around 1800 the theme even takes an erotic turn similar to that of the sixteenth and seventeenth centuries. Yet that period's

terrifying variant of the theme did survive sporadically, even as the Romantic Age was giving death a kinder face. It survived not only in Schiller's fearful "tsar," whom one might visualize as the apocalyptic horseman typical of the age when the plague ruled supreme, but most memorably in Gottfried August Bürger's poem "Lenore" (1773), which was an international success until well after 1800. In this ballad of sheer horror, strongly reminiscent of "Sweet William's Ghost" in Percy's *Relics of Ancient English Poetry*, the lover, believed to have fallen in battle, returns on horseback one stormy moonlit night to fetch his fiancée and take her to their "bridal bed" – which turns out to be a coffin in the cemetery. Here the bridegroom, in a hair-raising horror scene, is transformed into a rattling skeleton whose hourglass and scythe reveal his true identity. Along with its gothic horror, the poem also revives the erotic aspect of the encounter with Death, which is one of the theme's hallmarks throughout the Romantic Age (defined, for the sake of convenience, as the period from roughly the middle of the eighteenth century to the 1820s). By contrast, this erotic aspect is entirely absent in another well-known German poem of the time featuring a young woman's encounter with Death and derived, like "Lenore," from the traditions of folk poetry. This is "Death and the Maiden in the Flower Garden" (Der Tod und das Mädchen im Blumengarten), published in Arnim and Brentano's famous collection of folk poetry, *The Youth's Magic Horn* (*Des Knaben Wunderhorn*, 1806–08); here unrelieved terror prevails. "Grim Death" is "a right horrifying man," an ugly skeleton, baring his white teeth. He surreptitiously follows the girl into the garden, where she is about to pick flowers for a wreath. As he accosts her, inviting her to dance with him, her only reaction is "great fear" – even before he tells her, in time-honored fashion, that worms will devour her "beauty," taking the place of her flowers, her gold and pearls, her silver and jewels. True to Dance of Death form, a dialogue ensues in which Death formally introduces himself as one "known far and wide, in all lands"; panic-stricken, the maiden offers her father's gold for a reprieve – to no avail. For, as Death explains, again with echoes from across the centuries, "each and everyone must follow me, / When I knock on the door." He throws her in the grass, "There lies the gentle maiden, / In bitter fear and pain."

Es ging ein Mägdlein zarte
Früh in der Morgenstund
In einen Blumengarten,
Frisch, fröhlich und gesund,
Der Blümlein es viel brechen wollt,
Daraus ein Kranz zu machen,
Von Silber und von Gold.

Da kam herzu geschlichen
Ein gar erschrecklich Mann,
Die Farb war ihm verblichen,
Kein' Kleider hatt' er an,
Er hatt' kein Fleisch, kein Blut, kein Haar,
Es war an ihm verdorret
Sein Haut, und Flechsen gar.

Gar häßlich thät er sehen,
Scheußlich war sein Gesicht,
Er weiset seine Zähne
Und that noch einen Schritt
Wohl zu dem Mägdlein zart,
Das schier für großen Aengsten
Des grimmen Todes ward.

"Nun schick dich, Mägdlein, schick dich,
Du mußt mit mir an Tanz! . . .

Der Würmer in der Erde
Ist eine große Zahl,
Die werden dir verzehren
Dein Schönheit allzumahl,
Sie werden deine Blümlein seyn,
Das Gold, und auch die Perlen,
Silber und Edelstein.

Willst du mich gerne kennen
Und wissen, wer ich sey?
So hör mein Nahmen nennen,
Will dir ihn sagen frey:

Der grimme Tod werd ich genannt,
Und bin in allen Landen
Gar weit und breit bekannt.["] . . .

["] Ich will dich reich begaben,
Mein Vater hat viel Gold,
Und was du nur willst haben
Das all du nehmen sollt!
Nur lasse du, das Leben mir,
Mein allerbeste Schätze,
Die will ich geben dir!" – . . .

Drauf sprach der Tod: "Mit nichten,
Ich kehr mich nicht daran,
Es hilft allhier kein Bitten,
Ich nehme Frau und Mann!
Die Kinderlein zieh ich herfür,
Ein jedes muß mir folgen,
Wenn ich klopf an die Thür."

Er nahm sie in der Mitten,
Da sie am schwächsten was,
Es half bei ihm kein Bitten,
Er warf sie in das Graß,
Und rührte an ihr junges Herz
Da liegt das Mägdlein zarte
Voll bittrer Angst und Schmerz . . .[2]

This horrid skeleton, the ugly "boneman" exulting in his power and severity, then, is a relic from the past and the very opposite of the – likewise male – friendly and even loving image of death that prevails in the Romantic Age. As art, literature, and criticism coalesce in this new iconography, they polemicize against the Christian tradition that had made the fear-inspiring skeleton *de rigueur*. At the same time, they join ranks with what they perceive to be the classical tradition of gentle and beautiful Death, of Thanatos, the brother of Sleep and the friend of mankind. Even the petit-bourgeoise Luise Miller, in Schiller's *Intrigue and Love* (*Kabale und Liebe*), has heard of the Greek youth in her

provincial German home town: "None but a howling sinner could have called death a skeleton; it is a lovely, charming youth, in the flower of life, the way they paint the god of love, only not so mischievous, a quiet, ministering spirit who lends his arm to the exhausted pilgrim soul to help her across the ditch of time, opens up the fairy castle of everlasting splendor [eternal glory], nods in a friendly fashion, and disappears." (Nur ein heulender Sünder konnte den Tod ein Gerippe schelten; es ist ein holder niedlicher Knabe, blühend, wie sie den Liebesgott malen, aber so tückisch nicht – ein stiller dienstbarer Genius, der der erschöpften Pilgerin Seele den Arm bietet über den Graben der Zeit, das Feenschloß der ewigen Herrlichkeit aufschließt, freundlich nickt, und verschwindet.)[3]

But Death's new friendliness in the Romantic era does not necessarily require an explicit polemic against the Christian personification of death, or any revival of the mythology of Antiquity – after all, Protestants were familiar with the hymn "Come, O Death, brother of Sleep" (Kömm, o Tod, du Schlafes Bruder). Death now makes his debut in cultural history not as Hein (as in earlier centuries) but as "Freund Hein" – a creation of the mythopoetic imagination whose vitality and originality remain undiminished in an age widely believed to have been rationalistic. At the same time the "Death and the Maiden" constellation not implausibly regains its erotic overtones, this time in a predominantly "sentimental" mode, though it may give way to passionately religious feelings. Death, having lost its terror, lures the lover to the bridal chamber; as Luise Miller says in the same context: "These are but terrors that lurk about the word – Take that away, and there is a bridal bed there, and over it the morning throws its golden coverlet and the springtimes strew their colored garlands." ("Das sind nur Schauer, die sich um das Wort herum lagern – Weg mit diesem, und es liegt ein Brautbette da, worüber der Morgen seinen goldenen Teppich breitet, und die Frühlinge ihre bunte Girlanden streun.")[4]

One way or the other, then, inspired by Antiquity or through its own creative imagination, the Romantic Age visualized death as a friendly and conciliatory, even loving and beautiful persona that paradoxically enhances life as it fades away.[5]

Today of course we might suspect "repression" here or deliberate self-

delusion as all-too-human forms of coping with what normally remains, after all, a shattering experience. Goethe's choice of words, in his account of the impact of the neoclassical image of death on his generation, in his autobiography, *Poetry and Truth*, may suggest as much: "We considered ourselves saved from all evil . . . We were particularly enchanted by the beauty of the idea that Antiquity had recognized Death as the brother of Sleep and had represented them as so similar that they could be mistaken for each other. So we could really celebrate the triumph of beauty to the utmost and, in the realm of art, could consign ugliness of all kinds, since it cannot be driven out of this world entirely, to the low level of the ridiculous." (Wir hielten uns von allem Übel erlöst . . . Am meisten entzückte uns die Schönheit jenes Gedankens, daß die Alten den Tod als den Bruder des Schlafs anerkannt, und beide . . . zum Verwechseln gleich gebildet. Hier konnten wir nun erst den Triumph des Schönen höchlich feiern, und das Häßliche jeder Art, da es doch einmal aus der Welt nicht zu vertreiben ist, im Reiche der Kunst nur in den niedrigen Kreis des Lächerlichen verweisen.)[6] And the context makes it clear that "ugliness of all kinds" includes most prominently the revolting skeleton of the Christian tradition. Even Herder, the Protestant minister, rejected this terrifying allegory of death and favored instead the gentle, beautiful Thanatos, even though he thought he could see through the aesthetic euphemism and escapism implied in this conciliatory representation of the greatest of evils.[7] Yet Herder added a curious twist when he also claimed that Antiquity's gentle conception of death and dying was borne out by the empirical truth of the deathbed, the Christian deathbed, that was familiar to him from professional experience:

> The *truth* strictly contradicts the hideous ideas the populace has of death and the forms in which it actually visualizes them under the lingering influence of monasticism. When our poets tell us, again and again, that *death* is a matter of agony, of eyes growing dim, of death rattles, stares, horror and trembling, fear and the flames of hell, they misuse both imagination and language . . . My reader should take the time to think about the cases of tranquil death he may have witnessed: where was the skinny boneman? Where was the grinning specter lacerating his victims with his

scythe? Where were the phantoms attacking the sick on their deathbeds? Dying is such a solemn, gentle, unnoticed moment of *falling asleep* and not waking up again, of *calm* undisturbed by any sound, of the silent, venerable *veil* that then covers the sacred face ... Not a frightening specter, therefore, but the *terminator of life*, the calm youth with downturned torch – that is Death!

Die strenge *Wahrheit* widerspricht den greßlichen Bildern, in denen sich der große Haufe den Tod denkt, und in denen er ihn aus Nachläßen des Mönchswesens sogar siehet. Wenn unsre Dichter immer und immer vom Todeskampf, vom Brechen der Augen, Röcheln, Starren, Entsetzen und Erbeben, Angst und Höllenglut, als wie *vom Tode* singen: so ist das Misbrauch der Phantasie und Sprache ... Ich laße meinem Leser Zeit, die Fälle ruhigen Todes zu überdenken, die er etwa erlebt hat: wo war der dürre Knochenmann? wo stand das grinsende, zerfleischende Gespenst mit der Sense? wo waren die Phantome, mit denen der Kranke auf seinem Bette kämpfte? Es ist ein so feierlicher, sanfter, unvermerkter Augenblick des *Einschlafens* und nicht mehr Erwachens, der *Ruhe*, die kein Geräusch mehr störet, des stillen, ehrwürdigen *Schleiers*, der sodann auf das heilige Antlitz sinkt ... Kein Schreckgespenst also, sondern *Endiger des Lebens*, der ruhige Jüngling mit der umgekehrten Fackel, das ist der Tod![8]

II

This pronouncement of 1774 echoes Lessing's epoch-making essay *How the Ancients Represented Death* (*Wie die Alten den Tod gebildet*, 1769), which was not so much an archeological investigation as a piece of cultural criticism, as Goethe fully realized when he penned the just quoted words on the liberating impact of Thanatos on his generation. With his customary polemical vigor, Lessing in this essay took his cue from a minor antiquarian difference of opinion and developed it into a far-reaching philosophical argument. Confronting the revoltingly macabre "boneman" of the Christian iconography of death with Thanatos, he proclaimed the latter to be the personification of death most appropriate for his own age. This

Death was the youth or genius (sometimes, but not always with wings) turning his torch downward, familiar to the eighteenth century from sarcophagi and tombs of Antiquity. It was an icon that Lessing's contemporaries eagerly accepted as one most congenial to the enlightened frame of mind, as it suggested a gentle rather than fearful, a beautiful rather than ugly ending of life, one that was humane and dignified rather than creaturely and demeaning.[9] The terror with which the churches surrounded the final hour, all the more familiar to Lessing as he had grown up in a Lutheran parsonage, gave way to serenely philosophical calm in the face of the inevitable. The only literary use that Lessing had for the "fearful skeleton" swinging its scythe was caricature; as such it appeared in the witty rococo poetry of his late teens, after he had put the parsonage behind him. (This Death, by the way, unlike his counterpart in the Dances of Death, is willing to strike a deal: he gives a reprieve to the hard-drinking medical student on condition that, once he is a doctor, he will surrender half his patients to the Grim Reaper.)[10] Lessing hoped that the hideous skeleton would be replaced in the visual arts and in literature by the beautiful youth, the brother of Sleep, who extinguishes the flame of life mournfully but without shocking us. Schiller put it more poetically than Lessing. True, in the polemical poem "The Genius with Down-turned Torch" (Der Genius mit der umgekehrten Fackel, 1796), he wrote the much-cited lines: "He may look charming with his extinguished torch, / But, gentlemen, Death is not so aesthetic, after all" (Lieblich sieht er zwar aus, mit seiner erloschenen Fackel, / Aber, Ihr Herren, der Tod ist so aesthetisch doch nicht).[11] But this sentiment is by no means Schiller's last word; consider the equally proverbial passage in his poem "The Gods of Greece" (Die Götter Griechenlands, 1788, 1798):

> In those days, before the bed of Death
> Stood no ghastly form. Then took away
> From the lips a kiss the parting breath,
> And a Genius quench'd his torch's ray.
> Necessity by airy visions
> Was measured to a kinder scale,
> And even Destiny's decisions
> Seemed milder through a human veil.

Damals trat kein gräßliches Geripppe
vor das Bett des Sterbenden. Ein Kuß
nahm das lezte Leben von der Lippe,
still und traurig senkt' ein Genius
Seine Fackel. Schöne, lichte Bilder
scherzten auch um die Nothwendigkeit,
und das ernste Schicksal blickte milder
durch den Schleyer sanfter Menschlichkeit.[12]

Lessing is more prosaic: "The condition of being dead has nothing terrible, and in so far as dying is merely the passage to being dead, dying can have nothing terrible" (212; XI, 40). The "ancient cheerful image of Death," he says, has been unjustly banished by the "terrible skeleton" derived from Christian "revelation" and its "terrors of death," which would "not of itself have occurred to the brain of a man who only used his reason" (225–226; XI, 55). Herder, conciliatory as always, tried to soften this harsh antithesis of Christianity and Antiquity in two essays (1774, 1786) by advancing the somewhat wishful argument that the classical genius of death turning his torch earthward was merely an anticipation of Christian thinking.[13] All the same, Herder and Lessing (who, for his part, granted in a moment of mellowness that even Christianity wanted at least the deaths of the righteous to be "gentle and restoring" [226; XI, 55]) join ranks in their rejection of the fear of death and in their appropriation of Thanatos as an image suitable for their own time. Quite unrelated to the "grim Death" of the German folksong that *The Youth's Magic Horn* brought to the attention of the educated classes, Thanatos, Herder agrees, points to a benevolent and beneficent, even loving universal force − death is "the masterstroke of love eternal" (der ewigen Liebe Meisterstück).[14] As Goethe confirmed, this message was congenial to the temper of the time.

It is therefore all the more surprising to realize that Lessing, championing Thanatos in his treatise on the representation of death in Antiquity, was fighting on two fronts: against the orthodoxy of the churches that held on to the skeleton, and against the orthodoxy of art historians who interpreted the ephebic genius of Hellenist and Roman sepulchral monuments not as Thanatos but as Eros/Amor. Most prominent among

the latter were Johann Joachim Winckelmann (though he did not particularly care about the issue, being more interested in other iconographical questions) and Christian Adolf Klotz, Lessing's main antagonist. Among the earlier scholars with whom Lessing differs, the most authoritative was Giovanni Pietro Bellori, who, in his *Admirable Vestiges of Roman Antiquities and Ancient Sculpture* (*Admiranda Romanorum antiquitatum ac veteris sculpturae vestigia*, 1693), had famously interpreted the youth with downturned torch as Amor. Unlike Herder, who opted for ambivalence in this case as in so many others,[15] Lessing preferred a clearcut decision as always and cast his vote for Thanatos, rejecting Eros categorically. What we see on the so-called Prometheus sarcophagus, he says, is the relief of

> a winged youth who stands in a pensive attitude beside a corpse, his left foot crossing his right, his right hand and his head resting on a reversed torch supported on the breast of a corpse, and in his left hand which grasps the torch, he holds a wreath with a butterfly. This figure, says Bellori, is Amor, who is extinguishing the torch, that is to say, the affections, on the breast of the dead man. And I say, this figure is Death! (p. 183)

> geflügelten Jünglings, der in einer tiefsinnigen Stellung, den linken Fuß über den rechten geschlagen, neben einem Leichname stehet, mit seiner Rechten und dem Haupte auf einer umgekehrten Fackel ruhet, die auf die Brust des Leichnames gestützt ist, und in der Linken, die um die Fackel herabgreift, einen Kranz mit einem Schmetterlinge hält. Diese Figur, sagt Bellori, sey Amor, welcher die Fackel, das ist, die Affekten, auf der Brust des verstorbenen Menschen auslösche. Und ich sage, diese Figur ist der Tod! (XI, 10)

The figure is reproduced on the title page of *How the Ancients Represented Death*.

According to modern art history, Lessing and his followers were wrong in their understanding of this genius as Thanatos: the (sometimes winged) figure with the torch, ubiquitous on the tombs of Antiquity,

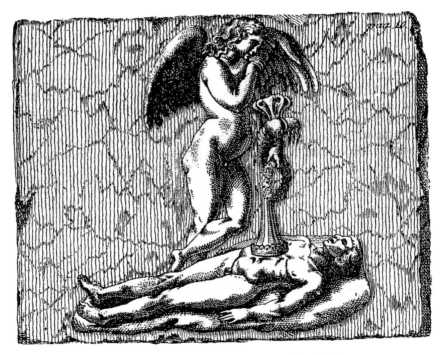

PLATE 15 G. E. Lessing: *How the Ancients Represented Death*, title-page vignette (1769)

generally interpreted before Lessing as a mournful and yet vigorously youthful genius of life and love, is indeed Eros and nothing else, certainly not an allegory of death.[16] Oddly enough, Lessing overlooked the fact that this figure often embraces a female body: Amor and Psyche. Or not so odd, perhaps, for in this matter as in others Lessing was the imperious legislator, seeing what he wanted to see; and when it came to the visual arts, his perception was notoriously limited. So for Lessing the youth was Thanatos, not Eros, and definitely not both, as Herder had it. In Lessing's eyes, the ambiguity of Thanatos and Eros would have endowed the gentleness of death with an erotic component which, to him, was inconceivable. The man who took the seraphic poet Klopstock to task for having the nerve to ask God "so earnestly for a woman" (IV, 376) could hardly have stood for this kind of eroticization of death, which was to become commonplace at the end of the century and beyond. This is no doubt the ultimate reason for his endeavor to distinguish Thanatos from Eros and his preference for Thanatos in the controversy described.

138

Herder on the other hand, some fourteen years Lessing's junior, proved to be the standard-bearer of the next generation, of the Romantics in the narrower sense, when he opted for the ambiguity of the classical youth in his argumentation with Lessing: to Herder the figure represented Thanatos *and* Eros. Ironically, he reserved his strongest statement on the identification of Amor and Death, and consequently on the eroticization of dying for "A Conversation at Lessing's Grave." This is the subtitle of his poem "Death" (Der Tod, 1785), which Lessing might have found somewhat lacking in clarity:

> Heavenly youth, why are you standing here, your smoldering torch
> Turned earthward? But the other torch is burning brightly
> On your ambrosian shoulder, with a glorious light!
> Never did my eye see more beautiful and resplendent purple!
> Are you Amor? –
>
> "I am! but in this form,
> Though I am Amor, I am known as *Death* to mortals.
> Among all genii the kindly gods saw
> None who releases human hearts as gently as I do.
> And they dipped the arrows with which I deliver them from their misery,
> Bitter missiles to them, into the goblet of joy.
> Then, kissing it, I conduct the parting soul
> To the true nuptial joys on high."
>
> "But where is your bow and arrow?" For the brave and wise
> Who long ago separated their spirit from their body
> I do not need arrows. For them I gently extinguish
> The shining torch, and then this other one quickly lights up
> With purple light. The brother of Sleep, I pour slumber
> Into their eyes until they awake up there.
> "And who is the wise man whose earthly torch
> You extinguished here and for whom the finer one is now burning?"
> It is he who, like brave Tydides, received from Athena

Eyesight so keen that he could see the gods.
Lessing recognized me by my sinking torch,
And soon I shall light for him the other, the shining one.

Himmlischer Knabe, was stehest du hier? die verglimmende
Fackel
Nieder zur Erde gesenkt; aber die andere flammt
Dir auf deiner ambrosischen Schulter an Lichte so herrlich!
Schöneren Purpurglanz sah ja mein Auge nie!
Bist du Amor? –

"Ich bins! doch unter dieser Umhüllung
ob ich gleich Amor bin, heiß' ich den Sterblichen *Tod*.
Unter allen Genien sahn die gütigen Götter
keinen, der sanft wie ich löse das menschliche Herz.
Und sie tauchten die Pfeile, womit ich die Armen erlöse,
ihnen ein bitter Geschoß, selbst in den Becher der Lust.
Dann geleit' ich im lieblichen Kuß die scheidende Seele
auf zum wahren Genuß bräutlicher Freuden hinauf."

"Aber wo ist dein Bogen und Pfeil?" Dem tapferen Weisen,
der sich selber den Geist längst von der Hülle getrennt,
Brauch' ich keiner Pfeile. Ich lösche die glänzende Fackel
sanft ihm aus; da erglimmt eilig vom purpurnen Licht
Diese andre. Des Schlafes Bruder, gieß' ich ihm Schlummer
um den ruhigen Blick, bis er dort oben erwacht.
"Und wer ist der Weise, dem du die Fackel der Erde
hier gelöschet und dem jetzo die Schönere flammt?"
Der ists, dem Athene, wie dort dem tapfren Tydides
selber schärfte den Blick, daß er die Götter ersah.
Mich erkannte *Lessing* an meiner sinkenden Fackel,
und bald zündet' ich ihm glänzend die andere an. (XXVIII,
135–136)

Nonetheless, it was Lessing's celebration of the male genius of death
in the guise of the unerotic, but gentle and friendly conveyor of peace and
harmony that had the powerful impact in the 1770s and 1780s described

by Goethe in his autobiography; and its echo was heard far into the nineteenth, even into the twentieth century, when other images of death were commanding greater attention. Even Herder, in his poetry, frequently evokes Thanatos as "sweet death" (holder Tod), without expressly identifying him with Amor as he had done in his dialogue at Lessing's grave. The keynote is a longing for death:

> Come, lead me to your silent land,
> And close with gentle hand
> My dim eyes.

> Komm, führ' mich in dein stilles Land,
> Und schließe mir mit sanfter Hand
> Die trüben Augen zu. (XXIX, 605)

Lessing's paean to youthful Thanatos also reverberates unmistakably in the fifth of the *Hymns to Night* (*Hymnen an die Nacht*, 1800), one of the signal works of the German Romantic poet par excellence, Friedrich von Hardenberg, writing under the name Novalis. At the dawn of history, life was an exuberant feast – until Death rudely interrupted the revellers:

> . . . it was death that marred the feast-joy thus
> With pangs and fears and weepings dolorous.

> Es war der Tod, der dieses Lustgelag
> Mit Angst und Schmerz und Thränen unterbrach.

At a more advanced stage of development, "Man yet the fearful Mask would beautify" (verschönte sich der Mensch die grause Larve), suggesting that the end of life is soothing, rather than terrifying:

> A tender youth put out the torch's gleam;
> The bud grew soft as harp-notes when they die[.]

> Ein sanfter Jüngling löscht das Licht und ruht –
> Sanft wird das Ende, wie ein Wehn der Harfe.[17]

Schiller's "Genius" mournfully turning his torch to the ground in "The Gods of Greece" has already been mentioned, as has the "lovely, charming youth" in *Intrigue and Love*. The early nineteenth-century Austrian poet Lenau speaks of the "gentle messenger of the gods" who in Christian times had "degenerated into an image of horror."[18] Gottfried Keller, the Swiss novelist and poet, welcomed the "beautiful slender youth" in mid-nineteenth century.[19] Throughout the Romantic Age, then, and beyond, Thanatos with his downturned torch gives his assurance that death is sweet. He extinguishes the flame of life "and conducts us into a more beautiful land," "into the dawn of a better life."[20]

These examples, which could easily be multiplied,[21] suggest that the time was ripe for the reception of this supposedly classical image of death. But not in all cases was such readiness of a pagan or Graecophile inspiration. The Thanatos image could even be welcomed in a specifically Christian context. Novalis, the Protestant author of pietistic poetry, and the Romantic poet Joseph von Eichendorff, a fervent Catholic, are cases in point. Shortly after the lines quoted from Novalis's *Hymns to Night* there follow some verses which, in the sultry atmosphere of religious longing, reinterpret the pagan genius of death as the bearer of the Christian glad tidings. A minstrel arrives in Palestine from the "remote shore" of Greece to pay homage to Jesus:

> Thou art the Youth who in our world of Tombs
> Hast stood so long, in solemn thought for aye;
> A Star of Hope amid the Night's thick glooms,
> Announcing nobler Manhood's dawning day:
> What darkened us with sorrow, now illumes
> And draws our longing eyes from earth away:
> In Death the Life eternal is revealed;
> Thou art the Death by which we first are healed.

> Der Jüngling bist du, der seit langer Zeit
> Auf unsern Gräbern steht in tiefen Sinnen;
> Ein tröstlich Zeichen in der Dunkelheit –
> Der höhern Menschheit freudiges Beginnen.
> Was uns gesenkt in tiefe Traurigkeit
> Zieht uns mit süßer Sehnsucht nun von hinnen.

> Im Tode ward das ewge Leben kund,
> Du bist der Tod und machst uns erst gesund.[22]

In these and subsequent lines Death, Thanatos, the Hellenic youth, is
fused with Jesus Christ, or at least with his message or role. Thanatos
becomes the Savior who brings the gospel ("die fröhliche Botschaft" – a
slight variation of the standard phrase for "glad tidings") to "Hindostan"
and beyond. Giving "Life eternal" to mortals and conveying the Christian
message to the world, Thanatos is Christ's alter ego. A similar syncretism
is evident in Eichendorff's poem "Twilight of the Gods" (Götterdäm-
merung, 1816). Here Thanatos with his torch ("how gentle") is the "quiet-
est of the guests" at a courtly festival which turns into a religious
celebration with Christian overtones. It culminates in Thanatos' quasi-
Christian ascent into heaven, which, in addition to the Ascension of
Christ, evidently incorporates Goethe's vision of the ascent of Ganymede
to his "father" Jupiter, thus giving an erotic tinge to the theme:

> His mouth is ready to kiss . . .
> As though he were bringing greetings
> From the heavenly realm . . .
>
> O youth from heaven,
> How beautiful you are! . . .
> I will follow you!
>
> What more could I hope for?
> Upward, o upward!
> Heaven is open,
> Receive me, father!

> Sein Mund schwillt zum Küssen . . .,
> Als brächt' er ein Grüßen
> Aus himmlischem Reich . . .
>
> O Jüngling vom Himmel,
> Wie bist du so schön . . .
> Mit dir will ich gehn!

Was will ich noch hoffen?
Hinauf, ach hinauf!
Der Himmel ist offen,
Nimm, Vater, mich auf![23]

Such specifically Christian associations are conspicuously absent when the visual arts of European neoclassicism represent Thanatos. They revive the pictorial and sculptural tradition, the sepulchral tradition in particular, of the Renaissance and ultimately of Antiquity in a more conservative manner, less inclined toward the adventures of syncretism. This fascination with Thanatos would be hard to account for without Lessing's treatise *How the Ancients Represented Death*, which spoke to his own and subsequent generations eager for an image of death answering their own psychological and philosophical needs.[24] Some of the most prominent artists of the time recreated this earnest and thoughtful "sweet death" of Hellenic provenance in the shape of the putto leaning on his torch; in particular the motif was often chosen for the ornamentation of tombs. Canova's sepulchral stela for Countess Elisabetta Mellerio (1812–13) or his Stuart memorial in St. Peter's Basilica (1817–19)[25] may come to mind or, on a more modest level, Philipp Jakob Scheffauer's relief "Genius of Death" (Todesgenius, 1805) in the Staatsgalerie, Stuttgart,[26] and certainly Thorvaldsen's Thanatos on the Auguste Böhmer memorial (ca. 1812) or his relief on the tomb of Baroness Schubart (1814), both in the Thorvaldsen Museum in Copenhagen.[27] Apart from sepulchral sculpture, the most impressive realization of the motif is perhaps Jean Simon Berthélemy's painting "Apollon et Sarpédon" (1781): inspired by the famous passage in the sixteenth book of the *Iliad*, it shows a turbulent battle scene with Thanatos, his still burning torch turned down, hovering above the fallen hero from Lykia.[28]

III

The Thanatos rediscovered by Lessing and interpreted with a view to the emotional needs of his enlightened time is a friend of mankind, unlike the grisly and threatening "boneman" of the Christian tradition (which, to be sure, had also had room, in medieval and later mysticism, for a few, and often tentative, approximations to a "dear Death," as we have already

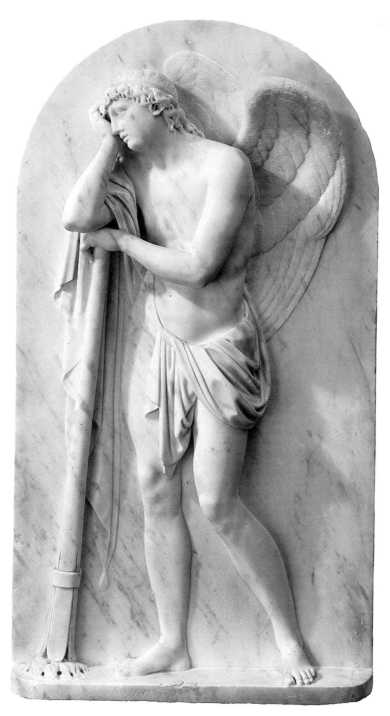

PLATE 16 Philipp Jakob Scheffauer: Genius of Death (1805)

seen).[29] "Not a frightening specter, then, is our last friend," Herder wrote
in his 1774 essay on Thanatos (Kein Schreckgespenst also ist unser letzte
Freund, xv, 431). The nod that Luise Miller in Schiller's *Intrigue and
Love* imagines this Thanatos giving her "across the ditch of time" is
"friendly" (freundlich). However, as this concept of the "friendliness" of
Death gains ground during the last third of the eighteenth century, it
may shed its classical, pagan associations entirely. It develops analogous
images of friendly Death, independently of the classical heritage, either
from Christian or from nonreligious premises, though apparently not by
reviving the mysticism of earlier ages. "There is . . . much that is sweet
about the thought of death," young Siegwart in Johann Martin Miller's
then much-read novel of the same title is instructed by a monk, of all
people. "Make him your friend, and you will have nothing to fear in the
world" (Leipzig: Weygand, 1776, p. 99). Death is man's friend, even and
particularly when he takes the shape of the traditional "boneman" that
could be so terrifying in the past. This is true of Matthias Claudius's well-
known, almost proverbial poem "Death and the Maiden," set to music by
Schubert – very much in contrast to the *Magic Horn* poem, cited at the
beginning of this chapter:

> *The Maiden:*
> Pass me by! O pass me by!
> Go away, wild boneman!
> I am still young, do go, dear man!
> And do not touch me.

> *Death:*
> Give me your hand, you beautiful and gentle form!
> I am your friend, and did not come to punish you.
> Be of good cheer! I am not fierce,
> You will sleep peacefully in my arms!

> *Das Mädchen:*
> Vorüber! Ach, vorüber!
> Geh, wilder Knochenmann!
> Ich bin noch jung, geh Lieber!
> Und rühre mich nicht an.

146

Der Tod:
Gib deine Hand, du schön und zart Gebild!
Bin Freund, und komme nicht, zu strafen.
Sei gutes Muts! ich bin nicht wild,
Sollst sanft in meinen Armen schlafen![30]

In the dedication of his collected works (1775–1812) Claudius dubbed this friendly Death "Freund Hain" and thereby created a highly success-ful indigenous literary mythology that lives to this day in popular par-lance. It has been suggested that Claudius had a real person in mind when he chose this name, his doctor, Anton Hein; but it is more proba-ble, though not necessarily in conflict with this view, that he simply picked up a phrase current in the population at the time (see above, p. 12). Be this as it may, there is no doubt that Claudius is responsible for the enduring vitality of the phrase "Freund Hain" or "Freund Hein" and his image. Interestingly, he polemically contrasts his mythology of Death the friendly neighbor with the received image of Thanatos. His is a non-classical personification of death, one that honors the Christian "bone-man" with his scythe, with the decisive difference, however, that now the rattling skeleton radiates sympathy and charity rather than terror – Enlightenment in Wandsbek, the remote village from which Claudius sent his works into the world. Claudius's polemic not withstanding, Thanatos, with his strong appeal to the age of the *lumières*, is not all that different from the skeleton as interpreted by Claudius in his typically col-loquial style; Hain is friendly and familiar, even beautiful:

> They say there are people, they call them strong spirits, who are unmoved by Hain all life long and behind his back even mock him and his scrawny legs. Myself, I am not a strong spirit; to tell the truth, there's a shudder running down my spine whenever I look at you. And yet I am willing to believe that you are a good man, once one gets to know you; and yet I have a feeling I have a kind of longing for you, old doorman Rupert, and confidence that one day you'll come to undo my belt and put me to rest in the right place where I may wait for better times . . .
> Our forebears are said to have represented him differently: as

Freund Hain.

PLATE 17 D. N. Chodowiecki: Friend Hain (1775), frontispiece of Matthias Claudius,
Sämtliche Werke des Wandsbecker Bothen

148

a hunter wrapped in the coat of night, and the Greeks as a "youth
in a calm poise, his eyes turned down mournfully as he extin-
guishes the torch of life beside the dead body." It is a beautiful
image reminding one so comfortingly of Hain's family and espe-
cially his brother when one is tired after running around all day
and is finally ready to put out the light in the evening – after all,
one has a restful night to look forward to, especially if the next
morning is a holiday!! It is really a good picture of Hain, but I've
preferred to stick with the boneman. That's the Death that stands
in our church, and that's how I have always imagined him ever
since I was a child: stepping over the graves in the churchyard,
just as my mother used to say (when one of us children was shud-
dering at night): Death stepped over the grave. It seems to me
that in this shape, too, Death is quite beautiful, and when one
looks at him long enough, he appears to be quite friendly.

s' soll Leute geben, heißen starke Geister, die sich in ihrem
Leben den Hain nichts anfechten lassen, und hinter seinem
Rücken wohl gar über ihn und seine dünnen Beine spotten. Bin
nicht starker Geist; 's läuft mir, die Wahrheit zu sagen, jedesmal
kalt über 'n Rücken, wenn ich Sie ansehe. Und doch will ich
glauben, daß Sie 'n guter Mann sind, wenn man Sie genug kennt;
und doch ist's mir, als hätt' ich eine Art Heimweh und Mut zu
Dir, Du alter Ruprecht Pförtner! daß Du auch ein mal komme
wirst, meinen Schmachtriemen aufzulösen und mich auf bess're
Zeiten sicher an Ort und Stelle zur Ruhe hinzulegen...
 Die Alten soll'n ihn anders gebildet haben: als 'n Jäger im
Mantel der Nacht, und die Griechen: als 'n "Jüngling, der in
ruhiger Stellung mit gesenktem trüben Blicke die Fackel des
Lebens neben dem Leichname auslöscht". Ist 'n schönes Bild und
erinnert einen so tröstlich an Hain seine Familie und namentlich
an seinen Bruder: wenn man sich da so den Tag über müde und
matt gelaufen hat und kommt nun den Abend endlich so weit,
daß man's Licht auslöschen will – hat man doch nun die Nacht
vor sich, wo man ausruhen kann! und wenn's denn gar den
andern Morgen Feiertag ist!! 's ist das wirklich ein gutes Bild

vom Hain; bin aber doch lieber beim Knochenmann geblieben.
So steht er in unsrer Kirch', und so hab' ich 'n mir immer von
klein auf vorgestellt, daß er auf'm Kirchhof über die Gräber hin-
schreite, wenn eins von uns Kindern's Abends zusammen-
schauern tat, und die Mutter denn sagte: der Tod sei übers Grab
gangen. Er ist auch so, dünkt mich, recht schön, und wenn man
ihn lange ansieht, wird er zuletzt ganz freundlich aussehen.[31]

This personification of death appears to be entirely home-grown, and
yet it makes sense to see it also as a domestication of the classical senti-
ment, though without the mythological trappings handed down from
Antiquity. As the lines about the skeleton in the village church suggest,
Hain is in a sense yet another *Christian* domestication of the classical
notion though, of course, without the hints of religious quasi-eroticism
found in Eichendorff's attempt to bring Thanatos closer to home by
viewing him as an analogue of Christ. Claudius's "Freund Hain" is closer
to another indigenous personification – to "Godfather Death" (Gevatter
Tod) found in the Grimm brothers' fairy tale (1812) of that title. This is
the story of a desperately poor man who chooses as godfather for his thir-
teenth child not God, nor the devil, but Death, because he, unlike God
and the devil, is just; above all, Death is a friend. "Whoever is my friend
cannot be wanting" (Wer mich zum Freund hat, dem kann's nicht
fehlen). "Friend Death" is more than an empty phrase here; it is in fact
the fairy tale's equivalent of the philosophically charged image of death
favored by the intellectuals at the time. Friend Death, in the fairy tale,
promises to make the child of the poor man rich and famous, and as the
child grows up he does indeed become a renowned doctor. However,
when for the second time he cheats Death by not handing over a patient,
Death's kindliness and forbearance are exhausted, and he lets the miracu-
lous healer die in his turn – still, his death, like that brought on by
Thanatos and Claudius's Freund Hain, is without the shivers of fear and
terror inspired by the traditional skeleton.

Claudius's coinage reappeared prominently in art, a decade after its
literary debut, in Johann Rudolf Schellenberg's series of twenty-four
copper engravings, with text in verse and prose by Johann Karl August
Musäus, entitled *Freund Hein's Appearances, in the Manner of Holbein*

(*Freund Heins Erscheinungen in Holbeins Manier*, Winterthur: Steiner, 1785).[32] True, even Holbein came close to the concept of Death as a friend when he presented him gently helping a stooped old man into his grave. Death was an equally friendly, or at least not fear-inspiring, companion in some scenes of a Dance of Death indebted to Holbein, the *Mirror of Dying* (*Sterbensspiegel*), engravings and verses by Conrad and Rudolf Meyer (Zurich, 1650, republished in 1759). Here, the dying hermit, for one, is tenderly led from his cell into a beyond whose paradisiacal overtones are clearly suggested. Such antecedents notwithstanding, the wording of Schellenberg's title was inspired, as his preface frankly admits, by none other than Claudius. The German language, Schellenberg says, has no word for "the allegorical ideal of death"; so he could not help taking over Claudius's phrase, deviating only in the spelling of the name (in order to avoid confusion with the German word for "grove," *Hain*). Consequently Schellenberg's Death is the skeleton, Claudius's "boneman" as illustrated by Chodowiecki in the first volume of Claudius's complete works. And like Claudius, Schellenberg sees fit to introduce him with a polemic against the "sweet death" of Antiquity, Thanatos, even though both are conceived as "friendly." Accordingly, the title page of Schellenberg's *Freund Hein* portrays fashionable contemporaries, among them an officer in dress uniform and a lady with a fan, studying a tomb dominated not by the by-now-familiar Thanatos but by a skeleton; the explicit message is the familiar Christian "memento mori."

Yet though Schellenberg asserts that his title, *Freund Hein*, is "a real gain" and "quite indispensable" it cannot be said that his Death – a skeleton as a rule, and rarely dressed – is the notably friendly figure Claudius's had been. Schellenberg's Hein is active in all sorts of real-life situations, and rather nastily so in many cases: he disturbs the rendezvous of lovers by throwing a net over them much like the fowler Death of the biblical tradition; he eagerly lends a hand to a suicide; in the guise of a cavalier, he visits a rococo lady at her dressing table; with supreme disregard for educational tact, he summons a schoolmaster in his classroom. No one is safe from his imaginative plotting, neither the gambler (whose life-long wish is fulfilled ironically when Death hands him the winning lottery ticket) nor the tightrope walker (whom he grabs by the foot), neither the

soldier (whom he recruits) nor the bookworm (who is slain by a bookcase crashing down on him). And there are times when "Freund Hein" is not only not friendly but downright brutal, as in the case of the usurer whom he crushes with the lid of his strongbox. At the very least, this boneman's friendliness is not immediately apparent. Schellenberg's Death is, however, a true friend, and most conspicuously so, in an engraving strongly reminiscent of Holbein's episode in which Death helps an old man into his grave; its caption is "Accompanied by a friend" (Freundes Geleit).

Death as a "friend": whether this friendliness is strikingly obvious or not, it is at least meant to be the cachet of this notable and much-noted volume. As such a friend, Schellenberg's skeleton Death is almost invariably male, either through his attributes or clothing or by virtue of his gender-specific role or action as a recruiter of soldiers, duellist, cavalier, etc. The odd one out in this respect is the engraving entitled "Frustrated Expectation" (Getäuschte Erwartung): a rococo dandy meets his equally elegant courtly lady for a tête-à-tête in a garden, only to be welcomed by a toothy grin from a skull crowned with a carefully piled-up coiffure. Musäus's narrative that accompanies the picture is not much help. (Schellenberg pointed out in the preface that the texts had been written after the engravings were finished and that their interpretations were not necessarily binding.) It is a trite cautionary tale about an aristocratic bachelor who finally falls victim to "Miss Atropos[,] the Parca in modern dress." The moral is: "Those who know their business, / Make their choice before the market is about to close" (p. 53) – not exactly commensurate with the would-be sophisticated evocation of a figure of classical mythology that had, after all, had more serious associations in the history of death images since its revival in the late Middle Ages. Still, this banal text does point in the right direction in that Schellenberg's "scenes of death" are designed not so much to remind us of the existential anxieties associated with the end of life but rather to present a broad and varied panorama of contemporary social reality. And in this respect, Schellenberg's engraving as well as Musäus's tale of Lady Death do make a significant contribution by introducing what remains the exception here, the female death figure. There is no anticipation in this scene of the obsessive idea of the syphilis-ridden turn of the century that woman is the source of man's death. Rather, in neat counterpoint to the deadly cava-

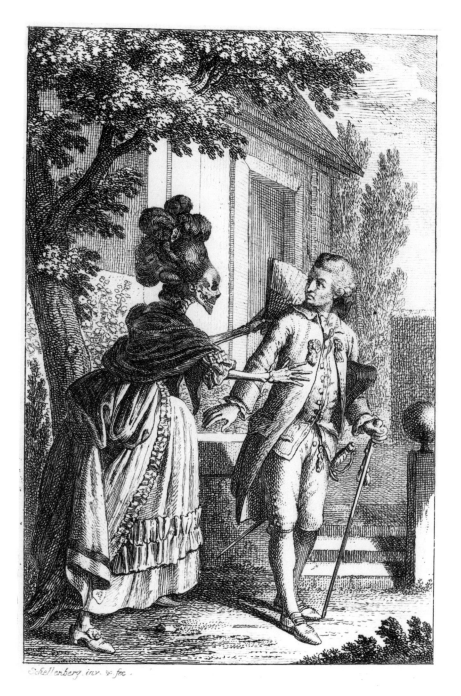

PLATE 18 J. R. Schellenberg: Frustrated Expectation (1785)

lier, the female death figure adds variety to the broad canvas of social life threatened by death in all its forms.

The same is true, it may be added in parenthesis, of Salomon van Rusting's *The Scene of Death or Dance of Death* (*Schau-Platz des Todes oder Todten-Tanz*, Nuremberg: Monath, 1736; originally published in Dutch in 1735). The scene of death is everywhere, and accordingly, Death makes his entry in a wide variety of roles; as a rule, they are male roles: the skater, duellist, tightrope walker, etc. One of the less predictable scenes is the engraving numbered twenty-five: as a pair of newlyweds leave the church, a skeleton holds the bride's train – the text explains: "Death is present as the chambermaid" (Der tod is da als zofe nah). Again, this is the only female personification of death in the entire volume, no doubt introduced for the same reason as in Schellenberg's *Freund Hein's Appearances*. A similar case is the so-called "Erfurt Dance of Death," a series of paintings by Jakob Samuel Beck, except that here we find two female death figures. In one of the paintings (1742), death takes the shape of an old woman raising her index finger menacingly behind a gypsy woman who reads an elegant lady's palm. The conceit of the second one, entitled "The King" (1735), is more eccentric. Considering that it is a product of German culture (where Death is so often male), it is perhaps a bit unsettling that Death appears here as the Queen (while there are instances of the supposedly more Germanic "King Death" in the Romance-language regions [see above, p. 29]). Not only that; in Beck's painting, Queen Death seizes the king's crown and drags him from the throne.[33]

It makes sense to rescue such relatively minor works from oblivion because female personifications of death tend to be less common in the Romantic Age. Attention should therefore also be called, in this context, to two further instances. One is the female angel of death ("like a very beautiful woman," both "cruelly serious" looking and "compassionate") in Johanna Schopenhauer's society novel *Gabriele* (1819–20); the other is an etching by Christian Bernhard Rode (1725–97) preserved in the Düsseldorf collection of death images; dated before 1759, it is captioned "La Mort vêtue en femme" and features a woman dressed in mid-eighteenth-century style whose skull is the only indication that she is death personified.[34]

To return to "Freund Hein" and the more prominent works of the

time: this designation is perhaps suited less to Schellenberg's volume than to the twelve etchings that make up Daniel Chodowiecki's *Dance of Death* (*Totentanz*) of 1791, a work even more widely known than Schellenberg's. Like a good neighbor and trusted associate, Death enters into a world here which in its turn has all the reassuring familiarity of Biedermeier *avant la lettre*. The eye will quickly be caught by the intimately domestic image of the death of the baby: the nurse has fallen asleep, the cradle beside her is empty and a winged skeleton is flying away with his little victim, kissing it tenderly.[35] This sentiment prevails throughout, although even Chodowiecki's Death can be brutal, as when, visiting the market, he furiously cuts down the "fishwife" with his scythe or when he uses his scythe to pull the "general" from his horse. Death is always skeletal here, but his clothes will sometimes identify him as a man, for example in the scene entitled "The Sentry" (Die Schildwache), where he wears a three-cornered hat and jackboots as he fetches the soldier standing guard. At other times, if more rarely, one is inclined to see a female figure, perhaps in the scene at the cradle just mentioned, or in the episode showing Death as the traditional fool, but wearing a long dress as she approaches the queen, hourglass in hand. This duality of personification is probably meant to imply, as it presumably did in Schellenberg's *Freund Hein* and as it will in the Dance of Death cycles of the nineteenth century, that death is ever present, ubiquitous, and capable of an infinite variety of metamorphoses.

Paradoxically, then, the omnipresence of death seems to haunt the living like a nightmare virtually as soon as Death has become familiar as Thanatos or "Freund Hein" or simply as a "friend." Still, viewed from the vantage point of the nineteenth century, the two popular Dance of Death sequences of the late eighteenth, Schellenberg's and Chodowiecki's, are really no more than very tentative and somewhat casual anticipations of the panic fear of the multiformity of death that lies ahead. Only at that later date did this fear also become associated with woman as a tangible symbol of biological growth and decay or even of fatal sexual disease (see below, pp. 190–193, 218). By contrast, the Romantic Age paid comparatively little attention to the personification of death as a woman. Thanatos and his indigenous Christian analogue, "Freund Hein" or just the (male) "friend," clearly dominate the scene, especially in literature.

This is as true of English literature of the time as it is of its German counterpart, except that English literary culture, lacking a widely accepted equivalent of "Freund Hein," could no doubt draw inspiration from "Death, death, o amiable lovely death!" (*King John*, III, 4, 25) and other eminently quotable lines of Shakespeare's, who continued to be a commanding presence. While it is true that *Pilgrim's Progress* with its severe "Master" Death (see above, p. 115) remained secure in popular culture, the English Romantic writers gave a hearty welcome to Death as the comforting brother of Sleep, Thanatos. "How wonderful is Death, / Death and his brother Sleep!" run the opening lines of *Queen Mab* (1813), which Shelley apparently liked so much that he used them again at the beginning of his long fragmentary poem "The Daemon of the World" (1816), again without feeling the need to refer to Thanatos by name. Both the name and the classical allusion are missing. And they are indeed superfluous as British writers, much like their confreres on the continent, domesticated Thanatos simply as the "friend" or "neighbor." This is the case in Scott's introduction to *A Legend of Montrose* (1819), for instance. It offers a vignette of the old soldier who recounted to the author some of the historical material that went into the novel: "His morning walk was beneath the elms in the churchyard; 'for death,' he said, 'had been his next-door neighbour for so many years, that he had no apology for dropping the acquaintance.'" Death is "now stingless, like a friend" as Young's *Night Thoughts* have it (IV, 656). The "friend," who had sporadically made his appearance in English literature ever since the Renaissance as any book of quotations will demonstrate, comes close to becoming a household word in well-known poems of the major British Romantics. Robert Burns's "dirge" "Man was made to mourn" (written in 1784) may come to mind, that litany of human misery ending on a note of relief: "O death, the poor man's dearest friend, / The kindest and the best." Coleridge's "Epitaph on an Infant" (1794) is a similarly familiar *locus classicus*:

> Ere Sin could blight or Sorrow fade,
>> Death came with friendly care:
> The opening Bud to Heaven convey'd,
>> And bade it blossom there.

The intimation, in the last two lines, that this friend, much like Christ, will open the gates to that true life that is to be found only in death, is familiar from earlier periods of cultural history. But it, too, is frequently revived in this period of Enlightened or Romantic secularization, again in a manner that does not necessarily obliterate its Christian overtones entirely. The best examples in English, it will readily be agreed, may be found in the "Pre-Romantic" *Night Thoughts* (1742–45), in lines such as "*Life* dies, Compar'd: *Life* lives beyond the Grave" (III, 510) or "Were Death deny'd poor Man would live in vain" (III, 528); "When shall I die? – When shall I live forever?" runs the last line of the third Book, while the still lingering orthodox frame of reference is more explicit in the fourth Book with lines like "Death's Terror is the Mountain Faith removes" (724). But in rare cases all such vestiges of Christian culture not only fade but disappear; the deservedly famous last words of Sir Charles Bawdin, about to be executed for treason against Edward IV in Chatterton's "The Bristowe Tragedy," choose an entirely vegetative simile of the renewal of life: "Nowe dethe as welcome to me comes, / As e'er the moneth of Maie." This seems to be a far cry from Coleridge's apparently Christian "Heaven" to which "friendly" Death conveys the soul of the child, and yet his "Epitaph" employs the nonreligious, vegetative imagery as well: it is the "opening Bud" that "friend" Death conveys to Heaven.

In this context, Southey's "Carmen nuptiale" (1816), a long poem celebrating the wedding of Princess Charlotte, the daughter of George IV, is illuminating. In the section called "The Dream," the princess (who was to die in 1817, the year after her wedding) has an extraordinarily prescient vision of Death – a male shape "with shadows dimly garmented";

> dreadful was his mien:
> Yet when I gazed intentlier, I could trace
> Divinest beauty in that aweful face. (Stanza 86)

In the last line there may be a suggestion of Thanatos, who is, however, not named in the poem; still, the next stanza introduces (an implicitly Christian) "Heaven" – only to end on the note that is one of the hallmarks of the representations of death at this time: Death is a "friend":

Hear me, O Princess! said the shadowy form,
　　As in administering this mighty land
Thou with thy best endeavor shalt perform
　　The will of Heaven, so shall my faithful hand
Thy great and endless recompense supply; . . .
My name is DEATH: the last best friend am I! (Stanza 87)

The last line (which has made it into the standard dictionaries of quota-
tions) not only refuses to lend this "friend" the aura of the religious that
was at least hinted at in Coleridge's poem; it also evokes a biblical verse
that would seem to imply that Southey for his part polemicizes against
any conceivable Christian analogues of the last best "friend," for in the
first Epistle to the Corinthians we read that Death is "the last enemy"
(15:26). Much like Claudius introducing "Freund Hain," the English
poet has found here, in his "last best friend," an image of death person-
ified that is free of any specific associations of either Thanatos or the
gentle Death sometimes found in Christian imaginative writing and yet
an analogue of both. As such it is representative of the attitude to death
widespread in the second half of the eighteenth and earlier nineteenth
century.

　　IV

The Northern and Central European equivalent of Thanatos – "Freund
Hein" or simply the "friend" – had a long afterlife subsequent to the
Romantic Age. In pictorial art, some of the more notable stages include
Franz Kugler's *Book of Sketches* (*Skizzenbuch*, 1830), Moritz von
Schwind's illustrations of Eduard Duller's *Freund Hein* (1833), the *Images
of Death* (*Bilder des Todes*) by JohannGottfried Flegel and Carl Gottlieb
Merkel (1850), Alfred Rethel's woodcut "Death as a Friend" (Der Tod als
Freund, 1851), Hans Meyer's *A Dance of Death* (*Ein Totentanz*, 1911) and
Käthe Kollwitz's lithograph "Death Recognized as a Friend" (Der Tod
wird als Freund erkannt, 1934–35)[36] – most of them "household art."
Generally missing in these equivalents of Thanatos, be it "Freund Hein"
or the unspecified "friend," is the eroticism which was not incompatible
with Thanatos in view of his similarity with Eros – Luise in *Intrigue and
Love*, it will be remembered, visualized the classical torch-bearer "the way

they paint the god of love," and in Herder's poem "Death," Amor/ Thanatos conducted "the parting soul, kissing it, / To the true nuptial joys on high."[37]

To be sure, death eroticism hardly faded away in the Romantic Age. It exists as a paradigm of its own, so to speak, side by side with the rediscovery of Thanatos, prefigured in some ways, of course, in the preceding two centuries. In this paradigm Death is the fervently desired bridegroom or "bridegroom of the soul" (more rarely the bride, as in Schellenberg's Atropos). The way to the wide acceptance of this image of death was paved by that longing for death characteristic not just of the graveyard poetry of the time, but of Sentimentalism and Romanticism generally. We encountered it in lines quoted from Novalis, but a few more examples of this longing for death may be in order before we turn to the bridegroom metaphor. The anthropomorphized object of this longing, if any, may be very vague, rather than the explicit "bridegroom" or "bride." Thus, in André Chénier's (d. 1794) posthumously published all-encompassing philosophical poem *Hermès*, the longing for death is merely "the hope of the unfortunates who no longer have any hope" (l'espoir des malheureux qui n'ont plus d'espoir, canto 2, III,16). Similarly indistinct is the object of this yearning in Thomas Moore's "Elegiac Stanzas" (1801): "How sweet is death to those who weep, / To those who weep and long to die!" Eroticism is hinted at, without making its object concrete, in the well-known lines of Keats's "Ode to a Nightingale": "Darkling I listen; and for many a time / I have been half in love with easeful Death" – to which Shelley seems to respond equally vaguely when, in the preface to *Adonais*, his elegy on Keats's untimely death, he describes the poet's grave in the Protestant cemetery in Rome: "The cemetery is an open space among the ruins, covered in winter with violets and daisies. It might make one in love with death, to think that one should be buried in so sweet a place." Like Keats, though more wordily, the German Sentimentalist Fritz Stolberg compares death with the seductive song of the nightingale which arouses a longing that may be discreetly erotic though it, too, leaves us in the dark about its object:

> Am I deceiving myself? Or does Death's name
> Sound lovely to me, like the song of the nightingale?

Will his rustling wings approaching me
Sound like the flight of swans?

Did I not drink sweet nectar from youth's
goblet, redolent of joy? . . .

Friends, I drank it and you shared my joy!
When I drink from the chalice of death, won't you
Rejoice in the higher
Joys of your friend?

Täusch' ich mich selber? oder tönt mir lieblich,
Wie der Nachtigall Lied, des Todes Name?
Wird mir auch sein rauschender naher Fittig
Schwanenflug tönen?

Trank ich nicht süßen Nektar aus der Jugend
Freudeduftendem Becher? . . .

Freunde, den trank ich, und ihr freutet mein euch!
Wenn ich leere den Kelch des Todes, wollt ihr
Dann euch nicht der höheren Freuden eures
Freundes erfreuen?[38]

Death, ending life with the promise of surpassing joy, takes the senti-
mental soul home to a long-awaited paradise in heaven. This is the
keynote associated with the longing for death, not only in Novalis but
also in the premier German graveyard poet, Ludwig Hölty. In his poem
"Death" (Der Tod, 1772) the end of life is eagerly awaited:

When, messenger of peace who opens paradise
To the tired pilgrim on this earth, Death,
When will you lead me with your golden
Staff to Heaven, to my home?

Wann, Friedensbothe, der du das Paradies
Dem müden Erdenpilger entschließest, Tod,
Wann führst du mich mit deinem goldnen
Stabe gen Himmel, zu meiner Heymath?[39]

As in Coleridge's "Epitaph on an Infant," the word "Heaven" may be an intimation of Christian modes of thought. Christian Stolberg is more direct in this respect. His "Dying Song" (Sterbelied, 1808), addressed to the "Lord," amalgamates in its final lines religious *Heimweh* and the conventional Christian dying formula "I commend my spirit into thy hands," which it quotes almost verbatim as a prelude to the mixed metaphor that the spark of divine light that constitutes the soul should return home on the wings of longing:

> Nicht im Tod' erst; weil mein Leben
> Noch in regen Stunden kreis't,
> Will ich weihend übergeben
> Deinen Händen meinen Geist;
> Ihm, den Funken deines Lichts,
> Gnüge nicht der Erde Nichts,
> Ach, schon hier, auf Sehnsuchts-Schwingen,
> Mög' empor er heimwärts dringen![40]

While in this poem the longing for the return "home" in death is purely Christian in inspiration, it was ironically left to the staunchly Catholic Eichendorff to link this sentiment with the classical heritage. In his poem "Twilight of the Gods," quoted in an earlier context, it was Thanatos, the "youth from heaven," who raised the longing soul up into an otherwise Catholic heaven. Still, whether the vagueness of this longing for death has classical or Christian overtones or both, or none, dying under its auspices does become more beautiful, "sweeter," more alluring and desired; the only surprising thing about it is that the Romantics think nothing of stating this matter-of-factly, for example in an otherwise pedestrian correspondence.[41]

Not surprisingly, Sentimentalists and Romantics will enhance the faintly erotic overtones observed in some of the lines quoted to where the object of their longing for death (vague in all the examples cited so far) is explicitly and concretely personified. Thus in Bürger's "Lenore," a gothic ballad on the theme of "Sweet William's Ghost," death is cast quite straightforwardly in the role of the "bridegroom," both loving and loved. Elsewhere, however, this death eroticism, no matter how

concrete, develops into a confused and overheated cult of emotions. Novalis, as the lines quoted earlier may have suggested, is the past master of this kind of fantasy-mongering. "Death to the [wedding] Feast doth call," we hear in one of the more homespun passages of his *Hymns to Night*, which mourn the loss of his beloved (Zur Hochzeit ruft der Tod, 1,150). But the momentary stability of imagining the male speaker called to a wedding with his deceased beloved is quickly lost in a vision that disconcertingly blurs male and female, worldly and other-worldly references. For the "longing for Death" ("Sehnsucht nach dem Tod," the Romantic keyword and the title of the final hymn) is not only one for "home" (both "Haus" and "Heymath"), not only for "the father's bosom" ("Schooß") *and* "the womb of the earth" ("Schooß"), but it is also the loving yearning for the dead bride *and* for a bridal Jesus Christ: "Down, down unto the sweetest Bride, / In Jesus fall asleep [*literally*, Unto Jesus the beloved]" (Hinunter zu der süßen Braut, / Zu Jesus, dem Geliebten, 1, 157, cp. 153, 155). This is how the *Hymns to Night* break off rather than conclude. Even the Revd. Herder, who was so adroit at fusing Thanatos and Amor, might have welcomed some clarification of this bewilderingly promiscuous death eroticism. And it is no help to remember that the Novalis who so lovingly mourned his fiancée Sophie von Kühn in this manner had at that time already taken up with another young woman whom a critic – in a book entitled *The Aesthetics of Escha-tology*, no less – described as the "solidly philistine daughter of a civil ser-vant."[42]

Confused in a different way is the death eroticism of *Godwi, an Over-grown Novel* (1801) by Clemens Brentano, one of the exponents of German Romanticism. As a compendium of Romantic sensibilities, *Godwi* would be incomplete without the eroticism of death and dying, no matter how arbitrarily introduced: "O sweet death, newly born in love" (O süßer Tod, in Liebe neugeboren).[43] In a poetic world where the pro-verbial swan song can only be a love song,[44] the love of death is, of course, not out of place; and "Sehnsucht," the Romantic susceptibility *par excel-lence*, is quite naturally paired with it throughout. As Godwi writes to the administrator of his father's estate in one of the letters that make up the substance of this key work of German Romanticism, "we are happy only when we do not know how and why we are happy, when we are newborn

and children. When we endeavor to get to the bottom of every mechanism of a life, we are ripe for death, and when we know death, we are gone; for at that point we have become fused with life and it is no longer; and every strong instinctive desire we have is longing [Sehnsucht] for death, just as every instinctive wish we have is a meditation on suicide" (p. 132). A little later in the same letter, the confused ecstasy of the young man in love is intensified to the point where it becomes an exercise in that Romantic arithmetic that equates love and death: "Now I see real happiness eluded me: that calm simple peace in which all longing is answered, like the ripple in a pond. Love has now given me all this. I have met a pure, unpretentious woman, and she removed all obstacles within me which she did not know, and she healed all illnesses of the world within me which she did not know. Isn't death recovery and love death? A universally applicable answer, a gentle, true solution of all mysteries of art, is to be found in pure nature, and nature placed it in the love of the purest woman" (p. 135).

Whatever the administrator of the family farm might have made of this, it almost looks as if the visual vagueness of Romantic fantasies about the shape of death as an object of longing gives way here to a clear-cut image of death, and a female one at that. Yet on closer examination one realizes that Brentano avoids any unequivocal allegorical personification of death in this effusion of feelings. In any case, a female death figure would be somewhat unusual in this period, as suggested earlier. When death is clearly anthropomorphized, without the confusion or vagueness observed repeatedly, it usually takes on a male identity in the imagination of the two generations around 1800: Thanatos, the (male) "friend," and now, in the context of eroticism, the bridegroom, rather than the bride. The bride in this wedding is the yearning soul or, more literally, a woman. The "Death and the Maiden" motif accordingly metamorphoses itself into the celebration of the fulfilled longing of the loving soul or the loving woman. At the end of the nineteenth century, this love will be sexualized beyond all eroticism, with the woman aggressively taking the initiative as she does emblematically and programmatically in Munch's etching "The Maiden and Death" (1894). A century earlier, the tone is much more subdued. It is set by Herder's "Elegy" (Elegie, ca. 1770):

Where to? – What am I seeing everywhere?
Youthful dreams vanished.
My most fervent wish evinced my vanity,
A seed that grew to eternal sorrow!
O God, what a sight, my eager heart
Melting in a flood of tears!
Come, funeral shroud, wrap me joyously
In the gown of a bride!

Wohin? – was seh ich weit und breit?
verflogne Jugendträume –
Mein liebster Wunsch war Eitelkeit
und ew'ger Gram im Keime!
o Gott! sein volles Herz so sehn
in bittre Thränenfluth zergehn!
Komm, Gruftkleid! mich mit Freuden
in Brautgewand zu kleiden! (xxix, 346)

This sentiment is echoed by Sophie in Johann Martin Miller's Senti-
mentalist novel *Siegwart* (1776); her love remaining unrequited, she
enters a nunnery, commenting: "I am a bride of Heaven and of Death"
(p. 514). This brings to mind Luise's suicidal wish-fulfillment fantasy
about the deadly "bridal bed" in Schiller's *Intrigue and Love*. Such death
eroticism is widespread in Romanticism, especially in its later phase. A
single example may suffice. The dramatist among the German Roman-
tics, Zacharias Werner, whose tragedies and "salvation plays" time and
again thematize the longing for death and the nuptial nature of dying,[45]
wrote a poem in 1880, entitled "Psyche-Galathea," a heavily mythological
torrent of words which in its opening lines evokes "loving death" with all
the naiveté that was common in the literature of the time. Psyche-
Galathea, the marine nymph of Greek mythology whose lover was slain
by Polyphemos, is here the "burning queen" or "flaming virgin" rushing
through sea and air in the light of the setting sun, yearning for the sight
of "loving death" (Weil sie schauen will, schau'n, durch Meer und
Gewölk / und Azur den – liebenden Tod!). This death is the be-all and
end-all of her life, indeed the ultimate goal and consummation of all
earthly activity, promising "salvation":

Alles im Ringen sich schlingen,
Alles erringen, gelingen,
Alles will spielend zum Ziele,
Alles muß eilen zum Heil![46]

In context, this Death, too, would have to be thought of as the bridegroom, like many another personification of death in the literature of Sentimentalism and Romanticism. The reason for the predominance of the bridegroom, and for the failure of the image of the "bride" to leave its mark on this period, is not difficult to make out if one remembers the Christian associations that repeatedly loomed large in its endeavors to visualize death. In the lines cited from Novalis's *Hymns to Night* and Eichendorff's "Twilight of the Gods," Death and Christ were fused. In another passage of the *Hymns to Night*, also referred to earlier, the wedding was not, or not only, one with Death, in whatever role, but with "Jesus the beloved." Jesus, according to a notion common then as now, is the bridegroom of the soul. So, when in the Romantic Age death is not only anthropomorphized but also eroticized and cast in the role of the bridegroom or the bridegroom of the soul, it would not seem to be far-fetched to interpret this role as an analogue of Christ's which was familiar from the Bible and the Protestant hymn book. Death the bridegroom is a more or less secular metamorphosis of the Savior.

This transformation, both conceptual and concrete, of the Christian bridegroom of the soul into a personification of death is illustrated most memorably in Gottfried August Bürger's ghost ballad "Lenore" (1773), which around 1800 enjoyed an enormous popularity not only in Germany but also in England. The several English translations that came out at the time made it one of the best-known works of German literature, second only to Schiller's *Robbers* or Goethe's *Werther*. Earlier in this chapter, "Lenore" was mentioned as an example of the lingering presence of the horrific image of death of a previous, more orthodox age even at this time of increasing secularization that tended to welcome death as a friend. And yet "Lenore" is very much a product of its own time as well, in that its central metaphor is that of Death the bridegroom, except that Bürger presents it more grippingly and "realistically" than any of his

contemporaries. Lenore, recently engaged, with all the formalities of middle-class and clerical respectability, is worried about her fiancé Wilhelm, the Prussian cavalryman fighting in the Seven Years War; she has not heard from him and fears him dead, when late one night she hears the clattering of hoofs outside her door; it is Wilhelm, of course, inviting her to join him:

> ["]Mount by thy true love's guardian side;
> We should ere this full far have sped;
> Five hundred destined miles we ride
> This night, to reach our nuptial bed."

> "Our nuptial bed, this night so dark,
> So late, five hundred miles to roam?
> Yet sounds the bell, which struck, to mark
> That in one hour would midnight come."
> "See there, see here, the moon shines clear,
> We and the dead ride fast away;
> I gage, though long our way, and drear,
> We reach our nuptial bed to-day."

> ["]Komm, schürze, spring und schwinge dich
> Auf meinen Rappen hinter mich!
> Muß heut noch hundert Meilen
> Mit dir ins Brautbett eilen."

> "Ach! wolltest hundert Meilen noch
> Mich heut ins Brautbett tragen?
> Und horch! es brummt die Glocke noch,
> Die elf schon angeschlagen." –
> "Sieh hin, sieh her! der Mond scheint hell.
> Wir und die Toten reiten schnell.
> Ich bringe dich, zur Wette,
> Noch heut ins Hochzeitbette."[47]

A few lines later there are more, equally unmistakable hints of the nuptial nature of this reunion:

["]Meanwhile of brides the flower and prime
I carry to our nuptial bed.
Sexton, thy sable minstrels bring!
Come, priest, the eternal bonds to bless!
All in deep groans our spousals sing,
Ere we the genial pillow press" . . .

Grim ghosts of tombless murderers dance.
"Come, spectres of the guilty dead,
With us your goblin morris ply,
Come all in festive dance to tread,
Ere on the bridal couch we lie."

["]Jetzt führ' ich heim mein junges Weib.
Mit, mit zum Brautgelage!
Komm, Küster, hier! Komm mit dem Chor,
Und gurgle mir das Brautlied vor!
Komm, Pfaff, und sprich den Segen,
Eh' wir zu Bett uns legen!" . . .

Ein luftiges Gesindel. –
"Sasa! Gesindel, hier! Komm hier!
Gesindel, komm und folge mir!
Tanz uns den Hochzeitreigen,
Wann wir zu Bette steigen!"

Slowly it dawns on the reader and on Lenore herself that this horse-man is not quite the same as her dashing suitor of not so long ago. To be sure, his statement to Lenore, "We and the dead ride fast away," suggests that "we" and "the dead" are not the same, otherwise he could have said "we, the dead" (and there is documentary evidence that Bürger took great pains with the stylistic polishing of his text; so nothing about the word-ing was left to chance). Yet there follow more and more hints (again, a matter of stylistic finessing for maximal horrific effect) that this Wilhelm is not the one who set out for the battle of Prague. The "nuptial bed" that he names as the destination of the hair-raising gallop is more likely a coffin: "Low lies the bed, still, cold, and small; / Six dark boards, and one

milk-white sheet." And soon, the horseman changes his tune in the most ominous manner: "Hurrah! how swiftly speed the dead!" – now "the dead" is "we," and this line reverberates verbatim, no less than three times in the stanzas to come. This Wilhelm is a revenant; it is not for nothing that he heads for the churchyard on his black horse – this is where he belongs. And no sooner has he arrived there, than the crucial transformation takes place: the dead lover becomes Death. On this point, Bürger does not spare us any explicitness:

> Lo, while the night's dread glooms increase,
> All chang'd the wond'rous horseman stood,
> His crumbling flesh fell piece by piece,
> Like ashes from consuming wood.
> Shrunk to a skull his pale head glares,
> High ridg'd his eyeless sockets stand,
> All bone his length'ning form appears;
> A dart gleams deadly from his hand.
> ["The scythe and houre-glasse," in William Taylor's more
> accurate translation of this line.]

> Ha sieh! Ha sieh! im Augenblick,
> Huhu! ein gräßlich Wunder!
> Des Reiters Koller, Stück für Stück,
> Fiel ab wie mürber Zunder.
> Zum Schädel, ohne Zopf und Schopf,
> Zum nackten Schädel ward sein Kopf;
> Sein Körper zum Gerippe,
> Mit Stundenglas und Hippe.

The galloping bridegroom is not the cadaver of Wilhelm who fell in the battle of Prague for the greater glory of his king. He is Death in person, whom the Christian imagination had visualized as a horseman for centuries. And the final lines leave no doubt that Lenore dies in his arms: "Now this cold earth thy dust shall take, / And Heav'n relenting take thy soul!" (Des Leibes bist du ledig; Gott sei der Seele gnädig!). But this is no ordinary Death. This bridegroom, while not Christ himself, is certainly his analogue; modeled on the "bridegroom of the soul." Hints of this

abound. In the fifth stanza from the end, at the latest, there can be no
doubt about it as the skeleton horseman exults: "Our course is done! our
sand is run! / The nuptial bed the bride attends" – in German these lines
include, literally, the last words of Jesus on the cross ("es ist vollbracht"
["it is finished"]), spoken by Death. Therese Heyne, the wife of the Göt-
tingen professor and privy councillor Christian Gottlob Heyne, did not
need a particularly good nose to scent blasphemy, as she did, in
"Lenore."[48] But Bürger, writing as he claimed, for the benefit of the
common people, does not leave it at that. He describes Wilhelm, the
bridegroom, with words that had traditionally been used to describe
Christ, the bridegroom of the soul, and even slips quotations from church
hymns and other texts of Christian orthodoxy referring to Christ into the
passages in which Lenore describes her lover and her relationship with
him.[49] Not only that: Christ is literally referred to as the bridegroom of
the soul – in this poem about the bridegroom who fetches the maiden's
body and soul. Distraught by her uncertainty about the fate of Wilhelm,
Lenore early on in the poem questions the wisdom and goodness of God.
Her mother cautions her:

> ["]Oh, child! forget thy mortal love,
> Think of God's bliss and mercies sweet;
> So shall thy soul, in realms above,
> A bright eternal Bridegroom meet."

> "Oh, mother! what is God's sweet bliss?
> Oh, mother! what is hell?
> With Wilhelm there is only bliss,
> And without Wilhelm only Hell!
> O'er this torn heart, o'er these sad eyes,
> Let the still grave's long midnight reign;
> Unless my love that bliss supplies,
> Nor earth, nor heaven can bliss contain."

> ["]Ach, Kind, vergiß dein irdisch Leid,
> Und denk an Gott und Seligkeit!
> So wird doch deiner Seelen
> Der Bräutigam nicht fehlen."

"O Mutter! Was ist Seligkeit?
O Mutter! Was ist Hölle?
Bei ihm, bei ihm ist Seligkeit,
Und ohne Wilhelm Hölle! –
Lisch aus, mein Licht, auf ewig aus!
Stirb hin, stirb hin Nacht und Graus!
Ohn' ihn mag ich auf Erden,
Mag dort nicht selig werden."

Eternal "bliss," according to conventional orthodoxy, was granted by Jesus, the bridegroom of the soul (both mother and daughter use the same word, "Seligkeit," rich in strictly religious connotations). Needless to say, this is not the "bliss" that Lenore seeks in her all-too-human, all-too-worldly bridegroom – and yet she uses the term, "Seligkeit," with reference to Wilhelm, just as she chooses another religiously charged word, "Hell," to describe life without him, all the while endowing him with attributes and associations traditionally the prerogative of the bridegroom of the soul. We are left to conclude that life with Wilhelm is, for Lenore, tantamount to eternal life in the presence of Jesus Christ. In the event, of course, the equestrian bridegroom is revealed to be neither the one nor the other bridegroom, but the allegorical skeleton with "the scythe and houre-glasse" in his bony hand. As such, however, Death is fused with the mundane bridegroom but also (as a result of the choice of religious vocabulary reserved for Christ) with the bridegroom of the soul. Once again, then, we see the amalgamation of Death and Christ noted earlier in Novalis, Eichendorff, and others: both are saviors from earthly bondage. True, Bürger's ballad differs from the passages quoted from Novalis and Eichendorff where Thanatos was seen as identical with or analogous to Jesus; in "Lenore" Death appears as he had been visualized in the Christian world – the terrifying skeleton with his scythe and the horseman of the apocalypse. It is he who serves as Lenore's bridegroom and, in blasphemous parody, as the bridegroom of the soul. In this respect Bürger's poem represents the ultimate realization of the conceit that was so appealing to the Romantic Age. The strong resonance of "Lenore" throughout Europe at the time is therefore hardly astonishing. Though other representa-

tions of death as the bridegroom, some of which were referred to earlier, are not always as explicit as "Lenore" in their choice of religious vocabulary for secular contexts, they, too, suggest the Christian bridegroom of the soul as the ultimate religious prototype. Religious concepts are obviously still very much alive in the awareness of a time that secularizes them.

Unlike the Christ of medieval theology, this bridegroom of the soul is not the vanquisher of Death. On the contrary, *both* Christ and Death, fused into an unorthodox union, lead us from this world to eternity. When Death in "Lenore" pronounces Christ's last words, this bridegroom does not merely identify himself with the bridegroom of the soul. Significantly, he also uses these words in a plural context: "*our* course is finished" (vollbracht ist unser Lauf), implying that this consummation is true not only of Christ and Death but also of Lenore, who now leaves this world for life everlasting. Similarly, in Novalis's fifth *Hymn to Night*, Christ, the bridegroom of the soul, is not the only one to promise salvation – but also "in Death the Life eternal is revealed."

This identification of Christ and Death the bridegroom clearly points back to an article of Christian faith ("the bridegroom of the soul"), but just as clearly it signals the secularization of this faith. This secularization in its turn reveals the closeness of this Death to the two other personifications of death prominent at the time, which testify in their way that religious orthodoxy is losing its grip on intellectual life: Thanatos and "Freund Hein" (or simply the "friend"). Eternity (with its Christian overtones) is associated with all three. "Lenore" yearns for eternal "bliss" with her bridegroom. "Eternal," we recall, was the "glory" ("Herrlichkeit," again a specifically Christian, indeed a biblical term) to which, in the words of Luise Miller, in Schiller's *Intrigue and Love*, the "charming youth" Thanatos will conduct us at the end of earthly life. And in Schellenberg's *Freund Hein's Appearances* the "friend" who "accompanies" the dying man (Freundes Geleit) is of course Death leading him to "Eternity": the copper engraving shows the *moriturus* raising his clasped hands with transfigured gaze to the symbolic light radiating from above, and the text explains that Freund Hein, Death, is the servant of the "doorman at the gates of Eternity" (p. 65).

Death the bridegroom, Thanatos, Freund Hein – each is an

anthropomorphic image characteristic of the secular myth-making of the Romantic Age, and yet none is entirely without references back to concepts dear to periods of more intense and more formal faith; all three promise "Eternity."

At the same time Death the bridegroom, the cachet of the death eroticism of the Romantic Age, points the way forward, to the subsequent history of the personification of death in art and literature. In the later nineteenth century and throughout the twentieth, not only will the encounter with death be eroticized to an unprecedented degree, but one of the hallmark variations of the theme will involve a role reversal in the dominant erotic constellation: the male lover of the Romantic Age now gives way to his female counterpart. The stage is set for the full emergence of Death as the bride, the seductress, the coquette, even the prostitute, as well as Mother Death. Underlying this change are developments and experiences of which the Enlightenment and Romanticism hardly had an inkling.

5

FROM DECADENCE
TO POSTMODERNITY:
THE STRANGER
AT THE MASKED BALL

ANGELS OF DEATH AND SKELETAL COQUETTES

I

"Modern art has made no contribution to the portrayal of death person-
ified," a much-used handbook of thanatology tells us in its chapter on art
history.[1] This comes as a surprise to those who have eyes to see. For in
most of the western world, representations of death personified are so
plentiful and manifold in the visual and the literary arts of the nine-
teenth and twentieth centuries that it is difficult at first glance to discern
the dominant images that define this period. As one keeps looking,
however, a few peaks will come into sight, towering over the wide pano-
rama. Remembering the predominance of male personifications of
death in the preceding period, one is struck by the ascendancy of female
death images; in the course of the nineteenth century, they rise to such
prominence that they become the defining cachet of the imaginative
encounter with mortality. This development culminates around the turn
of the century, in literature as well as in the visual arts, but it continues
well into the twentieth century, flourishing in several national cultures
and hence also in languages in which death's grammatical gender is not
feminine. What is behind this phenomenal ascent of "Madame La
Mort"?

The triumph of female Death is preceded in the earlier nineteenth
century by a number of then prominent literary and pictorial works, or
sequences or cycles of works, that personify death as a man as well as a

woman, indeed place male and female images of death side by side. What prompts such juxtaposition? Does it not make any difference what shape death assumes? Or is there some deeper meaning in this dual image? The challenge of such questions is not easily overlooked.

When Austrian poet Adolf von Tschabuschnigg, a remarkably successful minor talent, in a poem entitled "Mr. and Mrs. Death" (Tod und Tödin, 1841) picked up the folkloric notion that Death has a wife, he failed to give a clear idea of the why and wherefore of his detailed elaboration of the conceit. The Biedermeier idyll of the odd couple's petit-bourgeois household, with its insistence on family life and domestic order (which calls to mind Wilhelm Busch's notoriously grotesque mockery of death), leaves the reader baffled by the two sexes of death and their easygoing familiarity. The poem remains a playfully bizarre piece, surely unusual in literary history, and not without a touch of kitsch in its fussy and folksong-like domestication of the ultimate "other":

> Who is awake so late and so busy still?
> There are splashing noises from the brook.
>
> Mrs. Death washes burial shrouds there,
> Kneading and wringing and bleaching them.
>
> It is a beautiful night, full of moonlight,
> Making it not so difficult to die.
>
> Mrs. Death keeps busy without rest
> As though there were still much for her to do.
>
> She is a beautiful, pale woman,
> Even if her slender body is almost too delicate;
>
> Earnest is her glance and sadly beautiful,
> Having seen so many eyes grow dim.
>
> And yet her eyes have never wept a tear
> Nor ever laughed.
>
> Now Death looks from his house
> In the cemetery and calls out to her:

Are you ready, my good wife?
My work is done, it's time for bed.

Gently she waves to him, folds the linen
And quietly slips into the house.

Death heartily welcomes her with a grin,
You can tell he is a good husband.

Their household thrives year in, year out.
They are a hardworking couple.

He places the dead in the coffin,
She wraps them neatly in linen;

He buries them deep down in the dark earth,
She plants flowers on the grave.

Wer ist so spät noch fleißig wach?
Es schlägt und plätschert laut am Bach.

Sterbhemden wäscht die Tödin dort,
Und pocht und dreht und bleichet fort.

Die Nacht ist schön, voll Mondenschein,
Heut' mag's nicht schwer zu sterben sein.

Die Tödin rührt sich ohne Ruh'n,
Als gäb's noch viel für sie zu thun.

Sie ist ein schönes, blasses Weib,
Nur fast zu zart der schlanke Leib;

Das Aug' ist ernst und traurig schön,
Hat viele brechen schon gesehn;

Doch nie hat's, wie's noch nie gelacht,
Je eine Thräne feucht gemacht.

Da schaut der Tod aus seinem Haus
Im Freithofgrün, und ruft heraus:

Du frommes Weib, bist du bereit?
Nun hab' ich Ruh', 's ist Schlafenszeit.

Leis winkt sie, deckt die Linnen aus,
Und schleicht dann still hinein ins Haus.

Der Tod grinst lachend froh sie an,
Man sieht's, er ist ein guter Mann;

Der Haushalt fördert Jahr für Jahr,
's ist gar ein emsig wackres Paar.

Er legt die Todten in den Schrein,
Sie hüllt sie blank in Linnen ein;

Er scharrt sie finster tief hinab,
Und sie pflanzt Blumen auf das Grab.[2]

This may provide an interesting glimpse of popular taste. But deeper insight into the meaning of the interaction of male and female person-ifications of death may be gained by examining some thematically related pictorial and literary sequences that were much noted at the time. Reviv-ing the Dances of Death of the late Middle Ages and the Renaissance in a contemporary mode, they continue to choose the skeleton – whether male or female – as their preferred allegory, identifying its sex through characteristic attributes. To interpret this convention, however, one can no longer be guided by those considerations that provided explanations for the same practice earlier. That is to say, in earlier centuries the dichotomy of male and female allegories of death could be seen in the light of Adam's or Eve's perceived responsibility for mankind's mortality, depending on whom one viewed as the principal original sinner; or the dichotomy could be seen in connection with the identification, common in the Renaissance, of Death and the devil, who for his part was believed to assume either male or female shape, or both. By the nineteenth cen-tury such theological frames of interpretive reference are a matter of the past; different considerations must be brought into play to account for the juxtaposition of male and female death figures. But which?

Death, hourglass in hand, may confront any one of us, at any time and in any place, regardless of our station in life – that was the conviction

inherent in the traditional Dances of Death, and it still underlies the imaginative reprises of the genre in the earlier nineteenth century: the bell that tolls "tolls for thee," as Hemingway, in search of a title for his novel, learned from John Donne. On the eve of the July Revolution in France, Jean Grandville (Jean Ignace Isidore Gérard), collaborator and kindred spirit of Honoré Daumier, translated this time-honored *memento mori* into a grotesque satire on contemporary daily life in his frequently reprinted series of nine lithographs entitled *Journey to Eternity: Public Transport by Express Coach, With Hourly Departures from all Points of the Globe* (*Voyage pour l'éternité: Service général des omnibus accélérés, Départ à toute heure et de tous les points du globe*, Paris: Bulla et Aubert, 1830). The title page sports a liveried coachman in a deferential posture, opening the door of a coach decorated with a pennant inscribed "Au Père Lachaise" – his face a grinning skull. Dazzled by the wealth of realistically drawn particulars of everyday life of the time, one almost overlooks this decisive detail.[3] Did the cleric who reclines comfortably on his upholstered seat inside the coach notice this working-class figure when he stepped aboard? Did the crowned gentleman sitting next to him? Nothing suggests that they did, and yet Death is but an arm's length away. Grandville cleverly uses the same method of sly suggestion in each one of these caricatures designed for popular consumption, effectively driving home the message that Death is always among us in our ridiculously trivial everyday life. The shapes this Death takes are as different as they are inconspicuous and familiar, yet never without a tinge of grotesque comedy or a satirical edge: the doctor, the coachman, the visitor, the dandy, etc. These commonplace types are easily recognized at sight, but not for what they are. Only after the initial impression sinks in, does this or that bony detail come into view in a flash of perception, instantly turning the harmless contemporary into death personified. Such a detail may be the eyeless skull of the otherwise almost fully dressed doctor or the bare and probably rattling bones below the knees of the visitor who politely bares his head as he enters, not to mention the bony rib-cage which is surprisingly revealed where the innocent viewer expects to see the dandy's immaculately starched dress shirt. Everyday life, it appears, is fraught with danger and especially unsettling are those aspects of it that one hardly takes note of. The coachman startles the suitcase-carrying

traveller with the announcement that he has reached his destination; a rustic hiker appears at the work-table of the watchmaker, holding an old-fashioned hourglass up to him, of all people: "it's running out terribly fast" (ça avance horriblement); the proverbial man in the street, wearing his work-clothes, takes the overweight baron by surprise; the cook, complete with skull and bare-boned feet, offers the gluttons assembled around the groaning table a platter of mushrooms as "a dish of my cooking" (un plat de mon métier) just as we catch sight of the servant's horrified stare and the dead dog in the corner; an elegantly dressed cavalier gallantly invites two ladies for a walk – they do not seem to notice his death's head; a bony officer leads a handful of recruits from their village to "immortalité," etc. – guises of Death, one and all.

What is interesting about Grandville's *Journey to Eternity* from the point of view of this essay is not so much its prerevolutionary satire that sees disaster lurking in every nook and cranny, as the realization that in the overwhelming number of cases death appears as a man and only once as a woman. To some, that might be a surprising imbalance in the work of an artist in whose mother tongue death is grammatically feminine. It might be a nod to Grandville's source of inspiration, Thomas Rowlandson's *The English Dance of Death* (1815–16), where the skeleton representing death, as so often in the Anglo-Saxon world, is male, either by virtue of its attributes or because the text accompanying the water-colors refers to it as "he" even when we see a nurse rocking the cradle.[4] But that is not the whole story. For Grandville apparently did not think that choosing a male death figure would trouble his typical French contemporaries (and he surely did not have an elite in mind when he drew his ominous caricatures). Side by side with these male personifications, we do, however, encounter a female Death, in the fifth of the nine images, between the cook and the doctor. Here we see a street scene, a tame anticipation of Félicien Rops's "Street Corner" (Coin de rue) and Wilhelm von Kaulbach's fantasy about Lola Montez: two young men, smartly attired from boots to top hat, are accosted by a prostitute, her bony feet as well as her skeletal midriff exposed, while she tries to hide her skull behind a madonna-like mask she holds in her hand: "Would you like to come upstairs with me, my dear sir, you won't be disappointed, come along" (Voulez-vous monter chez moi, mon petit Monsieur, vous n'en serez pas

fâché, allez). The similarity with Rops's turn-of-the-century "Street Corner" notwithstanding, it would be rash to see in Grandville's lithograph the conviction that the female sex is by definition dangerous, pernicious, and deadly – a view that would become common by the turn of the century, when, once again, the mask suggested that female charm is not what it seems to be. If one were to read Grandville's treatment of the motif in this manner, it would be only logical to contrast this female threat with the lethal sexual allure of those several men who embody death in the *Journey to Eternity*. That, however, would evidently be a mistake since, with the single exception of the dandy, this male Death – the coachman and the cook, the visitor and the officer, etc. – is invariably presented as nonerotic and in nonerotic situations. Underlying Grandville's male and female embodiments of death is something much more harmless, in a sense, than a philosophy of the respective dangers of their sex. His sequence of scenes is, rather, a sometimes satirical, sometimes humorous commentary on the omnipresence of death in modern life, and especially on its presence in life's most ordinary social situations. Not only does death, true to form, strike every man and woman regardless of class (as the late medieval and early modern Dances of Death kept pointing out). More interestingly, instead of appearing again and again in more or less the same skeletal form, as he had done in the older Dances of Death, Death is now cast in a wide variety of roles rendered realistically and with loving detail. And one of the roles, unsurprisingly, is the prostitute, who is no less commonplace in this world than the coachman and the apothecary's apprentice, the cook and the doctor, the recruiting officer and the seducer of women. Death lies in wait everywhere, especially where least expected. The world, accurately portrayed as the world of the satisfied and prosperous bourgeois on the eve of the 1830 revolution, is perched on the brink of its demise – death's coach departs from "all points," at all times and, above all, "express." The final hour of the prerevolutionary world has arrived, yet Grandville trivializes the historic moment through his humor, which is not invariably bitter and unrelentingly ominous but also "serene" (as Balzac found)[5] – serene in a way, to be sure, that makes one's hair stand on end. For appearances, patriotic, social, erotic appearances, are deceptive; the routine dance of daily life, French style, is a dance on a volcano that is already rumbling, if only intermittently.

Such ominousness again emerges from under the surface realism when mid-nineteenth-century German commercial artists turn to the theme of death's ubiquity. Much like Grandville, they choose male *and* female anthropomorphization as one of the indices of death's uncanny omnipresence and multiformity. At the same time their intimations of imminent disaster are toned down, at times to the point of harmlessness. There is nothing short of a Biedermeier touch in the treatment of the theme in the then fashionable "narrative" painter Moritz von Schwind's woodcuts illustrating Eduard Duller's collection of poetry and prose *Freund Hein* (Stuttgart: Hallberger, 1833). The title refers back, of course, to the homespun death figure familiar from the Romantic Age. The sub-title, *Grotesqueries and Phantasmagorias* (*Grotesken und Phantasmagorien*), on the other hand, might lead us to expect something along the lines of Grandville's *Journey to Eternity*, but this expectation is soon dis-appointed. The world into which Schwind introduces us is the petit-bourgeois ambiance of a provincial German town where life takes its uneventful course day in, day out. All the same, there is an element of sur-prise in the idea of letting Death make its entry not only as a man, but also as a woman. As a man, he appears as the familiar "Freund Hein," though Claudius's homely "boneman" has now been transformed into a fashionably dressed young gentleman, without so much as a hint of the skeleton. But "friendly" he still is, as we see him approaching a woman in black kneeling at a fresh grave – a widow, we gather. Death accosts her as a "suitor," the text explains – as if he were not in the cemetery but in some other public place in this idyllic small town silhouetted in the back-ground. In another woodcut, Death is a bald but otherwise not skeletal elderly gentleman who opens the wrought-iron prison for an equally bald debtor, releasing him into a sunny landscape. On other pages of this sequence, Death is a similarly caring "Freund Hein." Once, however, the male-gendered title of the book notwithstanding, death is presented as a woman, a nurse ("Wehfrau"). She is not the winged skeleton that we saw in Chodowiecki's *Dance of Death*, but a woman conventionally dressed, without the slightest suggestion of bare bones or skull. As this nurse places the newborn in the cradle, the mother in her alcove in the back-ground raises her hands in horror. Alerted by her screams, a man rushes to her – but it is too late: the child is dead. "The faithful nurse was –

Freund Hein," the text comments (Die treue Wehfrau war – Freund Hein, I, 40). Upstairs, meanwhile, a celebration is underway in honor of the new arrival. The heavyhanded irony of that joyful scene makes us wonder: is this Death really a friend, a "Freundin Hein"? The scene is latently uncanny; one can imagine how Grandville, with his sense of the grotesque, might have developed its sinister portents. But in Schwind's woodcut there is hardly a sense of horror; the atmosphere of everyday Biedermeier is all-encompassing.[6] On balance, we are not allowed to forget that death lurks everywhere, yet the satisfaction exuded by this sheltered world overshadows the horror of the daily endgame.

The general view underlying the *Images of Death or Dance of Death for all Classes* (*Bilder des Todes oder Todtentanz für alle Stände*, 1850)[7] – Johann Gottfried Flegel's woodcuts after drawings by Carl Gottlieb Merkel – is roughly the same. As in the other sequences discussed, the male person-ifications of death predominate in these eighteen pictures and their brief texts in verse; several "incarnations" are gender-neutral skeletons, and only one is female. While this may be reminiscent of Grandville, Grandville's sense of the grotesque and satirical is certainly missing once again. Instead, there is a predilection for Romantic philistinism, without any ironical edge: the failed German revolution must have shocked these two artists into good behavior; characteristically, the final image shows not freedom but Christ victorious over Death, who bows meekly under his master's imperious gesture and even symbolically drops his hourglass. This conclusion is somewhat out of character, as the point of the entire sequence had been, much like Grandville's, not only that death is an ever-present menace in all walks of life ("für alle Stände") but, more impor-tantly, that death appears in many different guises which the artists indicate by attributes that define his social station and function. Accord-ingly, Death is not just the horseman, shades of the Apocalypse, not just the skeleton endowed with bat's wings or the Grim Reaper with his scythe. More specifically, he is the warlord, complete with helmet and lance, crouching on a horse-drawn canon; he is the village schoolmaster at his desk in front of his class; he is the fiddler, reveller, cardplayer, the political agitator wearing a hunter's hat, the executioner, the second at a duel, etc. The sole female role is elaborated in the woodcut titled "Pro-curing" (Kuppelei).[8] It shows a modestly dressed girl sitting in her room

at the distaff as a female shape, all wrapped up except skull and curtseying footbones, enters and hands her some coins; through the open door one catches sight of the customer who will presently enter the room in which a cat lies under the wash-stand and the Bible rests on the floor. The text leaves nothing to the viewer: "If you sell your innocence out of poverty and misery, / You are taking earnest money from eternal death" (Verkauf'st du die Unschuld aus Mangel und Noth, / So nahmst du das Aufgeld vom ewigen Tod). In this instance, too, the choice of a female personification does not imply an ideology based on the presumed deadly qualities of the female sex, as was to be the case later in the century. Instead, the inclusion of a female death figure in the panorama of these *Images of Death* merely demonstrates that death lies in wait in all constellations of everyday life, and particularly in the most common ones. Death is predominantly male, as it is in all such cycles discussed in this section. But there is no ulterior meaning in this choice. The most likely explanation is that women had fewer roles in public life at the time and were consequently less visible, confined to the family.

One comes away with a similar impression from the *Dance of Death in Pictures and Verse* (*Todtentanz in Bildern und Sprüchen*, 1862), twelve woodcuts after drawings by the Bavarian count Franz Pocci.[9] He is primarily known as a folk poet and writer of children's stories; but this sequence stands out among the hallmark happy-go-lucky cheerfulness of the rest of his works in that it introduces the sinister and demonic overtones that had been conspicuously absent in the Merkel/Flegel Dance of Death.[10] The shawm-playing death figure featured on the title page seems to promise harmless pleasures – sitting on a tree stump, he appears to be a well-meaning garden gnome, his skull being mostly concealed by a hunter's cap sprouting the customary plume; but it will turn out soon enough that he invited the reader under false pretenses. The pictures following the title page are hair-raisingly gruesome, and the verses accompanying them heighten this effect. Death, always respectably and appropriately attired, with only the toothy, eyeless skull giving him away, is the ferryman pretending to row a trusting young couple across a lake; he is the mountain guide taking a mountaineer to a peak from which, as his anxious glances suggest, he will not return alive. In another scene Death drives a hearse – in it sits one of the usual victims of the older

Dances of Death, the fool identified by his cap, except that this one does not seem to have an inkling of what is in store for him. Once again, male death figures are in the majority; apart from the ones mentioned, there are the reaper, the archer, the bellringer, the standard-bearer, and the gardener. Three times, however, death slips into the role of a woman: the nurse, tearing the baby away from his mother who pleads for mercy; the old crone in the woods, with a cane and a basket strapped to her stooped back, who shows a young boy the way into the thicket where, the text explains, he will find poisonous berries;[11] and finally a wizened hag, her bare skull crowned with a wreath, sitting atop a basket that a peasant carries on his bent back – unaware of his sinister companion who ominously breathes down his neck as he wends his way home on the dreary mountain path. The well-ordered and secure world of the post-1848 Restoration is overshadowed by a force that makes it eerie and even frightening. For once, Count Pocci, normally the genial friend of the people and of children, shows his own skull, so to speak, grinning knowingly, triumphantly. Like Merkel/Flegel and Schwind, he too knows of the omnipresence of death in everyday life, except that this knowledge gives him the shivers; his anxiety is clearly more gripping than the innocuously sentimental title page leads us to expect. And, interestingly, this knowledge of a seemingly intact world given over to death includes a greater awareness than his predecessors' of the danger associated with women, who are more commonly objects of reverence in the literature of the time. But like his predecessors, Pocci does not demonize the female sex as such, stylizing it as the premier threat to the male world. That was not to happen until later in the "history of death."

From the at least seemingly idyllic world of woods and villages to the modern world of the machine and the metropolis – this transition is epitomized in the nineteenth-century Dances of Death by the sequence of twenty-five steel engravings and couplets entitled *Death at Work: A Dance of Death* (*Die Arbeit des Todes: Ein Todtentanz*, 1867) by Ferdinand Barth, who was much in demand at the time as a versatile craftsman.[12] Here Death enters the scene as a locomotive driver and a tobacconist, as the recruiter on an emigrants' ship and as a would-be heart-throb at the masked ball: "Come out, my love, it's cool out here" (Komm' raus, mein Lieb, bei mir ist's kühl); nor does he shun the more common nineteenth-

century roles, such as the mountain guide and the reaper. This variety of personae bears witness to Death's "proximity at all hours" (seine Näh' zu jeder Stund) that the title page proclaims; particularly unsettling are the pointedly machine-age embodiments of death as they undermine the triumphant confidence of that period in its life-enhancing inventions. For the ubiquity of this Death hardly inspires the trust in God that the title page promises to those who fully understand these images – trust in God "who sets everything right and ends all tribulations through death" (der Alles richtet, / Und durch den Tod all' Wirrsal schlichtet). On the contrary, instead of offering theological comfort, Barth keeps his gaze focused on the surface of the social life of his time, describing its many forms of corruption with evil-eyed attention to detail. Once again, death is everywhere: in wine and in gambling, in the cradle and in the coal stove, in a thunderstorm and in the workplace, and equally manifold are his roles. With one exception, they are male roles (insofar as attributes and clothes will allow gender-specific identification). The exception is the woman in the rather elaborate eighth engraving. Only the skull, almost disappearing under a lace bonnet, reveals that the saleswoman offering jewellery and fashion accessories from "Paris" to a vain and bored young lady idly reclining in her chair, is in fact Death "at work." While the lady regards her deep-cut décolleté in a hand-mirror, the saleswoman is already setting her dress on fire with a magnifying glass: women among themselves; but this is not, as so often at a later date, presented as the vision of man feeling threatened by women. If anything, a somewhat cheap cynicism comes into play here, just as in Barth's images featuring male death figures – the hard-bitten kitsch of pretended loss of illusions about human nature. What is lacking is a more sophisticated overall view of the omnipresence of death in the modern world of machines and metropolitan luxuries.

It was left to Wilhelm von Kaulbach, the prominent painter who served Ludwig I of Bavaria, to transpose the theme of the ubiquity of death into the sphere of more demanding artistic expectations. Over two decades, from the middle of the century to about 1870, he repeatedly tried his hand at a Dance of Death sequence that was to remain largely unfinished. What we have are delicate pencil drawings with sly satirical touches, adding up to the idea that death stalks us in all walks of life and

in different guises, male and female. Some of the sketches, in addition to their exquisite execution, are original variations on familiar constellations: as a pipe-smoker Death blows rings in the air in what one might be tempted to read as an anticipation of present-day concerns; at a children's ball he plays the fiddle; he helps Louis XVIII into his coffin; he dances into the life of the miser to hold his hourglass up to him; with Madame Laetitia he chats genially by the fireplace in the guise of a cavalier making a courtesy call, sporting a medal on his chest and a sword at his side. In all cases Death wears mid-nineteenth-century clothes: frock coat or knee-breeches or the shabby outfits of ordinary folk. As a rule they are the clothes of a man. This makes all the more noteworthy the female death figures Kaulbach cleverly integrates into some of his compositions of the contemporary social scene. In the draft entitled "The Corset" (Die Schnürbrust) we see a young lady dressing before a mirror: her maid almost kills herself trying to bind the corset as tightly as vanity demands – suffocating her mistress in the service of fashion; for of course she is no ordinary maid as her skull and bony legs protruding from under her dress reveal all too clearly. As in Merkel/Flegel's Dance of Death, there is a "Procuress" in Kaulbach's as well. She is clothed in a long dress, with a bonnet over her empty eye sockets, except that in the configuration chosen by Kaulbach, a procuress seems hardly necessary. For the over-eager customer is already hurriedly approaching, his hands outstretched – and ridden by a whip-cracking, bat-winged miniature devil; meanwhile a relaxed young woman, looking interested, bares her shoulder and more.[13] In another sketch of female Death, Kaulbach even gives her the name of King Ludwig's mistress, Lola Montez (see below, p. 209).

An intriguing case, standing out among the cluster of Dances of Death featured so far because of its combination of text and music, rather than text and graphic art, is Modest Musorgsky's *Songs and Dances of Death* (1875–77).[14] The first part of this *lieder* cycle, "Lullaby" (Kolybel'-naia), takes us into the small world of a peasant's cottage: a mother sits by the bed of her dying child. Night has fallen; Death, a woman, knocks on the door, enters and, ignoring the mother's protests, starts singing a lullaby. The child falls asleep peacefully, never to wake again. For the Russian reader there is nothing startling about a female death figure, not so much because the word for death is grammatically feminine in Russian

but because Russian folklore tends to personify death as a woman. The fourth and final part of the cycle is therefore all the more surprising. For it is entitled "The Field-Marshal" (Polkovodets), and though "death" is referred to here with grammatically feminine forms (the Russian language has no other option), this Death – Death in the great world of history – is unequivocally male, the powerful warlord. After a bloody battle, this General Death, a white-boned skeleton, rides by moonlight across the fields strewn with the dead and the dying, a proud smile lingering on his lipless jaw – a grotesque troop review which unites friend and foe in death. Taken together, then, the beginning and the end of this tetralogy of songs encompass the universal activity of death in its many forms, ranging from the cradle to the mass-grave, and one indication of death's universality is its male/female dichotomy.

II

Whereas the representations of death of the earlier and mid-nineteenth century discussed so far intend to call to mind the omnipresence and multiformity of death, male and female, a very different vision of death personified commands attention in the second half of the century and continues to dominate the scene, especially at the turn of the century and for some time thereafter. Specifically, the significance it assigns to the sexual identity of death is entirely at odds with what was observed in the nineteenth-century Dances of Death, whether pictorial or literary. Now, in the phase of the history of art and literature that is variously called Aestheticism, Symbolism, and Decadence, the representations of death that set the tone portray death as a woman, or rather, as two female figures, not always neatly distinguishable from each other: the angel of death and the seductress. (Hints of motherliness may be associated with either.) While the German Romantic Friedrich Schlegel could muse, no doubt under the impact of the discovery of Thanatos, that "Death is perhaps male, Life is female,"[15] the opposite view would be appropriate from the second half of the nineteenth century on, at least as far as the sexual identity of death is concerned – with the decisive qualification, however, that in this period female Death may in its turn adopt the mask of life, or indeed of love. This fusion of death and love, inherited, in a sense, from the Renaissance, takes many forms and

implies many meanings; it ranges from *Liebestod* as the fulfillment of love in joint death (as in Wagner's *Tristan*) all the way to the erotic pleasures offered by Rops's "Mors syphilitica" (ca. 1892).[16] What all the forms have in common is the interchangeability of love and death, to the point where one may be mistaken for the other. This happens memorably in two antithetical sonnets, one by Elizabeth Barrett Browning, the other by Dante Gabriel Rossetti. "Not Death, but Love," runs the final line of one, "I and this Love are one, and I am Death" are the concluding words of the other:

> I thought once how Theocritus had sung
> Of the sweet years, the dear and wished-for years,
> Who each one in a gracious hand appears
> To bear a gift for mortals, old or young:
> And, as I mused it in his antique tongue,
> I saw, in gradual vision through my tears,
> The sweet, sad years, the melancholy years,
> Those of my own life, who by turns had flung
> A shadow across me. Straightway I was 'ware,
> So weeping, how a mystic Shape did move
> Behind me, and drew me backward by the hair;
> And a voice said in mastery while I strove, –
> "Guess now who holds thee?" – "Death," I said. But, there,
> The silver answer rang, – "Not Death, but Love."
> (E. Barrett Browning, *Sonnets from the Portuguese*,
> First Sonnet, 1850)

Death-in-Love

> There came an image in Life's retinue
> That had Love's wings and bore his gonfalon:
> Fair was the web, and nobly wrought thereon,
> O soul-sequestered face, thy form and hue!
> Bewildering sounds, such as Spring wakens to,
> Shook in its folds; and through my heart its power
> Sped trackless as the immemorable hour
> When birth's dark portal groaned and all was new.

But a veiled woman followed, and she caught
> The banner round its staff, to furl and cling, –
> Then plucked a feather from the bearer's wing,
And held it to his lips that stirred it not,
> And said to me, "Behold, there is no breath:
> I and this Love are one, and I am Death."
(D. G. Rossetti, "The House of Life," Twenty-third Sonnet,
1870)[17]

These images of death, one explicitly female, the other at least inti-mated to be female, were deliberately chosen from the literature of a lan-guage that has no grammatical gender, a literature that most commonly personifies death as male, as the Grim Reaper. As such, these examples demonstrate that the female death figure is a European phenomenon in this period, not one limited to the Romance or Slavic language cultures. And the closer the century draws to its end, the greater the fascination of the fusion of love and death, and woman and death, in art and literature. The two most characteristic expressions of this fascination, the angel of death and the seductress or *femme fatale*, are not quite as unrelated as they may first appear. With the mankilling water-nymphs, vampires, Undines, Loreleis, Liliths, Sirens, Chimaeras, Gorgons, Amazons, and Sphinxes – mythological forms that Death as *belle dame sans merci* will sometimes take – the angel of death, more often than not, will share her feminine beauty and erotic appeal or even her "demonization." Malczew-ski or Moreau may come to mind most readily (see below, pp. 199, 206). Also, the ontological status of both, the angel of death and the allegorical *femme fatale*, remains suspended between death and the promise of death. S. T. Coleridge's almost proverbial "Nightmare Life-in-Death" from "The Rime of the Ancient Mariner" (1798) may suggest itself in this connection: is she, with her red lips, white limbs, golden locks, and seductive glances, an analogue of Baudelaire's "meager coquette" ("Danse macabre") and of Rops's street corner prostitute? *Or is she* Death herself, Death in person, as Baudelaire's coquette and Rops's "Mors syphilitica" are as well in the final analysis? "Life-in-Death" or "Death-in-Life"? Needless to say, conceptual precision would be ludi-crous here. Death and the instrument or conveyor or messenger of death

(comparable, in principle, to Thanatos in the eighteenth century) are merged in a single artistic shape in all these figures. At any rate, in the cases to be discussed in what follows, it is clearly Death, and not (merely) the conveyor or messenger of death, that is symbolized in a female figure.

But what is behind this fascination among authors and artists with the deadly woman, female Death, the goddess of death? Historians might remind us of long-standing thematic traditions reaching back to mythical beginnings. Yet why did such traditions not dissipate, why were they revived at this time? "The neurosis of men vis-à-vis women" is the likely response of psychologists and psychoanalysts today, who have made sexual "confusion" a topic of tea-table conversation. Or would sociologists be on the right track when they interpret the fascination with female Death as "a consequence of emancipatory aspirations" of women throughout the nineteenth century, in other words, as a reaction of the male world against feminism?[18] Or is the underlying cause, as feminist emancipationists might claim in their turn, men's fundamental misogyny coming into its own after a long latency, a fear of women remotely comparable to the diabolization of Eve in the Middle Ages? But again: why now?

Such interpretations are as widespread as they are glib. Adorno and Horkheimer raised them to a more sophisticated level in their *Dialectics of Enlightenment* (1947). Their starting point is the intimate connection of the female sex with the "elemental," with "nature," or biological processes. The decadents or aesthetes from the second half of the nineteenth century to the *belle époque* – from Flaubert and Moreau to Wilde and Huysmans – experienced this "nature" as a threat and escaped from it into the cult of the mask and of the artificial: women were turned into works of art studded with jewels, beautified with cosmetics, dressed as in paintings; Baudelaire's "In Praise of Make-up" ("Eloge de maquillage") may give the cue.[19] In the cultural philosophy of Adorno and Horkheimer, on the other hand, fear of the female sex and its consequent suppression is one aspect of the project of "Enlightenment" which aims to dominate biological and "animal" nature because it is perceived as incalculable and contrary to reason, hence foreign and hostile. At best, there can be a "love-hate relationship with the body" and with everything creaturely that woman represents in this view.[20] Woman "became the

embodiment of the biological function, the image of nature, the subjuga-
tion of which constituted that civilization's title to fame . . . This was the
significance of reason" (p. 248). The other side of such suppression or
even annihilation of woman by male-dominated rationalist culture is,
however, that the woman returns as a horrifying revenant, threatening
her opponents with nothing short of death. Those who diabolize nature
become its victims. "Subjected woman in the guise of a Fury has survived
and . . . wears the grimace of a mutilated nature" (p. 250). To quote a
more recent interpretation, "the fantasy of the dead woman changes into
the nightmare of death-inflicting woman."[21] The Fury, a goddess of
revenge, not only inflicts death, she also comes to stand for it, indeed to
embody it.

But why? The socio-philosophical perspective of *Dialectics of Enlight-
enment* is perhaps too narrow for a full understanding of the phenome-
non under discussion, i.e., the female image of death that rose to
predominance in modern art and literature in the later nineteenth cen-
tury. Adorno's sociological focus may be enlarged by a more basic
consideration which comes closer to doing justice to this icon of moder-
nity, especially in the form in which it was popularized by Simone de
Beauvoir in her book *The Second Sex* (*Le Deuxième Sexe*, 1949). Beauvoir
takes the matter back beyond the essentially rationalistic "project" of the
Enlightenment (which is a fact of relatively recent history) to the puta-
tive primordial anxiety of men about the closeness of woman to biolog-
ical or animal "nature." This is evidently the anxiety that threatened to
overwhelm the decadents and aesthetes of the *fin de siècle*. The manifest
subjection of woman to the biological processes reminds man of his own
creatureliness, of his own biological origin and therefore of his own, no
less biological death. For the biological development of woman – birth,
menstruation, childbearing, menopause – heads for an equally biological
physical end. Inexorably cyclic, the spontaneity of organic beginning and
growth is destined to an equally organic decay and physical ending. As a
result, the image of the woman and mother, the obvious symbol of life
and eros, becomes at the same time a powerful personification of death.
Today, this may be a less commonplace association, even in the minds of
the educated; but in folklore and mythology the notion is widespread (see
above, pp. 18–19). She who gives life, gives death; as Beauvoir puts it:

The Mother dooms her son to death in giving him life; the loved one lures her lover on to renounce life and abandon himself to the last sleep. The bond that unites Love and Death is poignantly illuminated in the legend of Tristan, but it has a deeper truth. Born of the flesh, the man in love finds fulfillment as flesh, and the flesh is destined to the tomb. Here the alliance between Woman and Death is confirmed; the great harvestress is the inverse aspect of the fecundity that makes the grain thrive. But she appears, too, as the dreadful bride whose skeleton is revealed under her sweet, mendacious flesh.

La Mère voue son fils à la mort en lui donnant la vie; l'amante entraîne l'amant à renoncer à la vie et à s'abandonner au suprême sommeil. Ce lien qui unit l'Amour à la Mort a été pathétiquement mis en lumière dans la légende de Tristan, mais il a une vérité plus originelle. Né de la chair, l'homme dans l'amour s'accomplit comme chair et la chair est promise à la tombe. Par là l'alliance de la Femme et de la Mort se confirme; la grande moissonneuse est la figure inversée de la fécondité qui fait croître les épis. Mais elle apparaît aussi comme l'affreuse épousée dont le squelette se révèle sous une tendre chair mensongère.[22]

The fusion or identity of birth and death is intensified to the point of an anxiety neurosis in the lapidary formulation of the celebrated East German dramatist Heiner Müller: "Death is a woman" (Der Tod ist eine Frau), where "woman" means "mother."[23] It was left to Georges Bataille, the mystical and vitalist writer and journalist, to elaborate this affinity of birth and death with intuitive logic in variation upon variation in his L'Erotisme.[24] But even Bertolt Brecht, normally more concerned with social issues, was no stranger to such psychological extrapolations, not even when he was involving himself in the burning questions of political exile and life-threatening racial discrimination – the surprise about this discovery, and indeed about the entire notion of "Mother Death," still reverberates in a critical comment published in the August 1995 issue of Merkur, the German journal of cultural conservatism: "What a horrible idea of motherhood underlies Brecht's well-known lines describing the

origin of wars: 'The womb that gave birth to that is fertile still.' Fertility equals continued destruction, birth is death, life is murder" (vol. 49, p. 746). The horror of this realization is grippingly present in Alfred Kubin's pen-and-ink drawing "Leap into Death" (Todessprung, 1901–02), designed for his unfinished cycle "Woman" (Das Weib): a nude, sexually aroused man, his arms stretched out as if he were diving, plunges into the vagina of an outsized, gigantic body resembling "a mountainous landscape, inimical to life, where the man has no choice but to jump into death. The female figure is thus endowed with the mythical significance of chthonic, primordial woman as she is called in the litera-ture of the time. She is . . . the symbol of nature inflicting death."[25] Woman "is" death personified.

Freud, whom Adorno and Horkheimer vaguely referred to in the context of their sociological speculations on the suppression and reemer-gence of the female sex, explained this archaic and mythological linkage of woman and death, motherhood and destruction, as "reaction-forma-tion"; in his essay on "The Theme of the Three Caskets" (1913), he states:

> The Moerae were created as a result of a discovery that warned
> man that he too is a part of nature and therefore subject to the
> immutable law of death. Something in man was bound to strug-
> gle against this subjection, for it is only with extreme unwilling-
> ness that he gives up his claim to an exceptional position. Man, as
> we know, makes use of his imaginative activity in order to satisfy
> the wishes that reality does not satisfy. So his imagination
> rebelled against the recognition of the truth embodied in the
> myth of the Moerae, and constructed instead the myth derived
> from it, in which the Goddess of Death was replaced by the God-
> dess of Love and by what was equivalent to her in human shape.
> The third of the sisters was no longer Death; she was the fairest,
> best, most desirable and most lovable of women. Nor was this
> substitution in any way technically difficult: it was prepared for by
> an ancient ambivalence, it was carried out along a primaeval line
> of connection which could not long have been forgotten. The
> Goddess of Love herself, who now took the place of the Goddess
> of Death, had once been identical with her. Even the Greek

Aphrodite had not wholly relinquished her connection with the underworld, although she had long surrendered her chthonic role to other divine figures, to Persephone, or to the tri-form Artemis-Hecate. The great Mother-goddesses of the oriental peoples, however, all seem to have been both creators and destroyers – both goddesses of life and fertility and goddesses of death. Thus the replacement by a wishful opposite in our theme harks back to a primaeval identity.[26]

One need not conclude, of course, that the anxiety neurosis that comes into play here underlies any and all of the imaginative portrayals of Madame La Mort in the art and literature of the nineteenth and twentieth centuries, including the representations of the female angel of death. Rather, the overwhelming impression given by the vast majority of the artistic articulations of the theme, and the one that gives the period its distinctive cachet, is that of the erotic fascination of death. This fascination was prefigured or rehearsed, to be sure, in the centuries from the Renaissance to Romanticism, but predominantly with a male death figure. It is the female image of death that now sets the tone. Another indication of the uniqueness of the modern erotic fascination of death is the intriguing fusion, even in the images of the angel of death, of ardor and elegance – a blend which marks their distance from the past as much as it reveals their closeness to the "decadence" widely prevalent from the second half of the nineteenth century on.[27]

III

Turning to the nineteenth- and twentieth-century iconology of the angel of death, one should keep in mind that the Old Testament angels were unequivocally male (Gen. 19), particularly the destructive, sword-carrying angels of death such as those Jehovah sent to destroy Sodom. They remain male (and unaffected even by the incipient trend toward androgyny observable at the time) in nineteenth-century illustrations of the Bible such as *The Bible in Pictures* (*Die Bibel in Bildern*, 1852–60), a series of woodcuts by Julius Schnorr von Carolsfeld, better known as a fresco painter of the German Nazarene School in Rome.[28] Schnorr's angels of death are winged, wrapped in shroud-like garments, their flaming swords

and peremptory gestures inspiring awe. Even more forbidding is the bib-
lical angel that Moritz von Schwind, introduced earlier as the creator of
Biedermeier death figures, painted as "The Angel of Death" (Der Todes-
engel) around 1850:[29] an austere figure, he wears armor under his flowing
garment and holds a formidable sword. With their majestic wings, such
figures are like male counterparts to Alfred Rethel's much reproduced
"Nemesis" paintings of the 1830s that represent a similarly dressed and
winged but pointedly female avenging angel of vaguely classical inspira-
tion holding the sword of vengeance in one hand and the hourglass, the
traditional Christian attribute of Death, in the other. The sand has run
through; the final moment has come for the murderer trying to escape
from the scene of his crime, above which Nemesis is hovering – clearly
this symbol-laden winged goddess of revenge with a Christian cross on
her breast is also death personified and as such an angel of death – a
female angel of death.[30] This identity is more explicit in the
contemporaneous but much less austere, indeed somewhat girlish,
winged female figure in the concluding panel of a highly symbolical
frieze created for the mansion of Wilhelm Schadow, the son of the sculp-
tor. The frieze (painted in oil on a zinc surface by Schadow's student
Julius Hübner) represents in a series of four allegorical tableaux the stages
of human life as well as the times of the day, with the angel of death
standing simultaneously for Death and Night. The draft, dated 1838,
shows an old man kneeling on a cloud, praying, with a transfigured
expression on his face. Regarding him kindly, the angel, her hair plaited
in long braids, her body wrapped in what appears to be a habit, has placed
one hand on his shoulder while the other points toward the light radi-
ating through the clouds.[31] If this suggests a bourgeois domestic altar,
and a somewhat esoteric one at that, that impression may be offset by the
many forms of consumer art designed for the emerging mass market.
The angel of death is commonplace in the cemeteries of the time as a
tomb sculpture; and it occurs even as a vignette on the title page of a book
like Oskar Schwebel's otherwise pedestrian *Death in German Legend and
Literature* (*Der Tod in deutscher Sage und Dichtung*, Berlin: Alfred Weile,
1876): inspired perhaps by Kaulbach's "The Eternal Home" (Zur ewigen
Heimat), the unnamed commercial artist presents a gently melancholy
angel with imposing wings and an unmistakably female coiffure; she

PLATE 19 Oskar Schwebel: *Der Tod in deutscher Sage und Dichtung*, title-page vignette (1876)

soars upward, holding in her arms the body of a boy or young man who peacefully sleeps his last sleep.

Somewhat incongruously, Rethel's "Nemesis" held an hourglass. When after the middle of the century this emblem becomes the attribute of the female *angel of death* (as, for instance, in Gustave Moreau's painting "The Young Man and Death" where Death holds an almost identical hourglass in her hand), this Death has gained an erotic appeal which previously would have been unthinkable. The new conception trickles down even to the work of a minor decorative craftsman like Henri Bellery-Desfontaines. His woodcut "The Angel of Death" (L'Ange de la Mort, 1897) presents a commanding figure in the splendor of her outspread wings reminiscent of peacock feathers, a lyre in her hand; she casts a seductive glance at the viewer from under her coquettishly draped long locks – while paying no attention at all to the woman at her feet who is nursing her baby.[32] The dialectics of child-bearing and nurturing on the one hand and eros (the eros of death) on the other, could not be more

195

emphatic than in this clever Symbolist composition: the female sex is both the source of life and a threat of death – which is in its turn surrounded by the aura of that erotic attraction that is also the source of life.

In the same decade that produced Bellery-Desfontaines's preciously decorative work, Symbolist representation of death also took a surprise turn toward religion, particularly to a brand of Catholicism receptive to occult mysticism as practiced by artists in the circle around Joséphin Péladan and his Salons de la Rose + Croix (1892–97). The poster announcing the first of these "salons" was created by Carlos Schwabe, the German-born painter and illustrator of Maeterlinck and Baudelaire who spent his entire artistic career in the French-speaking west of Europe.[33] And just as his biography transcends national cultures, so too does his female death image which was to be his most enduring contribution to the history of art. His Symbolist water-color "The Death of the Gravedigger" (La Mort du fossoyeur, 1895–1900),[34] strongly evocative of the Pre-Raphaelites, takes us to a snow-covered cemetery with tombs typical of the time. The aged gravedigger, standing in an open grave he is still digging, turns his Düreresque face to the feminine angel of death crouched above him at the rim of the grave; his glance is questioning, but without fear. (It is appropriate to call this winged female figure an angel of death, not least because the painting derives from Schwabe's drawing "The Angel of Death" [L'Ange de la Mort].)[35] The angel envelops, or should one say, embraces, the old man with her long pointed wings. There is no horror: the face of the angel, a figure of unearthly yet familiar beauty, softly illuminated by the greenish light of a candle she holds, exudes tranquillity and mildness which are not of his world. Her left hand points heavenwards in a gesture of promise and allure: death as redemption through female beauty. In a sense, it is the beauty of a seductress, *fin de siècle* or Pre-Raphaelite style, the beauty of a sensuous but silent siren perhaps, and yet the man's transfigured glance upward suggests the adoration of the madonna. The erotic and the religious are fused; death and life, represented by the burning candle held by the angel of death, time and eternity, this world and the next are symbolically commingled to the point where one can stand for the other. In the hour of his death, the gravedigger is seen quite literally with his feet deep in the earth that awaits him, and yet his eyes are intensely seeking that realm on high to which the angel, her eyes closed, is

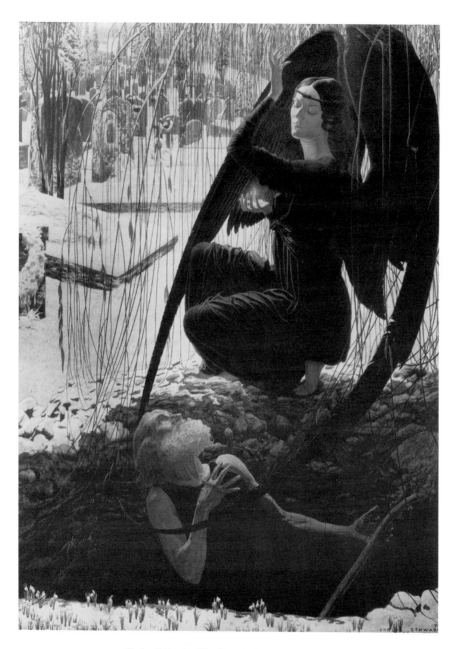

PLATE 20 Carlos Schwabe: The Death of the Gravedigger (1895–1900)

pointing. The ends of her wings, soon to soar upward, reach into the open grave. Even the choice of colors accentuates this paradoxical ensemble of death and life: nature from which man is to be released is painted in a wintry white; the angel of death is garbed in the rich green of life.

Schwabe's famous painting is a reminder that among the great themes of human existence that fascinated the Symbolists, death ranked foremost. It was particularly the Pole in this group or cluster of groups, the painter Jacek Malczewski, who, from the nineties on and with special intensity around the turn of the century, turned time and again to the challenge of personifying death. He repeatedly designated paintings as "Thanatos," and indeed some of Malczewski's Symbolist props refer back to the iconology of Antiquity. Nonetheless, Malczewski does not introduce death in these works in the shape of the Greek youth but rather as a woman, a winged female angel in particular[36] (surely not so much in deference to the Polish word for death, śmierć, which is grammatically feminine, as in conformity with the Symbolist iconography of other countries, including England and Germany, where grammatical gender or custom might be thought to dictate male personification). Death is female in Malczewski's probably best known oil painting, "Thanatos I" of 1898.[37] Against the background of a neoclassical columned portico, we see a beautifully, even elegantly dressed young woman in a posture strongly suggestive of classical statues of Greek goddesses, but her wings, scythe, and whetstone clearly identify her as an angel of death. Her graceful near-nudity, the shapeliness of her scantily clothed figure, and her attractive face exert an undeniable erotic appeal – the eros of death. An original detail epitomizes this union of eros and death: as more than one observer has noted, "the pocket holding the whetstone [about whose symbolic form Freudians will not be in doubt] is positioned in the place of female fertility."[38] The same female death figure or angel of death appears again – without wings but with the same scythe, and eroticized even more conspicuously – in Malczewski's much reproduced "Thanatos" painting of 1898–99, this time in an eerily moonlit night in the garden before a Polish manor house (said to be where the artist's father died). The nature symbolism is precisely the opposite of Schwabe's: it is spring or summer; lilacs, tulips, and narcissi are in sumptuous bloom. This, however, is merely meant as an appropriate

PLATE 21 Jacek Malczewski: Thanatos I (1898)

backdrop for Death, for the garden is just as sensuously beautiful and just as brimming with life as the luscious female figure seen from behind, dressed in a bright-red flowing garment that reveals more than it covers – the erotic magic almost makes the viewer forget that her scythe identifies her as death personified. Almost, but not quite, for her glance is fixed on the manor's open window at which the slumped figure of an old man can be made out – one cannot tell whether dead or sleeping or dying, though he is by no means staring "horrified at the nocturnal guest"; on the contrary, once again death is not in the least fearful or threatening but "the masterstroke of love eternal."[39] Life at its most vital is death, as the sexual vocabulary of some languages implies. If Malczewski's angel of death suggests "redemption" or "salvation," as Schwabe's did, it would be a redemption devoid of any specific religious connotations, which were still present in Schwabe's work produced at the same time. In Malczewski's, dying is rather the return – familiar from the mythologies of many cultures – to that realm of the female where man had his origin. (This pattern is still formative around 1914 when the American painter Albert Sterner produced his lithograph "The Angel of Death": a veiled winged female figure without a hint of the skeleton gives the kiss of death to an apparently tubercular, childlike girl sitting naked on her bed and gazing longingly into the beyond: "redemption" or "salvation" – of the woman, this time – is the return to the primordial realm of the female.)[40]

The motherliness of death suggested in these latter instances is, among the Symbolists, the domain not so much of Malczewski as of George Frederick Watts or, in a different context, of Walt Whitman. (More of them shortly.) But in two paintings by Malczewski the female death figure is more maternal than erotic. Both "Death" (Śmierć, 1902) and "Thanatos" (ca. 1911) portray death as a young woman symbolically closing the eyes of an old man, the expression on her face intimating gentleness and strictness at the same time. In the earlier painting, she once again holds a scythe, with a harvest scene in the background; the later one suggests the landscape of a manorial estate as well. What is striking about both is that the old man, on his knees in the earlier work, is cast in the role of a helpless and trusting child opposite the female death figure who is younger but endowed with caring authority: once again dying is intimated to be the return to the beginning, to the stage of the

child dependent on his mother.[41] Neither painting features the specific attributes of the traditional iconography of angels, yet it is customary to refer to their dominant female figures as angels of death.[42] Again, this designation is not meant to suggest the sort of religious aura that was present in Schwabe's keynote painting. But there can be no doubt about the presence in these two works of that longing, widespread at the turn of the century, for death as an otherworldly realm promised to man by woman, and specifically by woman in her role as mother.[43]

Motherliness definitely sets the tone in the rendering of the angel of death in several paintings by the British Symbolist George Frederick Watts (1817–1904). And, strange as it may sound, in this respect Watts is close to an American contemporary whose oeuvre would normally not be thought of in the context of Decadence or Symbolism: Walt Whitman. A brief excursus may therefore be in order before returning to Watts. (See also note 90.)

Included in all editions of *Leaves of Grass* from 1867 to the "Deathbed Edition" of 1892 (which had a significant impact well beyond the turn of the century) we find a poem which is frequently anthologized to this day: "When Lilacs Last in the Dooryard Bloom'd." It was occasioned by the assassination of Abraham Lincoln, the champion of national unity apostrophized here as "the powerful western fallen star." Mourning is the keynote; the entire country from coast to coast joins in the lament for the great dead "comrade." Indeed, all of nature shares the nation's loss, the grey-brown thrush leading the way: "He sang the carol of death, and a verse for him I love." The song of the thrush arouses a powerful echo in the soul of the mourner so that the bird's elegy becomes "my song for thee." Significantly, this voice of nature, which welcomes death as the loved and loving partner, personifies death as a woman, and more specifically as the nurturing mother to whom all living beings will eventually return. But, curiously, while there are undeniable reverberations of the Romantics' longing for death, there are no echoes of the various mythologies of "Mother Death" revived by Simone de Beauvoir. Correspondingly, the life-threatening aspects that the mother has in such mythologies as the principle of the origin *and* extinction of life are entirely absent in Whitman's poem – which sets it (and similar pieces in *Leaves of Grass*) apart from the fascination of the turn of the century and

following decades with horrifying images of Mother Death, "equally terrible and fertile" (également terribles et fécondes) as Victor Hugo has it in his 1871 poem "Ave, Dea; moriturus te salutat" (in his *Toute la lyre*). In Whitman's poem Mother Death is love personified, akin to the angels of death introduced earlier:

> Come lovely and soothing death,
> Undulate round the world, serenely arriving, arriving,
> In the day, in the night, to all, to each,
> Sooner or later delicate death.
>
> Prais'd be the fathomless universe,
> For life and joy, and for objects and knowledge curious,
> And for love, sweet love – but praise! praise! praise!
> For the sure-enwinding arms of cool-enfolding death.
>
> Dark mother always gliding near with soft feet,
> Have none chanted for thee a chant of fullest welcome?
> Then I chant it for thee, I glorify thee above all,
> I bring thee a song that when thou must indeed come, come
> unfalteringly.
>
> Approach strong deliveress,
> When it is so, when thou hast taken them I joyously sing the
> dead,
> Lost in the loving floating ocean of thee,
> Loved in the flood of thy bliss, O death.
>
> From me to thee glad serenades,
> Dances for thee I propose saluting thee, adornments and feastings for thee,
> And the sights of the open landscape and the high-spread sky are
> fitting,
> And life and the fields, and the huge and thoughtful night.
>
> The night in silence under many a star,
> The ocean shore and the husky whispering wave whose voice I
> know,

And the soul turning to thee, O vast and well-veil'd death,
And the body gratefully nestling close to thee.

Over the tree-tops I float thee a song,
Over the rising and sinking waves, over the myriad fields and the
prairies wide,
Over the dense-pack'd cities all and the teeming wharves and ways,
I float this carol with joy, with joy to thee O death. (Section 14)

Watts, a late Romantic like Whitman, portrays Mother Death in a
way that is comparable in spite of their otherwise divergent styles. His
choice of a female death figure rather than the Grim Reaper indicates
that he, too – highly regarded at the time not only in England but also on
the continent – shares the iconographic preference of European Symbol-
ism. He is in fact closer to the Symbolists of the continent than to the
Pre-Raphaelites of his own country, though he has some of his typically
sublime themes in common with them. What allies him with both is his
predominant concern with thematic substance rather than form. Watts
was fond of pointing out that he painted in order to "say" something: "I
paint ideas, not things; I paint primarily because I have something to say,
and since the gift of eloquent language has been denied me, I use paint-
ing; my intention is not so much to paint pictures which shall please the
eye, as to suggest great thoughts which shall speak to the imagination
and to the heart and arouse all that is best and noblest in humanity."[44]

Foremost among these grand themes, which Watts tends to treat
with a shade too much allegory and didacticism, are death and love. He
has been called "the painter of love and death"[45] – rightly so, and yet this
designation says very little unless one keeps in mind his pervasive attrac-
tion not just to the loving but to the motherly woman, to woman in her
relation to the child. Even when a woman symbolizes death, her mother-
liness is usually in evidence. This is especially true of his painting "Death
Crowning Innocence" (1886–87). Once again Death appears here as the
winged female angel, but now she is neither awe-inspiring nor seduc-
tively beautiful; instead she is lovingly devoted to the small child on her
lap: a madonna-like figure in modest garments enveloping the helpless
infant with her solicitous glances. The association of the Christian

mother of god is enhanced by the fact that the "innocence" of the child is not actually "crowned" but surrounded by a halo.[46] This angel of death, who is motherly love personified, recurs in one of Watts's most renowned and intellectually ambitious canvases: the unfinished "Court of Death" dating from the last years of his life.[47] Watts's frequently expressed view that death held no terror, that it was much like "the gentle nurse that puts the children to bed,"[48] is obviously true of this work, his last in the sense that he kept adding "finishing" touches to it until the very end of his life. To be sure, in the "Court of Death," death is not personified as the nurse (an appealing motif to many artists before and since Watts).[49] Death is the regal figure holding court, familiar from the time of Shakespeare and the Spanish Golden Age, except that here Death is not a king but a winged angel, and a female one: with a gentle rather than terrifying expression on her face she sits on the ruins of the world – a mother cradling a child on her lap. In a conversation with the writer Augustus Hare, Watts commented in 1893, more than a decade before his death, on the dense symbolism of this painting: "I have given her wings that she may not seem like a Madonna. In her arms nestles a child – a child unborn, perhaps, who has taken refuge there. By her side the angels of silence guard the portals of the unseen. Beneath is the altar of Death, to which many worshippers are hastening: the old mendicant comes to beg; the noble offers his coronet; the warrior does not offer – but surrenders – his sword; the sick girl clings for refuge to the feet of Death. I have wished to paint Death entirely without terrors."[50]

While this female Death holding court is identified as an angel by her wings, Watts's other much-noted painting, "Time, Death, and Judgement" (1884), portrays death simply as a woman,[51] pointing the way to the period's other favorite incarnation of death, the seductress. Here the language of allegory is overly explicit: the figure of Judgement, an ample (and amply dressed) woman holding the scales of justice, hovers above a young couple vigorously striding ahead into the foreground. The bare-chested athletic man represents Time (formerly portrayed most commonly by a bearded old man), the richly dressed, saintly-looking but buxom woman by his side is Death. The point is that they are walking hand in hand. A similar female figure appears in the role of death in Watts's painting "Love and Death" (1875), except that here she is presented not in harmony but in

conflict, in conflict with Love.[52] As elsewhere in Watts's oeuvre, Love is a winged youth of classical inspiration. He is shown on the threshold of his house trying to deny access to Death, a – wingless – female figure attired in a long white dress. She extends her arm to the portal adorned with roses, but the outcome of their struggle remains open, and yet it is not difficult to guess, as Watts confirmed himself.[53] Even so, though this Death is meant to be victorious, she does not come across as menacing, aggressive, or hostile; there is nothing imperious about her outstretched arm, similar though this gesture may be to that of the traditional, more awe-inspiring angel of death. (In this respect, Watts's image evokes the frieze of the American sculptor Daniel Chester French, "Death Staying the Hand of the Sculptor" [1893] in the Metropolitan Museum of Art in New York: the sensuously female angel of death, identified by her majestic wings, extends her arm to take the chisel from the hand of the young artist who attempts to put the finishing touches to a frieze.)

In "Time, Death, and Judgement" and "Love and Death," Watts not only deprived the female death figures of their angel's wings but also of the motherliness that is the hallmark of some of his best-known work on the theme of death. (It should be noted, however, that this is not a satirical unmasking in the manner of the then prominent graphic artist Hermann Vogel in whose 1902 caricature "Mère du Salut" the statue of the Virgin Mary holding Jesus in her arms is slyly revealed to be Death.)[54] What remains in Watts's two paintings are graceful, kindly female figures representing death. With these images Watts joins the iconographic mainstream of European Symbolism. In particular, he reveals his closeness to the commanding figure of Symbolism in the visual arts, Gustave Moreau.

In the allegorical world of Moreau's canvases, Death plays a major part, and always in the shape of one of the many equally seductive and alienating women that populate his oeuvre. The best-known example may be the overly symbolic and decorative macro-composition "Jupiter et Sémélé" (1896). Below the throne of Jupiter, two beautiful, sumptuously dressed female figures emerge from a profusion of precious artificial objects; Moreau himself identified them as Death and Pain.[55] But nowhere in Moreau's repetitive work is female Death represented with more stunning power of suggestion than in his almost life-size oil painting completed in 1865, "The Young Man and Death" (Le Jeune Homme

et la Mort). Even though the female death figure is rendered without wings here just as it was in the two of Watts's canvases, Moreau's work, created early in the Symbolist movement, is the paramount icon of this period's representations of the angel of death.[56]

It owes its origin to the death in 1856 of Moreau's friend and mentor, the painter Théodore Chassériau: "The Young Man and Death" is a memorial to him. But while the conception of the painting goes back to the year of Chassériau's death, the Symbolist execution overlies its personal significance. Likewise, the physical beauty of the two barely dressed figures, which it might have been possible to stress more, is overshadowed by the dense assemblage of Symbolist references scattered all over the work. The young man has apparently just descended the marble stairs visible in the background and stepped into a sumptuously appointed palatial room. Placed in a curiously diagonal position behind him, hovering or floating rather than standing or sitting, a female figure holds the biblical sword and the medieval hourglass – attributes which identify her as the traditional angel of death despite the missing, or invisible, wings. The young man is likewise surrounded by Symbolist props. The laurel wreath with which he crowns himself contrasts with a bouquet of narcissi in his other hand and with the withered flowers on the marble floor; one wonders: is transitoriness survived by fame or is fame subject to death as well? In the lower left corner, a winged putto turning down a still burning torch evokes the classical image of death, while a metallically shimmering blue bird flying away in the upper right may suggest the soul released from the body soaring to its destination. The entire ensemble is cast in a dreamy clair-obscure that sets off all the more vibrantly the symbols studding this artificial world. They are the hidden core of this fantastic pageant of color. But even they, the multicultural allegories, tend to merge indistinctly into each other in this highly eclectic and syncretistic composition. Christian and classical motifs are interwoven, especially around the female angel of death. Poppies and asphodels (symbolizing sleep and death) grace her hair, but the hourglass is in her hand; the sword which would *prima facie* seem to evoke the biblical angel of death reminds some critics of Atropos who, however, used scissors to cut the thread of life, while others associate it with Vishnu Narayana of Indian mythology.[57]

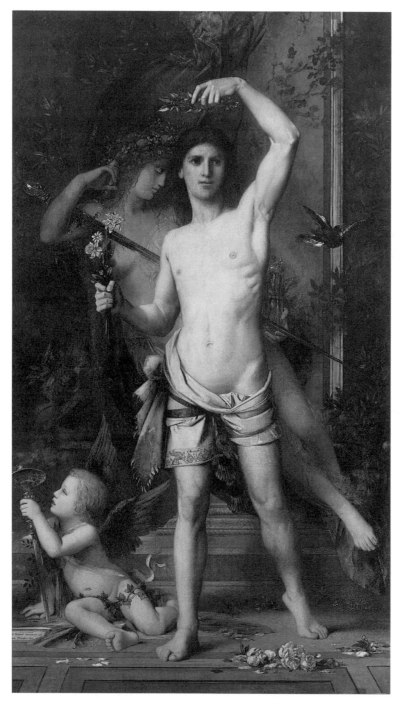

PLATE 22 Gustave Moreau: The Young Man and Death (1865)

Be this as it may, what matters from the perspective of this essay is that the transparently veiled "Mort" is a woman – a very deliberate choice on Moreau's part. For a pencil draft has survived that shows a winged skeleton, rather than a female figure, behind the young man; and two preliminary oil sketches are extant that allegorize death as a winged greybeard, analogous to the conventional Renaissance image of Time. Moreau himself, in an extensive statement of December 1856 on "The Young Man and Death," considered this change from a male to a female image of death highly important, and, interestingly, he described the female death figure in this context as a *winged* young woman, which would in its way corroborate the interpretation of his "Mort" as an angel of death.[58]

The basic idea underlying "The Young Man and Death" is hard to miss: death gives every earthly accomplishment over to transitoriness; even fame, symbolized by the laurels, seems to be no exception, unlike "fama" in Petrarch's *Trionfi*. Death is triumphant, but not in the manner of Caravaggio's Amor stridently triumphing over life and its cultural accomplishments ("mors imperator"): Moreau's Death is presented in an elegiac rather than gloating mood. We see his Death in a melancholy, pensive reverie, with closed eyes as if half asleep and almost disappearing behind the young man who places a laurel wreath on his head. Nonetheless, the erotic seductiveness of Death is at least hinted at through the casually understated lasciviousness of the body and its sensuous posture. Gone are the awesomeness and sublimity that the angel of death had in earlier as well as in later representations, but the attributes half-hidden in the colorful shadows, the sword and the hourglass, are eloquent reminders of just that quality of death personified. As a result, the mysterious atmosphere enveloping Moreau's "Mort" is heightened to a vaguely religious aura, and yet an undeniable and undeniably mundane erotic appeal emanates from the configuration. It is these mixed qualities that make "The Young Man and Death" the archetype not only of the Symbolists' angels of death but also of their images of death as the seductress par excellence. The latter was to have an irresistible attraction for the creative imagination of artists and writers in the latter half of the nineteenth century and at the turn of the century – the seductress with either the exotic charm of the *femme fatale* or the obtrusiveness of the street corner prostitute à la Félicien Rops.

IV

The idea that death might take the shape of an erotic seductress had made a very tentative appearance in one or the other of the late medieval Dances of Death; it reappeared no less sporadically and marginally in the Renaissance and in some of the early or mid-nineteenth-century Dances of Death. In Grandville's *Journey to Eternity*, for example, one of the impersonations of death was the fashionably dressed masked prostitute offering herself to a couple of flaneurs. This version of the encounter with death, partly through its reprinting in Jules François Champfleury's popular *Histoire de la caricature moderne*, became a sort of cliché in later nineteenth-century France.[59] In Germany Kaulbach included in his drafts for a Dance of Death a sketch of Lola Montez in a similar guise: hiding her death's head behind a mask, she smiles at King Ludwig I of Bavaria, who kneels at her feet, his crown and scepter scattered on the floor, while a cat plays with his orb.[60]

In literature, Death had made her entry as the "meager coquette" as well, long before Baudelaire. A modest beginning was S. T. Coleridge's "Rime of the Ancient Mariner" (1798) which introduced into poetry the albatross that the author of *Les Fleurs du mal* was fond of using as a metaphor for his own predicament. On the phantom ship conjured up by the mariner who killed the albatross, Death and a woman are seen playing dice; the woman seems more like Death than Death himself:

> Her lips are red, her looks are free,
> Her locks are yellow as gold:
> Her skin is as white as leprosy,
> And she is far liker Death than he[.]

The final version (1834) evokes the deadly coquette even more pointedly:

> The Night-mare Life-in-Death was she,
> Who thicks man's blood with cold.[61]

Théophile Gautier took up the motif in his cycle of poems *La Comédie de la Mort* (1838), endowing it with all the gruesomely attractive

haut goût that it permits. The first part, "Portal" (Portail), takes us to the
sepulchral world of a Campo Santo:

> Death plays the coquette and the queen,
> And only her forehead under her ebony-dark hair
> Retains, all the more charmingly, a little pallor.

> La mort fait la coquette et prend un ton de reine,
> Et son front seulement sous ses cheveux d'ébène,
> Comme un charme de plus garde un peu de pâleur.

Death, the "coquette," clasps the dead firmly in her arms:

> In her meager arms, like a tender spouse, in bed
> Death holds them jealously in tight embrace.

> Entre ses maigres bras, comme une tendre épouse,
> La mort les tient serrés sur sa couche jalouse[.]

The final stanza introduces Death as a courtesan or prostitute, which was
to become a widespread metaphor in the subsequent decades:

> But who is this woman,
> So pale under her veil? Ah, it is you, loathsome old crone!
> I see your bald skull,
> I see your big hollow eyes, vile whore,
> Eternal courtesan, embracing the world
> With your meager arms!

> Mais quelle est cette femme
> Si pâle sous son voile? Ah! c'est toi, vieille infâme!
> Je vois ton crâne ras,
> Je vois tes grands yeux creux, prostituée immonde,
> Courtisane éternelle environnant le monde
> Avec tes maigres bras![62]

From there it is only a small step to Baudelaire – who wrote famous
essays on Gautier as the founder of the Parnassian school of poetry, while

Gautier, for his part, repeatedly paid homage to Baudelaire. To be accurate, Death in the *Fleurs du mal* (1857; 1861) can be male as well as female. "O Death, old captain, it is time! Let us weigh anchor!" (O Mort, vieux capitaine, il est temps! levons l'ancre!) we read in the conclusion of the final poem, "Le Voyage," while "the two good sisters" (les deux bonnes sœurs) of the poem of that title are "la Débauche" and "la Mort." Still, Baudelaire's most incisive and most influential portrayal of Death is without a doubt that in the *Fleurs du mal* poem "Danse macabre," which personifies death in memorable formulations as a meager coquette and an aging prostitute at the masked ball of life. "Danse macabre" may be seen as the cachet of this entire subset of representations of death as a woman, of death as the seductress of men. Not surprisingly, it had a measurable impact, most notably on Félicien Rops but by no means on him alone. The "coquette maigre" appears in Baudelaire's poem at the ball, a dance of life, it seems, instead of a dance of death, a "fête de la Vie." A routine erotic tease, she reveals her tawdry attractions to the equally tawdry *beau monde*; flirting lasciviously in perfumed ecstasy, she believes herself irresistible, no matter how bony her figure and how patently artificial her charm. From the beginning to the end of this poorly staged carnival, we find ourselves in a seedy world of appearances as dazzling as they are shabby. The would-be elegant dress suggesting fleshy forms and the cleverly deceptive splendor of the frills and flowers are the attractions of Nothing parading foolishly as the fullness of life – the waist as slim as only a skeleton can have it, the bony foot that fits the most delicate dance shoe, the hollow-eyed skull "coiffured in flowers down her neck." The serpent, familiar from late medieval realism, writhes through the grille of her fleshless ribs – ribs which men press to their bodies nonetheless, because their undulations stimulate them so powerfully. Death in female shape, oscillating between the apparent charm of the ingenue and the routine flirtation of the whore, is an "irresistible strumpet" (un irrésistible gouge). Baudelaire vehemently defended his use of this old-fashioned expression as "an excellent word," reminiscent of the late medieval *danses macabres* and suggestive, moreover, of the camp-follower whore in the wars of an earlier period – and why not, he continued, in the train of the "Grande Armée," which in French is the proverbial army of the dead.[63] Such allusive word play and such "irony" are not the least features that make Baudelaire's courtesan "irresistible"

("ironie" occurs in the last line of the poem, where Odilon Redon was to pick it up in order to integrate it into his version of death as *femme fatale*). Changing from an aging would-be *grande dame* to the cheeky streetwalker and back again, Baudelaire's Madame La Mort (as "Rachilde" and Rilke were to call her) displays a charm that sends up its own artificiality:

Proud, like one living, of her noble height,
With handkerchief and gloves, her great bouquet,
She has the graceful nonchalance that might
Befit a gaunt coquette with lavish ways.

At any ball does one see waist so slim?
In all their regal amplitude, her clothes
Unfurl down to a dry foot, pinched within
A pomponned shoe as lovely as a rose.

The frill that plays along her clavicles,
As a lewd streamlet rubs its stony shores,
Modestly shields from jeering ridicule
Enticements her revealing gown obscures.

Her eyes, made of the void, are deep and black;
Her skull, coiffured in flowers down her neck,
Sways slackly on the column of her back,
O charm of nothingness so madly decked!

You will be called by some, "caricature,"
Who do not know, lovers obsessed with flesh,
The grandeur of the human armature.
You please me, skeleton, above the rest!

Do you display your grimace to upset
Our festival of life? Some ancient fire,
Does it ignite your living carcass yet,
And push you to the sabbath of Desire?

Can you dismiss the nightmare mocking you,
With candle glow and songs of violins,
And will you try what floods of lust can do
To cool the hell that brands the heart within?

Eternal well of folly and of fault!
Alembic of the old and constant griefs!
I notice how, along the latticed vault
Of ribs, the all-consuming serpent creeps.

Truly, your coquetry will not evoke
Any award that does not do it wrong;
Who of these mortal hearts can grasp the joke?
The charms of horror only suit the strong!

Full of atrocious thoughts, your eyes' abyss
Breathes vertigo – no dancer could begin
Without a bitter nausea to kiss
Two rows of teeth locked in a steady grin.

But who has not embraced a skeleton?
Who has not fed himself on carrion meat?
What matter clothes, or how you put them on?
The priggish dandy shows his self-deceit.

Noseless hetaera, captivating quean,
Tell all those hypocrites what you know best:
"Proud darlings though you powder and you preen,
O perfumed skeletons, you reek of death!

Favourites faded, withered – in the mob
Antinous, and many a lovelace –
The ceaseless swirling of the *danse macabre*
Sweeps you along to some unheard-of place!

From steamy Ganges to the freezing Seine
The troop of mortals leaps and swoons, and does
Not see the Angel's trumpet aimed at them
Down through the ceiling, that black blunderbuss.

In every climate Death admires you
In your contortions, o Humanity,
And perfuming herself as you would do,
Into your madness blends her irony!"

Fière, autant qu'un vivant, de sa noble stature,
Avec son gros bouquet, son mouchoir et ses gants,
Elle a la nonchalance et la désinvolture
D'une coquette maigre aux airs extravagants.

Vit-on jamais au bal une taille plus mince?
Sa robe exagérée, en sa royale ampleur,
S'écroule abondamment sur un pied sec que pince
Un soulier pomponné, joli comme une fleur.

La ruche qui se joue au bord des clavicules,
Comme un ruisseau lascif qui se frotte au rocher,
Défend pudiquement des lazzi ridicules
Les funèbres appas qu'elle tient à cacher.

Ses yeux profonds sont faits de vide et de ténèbres,
Et son crâne, de fleurs artistement coiffé,
Oscille mollement sur ses frêles vertèbres.
– O charme d'un néant follement attifé!

Aucuns t'appelleront une caricature,
Qui ne comprennent pas, amants ivres de chair,
L'élégance sans nom de l'humaine armature.
Tu réponds, grand squelette, à mon goût le plus cher!

Viens-tu troubler, avec ta puissante grimace,
La fête de la Vie? ou quelque vieux désir,
Éperonnant encor ta vivante carcasse,
Te pousse-t-il, crédule, au sabbat du Plaisir?

Au chant des violons, aux flammes des bougies,
Espères-tu chasser ton cauchemar moqueur,
Et viens-tu demander au torrent des orgies
De rafraîchir l'enfer allumé dans ton cœur?

Inépuisable puits de sottise et de fautes!
De l'antique douleur éternel alambic!
A travers le treillis recourbé de tes côtes
Je vois, errant encor, l'insatiable aspic.

Pour dire vrai, je crains que ta coquetterie
Ne trouve pas un prix digne de ses efforts;
Qui, de ces cœurs mortels, entend la raillerie?
Les charmes de l'horreur n'enivrent que les forts!

Le gouffre de tes yeux, plein d'horribles pensées,
Exhale le vertige, et les danseurs prudents
Ne contempleront pas sans d'amères nausées,
Le sourire éternel de tes trente-deux dents.

Pourtant, qui n'a serré dans ses bras un squelette,
Et qui ne s'est nourri des choses du tombeau?
Qu'importe le parfum, l'habit ou la toilette?
Qui fait le dégoûté montre qu'il se croit beau.

Bayadère sans nez, irrésistible gouge,
Dis donc à ces danseurs qui font les offusqués:
"Fiers mignons, malgré l'art des poudres et du rouge,
Vous sentez tous la mort! O squelettes musqués,

Antinoüs flétris, dandys à face glabre,
Cadavres vernissés, lovelaces chenus,
Le branle universel de la danse macabre
Vous entraîne en des lieux qui ne sont pas connus!

Des quais froids de la Seine aux bords brûlants du Gange,
Le troupeau mortel saute et se pâme, sans voir
Dans un trou du plafond la trompette de l'Ange
Sinistrement béante ainsi qu'un tromblon noir.

En tout climat, sous tout soleil, la Mort t'admire
En tes contorsions, risible Humanité,
Et souvent, comme toi, se parfumant de myrrhe,
Mêle son ironie à ton insanité!"[64]

The echo of "Danse macabre" is heard well into the next century. The reason for this is not necessarily the personal affinity of a given writer or artist for Baudelaire; for the idea of woman as a death-inflicting coquette flourishes like few others in the misogynous atmosphere of which Otto

Weininger's *Sex and Character* (*Geschlecht und Charakter*, 1903) was just the most conspicuous manifestation. As a recent art historian put it, "Under the impact of the emancipation of women and the double standard of society, biologists and psychologists, philosophers and cultural historians, men of letters and artists, unlike any previous generation, defined the female sex almost unanimously in negative terms: woman was generally singled out as the scapegoat of life and society . . . In the judgment of men at the turn of the century, she became the incarnation of a destructive and inherently mysterious power, working havoc in personal lives and in the cosmic scheme of things."[65]

A particularly good example is Félicien Rops, the Belgian illustrator of the Symbolist poets, most notably Baudelaire and Péladan. His talent, Baudelaire claimed in a sonnet, rose to the heights of the pyramid of Cheops (truth in rhyming) while Rops, in his turn, was delighted to find in Baudelaire's poems his own "strange love" of the skeleton.[66]

Rops's painting "Death at the Ball" (La Mort au bal, 1865–75) strikes one as nothing short of an illustration of Baudelaire's "Danse macabre."[67] The double standard in sexual matters which men regarded as a matter of course at the time is blamed here on women: having first been degraded to mere objects of man's lust, they now arouse man's disgust, which is really ill-disguised fear of his own unrestrained promiscuity – and death. Appealing and revolting at the same time, the female Death at Rops's masked ball displays coquettishly what remains spine-chilling even when merely hinted at: the bony reality of nothingness. While "Death at the Ball" is reminiscent of Baudelaire's "Danse macabre," Rops's etching "Dancing Death" (La Mort qui danse), derived from a pencil sketch of about 1865,[68] was directly inspired by that poem. The decadent eroticism as a way of *épater le bourgeois* that had been conveyed in Baudelaire's poem with a certain playful charm is expressed here more demonstratively by crass nudity; it is exposed rather than cleverly hidden by the scanty ballet skirt and the flower-studded hat on the grinning skull of the otherwise still fleshy dancing whore. Female Death now exposes herself not in a ballroom but in a striptease club. The properly attired soigné gentleman visible in the background closes his eyes: is he fantasizing or disgusted, taken in by the exotic lure of vulgarity or by fear and horror? The female sex here is at once an object of fascination and an icon of

PLATE 23 Félicien Rops: Dancing Death (ca. 1865)

depravity – which, as the spectators in the background suggest, is not only that of woman.

The prostitute as an incarnation of death is a leitmotif in Rops's work. As in "Death at the Ball," coquette rhymes with "squelette" in his charcoal drawing "Street Corner" as well.[69] It is evocative of Grandville's lithograph in *Journey to Eternity*: the streetwalker, dolled up in the tawdry splendor of her evening dress, but hiding her death's head behind a mask, propositions a respectably dressed bourgeois in the dim light of a street lamp – the female face of the mask is the face of Death. (As late as 1927 the German illustrator Renate Geisberg-Wichmann all but quoted Grandville and Rops in "The Dark Street" [Die dunkle Straße, number eleven of her sequence of woodcuts called *Dance of Death, Totentanz*]:[70] taking a provocative stance on the sidewalk, a whore, fully dressed except for her skull between her hat and fur collar, beckons a bumbling peasant youth with finger bones which one can almost hear rattling.)

Rops's famous etching "Mors syphilitica" (ca. 1892) attempts to remind us that one weapon with which the female inflicts death on the male has a specific name.[71] Around the turn of the century, that was of course not a far-fetched designation for death in the shape of woman – Mrs. Warren's profession was flourishing and man's fear of sexual infection was a ghost haunting literature like few others. (Yet another "Mors syphilitica" etching can be found in Munich graphic artist Paul Bürck's Dance of Death series *Totentanz* [1909–14]; it shows an almost naked but not skeletal prostitute striking a triumphantly provocative pose on top of the dead bodies of several young men – Madame La Mort as purveyor of the joy of sex.)[72] Rops's "Mors syphilitica" differs from his other portrayals of death in that here it is not the skull, the death's head, that explicates its title. Instead an almost vivacious, full face is turned to the viewer with expressive eyes and a slightly open mouth; the body, hardly skeletal, is draped teasingly in a décolleté dress; a casual get-acquainted chat seems to be underway as the whore stands in the doorway of her boudoir – if it were not for the scythe that disconcertingly gleams in the light above her head. The traditional symbol, used as an attribute of female Death as early as the Middle Ages, reminds us of the wages of sin and the figure's true meaning.[73]

Representation of death from another period – the Renaissance –

PLATE 24 Félicien Rops: Street Corner (1878)

similarly resurfaces in Rops's etching "Kisses of Death" (Les Baisers morts, 1893), which served as the frontispiece of Paul Vérola's volume of poetry of the same title.[74] As in the graphic work of Beham, Death is a winged skeleton here, except that a full breast clearly identifies it as a woman, the physiological improbability notwithstanding. Hovering above a deathbed, she almost aggressively places the proverbial kiss of death on the lips of a male figure floating toward her in mid-air. The Renaissance horror of the (winged) skeleton, cast in the male role in the predominant "Death and the Maiden" constellation, has now given way to the female skeleton's erotic appeal to the male *moriturus*. Moreover, this work is a telling example of the fusion of the two characteristic personifications of death at the turn of the century: the angel of death and the seductress.

Redolent of earlier periods in "the history of Death," this ambiance also offers a congenial welcome to the mystical and fantastic death images of Odilon Redon, the most mysterious among the Symbolists (no matter how solidly bourgeois in private life). That Redon's portraits of female Death are illustrations of Flaubert's eerily surrealist novel *The Temptation of Saint Anthony* provides part of the explanation. Death is personified twice in Redon's three series of lithographs transposing the literary text into the visual medium. The third series (1896) includes a vision of Death as an entirely traditional skeleton, partly veiled by a nondescript garment. But this death figure is remarkable in that it holds by her arm a naked woman who seems to soar upward. In the context of the novel, this woman is Lust, and Flaubert's wording merges death and lust into that horribly beautiful union so dear to the Symbolists' fantasies. Flaubert's Death says to Lust: "It is I who make you serious; let us embrace" (C'est moi qui te rends sérieuse; enlaçons-nous).[75] While in this illustration it is two separate entities, death and female eros, that yearn to merge into one, the two figures have been fused completely in Redon's second series of lithographs (1889). Here the text has Death say: "My irony exceeds all others" (Mon ironie dépasse toutes les autres!).[76] It is the irony of death that surpasses all the others – an echo from the final stanza of Baudelaire's "Danse macabre." Redon's lithograph illustrating this episode shows a nude woman in an unearthly atmosphere, soaring up in a fantastic vortex of air; her upper body emphasizes her sex appeal,

but her head, airily crowned with floating flowers and bathed in the uncanny light that stagily falls into the scene from above, is a death's head. The "irony" of this female Death can only refer to the falseness of the beguiling charm that she displays, to the deceptiveness of the Baudelairean perfume of myrrh or musk with which the "meager coquette" lures gullible men to their ruin.

It is but a short jump from here to Gauguin's frontispiece to the play *Madame La Mort* (1891) by the then much-read "Rachilde" (Marguérite Vallette), co-founder of the *Mercure de France*, the journal closely associated with the Symbolists. Gauguin's drawing, thriving on a suggestive clair-obscure, limits itself to the face and upper body of the mysterious woman that gives the play its title. In the text itself, where this *dramatis persona* is described as "young" and "supple," the author, flirting with pornography as always, uses her to explore new facets of decadent eroticism. For this waif of a woman, who brings her seductive appeal into play everywhere she goes, is a ghost, a spirit ("une apparence"). As such, she is not a revenant, as Rachilde is careful to point out, but death incarnate, in the role of lover and beloved. She is the *femme fatale* par excellence, though without all mythological or folkloric trappings, a Death in love, a Love who kills: "Madame La Mort."[77] The play was a success throughout the continent at the time, and it is not unthinkable that Rilke's "Madame Lamort," in the fifth *Duino Elegy*, is a kind of allusion at least to its title; Rilke's Madame Lamort (a conspicuous name in a German poem) is the milliner who makes and sells the frivolous trumpery of feminine seductiveness:

> Squares, o square in Paris, endless showplace,
> where the *modiste*, Madame Lamort,
> twists and winds the restless ways of the world,
> those endless ribbons, and from them designs
> new bows, frills, flowers, cockades, artificial
> fruit – all cheaply dyed – for the paltry
> winter hats of fate.

In German-speaking lands, the haunting fascination of the female death figure is most pronounced, within the confines of pictorial Symbol-

ism, in the work of Max Klinger and Alfred Kubin. Klinger (who was, to be sure, well-versed in male personifications of death as well, as for example in his etching "Amor, Death, and the Beyond" in his sequence *Intermezzi* of 1881, where a bearded skeleton sits astride a coffin) comes closest to the theme of Madame La Mort in his cycle *Of Death II* (*Vom Tode II*), specifically no. 9, an etching entitled "Temptation" (Versuchung, 1890). Unlikely as it may seem at first glance, the half-naked ascetic man with an animal hide slung over his shoulder who has just rammed a rough-hewn crozier into the desert-like ground, suggests the theme of the deadly nature of female eros. For opposite him there is a richly and provocatively dressed woman who, striking a lascivious pose, holds up a crown to him as the epitome of what "this world" has to offer. The overall title, *Of Death*, and the densely allegorical aura of this and other etchings of the series, permit the interpretation that, once again, the seductive, tempting female and death – Eve in the desert – are inextricably fused.[78]

The identification of death and woman as the agent of erotic seduction is more palpable in the graphic work of Alfred Kubin – who stated in his autobiography that the graphics of Klinger had opened his eyes for the direction to choose in his own artistic production.[79] Prominent in this respect among Kubin's better-known pieces is the much-reproduced pen-and-ink drawing "The Best Physician" (Der beste Arzt, 1901–02).[80] Later, in *A Dance of Death* (*Ein Totentanz*, 1918), Kubin was to show his familiarity with female Death in the guise of a cunning old woman luring a child out of life (a motif prefigured in the work of Barth, Pocci, Otto Seitz, Tobias Weiß, and others)[81] as well as with male personifications of death, including the monk, the fool, the bedouin on his camel (all in *A Dance of Death*) and the long-bearded death's-head in his lithographs "Death Chamber" (Sterbezimmer, 1923) and "Death as Pierrot" (Tod als Pierrot, 1922), and even "Bluebeard" (Blaubart, no. 16 of *A New Dance of Death* [*Ein neuer Totentanz*, 1947]). The turn-of-the-century "Best Physician," on the other hand, is an original variation on the theme of Death as seductress; it remains uncannily fascinating to this day by virtue of its mysteriousness. A dead or dying figure is stretched out on a bed with his hands raised in a strangely praying or entreating gesture; a white shroud-like garment covers almost the entire body, the head indicating that it is that of a man. By his side stands a somewhat unreal, specter-like woman,

apparently closing his eyes with her outstretched hand. A curiously solemn Madame La Mort, with a hieratically elongated arm, she wears an elegant black evening gown that demonstratively uncovers her fleshy arms and shoulders while her head is the bare skull familiar from Rops, Redon, and others, with long strands of disheveled hair hanging down, as they did in so many medieval portrayals of female Death. The eroticism of this female "physician" derives primarily from her posture: her other hand is placed on her hip with a suggestion of lasciviousness, so that the slender figure comes close to assuming the soliciting pose of a prostitute. "The Best Physician" – a reprise of Flaubert's, Rops's, and Baudelaire's misogynous "irony"? Certainly a unique variation on the theme of the uncanny deathly threat that Kubin saw emanating from the female sex throughout his life. (See Plate 2, p. 25).

A mellower light of mystery, even a tentative allusion to the *Mona Lisa* smile, is suffused over Madame La Mort in an oil painting much reproduced in recent years in conjunction with the *fin de siècle* vogue in art history: "Death the Bride" (1895) by the English portraitist Thomas Cooper Gotch, a late Pre-Raphaelite among the Symbolists.[82] A female figure, crowned, Ophelia-like, with flowers, and almost sinking into a field of poppies that may hint at the Proserpina myth, raises her veil with a half-inviting, half-rejecting gesture, revealing her dreamy gaze. Angelically otherworldly and erotically seductive at the same time, she seems to promise blissful reverie in sleep and death. Once again, as in Rops's "The Kisses of Death," one senses the proximity of that other female personification of death prevalent at this time: the angel of death, an angel of death, to be sure, that does not deny her sex appeal – "Death the Bride" indeed. Similar, if less alluring associations are evoked by John Singer Sargent's 1918–22 mural in the main stairway of Harvard University's Widener Library. It memorializes the death of the Unknown Soldier of World War I who is gently carried aloft in the embrace of two shrouded female figures, "Victory and Death." The caption explains: "Happy those who with a glowing faith / In one embrace clasped death and victory."

Like the female death figures of G. F. Watts, the *Mona Lisa* Death of Gotch and Sargent's female Death of the battle fields originated in a culture whose death incarnation of choice was and remains a male figure – the Grim Reaper. Similarly, Klinger's and Kubin's female death personae

PLATE 25 Thomas Cooper Gotch: Death the Bride (1895)

stand out all the more when seen against the background of a culture in which death is ordinarily "der Schnitter," not "die Schnitterin." In conclusion, two *literary* works, one German, one English, may corroborate the observation that neither conventional male death figures nor supposedly formative grammatical gender (which English did have until the early Middle Ages and German still retains) have the power to prevent the emergence of those female images of death that set the tone throughout Europe in the late nineteenth and early twentieth centuries.

Sacher-Masoch's narrative or short novel *Raphael the Jew* (*Der Judenraphael*, 1882) sets its story of the unrequited love of the painter Plutin for the Jewish girl Hadaßka in rural Galicia. When his love appears to him in a dream, Plutin, though still in the prime of life, feels that his final hour is approaching, and he prepares himself for death. He sinks

> to the ground under the flowering wild cherry tree that stood in front of his cottage.
>
> His dog was sitting by his side, eying him attentively and shyly.
>
> "You are coming at last," Plutin whispered, "you, whom I have been expecting so long and so longingly. You come to me not as the horrible skeleton carrying the scythe and not as the beautiful youth extinguishing the torch either, no: I see you coming, sweet girl, with a smile on your lips, the sickle in your hand! Come! Oh, come, beautiful reaper, it is harvest time!"
>
> He pulled out his sketch-book and began to draw; it was the angel of death that he created magically on the empty page with a few, inspired strokes; it was Hadaßka as a reaper, wearing a wreath of poppies, holding a sickle in her hand.
>
> Then the pencil dropped from his hand, and he leaned back against the tree that rained blossoms and fragrance down upon him, and he sank into a slumber.

> erschöpft unter dem blühenden wilden Kirschbaum nieder, der vor seiner Hütte stand.
>
> Sein Hund saß neben ihm und betrachtete ihn aufmerksam und scheu.

"Endlich kommst Du," flüsterte Plutin, "Du, den ich so lange
und so sehnsüchtig erwartet habe. Nicht als schreckliches
Gerippe mit der Sense nahest Du, nein, auch nicht als schöner
Jüngling mit der verlöschenden Fackel, nein, ich sehe Dich
kommen, ein holdes Mädchen, mit einem Lächeln um die
Lippen, die Sichel in der Hand! Komm! Ach, komm, Du schöne
Schnitterin, das Korn ist reif!"

Er zog sein Skizzenbuch hervor und begann zu zeichnen, es
war der Todesengel, den er auf das leere Blatt hinzauberte, mit
wenigen, genialen Strichen, es war Hadaßka als Schnitterin, mit
Mohn bekränzt, eine Sichel in der Hand.

Dann entsank der Stift seiner Hand, und er lehnte sich
zurück an den Baum, von dem es weiße Blüthen und Duft auf ihn
herab regnete, und schlummerte ein.
(Leipzig: Morgenstern, 1882, pp. 155–156)

The reaper, canonically male in German speech and folklore and sanc-
tioned as such by the Bible, is pointedly reinterpreted here as female, as
the "Schnitterin." Moreover, the normally horrifying and violent reaper
is reinterpreted as the enticing, erotically seductive angel of death, fusing
into one the two icons of death predominant in the visual arts of the time:
the angel and the lover.

A comparable reinterpretation may be observed in English literature
of the time. The most haunting example is easily the story "The Dance of
Death," written shortly before the outbreak of World War I by Algernon
Blackwood, the celebrated master of the macabre, uncanny, and super-
natural.[83] Remotely reminiscent of Melville's *Bartleby*, this story of the
solidly unremarkable London office worker named Browne starts out on
a pointedly realistic note, but only to slip almost imperceptibly into
surrealism. The doctor diagnoses the twenty-six-year-old as having a
heart ailment; he warns him that his health, indeed his life, is at risk if he
overexerts himself, cautioning him especially against his love of dancing.
Though Browne is a serious and responsible young man, he is drawn, in
his sadness, to a ball in his urban neighborhood. A girl emerges from the
half-light of the dance-hall apparently without being seen by anybody else
and "galvanizes" him with her smile – one cannot help thinking of

Gotch's mysterious "Death the Bride." Bits and pieces of their conversation have a hypnotic effect on Browne. With "magical" power, the girl, who leaves no image on the mirror on the ballroom wall, draws him into the swirl of a dance that becomes ever more unreal, ethereal, soundless, effortless. In supernaturally vibrant exhilaration, they dance into the sky – or is it heaven? "They were off their feet and the wind was in their hair. They were rising, rising, rising towards the stars" (p. 302). They merge into one another, "they had become one being. And he knew then that his heart would never pain again on earth, or cause him to fear for any of his beloved dreams" (p. 302). Two days later his supervisor reads in the newspaper that Browne died at two in the morning of a heart attack on the dance floor. Of his dance with Death the daily press knows nothing.

This surrealist story of the seduction of an ordinary man by a woman who is Death subtly evokes that angel of death named expressly in Sacher-Masoch's novel. In other words, even Blackwood's unpretentious narrative reminds us how closely related this period's two dominant images of death remain: the seductress, desired as much as she is feared, and the fearful angel of death that is a harbinger of release from all earthly anxieties, including those that parade as ecstasies. Fear of the female sex and longing for it, though often antagonistic in seemingly contrary representations of female incarnations of death, condition and supplement – even merge into – each other. Odilon Redon had an inkling of this when in 1885, after a visit to a cemetery, he wrote in his diary:

> Death, there, under my feet, in the dark graves, where friends and relatives rest, finally happy because they no longer feel anything; death, there, certain and come too early, hovering over our sorrowful days as the sole balm of our misery; death, there, mistress and sovereign forever; I have seen her, divine refuge, happy end to the pains of life . . .
>
> O divine unknown one, speechless presence, nameless fear, august and unmoving, how beautiful you are!
>
> La mort, là, sous mes pieds, dans les fosses sombres, où des amis et des proches reposent, heureux enfin, parce qu'ils ne sentent plus; la mort, là, certaine et sitôt venue, qui plane sur nos jours

soucieux comme le seul baume à nos misères; la mort, là,
maîtresse et toujours souveraine à jamais; je l'ai vue, divin refuge,
heureuse fin du mal de vie . . .

O divine inconnue, au muet visage, crainte sans nom, auguste
immobilité, que tu es belle![84]

V

The various images of female Death current during the nineteenth cen-
tury have their sequels and variations well beyond the turn of the century;
indeed, they survive to the present day. Some of them were already men-
tioned when the thematic context called for such reminders. Examples of
a *sequel* include Alfred Kubin's drawing of Death as an old woman (1918)
who with seeming kindness conducts a young girl out of this life, and the
East German Klaus Drechsler's aluminum print "Death with a Child" of
1991 which presents death as a nurse furtively hurrying away with a child
nestled in her arms.[85] The *femme fatale*, at once libidinous and destruc-
tive, continues to fascinate a graphic artist like Louis Legrand at the out-
break of World War I, in an etching that the Düsseldorf collection
catalogues as "Embrace (Lovers, Death as a Woman)" (Umarmung
[Liebespaar, Tod als Frau]). The lovers are seen "in the high grass among
the delicate flowers of the field. . . the young man lies with his eyes closed
and as if lifeless under the weight of the woman who embraces and kisses
him passionately. Her body, dressed in white, is plump, her bare arms
round and fleshy, her long black hair flows down her back; but amidst all
this lusciousness, there is a face with hollow black-ringed eyes and an ugly
grinning mouth, the unmistakable face of Death, desirous and at the
same time evidently satisfied"[86] – a late and almost drastic sequel of a
motif that one would associate primarily with the turn of the century and
the decades immediately preceding it.

An original *variation*, on the other hand, on the female incarnations
of death prevalent in the nineteenth century and at the *fin de siècle* is
Honoré Daumier's satirical lithograph "Peace, An Idyll" (La Paix, Idylle,
1871).[87] In the foreground of a battlefield strewn with bones, a skeleton
sits on a crumbling wall, playing the shawm: while the tune may
announce peace, the player is not Peace but Death, female Death – the
hat the figure wears, adorned with ribbons and flowers, would hardly

befit a male skull. When the next European war broke out, Dutch drafts-
man and political satirist Albert Pieter Hahn (in whose language, unlike
Daumier's, death would not be grammatically female) returned to the
motif in "The New Offensive – Dance of Death" (Het nieuwe offensief –
doodendans, 1915),[88] except that here the skeletal female incarnation of
death plays the violin while the battle is still in full swing. Whereas this
Death, like Daumier's, comes close to being nothing more than a simple
if imaginative allegory, the exotic female death figure in the parable-like
prelude to John O'Hara's *Appointment in Samarra* (1934), introduced to
serve as a sort of key to the novel's symbolic meaning, is enveloped in an
air of mystery and fatalistic mysticism (see above, p. 26). Eccentric in a
different way is Klaus Rosanowski's variation on the idea of the beauty of
the seductress Death, in his color woodcut "Hairdresser and Death"
(Coiffeur und der Tod, 1973). It translates the sexual allure of Madame
La Mort into tonsorial and cosmetic exuberance and, mindful of the *fin
de siècle* fascination with the artificial and unnatural, stuns the viewer
with the color of Death's hair: the profusion of curls overwhelming the
eyeless death's head that the hairdresser attends to with professional
servility is bright blue.[89]

Other twentieth-century artists link their variations on the theme of
the seductiveness of female Death with an even older iconographic
convention: the Dance of Death. Hahn's "New Offensive," to be sure,
which its subtitle designates as a Dance of Death, is a Dance of Death
only in a very loose sense of the word. Similarly, the German graphic
artist Hans Groß found an interesting new angle in his woodcut "The
Mother" (Die Mutter), in his cycle *A Dance of Death: Poems and Woodcuts*
(*Ein Totentanz: Gedichte und Holzschnitte*, 1921).[90] The skeleton, grab-
bing the intended victim by the arm from behind and holding a knife
that is about to deliver the fatal stab, arrests the eye with an opulent and
unmistakably female coiffure of the latest fashion. There is no suggestion
of a dance with this Death here either, the title of the collection notwith-
standing. This is where "Selfportrait with Dancing Death" (Selbstbildnis
mit tanzendem Tod, 1918) by the prominent Expressionist Ludwig
Kirchner (which may have inspired the hairdresser's conception of death
in Rosanowski's woodcut) is strikingly different.[91] Likewise, the
constellation of figures in the linoleum cut by Swiss painter Alfred

Bernegger (1912–78) entitled "Dance with Death" (Tanz mit dem Tod, undated) suggests that death, who dances holding a scythe, is to be thought of as female.[92] The medieval Dance of Death, creatively revived by Grandville, Schwind, Pocci, Barth, and others in the early and mid-nineteenth century, thus lives on well into the twentieth century, in characteristic transformation.

Yet another medieval conceit was revived in 1966 by the prolific German political satirist and graphic artist Andreas Paul Weber, who is much noted in academic circles: Death as a chess player (see above, p. 14 and note 93). But unlike Ingmar Bergman in his film *The Seventh Seal*, Weber transforms the medieval male chess player into a female one, in keeping with the widespread preference in the twentieth century for female anthropomorphization of death – the preference also observed in the twentieth-century revivals of dancing Death just mentioned. In dozens of graphics, Weber captured the interplay of powers governing our daily lives and events of world history in the image of chess games played by doctor and patient, Don Quixote and Sancho Panza, blacks and whites, Lenin and the tsar, Wagner and Nietzsche, a prince and a banker, etc. – and by Death and the devil. Indeed, so fond was Weber of this particular constellation as a cipher of the intellectual predicament of our time that he had Death and the devil play their game several times, with Death represented by a gender-neutral skeleton, by an officer identified by his epaulettes, and, most hauntingly, by a woman. In his lithograph "Death and Devil" (Tod und Teufel, 1966), "der Tod" is seen lolling in a Louis XV chair in the shape of a curly-haired yet death's-headed, cigarette-smoking woman wearing a transparent cocktail dress; opposite her at the chessboard is a fat businessman type in an ill-fitting tuxedo, whose wrinkled brow discreetly sprouts a horn under his hat set askew. At their feet and in the background is a burnt-out urban land-scape, apparently devastated by war. "Frau Tod," if one may call her that, throws up her arms in the pose of a victor.[93] Her would-be erotic appeal is somewhat overshadowed by the implied brutality of this flower of evil straight from the demi-monde.

For "human interest," it may be added as an aside that pop culture, too, even in the Grim Reaper-dominated Anglo-Saxon countries, has accepted the turn-of-the-century idea that death might be a woman, and a

PLATE 26 Klaus Rosanowski: Hairdresser and Death (1973)

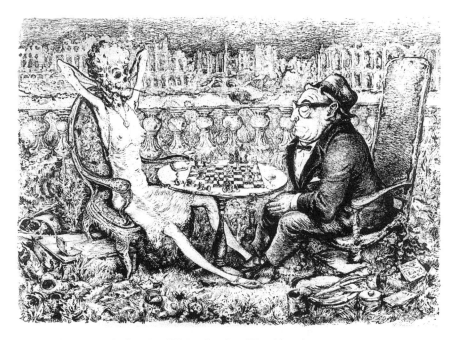

PLATE 27 Andreas Paul Weber: Death and Devil (1966)

beautiful one at that. This is not a unanimous acceptance, evidently, as a new brand of vodka, "Black Death," may remind us: its label features a skull wearing a top hat – clearly an elegant version of the Grim Reaper, *pace* Marlene Dietrich. But a junior Madame La Mort has made a spectacular debut in the pop world of comic strip magazines, which in America is not just the world of teenagers. In Neil Gaiman's popular comics series, an entire volume is dedicated to her; it is entitled *Death* and stars a long-haired attractive girl (New York: DC Comics, 1994). For good measure, one might add that the balance is restored, in pop culture, in Gary Larson's 1998 *The Far Side* desk calendar (Kansas City: Andrews McMeel) where the illustration for the first week of June features a fat man disturbing the lower middle-class domestic idyll of "The Deaths," Mr. and Mrs. Death, as they are watching television, drinking tea, and reading the paper after a full day's work, the scythe leaning against an easy-chair: "Dang, if it doesn't happen every time! . . . We just sit down to relax and someone's knockin' at the door."

The twentieth-century sequels and variations of female images of death prevalent at the turn of the century reviewed thus far are over-

whelmingly from the visual arts. But they are by no means limited to them as Gaiman's heavily textual comic book may indicate. For example, another "belated" occurrence of death as an erotically appealing woman, a literary one, is interesting not only because it originated on the geographical fringe of European culture, but also because it is the work of a poet who lived most of her life in Finnish-speaking Karelia but wrote in Swedish (languages whose grammar is not conducive to the personification of death as female). In her collection *Poems* (*Dikter*, 1916), the Expressionist-inspired founding document of Finnish-Swedish modernism, Edith Södergran published a poem, "Life's Sister" (Livets Syster), whose very title evokes a profusion of thematic reverberations from the past:

> Life resembles death most closely, her sister.
> Death is not different,
> you can caress her and hold her hand and smooth her hair,
> she will offer you a flower and smile.
> You can bury your face in her breast
> and hear her say: it is time to go.
> She will not tell you that she is someone else.
> Death does not lie greenish-white, her face to the ground,
> or on her back on a white bier:
> death goes around with pink cheeks and talks to everyone.
> Death has tender features and pious cheeks,
> upon your heart she lays her soft hand.
> Whoever has felt that soft hand on his heart,
> the sun does not warm,
> he is cold as ice and loves no one.

> Livet liknar döden mest, sin syster.
> Döden är icke annorlunda,
> du kan smeka henne och hålla hennes hand och släta hennes hår,
> hon skall räcka dig en blomma och le.
> Du kan borra in ditt ansikte i hennes bröst
> och höra henne säga: det är tid att gå.
> Hon skall icke säga dig att hon är en annan.
> Döden ligger icke grönvit med ansiktet mot marken

eller på rygg på en vit bår:
döden går omkring med skära kinder och talar med alla.
Döden har veka drag och fromma kinder,
på ditt hjärta lägger hon sin mjuka hand.
Den som känt den mjuka handen på sitt hjärta,
honom värmer icke solen,
han är kall som is och älskar ingen.[94]

This case may serve as a reminder that the literary artist, unlike the visual artist, encounters a basic problem in the attempt to render a female personification of death: the Germanic languages do not readily yield a word for female Death (just as in Romance languages it is difficult to come up with a widely acceptable single word for male Death). Imaginative experimentation is required. In German a female death figure might be called "Tödin," in analogy to "Tod." The term is indeed a familiar one in nineteenth-century folklore (see above, pp. 18–19); no lesser poet than Paul Celan, probably feeling the need for a German word all the more acutely as he came from and eventually lived in a polyglot world, still uses it in our own time. Of course, his best-known, indeed iconic poem casts death in the role of "a master from Germany" (ein Meister aus Deutschland). Still, his volume *Thread Suns* (*Fadensonnen*, 1968) conspicuously reintroduces the "Tödin" in a much-anthologized poem:

> TO MY RIGHT – who? The deathwoman.
> And you, to my left, you?
>
> The travelling sickles at the extra-
> celestial place
> mime themselves whitish-grey
> into moon-swallows,
> into star swifts,
>
> I dip to that place
> and pour an urnful
> down you,
> into you.

234

ZUR RECHTEN – wer? Die Tödin.
Und du, zur Linken, du?

Die Reise-Sicheln am außer-
himmlischen Ort
mimen sich weißgrau
zu Mondschwalben zusammen,
zu Sternmauerseglern,

ich tauche dorthin
und gieß eine Urnevoll
in dich hinunter,
hinein.[95]

Interestingly, other, less well-known contemporary poets writing in German similarly conceive of Death as a woman, indeed as a "Tödin," in their verse.[96] In a culture that more commonly portrays death as male, the female incarnation of death may present a certain appeal to males, even if her erotic attractiveness is not specifically brought into play. This is an idea that two men in Botho Strauß's drama *Der Park* (1983; translated in 1988 as *The Park*) sympathize with, with reference to the death figure that stalks this play's *dramatis personae*, and particularly a female character, in the shape of a "Black Man" (again, a motif harking back to the Middle Ages). In a conversation with Wolf, Georg generalizes with Teutonic thoroughness: "I want to ask you something, Wolf. Do you think, our death – I mean: Do you think that for us men death will come as a woman?" Wolf replies: "By rights she ought to be a woman. Black hair, black breasts. I don't know how it'd be if it wasn't like that. If in the last moments there was a man facing me!"[97]

This calls for a brief excursus on twentieth-century drama. It is tempting to think that twentieth-century dramatists might take Strauß's intriguing idea as a cue, but in fact this is not the case when death enters the modern stage in person. And rightly so, perhaps, since logic would then probably require that, depending on the human constellation, Death would change gender in the course of one and the same play. This does indeed happen, to be sure, in Rolf Hochhuth's "Dance of Death" play *Summer '14* (*Sommer '14*, Reinbek: Rowohlt, 1989). Here Death, getting

ready for its triumph in World War I well ahead of time, appears on the scene not only in "historical" guises such as Thanatos and the skeleton, but also as drum-major, grand admiral, army chief-of-staff, zeppelin pilot – and as the female owner of a munitions factory. What Hochhuth has in mind with this duality of gender is, however, not Strauß's idea of sexual complementarity; instead, he uses the two genders of Death to hint at the guilt that all Europeans share, some of whom (Hochhuth thinks) are required by their language to speak of death as "he," while others are grammatically obliged to say "she" – and consequently obliged to person-ify death as male or female, respectively (p. 28; see also p. 262 below, ch. 1, n. 49). Hochhuth's ambisexual Death derived from this mistaken notion is both one of the *dramatis personae*, in the roles mentioned, and a specta-tor of the historical drama as it unfolds: "The fortress of death remains in the background. Just as a secular prince would in the old days view the performance of strolling players, so Death – a man or a woman, for Death is androgynous – observes the shadows of those arrogant or abused fools who in 1914 politicized Europe into the First World War" (p. 15).

The "androgyny" of Hochhuth's Death within the same play remains an exception. As a rule, when death appears on the modern stage, it is cast in a male role – surprisingly so, in view of the prominence of female death figures in the arts of this period. This is how he materialized in Wolfgang Borchert's *The Man Outside* (*Draußen vor der Tür*, 1947), one of the greatest box-office successes of the immediate post-war years; but Borchert's Death is able to vary his role within his male gender: "Today [he appears] as a street-cleaner, tomorrow as a general, Death must not be choosy" (sc. 5). Similarly, in Manfred Hausmann's play *The Dark Dance* (*Der dunkle Reigen*, 1951), Death appears as the (male) beloved; in Wolfgang Weyrauch's *Dance of Death* (*Totentanz*, 1961), he is "an ordi-nary pedestrian" (ein beliebiger Fußgänger), a man wrapped in a worn-out raincoat. Already in the aftermath of World War I, Death had made its entry on the stage of the losers in comparably arbitrary male roles, such as "a soldier, the professor, the judge, the nocturnal visitor," in Expressionist Ernst Toller's keynote postwar play *The Transformation* (*Die Wandlung*, 1919), while during the war, Mechthilde Lichnowsky's *A Play about Death* (*Ein Spiel vom Tod*, 1915) had introduced Death as a

crippled youth and also as the long-familiar gardener (revived at about the same time by Hofmannsthal in a note for his *Everyman* play [1911]).[98] Between the wars the male guises of Death predominated as well, much as they did before and after. Leo Weismantel's *Dance of Death, 1921* (*Der Totentanz 1921*, 1924) may come to mind, or Hofmannsthal's *The Great Salzburg World Theater* (*Das große Salzburger Welttheater*, 1922) as well as Fritz Lang's film *Tired Death* (*Der müde Tod*, 1921) and even Hans Henny Jahnn's *New Lübeck Dance of Death* (*Neuer Lübecker Totentanz*, 1931) where a bespectacled death figure, wearing a "cream-colored suit," makes his debut, surely a unique one, no matter how deliberate the reference back to a traditional genre in the very title of the play. The English-speaking world, which favors the Grim Reaper much as the German-speaking countries favor the "Schnitter," contributed concretely visualized male death figures in plays like Thornton Wilder's *Mozart and the Grey Steward* (1928), where Death has a function similar to that of "the eternal Footman" in T. S. Eliot's "Love Song of J. Alfred Prufrock," and Paul Osborn's *On Borrowed Time* (1938). The trend continues to the present day with Woody Allen's one-act play *Death Knocks* (1971), not to mention videos (see above, p. 14). In the Romance language regions of Europe, on the other hand, female death figures seem to be more common – which, interestingly, does not mean that they are masculinized in German or English translations. Theater-goers will readily think of Cocteau's *Orphée* (1927) and his dance dialogue *The Young Man and Death* (*Le Jeune Homme et la Mort*, 1946) or of Camus's *Etat de siège* (1948). But there are significant and by no means esoteric exceptions, such as Anouilh's *Eurydice* (1958) and Ionesco's *Massacre Games* (*Jeux de massacre*, 1970): a male death figure is conspicuous among the cast of each (see above, pp. 27–28).

Against this background of preferred genderization of death *and* the "exceptions" to it, modern German and English drama also has some "atypical" instances – as if Botho Strauß's character's wish had come true, one might add, if only to discover that his dream is a nightmare. In Lotte Ingrisch's and Gottfried von Einem's revisionist opera *The Wedding of Jesus* (*Jesu Hochzeit*, 1980[?])[99] this female death figure is even called "Tödin," as she had been in Celan's poem, and moreover "Godmother Death" (Gevatterin Tod) in a polemical allusion to "Godfather Death"

of the fairy-tale tradition. She is "a beautiful woman," but under her velvet cape she is nothing but a skeleton (as Justina was in an illusion-shattering scene in Calderón's *El mágico prodigioso*). The opera's "Death-Woman" behaves in a way that is deliberately antagonistic to that of Jesus, her biblical enemy: not only is she the rival of the savior who welcomes those "that labor and are heavy laden" and revives Lazarus, whom she claims as her own; she is also, with the necessary love-hate, his would-be erotic partner. Slipping into the role of Judas, she interprets her kiss of death as a "wedding" (Hochzeit machen, xv, 28). "I am seduction, I am betrayal, and I am the court of law" (xvii, 35). The court of law accuses Jesus of truthfulness, grace, and love – and finds him guilty. Accordingly, Death is given the line "Nail him to the cross!" as well as "It is finished" (xviii, 47; xix, 65). This blasphemous parody points to a modernizing revival of the biblical and medieval notion that woman is the root of all evil – a revival with a vengeance. For all of Christian history, from the Passion of Christ to the salvation of mankind (which had been read as the story of the overcoming of death), is now perverted to stand for a triumph of Death in female shape. Theological misogyny, taking aim at the very foundations of Christian beliefs, could not be more crass.

"Frau Death" is less theologically charged in George Tabori's "farce" *Mein Kampf*, originally written in English, but first performed in German in Vienna in 1987. True, the author, a Hungarian Jew by birth, very successful today in Germany and Austria with his topical films and plays, called it "a theological farce" in a published interview, but what he had in mind was nothing more theological than the Christian notion of the love of enemies, which is indeed a dominant theme of the drama.[100] This conflicted love is the curious sympathy and even symbiosis that the play establishes between Adolf Hitler and the Jew Schlomo Herzl, who meet in the 1920s in a flophouse in Vienna. What brings this play – a grotesquely off-beat exploration of the vulgarity and banality of evil – into the orbit of the problem of death personification is the bizarre conceit that Hitler was chosen by Death as a tool of mass-murder: "As a corpse, as a victim, he is absolutely mediocre. But as a criminal, as a mass murderer, as an exterminating angel, a natural talent" (p. 77).

A petit-bourgeois woman who introduces herself as "Death" comes to fetch Hitler in the Vienna flophouse in order to make use of his

murderous talent. "What's he want?" Hitler asks and is told: "It's a she. And she wants you" (p. 74). Her manner and appearance (she is accompanied by two "dashing gendarmes") are as trivial as they are chilling:

> FRAU DEATH: Finita la commedia. – Follow me inconspicuously.
> HITLER [To his followers]: Follow me inconspicuously.
> TYROLEAN FREAKS and HIMMLISCH: No, thanks. [They vanish into the air. The GENDARMES grab HITLER.]
> HITLER: May I get my toothbrush?
> FRAU DEATH: Yes, of course. There are plenty of teeth, hair, and gold fillings in the place we're going. (p. 81)

Why is Death a woman here? The text itself does not answer the question *expressis verbis*. But considering the extent of the devastation brought about by this particular Death, one may think of the destructiveness that the female sex, in particular the mother, connotes in those mythologies, the world over, that view the source of life as the source of death. The notion recurs in psychologized form not only in Simone de Beauvoir's *Second Sex*, but also in Heiner Müller's aperçu "Death is a woman." But such a "philosophical" interpretation might take Tabori's "farce" altogether too seriously. As Tabori implied himself in the interview mentioned earlier, *Mein Kampf* amounts to a clever idea, rather than a sustained analysis.

Summing up all the associations that the female death figure evoked in art and literature during the nineteenth and earlier twentieth centuries – associations ranging from the sublimely transcendent to the obscenely mundane, from the motherly to absolute beauty – one might cite a work by a largely unknown contemporary artist that seems to bring all these strands together. This is the drawing called "Callipyge with Death's Head" (Callipyge à tête de mort, 1983; preserved in the Düsseldorf collection of death images)[101] by the Toulouse biologist Jean-Pierre Lamon. A voluptuous nude female figure, with plump hips and breasts, surprises and shocks the viewer with her unmistakable, anatomically correct death's head. A man of many talents, Lamon wrote an explanatory poem which gives precise expression to the strange mixture of allure and vulgarity in this personification of death; the poem is at the same time a suitable

motto for the themes that have been casting a broad shadow over the visual and literary arts since the Victorian age:

> Death like a big woman,
> Neither ugly nor fleshless, BEAUTIFUL,
> A goddess, a princess, a whore,
> Sweet belly, warm refuge of the soul,
> Of the soul crumpled like a tear-stained face,
> DEATH like a mother,
> > A wife,
> > A sister.

> La Mort comme une grande femme
> Ni laide, ni décharnée, BELLE
> Déesse, princesse, putain
> Doux ventre chaud refuge de l'âme
> L'âme fripée comme un visage en pleurs
> La MORT comme une Mère
> > une Epouse
> > une Sœur.[102]

VI

The discussion of male Death in modern drama notwithstanding, this chapter has, on balance, paid more attention to the various female personifications of death because they are the images that are most significant historically, though they are in all likelihood outnumbered by other images, gender-neutral[103] as well as male. But statistics do not necessarily have the last word in cultural historiography, and particularly not in this case. For unlike the female anthropomorphizations of death with their distinct thematic profile that gives the period its unique cachet, the male (and gender-neutral) incarnations are less arresting, since by and large they tend to revive motifs that had been current for centuries. Variations abound, to be sure; but from the diffuse wealth of such visual and literary representations there emerges no cluster of dominant themes that might give this period an imprint comparable to that of the female image of death. Nonetheless, a number of striking and resonant articula-

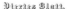

PLATE 28 Alfred Rethel: Death as Political Orator (1849)

tions of death personified as a man will be introduced briefly to help
define the surroundings of the iconography of "death as a woman." Of
particular interest among these, from the point of view of genderization,
are the modern versions of "Death and the Maiden" and the variations on
the similarly erotic theme of the masked ball featuring a male death
figure. But first it seems worthwhile to survey a few other motifs that may
serve as a background to such erotic articulations of the theme.

Among well-known German artists of the time, Alfred Rethel gave
the traditional Dance of Death a topical and satirical twist in his pro-
digiously successful sequence of six woodcuts that conveyed his view of
the failed 1848 revolution; it is pointedly entitled *Another Dance of Death*
(*Auch ein Todtentanz*, 1849, later editions add *aus dem Jahre 1848*).[104]
Unlike Death leading off the older Dances, Rethel's Death, inciting the
populace to rebellion, does not rob his victims of anything; on the con-
trary, he has something to offer, namely freedom, equality, and fraternity
– the postulates of the revolution in the several continental countries.
But, of course, these gifts can be enjoyed only by those who do not

241

survive the fighting on the barricades. With mordant ironical punch, they are gifts that only Death can offer. And this death presents itself in decidedly male roles: he is the reaper on horseback (!), the crowd-pleasing orator, the military officer, and the freedom fighter in the streets.

A less resourceful return to conventional male images may be seen, around the turn of the century, in the work of some minor German artists, worth mentioning because they indicate that the male incarnation of death has by now entered the mainstream of consumer art, not to say mass culture. These works include (to mention just a few that have been reproduced recently) Matthias Schiestl's color lithograph "Old Peasant and Godfather Death" (Alter Bauer und Gevatter Tod, 1900), which has Death solicitously show a decrepit old man the way to the cemetery, and Hans Jentzsch's woodcut "The Captain" (Der Herr Hauptmann) in his *New Dance of Death* (*Ein neuer Totentanz*, 1904), which features Death as an officer wearing a Prussian spiked helmet on his bony skull, with the caption reading: "Forward march! The destination must be reached," as well as another image in the same cycle that personifies death as a pharmacist filling a bottle: "The potion will do you good, my friend." One might also mention death portrayed as the mountain guide (not only by Jentzsch but also by Otto Seitz, Tobias Weiß, and others at the time) and finally Death as the mail-coach driver in a poem in a much-reprinted volume by Otto Julius Bierbaum (1901) but also, on a higher level of literary craftsmanship, in lines by Emily Dickinson (1890).[105]

In the 1920s, "Mr. Death" (as E. E. Cummings called him in a frequently anthologized poem)[106] continued to take on a wide variety of shapes in the work of major as well as minor artists and writers. He surfaces as the cardsharp in German Expressionist Arminius Hasemann's woodcut and the pimp in Belgian graphic artist Walter Sauer's, both dated 1921 and evocative of the notorious Berlin demi-monde of the period captured in Christopher Isherwood's novels.[107] While Expressionist dramatist and sculptor Ernst Barlach gave his "Wandering Death" in the lithograph of that title (Wandernder Tod, 1923) an air of bonhomie by inserting a pipe between his teeth,[108] the death figure in Alfred Döblin's panoramic novel of 1920s Germany *Berlin Alexanderplatz* (1929) is more intimidating: "the great sacrificer, drummer, and axe-wielder."[109] As this violent image reminds us, Death had also been

popular, even before World War I, in the similarly brutal guise of a military figure: as a field-marshal, commander, or soldier (Grandville, Musorgsky, and Jentzsch were singled out earlier). The motif naturally had even greater poignancy after the war broke out,[110] nor did it fade away in the subsequent years. It gained a new topical appeal among opponents to the Nazi regime, even before the war broke out. The montage "The Seeds of Death" (Die Saat des Todes) that John Heartfield, the left-wing political and social satirist, associated with George Grosz, published in 1937 in the Prague *Arbeiter-Illustrierten-Zeitung*, speaks volumes; it presents a steel-helmeted skeleton sowing swastikas: "Everywhere this sower goes, / He will harvest hunger, war, and conflagration."[111] Working in political exile in Moscow in 1934, the communist graphic artist Heinrich Vogeler followed a similar tack in a pen-and-ink drawing portraying Death as a storm-trooper literally making his way over dead bodies; in interior exile, *Vorwärts*, the official newspaper of the Social Democrats, incarnated death as Hitler himself in October 1933, while Eduard Winkler's heliogravures collected in his *Brown Death* (*Der braune Tod tanzt!*), published in 1946 in English and in German "in memory of the liberation of Munich from 'Brown Death' . . . on May 1, 1945," harked back to the time-honored Dance of Death: taking the lead is a skeleton in jackboots and military cap, swinging the swastika flag.[112] Even during the first years of the Cold War, lingering fear found expression in the image of a highly decorated officer who stares out of his hollow eye-sockets on an Ordnance Survey map in Andreas Paul Weber's lithograph "Death as Commander" (Der Tod als Kommandierender, ca. 1950).[113]

The violence implied in the military metaphors of death is offset in the post-war period, as it was earlier in the century, by more "good-neighborly" death figures in the manner of Barlach's "Wandering Death." These worthies may have their satiric or sinister implications, though. Consider Louis Rauwolf's grim caricature in an engraving dated 1960. Death – dressed in solemn black, taking a top hat from his skeletal skull – is the doctor who assures his bedridden patient: "I'll attend you free of charge."[114] Similarly, an all too familiar, entirely ordinary Death sends shivers down the reader's spine in the nightmarish story *Interview with Death* (*Interview mit dem Tode*, 1948) by the German Existentialist and

perennial Nobel Prize nominee Hans Erich Nossack. Death here "comes alive" as a petit-bourgeois funeral director whom we encounter not at work but at home among his tacky furniture. He is the sort of Book-keeper Death that must have come across as particularly congenial to the drab early postwar period. At any rate, this Death is perfectly aware that his previous roles or incarnations – the reaper, the angel of death, and the "pale young man" – are passé, while he himself is not.

To return to the erotically charged personifications of death: the erotic motifs involving female death figures discussed in the two previous sections frequently have their male counterparts in the art and literature of the same period. One group of such images is made up of variations on the "Death and the Maiden" motif that dates back to the Renaissance and by 1800 had merged with the Romantic fixation on Death in the bridal chamber. The fascination with this motif (and with the masked ball, with death as one of the dancers) remained virulent throughout the nineteenth century, especially its second half. The emotional scale ranges from violence to sweetness. In Ferdinand Barth's cycle *Death at Work* (1867), discussed earlier, there is a starkly unsettling "Death and the Maiden" scene (No. 2), while Emily Dickinson predictably introduces Death as a "suitor" in a minor key, a gentler, yet ultimately no less per-emptory Death: "Death is a supple Suitor / That wins at last" (ca. 1878).[115] The motif continues to demonstrate its vitality around the turn of the century and indeed until our own days: Dalí's color etching "Death and the Maiden" (1967) may come to mind, or the more esoteric woodcut "Pregnant Woman and Death" (Schwangere und Tod, 1959) by Gerhard Marcks, better known for his sculptures; and then there are, in Germany, Horst Janssen's typically eccentric *Totentanz* etchings (1974) and, in Aus-tria, Ernst Fuchs's "Sylvan Idyll" (Waldidyll) of the early 1990s, which crassly perverts the motif to *a tergo* intercourse. Even the much-quoted self-introduction of Death in Hofmannsthal's *Death and the Fool* (*Der Tor und der Tod*, 1893), which at first sight harks back to the Enlighten-ment's attraction to Thanatos and Freund Hein ("I am not gruesome, am no skeleton"), amounts to an eroticization of male Death: "As a great god of the soul I now appear, / To Dionysos, Venus most akin."[116]

However, the most interesting and innovative variation on the theme of Death as "ladykiller" is no doubt Edvard Munch's etching "The

Maiden and Death" (Pigen og Døden, 1894). The catalogue of the Düsseldorf collection of death images puts it aptly: "The traditional 'Death and the Maiden' motif is given a much more complex meaning in keeping with the end-of-the-world mood of the intellectual movements of [Munch's] time and above all with his own peculiar and highly complicated pessimistic and angst-ridden attitude to women, love, and death. Unlike the older representations [of "Death and the Maiden"], in which Death's assault on the defenseless girl brought home the vanity and transitoriness of this world, Munch shows the couple standing in a passionately erotic embrace, in which the beautiful and decidedly sensuous woman does not resist the skeleton but clearly yields to his embrace."[117] Munch's interpretation of "Death and the Maiden" (in which the maiden is apparently the more aggressive of the two) reflects in its way the turn of the century's negative view of the female sex that was so pronounced in the many portrayals of death as seductress discussed above: women, exemplifying the biological processes of growth and decay more directly than men, aroused anxiety in the male about his own decay and death. The fusion of birth and death is clearly hinted at in the "frame" of Munch's etching: the loving couple, Death and the maiden in sexual union, is surrounded by sketches of seminal cells and embryos.

Only two years after Munch's etching, Max Slevogt's painting "Dance of Death" integrated a very similar view of the female sex into that other cluster of erotic images of male death that rivals "Death and the Maiden" in the art and the literature of the time: the "Masked Ball." The transition from "Death and the Maiden" to the "Masked Ball" is, of course, easy and natural: Death the seducer becomes the dancer, without really changing identities. This is most patent, to cite just two examples, in the sequence of woodcuts entitled *Eros Thanatos: A Dance of Death* by the cosmopolitan German sculptor and graphic artist Arminius Hasemann (1921), where Death, recognizable by his eyeless skull, but otherwise the perfect beau in dinner jacket, dances with half-nude demi-monde girls, and in Christoph Hessel's color etching "Viennese Waltz" (Wiener Walzer, 1978), where Death, again identified by his skull and fashionably dressed, is seen waltzing on a grave with a buxom young woman – surrounded by an obtrusively respectable residential neighborhood in the background.[118] Such a dance with Death can easily be

transformed into a masked ball. In 1911, the left-of-center arts and politics journal *Jugend* published a graphic work similar to Hessel's or Hasemann's by Austrian illustrator and sculptor Otto Lendecke, which neatly shows the transition: "Her Last Dancer" (Ihr letzter Tänzer) is Death in the guise of a domino and masked, as is his partner.[119] All that is needed to complete the metaphor of life as a masked ball with Death is a throng of masked dancers. In literature this full-fledged masked ball had made its debut as early as 1842 in Edgar Allan Poe's *The Masque of the Red Death*, if not earlier. For Poe, for his part, may have been inspired by *Presentiment and Present* (*Ahnung und Gegenwart*, 1815), by German Romantic Joseph von Eichendorff. In this novel, the protagonist finds himself at a ball in the prince's palace; a knight wearing a black mask attracts everyone's attention, "but no sooner had they exchanged a few words with him than they all turned away from him, for sticking out of the knight's lace sleeves were the bony hands of a skeleton." Alluding to a famous painted Dance of Death, the stranger reveals himself as "The Basle Death": "if he takes you in his arms you must die" (Book 2, ch. 11). In Poe's story, Death at the masked ball is "Red Death" – the male personification of a plague-like epidemic that rages in the realm of prince Prospero, leaving its victims lifeless within half an hour, their faces turned a frightening scarlet. The prince and his friends escape from this pestilence to a remote abbey. Secluded from the real world, he gives a masked ball there – at the stroke of midnight, as the festive merriment subsides, a gaunt figure appears, whose mask and disguise recall the bodies of the plague-stricken. The prince confronts the intruder, but his sword drops from his hand and he falls to the floor, dead. The guests seize the masked trouble-maker, only to discover that there is nothing behind his cadaverous mask. "And now was acknowledged the presence of the Red Death. He had come like a thief in the night. And one by one dropped the revellers in the blood-bedewed halls of their revel, and died each in the despairing posture of his fall. And the life of the ebony clock went out with that of the last of the gay. And the flames of the tripods expired. And Darkness and Decay, and the Red Death held illimitable dominion over all." So ends the story.

Two years after Poe's death, Alfred Rethel created his famous woodcut "Death as a Strangler" (Der Tod als Erwürger, 1851), which transposes Poe's verbal vision into the pictorial medium with uncanny accuracy. A

sort of connection is spelled out by the subtitle: "The First Appearance of Cholera at a Masked Ball in Paris in 1831" (Erster Auftritt der Cholera auf einem Maskenball in Paris 1831), even though Rethel was inspired more directly by Heinrich Heine's report on the outbreak of cholera, published in 1833 in his *French Conditions* (*Französische Zustände*). Wrapped in a foot-length shroud-like garment, a skeletal death figure paces through the ballroom as the musicians leave in panic. He is the traditional fiddler, familiar from scores of Dances of Death, both pictorial and literary, except that here he plays his bony-looking instrument with a bone as a bow, while the masked and costumed dancers lie dead or dying on the floor. In the background one can make out a shrouded figure holding a scourge that is believed to be an allegory of cholera.[120]

At the turn of the century, the masked ball motif recurs in one of the most accomplished paintings by Impressionist and Secessionist Max Slevogt, "Dance of Death" (Totentanz, 1896). It is intriguing because it is strongly reminiscent of Munch's transformation of the encounter of

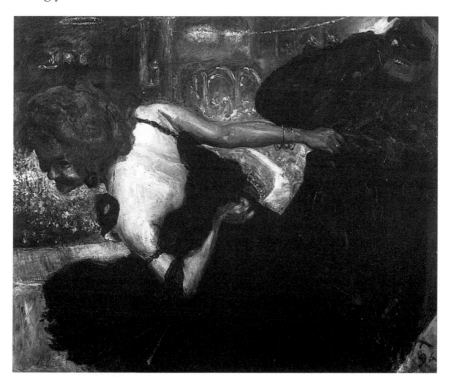

PLATE 29 Max Slevogt: Dance of Death (1896)

Death and the maiden: for here, too, it is not the masked death figure that takes the initiative by approaching the woman – as was the case, for example, only a year earlier in Tobias Weiß's drawing in his cycle *A Modern Dance of Death* (*Ein moderner Totentanz*) where a shrouded skeleton similar to Rethel's tries to win the favor of a lady at a masked ball by obsequiously proffering a bouquet.[121] In Slevogt's painting, the constellation is reversed: the woman, with a lustful grin on her face, from which the mask has already fallen onto her shoulder, is forcibly dragging Death, costumed and still wearing an eye mask on his toothy skull, along with her, trying to draw him closer to her body.[122] While this image has room for only two figures, in several of the starkly sexual woodcuts of Arminius Hasemann's *Eros Thanatos* of 1921 life has become a densely crowded masked ball, indeed a vortex of pleasure and pleasure-seeking. Death dances with scantily clad women in a festive turbulence suggestive of Berlin that was just then thriving on its reputation as the world capital of enjoyable sinfulness. To be sure, Hasemann's Death does not mask his hollow-eyed skull, but the elegant dinner jacket to which he presses the adoring demi-monde is a sufficient disguise.[123] In a frenzy of sexual abandonment, life is consummated in death: Mors Imperator ruling supreme in the sleazy world of night-clubs.

Finally, the vision of life as a masked ball with Death as the keynote dancer is distorted into unprecedented grotesquerie in Andreas Paul Weber's lithograph "A Dance of Death" (Ein Totentanz, 1970); the catalogue of the Düsseldorf collection of death images describes it as follows:

> On a stage – the stage of life – in front of which the heads of the musicians emerge from the dark in the bottom margin of the image, the skeleton of Death, dressed in tails and hiding his face behind a white mask, dances with a high officer wearing a spiked helmet. Behind this couple there is a semi-circle of dancers, of grotesque caricatures of modern "high society" jumping about hand in hand; they are the familiar types Weber was fond of representing in his works of social criticism (whereas in the traditional Dances of Death all classes and professions had to dance with Death, suggesting that no one is exempt from death): on the extreme left a naked corpulent lady with the head of a duck, hold-

ing sunglasses and a scandal-sheet in her hands; next, the potbel-
lied diplomat wearing tails, a bowler hat, and medals on his chest,
embracing a wizened décolleté queen; next to the queen the pope
who loses his tiara as he dances, while a politician – a fat, brutal
looking gentleman in tails, with sash and medals, his chained,
naked legs protruding from prisoner's trousers – tugs on his
sleeve; next to him a richly dressed man with sunglasses on his
overlong beak-like nose and then an affected young girl moving
her legs gracefully; hand in hand with her, the fat doctor with his
broad animal face and his sunglasses and next to him the astro-
naut on whose protective helmet the American flag flutters
between his protruding donkey ears; next to last on the right a
manager with a goatee, a cap and sunglasses and finally the
wigged judge hopping about in his robe, holding the statute
book. In the extreme foreground on the right, at the edge of the
stage, sits the little fool with his big nose and cap and bells, an
open copy-book on his lap and a microphone in his hand – the
stage director.[124]

With this rendering of the masked ball of life, death eroticism reaches a
grotesque and macabre *ne plus ultra*; in comparison, images from the turn
of the century seem downright tame. Yet just as the modern versions of
"Death and the Maiden," no matter how extreme or esoteric, ultimately
refer back to the late-medieval notion of the Dance of Death, so too do
the modern representations of the Masked Ball featuring Death as the
most prominent dancer – an astonishing continuity, reinforced by the
very titles of some of the works.

VII

With its various constellations and associations, erotic and otherwise, the
male death figure emerges as a viable (though perhaps not equally inter-
esting or original) counterpart to Madame La Mort, who was a com-
manding presence in the visual and literary arts during the same period,
from the second half of the nineteenth century to the present day. How
to account for this ever-changing ensemble of male and female images of
death over more than a century?

The factors of cultural history touched on earlier in an attempt to explain the ascent of the female image of death – notably the emancipation of women, said to arouse primal, elementary anxieties in men – may at the same time help us understand the virulence displayed by the male image of death during the same period. The emergence or reemergence of the female image of death in modern times is a challenge that brings its opposite on the scene; as Goethe noted in his novel *Elective Affinities*, "Every word that is uttered provokes its opposite" (jedes ausgesprochene Wort erregt den Gegensinn).[125] Witness the internationally acclaimed fresco on metal by contemporary Mexican artist Francisco Toledo, entitled "Death Descending the Stairs" (La Muerte bajando la escalera, 1988). For centuries the tradition of Mexican folklore has mandated a female personification in art and literature; Death is commonly known as "Doña Sebastiana," or "Aunt Sebastiana" (la tía Sebastiana), of which All Souls' Day, the Day of the Dead (still the most important Mexican holiday), reminds tourists and natives alike year in, year out. Seen against this background, Toledo's painting may be understood as taking up the challenge of this tradition: his death figure descending the stairs is a skeleton, yet, with supreme disregard for physiological probability, the artist endowed this skeleton with demonstrative male sexual organs.[126] Does this not suggest a fundamental reason for the *ensemble* of male and female death figures? That is to say, the creative imagination, feeling threatened or overwhelmed by the perceived prevalence of "Dame Death" and looking for inspiration for a different view, revives iconographic traditions that, ever since the Middle Ages at the latest, visualized death personified as male, as male power and authority, last but not least as power and authority over women. Conversely, in other quarters, the perceived prevalence of the male image of death may be taken as a challenge to contradict what is felt to be an iconological convention – in other quarters and at other times; for in principle the interplay of E. E. Cummings's "Mr. Death" and Rilke's "Madame Lamort" is a phenomenon that can be observed throughout the history of the personification of death; and it may be assumed that the principle of answering a perceived provocation (by one or the other image of death, male or female) was operative throughout that history.

The proverbial battle of the sexes, then, would seem to be fought in this history as well, though with ever-fluctuating fronts which, on both sides, fuse love and aversion, hope and fear. The ensemble of such conflicting yet compatible emotions will constantly vary, taking shape within the historically changing intellectual frameworks outlined in the previous chapters. (To repeat: in the Middle Ages, death was the wages of sin, Adam's or Eve's; in the Renaissance, the devil, as the alter ego of death, was the ultimate source of our mortality; in the Romantic Age, Thanatos, Freund Hein, and the bridegroom of the soul functioned as ciphers of the liberation from the stranglehold that the horror of death had had on the Christian believer for centuries; since then, the emancipation of the female "flesh" has often been seen as a death-threat to the male.) The interplay of the two basic personifications of death, male and female, which is acted out over the ages in many variations and with many shades of meaning, is, therefore, not the subjective antagonism of images created by individual male vs. individual female authors and artists. Rather, the tension or antinomy, not to say dialectic, is grounded, in its characteristically changing, yet also persistent forms, within the intellectual and emotional economy of cultures and periods, regardless of whether this dichotomy is considered a natural given or a social construction.

Male and female images of death would consequently be necessary and necessarily antagonistic expressions of human self-awareness and self-realization, icons of the ongoing articulation and exploration of the self vis-à-vis the "other." Such "Discovery of the Self"[127] has more than one dimension in a given cultural context and historical period. However, the dimension revealed by the confrontation of the self with death as its ultimate other is hardly one of the more trivial ones. "It is death alone that one should ask about life."[128]

EPILOGUE / DEATH IMMORTALIZING LIFE

> In the depth of anxiety of having to die
> is the anxiety of being eternally forgotten
>
> PAUL TILLICH *The Eternal No* [1]

Death as a man, Death as a woman – paradoxically, the imaginative representation of the end implies a new beginning. "In my end is my beginning."[2] Mortality validates immortality, the evanescent is evidence of timelessness. For as life is extinguished, it enters into memory, which preserves it and thus gives it permanence. The idea is universal: death bears witness to life, "mors igitur vitae est testimonium," as the church father Ambrose put it in his treatise on the "good" of death, *De bono mortis*.[3] Antiquity was familiar with similar thoughts. The pre-Columbian Aztec wondered, not without anguish, whether any trace would remain of his days on earth, of his name and his fame ("mi fama aquí en la tierra"), and the answer of a well-known poem assured him that at the very least, songs will remain.[4] The Renaissance made a veritable cult of the idea of personal survival in the work of art or in fame. If in Petrarch's *Triumphs* death wins out over life, death in its turn is overcome by fame, by the living memory of those who come after us; fame is life not subject to death.[5] Not only Christian, but also secular eternity begins with death (as Tertullian and other church fathers grudgingly acknowledged but regretted):[6] only what is past or gone can remain unforgotten, only what is dead can be alive. This is no *jeu d'esprit*. The art of the Renaissance and the Baroque expressed the idea in the language of classical mythology as it appears, for example, on the so-called Prometheus sarcophagus in the Museo Capitolino in Rome. On a lateral relief Atropos, one of the most familiar Greek incarnations of violent death, is seen, not cutting off the thread of life, but sitting by the side of the deceased, holding a scroll. Evidently she is recording, memorializing the life that she has just ended – Atropos' epithet was "scribunda," she who writes (and through writing preserves).[7] The same sentiment is expressed in the language of Christian iconography in a woodcut in the *Book about the Tree of Human Life* (*Buoch arbore humana*), a posthumous collection of sermons by the popular Swiss Catholic preacher Geiler von Kaisersberg (Stras-

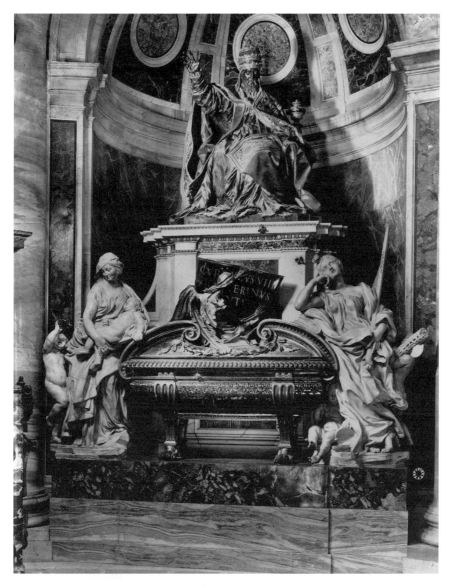

PLATE 30 Gian Lorenzo Bernini: Tomb of Pope Urban VIII (1628–47)

bourg: Grueninger, 1521): it features two *transi* figures with death's heads, symbolizing death; one writes on a piece of paper or parchment while the other shows the dying man a written document. The implication is that it is Death that records and preserves the *summa* of a life at the moment of its extinction (p. CXLV).

253

This image may still recall the Christian "book of life," or register of sins presented to the dead at the Last Judgment (Rev. 20:12).[8] However, the same recording and preservation of a life through the testimony of Death is epitomized without such an association in Bernini's tomb of Pope Urban VIII in St. Peter's Basilica (1628–47). Before the pedestal on which the pope is enthroned, his hand extended to offer a blessing to the faithful, a winged skeleton of indeterminate gender crouches on the sarcophagus – the familiar allegory of death. Yet Death's role is unusual here in that it holds a book into which it inscribes the name of the dead Barberini pope; his predecessor's name has already been recorded on the previous page in the same golden letters.[9] Death – the figure has been recognized as such ever since Bernini's first biographer, Filippo Baldinucci[10] – takes on the role of historiographer: the angel of death and destruction that symbolizes mortality prevents oblivion. At the moment of dying, the moment that seals our finiteness, immortality begins in a sense quite different from the traditional Christian view. It is not the immortality of the soul in the beyond, the immortality that St. Paul speaks of in his First Letter to the Corinthians (15:54). Rather, what is past at the moment of death is preserved in unending memory here on earth; what has died remains alive as remembered and cherished by those who survive and by their descendants, *ad infinitum*. Life, once it is over, becomes part of history, indeed of perennial history. The paradox was appreciated by Cicero: "The Life of the dead is placed in the memory of the living" so that – Seneca continued this line of thought – the day of death becomes the birthday of our personal "eternity."[11] The idea reverberates in the proverbial lines of Thomas Campbell's poem "Hallowed Ground" (1825): "To live in the hearts we leave behind, / Is not to die." Taking another look at Bernini's monument to death, one is no longer puzzled by the life-affirming allegorical figures positioned on the right and the left of the tomb's pedestal: recording the life of the dead, Death is no longer seen as triumphant over life (as it had been long enough, particularly in the Dances of Death where it triumphed over the high and mighty, including the pope); instead Death is paradoxically viewed as serving life, which in the end triumphs over its own extinction. Further, what death validates is not merely life but that truth and essence of a life that

is revealed in death and only in death. Even St. Ambrose (who could be expected to be concerned primarily with immortality in the sense of the afterlife of the pure soul in heaven) had this in mind when he stated that death bore witness to life:

> That is also excellent which is said in the Bible: "No one must be praised before his death"; for every man is known only in his last moments . . . Death, then, bears witness to life. For if the helms-man cannot be praised before he has brought the vessel to port, how can one praise a man before he has reached the harbor of death? . . . The very leader does not assume the laurel before the battle has come to an end, nor does the soldier lay down his arms to be favored with a reward for his service, before the enemy is vanquished. Death is the fulfillment of our service, the sum total of our rewards, the grant of our release.

> Illud quoque egregium, quod ait Scriptura: Ante mortem non lau-daveris quemquam. Unusquisque enim in novissimis suis cognoscitur . . . Mors igitur vitae est testimonium. Nam si laudari ante gubernator non potest, quam in portum navem deduxerit, quomodo laudabis hominem, prius quam in stationem mortis successerit? . . . Dux ipse nisi confecto praelio non sumit lauream, nec miles arma deponit, nec stipendii mercedem adipiscitur, nisi hoste superato. Mors igitur stipendiorum plenitudo, summa mer-cedis, gratia missionis est.[12]

With these words the church father speaks from a cultural tradition older and more widespread than Christianity, one that was revived in the Renaissance (by Montaigne for example) and continues to be viable to this day: the last moment is the summation of a life; the truth it discloses can be experienced and communicated only at this moment. This signa-ture truth, a long-standing tradition has it, is revealed in the last words, which, handed down from generation to generation, overcome the evanescent flux of time.[13] Paradoxically, with St. Ambrose as with Bernini, it is death that passes on the legacy of a life and ensures its enduring survival. A death that would fail to accomplish this, that would

instead extinguish all memory of a person's life (a fate feared more than anything else, according to Tillich), would be a "death beyond all death" (mort par delà toute mort) – the legendary French historian Michelet was not the only one who thought it unimaginable.[14]

In Bernini's tomb of Urban VIII and in comparable works, it is an *artistic* representation of death that preserves the legacy of life from the ravishes of time and decay. And just as treasured last words, which may be such a legacy in their way, are often *artifacts* whose truth is not empirical but artistic, shaped by the creative imagination, so too are the images of death "in person," whether male and female. The insight, the truth these images convey is the truth of artistic vision. This truth may not tell us anything about "the nature of death." But it does tell us something about the nature of our species – human nature that creates these images as a way of orienting itself in the world and that tries to live – and die – in accordance with such images, for better or for worse, and sometimes very much for worse. Appreciating and understanding the representations of death that art and literature have produced over the centuries yields less than those comprehensive and definitive "answers" that theologians and philosophers have sought since the dawn of time and have been eager to convey to the rest of us. And yet, less may be more: an insight into humans as image-makers who, by making such images, not only shape their world but also define themselves.

NOTES

INTRODUCTION: WHY THIS BOOK?

1 Ill.: Eva Schuster (ed.), *Das Bild vom Tod: Graphiksammlung der Heinrich-Heine-Universität Düsseldorf* (Recklinghausen: Bongers, 1992), fig. 95.

2 Stockholm and London: Fritze, 1951.

3 See Eva Schuster (ed.), *Mensch und Tod: Graphiksammlung der Universität Düsseldorf* (Düsseldorf: Triltsch, 1989), no. 1024. There are several illustrations in Saarikivi's book. If it should be argued that Simberg was also at home in Swedish, it must of course be remembered that in Swedish, masculine and feminine grammatical gender were collapsed into the "common gender" at the end of the Middle Ages. Either way, then, by Simberg's time, grammatical gender could have no influence on the genderized personification of death.

4 Ill.: Schuster (ed.), *Mensch und Tod*, cover; see *ibid.*, no. 109. The untitled work is an illustration for Apollinaire, *Poèmes secrets* (Paris: Editions Argillet, 1967), no. 10.

5 See Schuster (ed.), *Mensch und Tod*, no. 44. Ill.: Phyllis Dearborn Massar, *Presenting Stefano della Bella* (New York: Metropolitan Museum of Art, 1971), p. 121; cp. the French text on another page of the cycle (*ibid.*, p. 125), which personifies death as an army commander.

6 See Schuster (ed.), *Mensch und Tod*, nos. 1202 (late eighteenth century), 1188 (eighteenth century), 1232 (1944).

7 Ill.: Schuster (ed.), *Das Bild vom Tod*, fig. 158.

8 See Schuster (ed.), *Mensch und Tod*, fig. 32 and nos. 807 and 808.

9 Ill.: *ibid.*, *Mensch und Tod*, fig. 34; Schuster (ed.), *Das Bild vom Tod*, fig. 92.

10 See Schuster (ed.), *Mensch und Tod*, no. 639. Strindberg, *Simoom/Samum* (1890): Strindberg, *Samlade Skrifter*, vol. XXIII (Stockholm: Bonniers, 1914), pp. 404–420; Edwin Björkman (tr. and ed.), Strindberg, *Plays*, third series (New York: Scribner's, 1914), pp. 65–77.

11 Fogg Museum, Harvard University. Ill.: Pierre Louis Mathieu, *Gustave Moreau* (Oxford: Phaidon, 1977), p. 91.

12 *Ibid.*, p. 271, n. 362; see also p. 90.

I. IMAGINING THE UNIMAGINABLE: DEATH PERSONIFIED

1 On the Pisa fresco, see above, pp. 71–75. Anon. etching: Eva Schuster (ed.), *Das Bild vom Tod: Graphiksammlung der Heinrich-Heine-Universität Düsseldorf* (Recklinghausen: Bongers, 1992), fig. 51. Eva Schuster (ed.), *Mensch und Tod: Graphiksammlung der Universität Düsseldorf* (Düsseldorf: Triltsch, 1989), no. 1167, considers this to be a male death figure. If this is correct, the etching, with its Italian text, would be yet another piece of evidence in support of my view that the genderization of death is not necessarily dependent on grammatical gender. On other Italian female reapers, see above, pp. 68–71. Broadside: M. Sánchez-Camargo, *La Muerte y la pintura española* (Madrid: Editora Nacional, 1954), fig. 155; see also above, p. 90, and below, p. 263 n. 70. For German examples of the (male) reaper, see, e.g., Schuster (ed.), *Mensch und Tod*, nos. 550, 754, 1027, 1044, 1179. On German female reapers, see below, p. 264, n. 94, p. 280, n. 73, and above, pp. 225–226, 230. A Hungarian representation of death as female reaper is mentioned above, p. 22. (Hungarian has no grammatical gender.) On Simone de Beauvoir's "grande moissonneuse," see above, p. 191; on Ronsard, see above, p. 112.

2 This is the view of Gion Condrau, stated in an argument with Heidegger as interpreted by Helmut Thielicke, *Tod und Leben* (Tübingen: Mohr, 1946), pp. 82–90 (cp. Jean Améry, *Über das Altern* [Stuttgart: Klett, 1969], p. 119: "leere Unkenntlichkeit"). See also Terry Eagleton's matter-of-fact statement that death "is beyond representation" in his review of Jonathan Dollimore's *Death, Desire and Loss in Western Culture*, *London Review of Books*, April 16, 1998, p. 13. Condrau, *Der Mensch und sein Tod*

(Zurich: Benziger, 1984) argues against Heidegger: "Death is not that impersonal" (p. 293). See also Werner Block, *Der Arzt und der Tod in Bildern aus sechs Jahrhunderten* (Stuttgart: Enke, 1966), p. 28: death is "always personified."

3 *Maximen und Reflexionen*, Goethe, *Werke* (Hamburg Edition), vol. XII, p. 470. See also Peter Horst Neumann, "Die Sinngebung des Todes als Gründungsproblem der Ästhetik," *Merkur* 34 (1980), 1071–1072.

4 Hauptmann, *Sämtliche Werke* (Centenary Edition), vol. II, p. 1246; *The Dramatic Works of Gerhart Hauptmann*, tr. Willa and Edwin Muir (New York: Huebsch, 1924), vol. VIII, p. 218. On Jung's similar view of the genesis and function of archetypical images, see Edgar Herzog, *Psyche und Tod: Wandlungen des Todesbildes im Mythos und in den Träumen heutiger Menschen* (Zurich and Stuttgart: Rascher, 1960), p. 48.

5 Hofmannsthal, *Sämtliche Werke* (Kritische Ausgabe), vol. III, pp. 79–80; "Wie wundervoll sind diese Wesen, / die, was nicht deutbar, dennoch deuten"; *Poems and Verse Plays*, tr. Michael Hamburger (London: Routledge and Kegan Paul, 1961), p. 137.

6 "Sans doute, toute civilisation est-elle hantée, visiblement ou invisiblement, par ce qu'elle pense de la mort" (*Antimémoires* [Paris: Gallimard, 1967], p. 266); *Anti-Memoirs*, tr. Terence Kilmartin (New York: Holt, Rinehart and Winston, 1968), p. 180. See also Walther Rehm, *Der Todesgedanke in der deutschen Dichtung vom Mittelalter bis zur Romantik* (Halle: Niemeyer, 1928), p. 1. Rehm quotes Wilhelm Dilthey, *Das Erlebnis und die Dichtung* (Leipzig: Teubner, 1919), p. 230, as does Heidegger, *Sein und Zeit*, 6th edn. (Tübingen: Neomarius, 1949), p. 249. Cp. William Ernest Hocking, *The Meaning of Immortality in Human Experience* (New York: Harper, 1957), pp. 5, 12: "Man is the only animal that contemplates death . . . The fact that life has a time limit allows it to have shape and character." Robert Browning, *The Ring and the Book*: "Even throughout life, 'tis death that makes life live, / Gives it whatever the significance" (Book 11, 2376–2377).

7 Montaigne, *Essais*, vol. 1, no. 20.

8 Cp. Thomas Mann, *Der Tod in Venedig, Gesammelte Werke in zwölf Bänden* (Frankfurt: Fischer, 1960), vol. VIII, p. 525: death is "verheißungsvoll ungeheuer" ("an immensity rich with unutterable expectation" [*Death in Venice and Other Stories*, tr. David Luke (London: Secker and Warburg, 1990), p. 267]).

9 Ekkehard Mai and Anke Repp-Eckert (eds.), *Triumph und Tod des Helden: Europäische Historienmalerei von Rubens bis Manet* (Milan: Electa, and Cologne: Museen der Stadt Köln, 1988), p. 195; the original is in the Musée Didier in Langres.

10 C. E. Sander-Hansen, *Der Begriff des Todes bei den Ägyptern* (Copenhagen: Munksgaard, 1942), p. 28; death is, however, hardly ever personified in Egyptian mythology; see S. G. F. Brandon, *Man and his Destiny in the Great Religions* (University of Toronto Press, 1962), p. 62, and Brandon, "The Personification of Death in Some Ancient Religions," *Bulletin of the John Rylands Library, Manchester* 43 (1961), 319–322.

11 "Der alte Schütz, der Tod genannt": see Henri Stegemeier, "The Dance of Death in Folksong, with an Introduction on the History of the Dance of Death" (diss., University of Chicago, 1939), pp. 14–15; *Ackermann*: ill. in Hellmut Rosenfeld, *Der mittelalterliche Totentanz*, 3rd edn. (Cologne and Vienna: Böhlau, 1974), fig. 10. Renaissance: see the illustrations in Karl Bernd Heppe et al. (eds.), *Bilder und Tänze des Todes: Eine Ausstellung des Kreises Unna* (Paderborn: Bonifatius-Druckerei, 1982), pp. 18, 32, 33. For examples of Death the reaper, horseman, hunter, fiddler, and gravedigger, see Rosenfeld, *Totentanz*, pp. 10–25; also Engelbert Kirschbaum et al. (eds.), *Lexikon der christlichen Ikonographie* (Rome: Herder, 1972), s.v. "Tod" (Hellmut Rosenfeld).

12 L. E. Kastner (ed.), Drummond of Hawthornden, *Poetical Works* (Edinburgh and London: Blackwell, 1913), vol. II, p. 28. Published in *Flowres of Sion* (1623).

13 Stegemeier, "The Dance," p. 136. For further examples of a fearful male Death in English and

258

German folksongs, see pp. 86, 102, 117, 121, 159, 181, 190, 197, 199, 207, 216, 218. On the "general," see also Erwin Koller, *Totentanz* (Innsbruck: Institut für Germanistik, 1980), pp. 344, 345 (eighteenth century).

14 See Joachim Fest, *Der tanzende Tod: Über Ursprung und Formen des Totentanzes vom Mittelalter bis zur Gegenwart* (Lübeck: Kunsthaus, 1986), p. 58. For a contrary view, see Urban Roedl (ed.), Claudius, *Werke* (Zurich: Buchclub Ex Libris, n.d.), p. 957, where the debate is summarized.

15 On the popularity of the motif, see Jacob Grimm, *Deutsche Mythologie*, 3rd edn. (Göttingen: Dieterich, 1854), vol. II, ch. 27.

16 Bernhard Suphan (ed.), Herder, *Sämmtliche Werke*, vol. XXVIII (Berlin: Weidmann, 1884), p. 135. An abundance of examples of the death personifications mentioned may be found in Oskar Schwebel, *Der Tod in deutscher Sage und Dichtung* (Berlin: Alfred Weile, 1876) and Koller, *Totentanz*, pp. 325–381; see also Koller's index, p. 744.

17 See above, n. 13.

18 Schwebel, *Der Tod*, p. 25; see also Ernst Jünger, *Siebzig verweht*, vol. III (Stuttgart: Klett-Cotta, 1993), p. 363. On Baudelaire, see above, p. 211.

19 Hans Abrahamsson, *The Origin of Death: Studies in African Mythology* (Uppsala: Almquist and Wiksell, 1951), ch. 10: "Death as Personification" (numerous examples of "Mr. Death").

20 Friedrich Wilhelm Wentzlaff-Eggebert, *Der triumphierende und der besiegte Tod in der Wort- und Bildkunst des Barock* (Berlin: de Gruyter, 1975), plate 9; J. E. Wessely, *Die Gestalten des Todes und des Teufels in der darstellenden Kunst* (Leipzig: Hermann Vogel, 1876), pp. 29–30; Francis Douce, *The Dance of Death* (London: Bell, 1902), p. 168. See also below, p. 281, n. 93.

21 See Herzog, *Psyche und Tod*, pp. 118–123. On folksongs, see Stegemeier, "The Dance," p. 19.

22 Florence Warren, *The Dance of Death*, Early English Text Society, Orig. Series, no. 181 (London: Milford, 1931), pp. xix–xx (on the

game); on the *Trionfi*, see below, p. 69. See also John Lindow, "Personification and Narrative Structure in Scandinavian Plague Legends," *ARV: Tidskrift för Nordisk Folkminnesforskning* 29–30 (1973–74), 83–92 (female anthropomorphization). Colin Platt's book on the plague in England is entitled *King Death* (London: UCL Press, 1996).

23 Gen. 19:2; 2 Kings 19:35; 2 Samuel 24:15–16; 1 Chr. 21:15; 2 Chr. 32:21; Is. 37:36.

24 Ills.: Garrett Stewart, *Death Sentences: Styles of Dying in British Fiction* (Cambridge, Mass.: Harvard University Press, 1984), title-page (D. C. French); *Le Symbolisme en Europe* (Rotterdam: Museum Boymans–van Beuningen, 1975), p. 205 (Schwabe); *Malczewski* (Stuttgart: Württembergischer Kunstverein, 1980), pp. 50, 51, 61, 127. Several examples of the Renaissance's winged Death are cited in Erwin Panofsky, "Mors vitae testimonium," *Studien zur toskanischen Kunst: Festschrift für L. H. Heydenreich* (Munich: Prestel, 1964), pp. 221–236.

25 On the iconography of angels, see *Die Religion in Geschichte und Gegenwart*, 2nd edn., vol. II (Tübingen: Mohr, 1928), cols. 137–140; Mircea Eliade (ed.), *The Encyclopedia of Religion*, vol. I (New York: Macmillan, 1987), pp. 285–286; Brandon, "The Personification," 325–326.

26 *Faust*, 11397; Wolfhagen: Schuster (ed.), *Mensch und Tod*, no. 1142; Rimbaud, "Les Sœurs de charité" (final line). Henry Thode, *Franz von Assisi* (Berlin: Grote, 1904), claims that St. Francis's last words were to "Brother Death" (p. 47); this is probably a "Germanification."

27 Rilke, *Gesammelte Werke*, vol. III (Leipzig: Insel, 1930), p. 282; *Duino Elegies and the Sonnets to Orpheus*, tr. A. Poulin (Boston: Houghton Mifflin, 1977), p. 39.

28 Graphics collection in the Dept. of History of Medicine, Düsseldorf University.

29 Altar: see fig. 35 in *Día de los Muertos: A Celebration of this Great Mexican Tradition Featuring Articles, Artwork, and Documentation from Mexico, Across the United States, and Chicago*

(Chicago: Mexican Fine Arts Center Museum, 1991), p. 25; see also p. 28: "Forceful examples are the *carretas de la muerte* (death carts) which contain powerful images of death affectionately known as *Doña Sebastiana*. It is *la Doña Sebastiana* which is the most potent icon of death in the visual iconography of the Southwest" (Tomás Ybarra Frausto). Toy: fig. 8 in Robert V. Childs and Patricia B. Altman, *Vive tu Recuerdo: Living Traditions in the Mexican Days of the Dead*, UCLA Monograph Series, no. 17 (Los Angeles: Museum of Cultural History, 1982), p. 14; *Lebende Tote: Totenkult in Mexiko* (Bremen: Überseemuseum, 1986), pp. 91, 113. Modern art: *Día de los Muertos*, figs. 39 (p. 29) and 40 (p. 30), dated 1987 and 1988, respectively. On (female) names and circumlocutions for death personified, see Luis Alberto Vargas, "Conception of Death in Mexico Today," *Artes de México* 145 (1971), 92 (Span., 57).

Colombian folklore knows of a female death figure called "Dama de la Hoz," the scythe woman; see Wolf Lustig, "Totentanz-Symbolik im modernen spanischsprachigen Roman," Franz Link (ed.), *Tanz und Tod in Kunst und Literatur* (Berlin: Duncker u. Humblot, 1993), p. 519. In the northeastern provinces of Argentina, on the other hand, we find a cult of San La Muerte, a (male) Saint Death not recognized by the Catholic Church; he may owe his existence to Indian (Guaraní) mythological concepts; he is addressed as "Señor La Muerte"; see Maria Susana Cipolletti, *Langsamer Abschied: Tod und Jenseits im Kulturvergleich* (Frankfurt: Museum für Völkerkunde, 1989), pp. 265–271.

30 See *Artes de México* 145 (1971), 46, ill.: an engraving of Death as Empress on the title page of Joaquín Bolaños, *La portentosa vida de la muerte, emperatriz de los sepulcros, vengadora de los agravios del altísimo, y muy señora de la humana naturaleza . . .*, impresa en México . . . 1792.

31 See *Lebende Tote*, pp. 103, 112, 113, and Lustig, "Totentanz-Symbolik," pp. 519–520.

32 See the illustrations in *Lebende Tote*, p. 122; C. A. Burland, *Peoples of the Sun* (New York: Praeger, 1976), pp. 57, 105; Eduardo Matos Moctezuma, *The Mask of Death in Prehispanic Mexico* (México City: García Valadés, 1988), pp. 53, 61, 70, 71; Cecilia F. Klein, "Post-Classic Mexican Death Imagery as a Sign of Cyclic Completion," E. P. Benson (ed.), *Death and the Afterlife in Pre-Columbian America* (Washington, D.C.: Dumbarton Oaks, 1975), pp. 70–71.

33 See the Czech example in Stegemeier, "The Dance", pp. 174–176, and also a Slovak example, pp. 177–178. On Slavic superstition, see Hanns Bächtold-Stäubli (ed.), *Handwörterbuch des deutschen Aberglaubens*, vol. VIII (Berlin and New York: de Gruyter, 1987), col. 978. On Giltine, see E. Washburn Hopkins, *The History of Religions* (New York: Macmillan, 1918), pp. 143–144: "worshipped even now." In Polish fairy-tales her name is Kostucha.

34 Richard A. Lipsius and Max Bonnet (eds.), *Acta Apostolorum apocrypha* (Leipzig: H. Mendelssohn, 1898), pt. 2, vol. I, p. 141.

35 Frederick H. Holck, "Sutras and the Mahabharata Epic," Holck (ed.), *Death and Eastern Thought* (Nashville and New York: Abingdon Press, 1974), pp. 58–61. In the Vedic period (1500–450 BC) Yama is the god of death ruling the subterranean realm of the dead, but he is not thought of as inflicting death himself; see Brandon, *Man and his Destiny*, pp. 309–313. In the *Mahabharata*, Yama is designated as Death's helper; see Holck, pp. 59–60, 67.

36 Grimm, *Deutsche Mythologie*, vol. II, pp. 799, 804; Herzog, *Psyche und Tod*, pp. 42–43, 121; Schwebel, *Der Tod*, pp. 15, 18.

37 Barbara G. Walker, *The Woman's Encyclopedia of Myths and Secrets* (San Francisco: Harper, 1983), s.v. "Death"; Philip Rawson, *The Art of Tantra* (Greenwich, Conn.: N.Y. Graphic Society, 1973), p. 112. Simone de Beauvoir revived the idea in *Le Deuxième Sexe* (see above, pp. 190–191); in Heiner Müller's work, too, there is a panic fear of the mother as the principle of life and death: "Death is a woman" ("Der Tod ist eine Frau"); see Müller, *Herzstück* (Berlin: Rotbuch, 1983), p. 36. See also the section "Mutter Tod" in Thomas H. Macho (ed.), *Bilder vom Tod: 168. Sonderausstellung des Historischen Museums der*

Stadt Wien (Vienna: Eigenverlag der Museen der Stadt Wien, 1993), pp. 15–16 (psychoanalytical interpretation); Erich Neumann, *Die Große Mutter* (Olten and Freiburg: Walter, 1974).

38 Gabriel Turville-Petre, "Dream Symbols in Old Icelandic Literature," *Festschrift Walter Baetke* (Weimar: Böhlau, 1966), p. 347. On norns, valkyries, and *dísir*, see Heinrich Hempel, "Matronenkult und germanischer Mütterglaube," *Germanisch-Romanische Monatsschrift* 27 (1939), 261–266.

39 *Handwörterbuch des deutschen Aberglaubens*, vol. VIII, col. 977.

40 Lutz Röhrich, "Der Tod in Sage und Märchen," Gunther Stephenson (ed.), *Leben und Tod in den Religionen: Symbol und Wirklichkeit* (Darmstadt: Wissenschaftliche Buchgesellschaft, 1980), pp. 169–170.

41 Josef Hanika, "Die Tödin: Eine Sagengestalt der Kremnitz-Deutschprobener Sprachinsel," *Bayerisches Jahrbuch für Volkskunde*, 1954, 171–184; Georg Graber (ed.), *Sagen aus Kärnten*, 4th edn. (Leipzig: Dietrich, 1927), pp. 195–197. See also Ingeborg Müller and Lutz Röhrich, "Der Tod und die Toten," *Deutsches Jahrbuch für Volkskunde* 8 (1967), 346–353.

42 4th edn. (Leipzig: Brockhaus, 1872), pp. 298–299. Cp. above, pp. 174–176.

43 P. E. Slater, unpubl. MS, quoted from Robert Kastenbaum and Ruth Aisenberg, *The Psychology of Death* (New York: Springer, 1972), p. 167.

44 Kastenbaum and Aisenberg (*Psychology of Death*, pp. 169–171) favor this view, following D. McClelland, "The Harlequin Complex," Robert W. White (ed.), *The Study of Lives* (New York: Atherton Press, 1964), pp. 94–119.

45 Wilhelm Franz, *Die Sprache Shakespeares: Shakespeare-Grammatik*, 4th edn. (Halle: Niemeyer, 1939), p. 197. My subsequent remarks are based on Franz, pp. 198–199.

46 Jacob Grimm, *Deutsche Grammatik*, vol. III (Gütersloh: Bertelsmann, 1890), p. 343. See also Götz Wienold, *Genus und Semantik* (Meisenheim: Hain, 1967), pp. 20–23.

47 Greville Corbett, *Gender* (Cambridge University Press, 1991), p. 308.

48 For example: Stegemeier, "The Dance," p. 178; Röhrich, "Der Tod," p. 170; Condrau, *Der Mensch*, p. 293; *Handwörterbuch des deutschen Aberglaubens*, vol. VIII, col. 978; *Lebende Tote*, p. 98, n. 2; Grimm, *Deutsche Mythologie*, vol. II, p. 801; M. W. Bloomfield, "A Grammatical Approach to Personification Allegory," M. W. Bloomfield, *Essays and Explorations: Studies in Ideas, Language, and Literature* (Cambridge, Mass.: Harvard University Press, 1970), pp. 244–245; Schuster (ed.), *Das Bild vom Tod*, p. 11; Liliane Guerry, *Le Thème du "Triomphe de la mort" dans la peinture italienne* (Paris: Maisonneuve, 1950), p. 33; Manfred Lurker, *Wörterbuch der Symbolik* (Stuttgart: Kröner, 1988), p. 734: "The grammatical gender of the word for death determined the gender of the personification." For skepticism about this view, see Eduard Dobbert, "Der Triumph des Todes im Campo Santo zu Pisa," *Repertorium für Kunstwissenschaft* 4 (1880), 23 (grammatical gender "alone" is not the decisive determinant) and Louis Edward Jordan, "The Iconography of Death in Western Medieval Art to 1350" (diss., University of Notre Dame, 1980), p. 69: grammatical gender is "a contributing factor but it does not explain the significance of the female Death figure."

49 Krolow, *Gesammelte Gedichte*, vol. II (Frankfurt: Suhrkamp, 1975), pp. 211–212:

> Jemand an der Tür.
> Man läßt ihn stehen
> oder öffnet.
> Keine notwendige Geschichte passiert.
> Kein Hausstand wird geprüft.
> Es bleibt beim alten,
> das Blut strömt weiter
> in die Glieder.
> Man legt die Hände an irgendwas,
> stellt Strom oder Gas ab,
> läßt den Wasserhahn tropfen
> und wartet, zählt die Puls-Uhr,
> läßt sich Zeit, hat sie,

sagt schließlich HEREIN
und bereut nicht.
Der Tod ist im Deutschen
männlichen Geschlechts.

Cp. Rolf Hochhuth, *Sommer 14* (Reinbek:
Rowohlt, 1989): will Death go to war as a man or
as a woman? It depends on whether the word for
death is masculine or feminine in a given
language:

Die Tod heißt's bei den meisten
Kombattanten:
Russen, Franzosen, Italiener, Serben,
Tschechen.
Du wirst als Knecht des Kaisers
mißverstanden,
kommst du als der Tod, wie nur Deutsche
sagen! . . .
Männlich bei Briten auch – tragen
wir also androgyn. Mann oder Weib – egal
. . . (pp. 28–29)

50 Stephan Kozáky, *Der Totentanz von heute*
(Budapest: Magyar Történeti Múzeum, 1941),
p. 266 and plate LXXVIII: 1.

51 Franz, *Die Sprache Shakespeares*, pp. 195–196; for
examples, see pp. 200–201.

52 *Ibid.*, pp. 196–197, 202–205.

53 See *ibid.*, p. 197. Franz thinks that French
linguistic influence is unlikely in the case of
Shakespeare, but not with Shakespeare's
contemporaries.

54 Corbett, *Gender*, pp. 30–32.

55 See *ibid.*, pp. 225–241; also Bloomfield, *Essays*,
pp. 243–260, esp. p. 248. Bloomfield lists several
dissertations on genderization of impersonal
nouns in the works of leading English writers
(p. 244).

56 Corbett, *Gender*, pp. 92–104, 183. The change of
gender may still be observed in our own time:
until the arrival of male nurses on the scene, the
word *nurse* must have had only female
associations.

57 Grimm, *Deutsche Grammatik*, vol. III,
pp. 347–348.

58 *Ibid.*, vol. III, pp. 537–551.

59 Grimm, *Deutsche Mythologie*, vol. II, p. 801.
Dobbert, "Der Triumph," 26–29, calls attention
to a few cases of at least inchoate female
personification.

60 Bayerische Staatsbibliothek, Munich;
Jordan, "Iconography," pp. 50–51; ill.:
Rosenfeld, *Totentanz*, fig. 7, see *ibid.*,
pp. 5–6.

61 Schuster (ed.), *Das Bild vom Tod*, fig. 158.

62 Ill.: Reinhold Hammerstein, *Tanz und Musik
des Todes: Die mittelalterlichen Totentänze und
ihr Nachleben* (Berne and Munich: Francke,
1980), fig. 214. Cp. also *ibid.*, fig. 196 (Niklaus
Manuel).

63 Lorenz Morsbach, *Grammatisches und
psychologisches Geschlecht im Englischen*, 2nd edn.
(Berlin: Weidmann, 1926), p. 17 ("fast durchweg
masculinum"); Erich Ausbüttel, *Das persönliche
Geschlecht unpersönlicher Substantiva . . . im
Mittel-Englischen seit dem Aussterben des
grammatischen Geschlechts* (Halle: Niemeyer,
1904), p. 53.

64 J. van Gogh-Bonger (ed.), *Verzamelde Brieven
van Vincent van Gogh*, vol. III (Amsterdam:
Wereldbibliotheek, 1953), p. 450; Ronald de
Leeuw (ed.), *The Letters of Vincent van Gogh*, tr.
Arnold Pomerans (London: Allen Lane, 1996),
pp. 451–452.

65 Ill.: Gottfried Sello (ed.), Grandville, *Das
gesamte Werk* (Munich: Rogner and Bernhard,
1969), vol. I, p. 37. Grandville's cycle took shape
under the influence of Rowlandson's *The
English Dance of Death* (1814–16), where Death is
male. If this should account for Grandville's
male genderization of death, he clearly did not
feel that he was imposing on French
sensibilities. For further, anonymous examples
of male Death in French art, see Schuster (ed.),
Mensch und Tod, nos. 1188, 1202, and 1232
(eighteenth century).

66 Alberto Tenenti, *La Vie et la mort à travers l'art
du XVe siècle* (Paris: Armand Colin, 1952), p. 34;
for another example, see p. 35. Leonard P.
Kurtz, *The Dance of Death and the Macabre Spirit*

in European Literature (1934; repr.: New York: Gordon, 1975), p. 210, erroneously regards a death figure in a stained glass window in the Rouen church of St. Patrice (sixteenth century) as male; see the ill. in Wessely, *Gestalten des Todes*, p. 19. Kurtz's ch. 8 ("Sex of Death," pp. 209–213) is based on insufficient evidence and includes misunderstandings (e.g., concerning Beddoes and the *Dança general*); it concludes: "No universally fixed gender can then be applied to 'Death.' It varies in different countries and even within them" (p. 213). This is no doubt correct, but why does it vary, and what are the implications?

67 Leonard P. Kurtz (ed.), *Le Mors de la pomme* (New York: Publications of the Institute of French Studies, Inc., 1937), p. 13.

68 Chantilly, Musée Condé; ill.: Heppe et al. (eds.), *Bilder und Tänze des Todes*, p. 31.

69 See *ibid.*, p. 17. Ill.: Heinrich Wilhelm Schulz, *Denkmäler der Kunst des Mittelalters in Unteritalien*, vol. III (Dresden: W. K. H. Schulz, 1860), p. 53, fig. 135. The skeleton sports what appears to be a beard and hair; it wears two crowns. See also Stephan Kozáky, *Anfänge der Darstellungen des Vergänglichkeitsproblems* (Budapest: Magyar Történeti Múzeum, 1936), pp. 162–163. On male images of death in medieval Romanian churches, see Anton Kaindl, "Die Darstellung des Todes bei den Rumänen," *Stimmen aus dem Südosten*, 7–8 (1940–41), 97–100. Romanians normally personify death as a – beautiful or old – woman. For a female death personification in contemporary Romanian poetry, see Rainer Stöckli, *Zeitlos tanzt der Tod* (Constance: UVK, 1996), pp. 69–70.

70 See Sánchez-Camargo, *La Muerte*, figs. 12, 61 (?), 68, 155 (a bearded angel of death), 186. In figs. 70 and 129, attributes (hairstyle, dress) suggest that the scythe-wielding skeleton is female.

71 Ill.: Schuster (ed.), *Mensch und Tod*, cover.

72 Ill.: Paul Westheim, *Der Tod in Mexiko* (Hanau: Müller und Kiepenheuer, n.d. [1948?]), fig. 39; Siegmar Holsten, *Allegorische Darstellungen des Krieges 1870–1918: Ikonologische und*

ideologiekritische Studien (Munich: Prestel, 1976), fig. 405.

73 Schuster (ed.), *Mensch und Tod*, no. 684; ill.: *ibid.*, fig. 31, and Holsten, *Allegorische Darstellungen*, fig. 406. On Posada's controversial authorship, see Roberto Berdecio and Stanley Appelbaum (eds.), *Posada's Popular Mexican Prints* (New York: Dover, 1972), commentary on fig. D. The "calaveras" form a large thematic unit in Posada's oeuvre (see figs. 1–32 in *Posada's Popular Mexican Prints*). To be sure, *calavera* means *skull* and, in context, *skeleton*, and Posada, Méndez, and others present a vast array of contemporary and historical figures, especially political ones, as such *calaveras*. So it must be doubted that *calaveras* are invariably meant to represent *Death*; in the two cases in question, however, there can be no such doubt. They evoke the horseman Death of the apocalypse; like him, these two Mexican skeletons have countless victims; they ride roughshod over a battlefield strewn with dead bodies, much like the "warlord" or "general" Death familiar from the history of the iconography of death.

74 *Doce maestros latinoamericanos* (Mexico City: Galería López Quiroga, 1992), p. 47.

75 Bloomfield, "Grammatical Approach," p. 245.

76 See above, pp. 3–4, 208.

77 Herzog, *Psyche und Tod*, ch. 14.

78 Kastenbaum and Aisenberg, *Psychology of Death*, ch. 6, esp. pp. 155, 163.

79 Corbett, *Gender*, p. 23.

80 Grimm, *Deutsche Grammatik*, vol. III, pp. 342–343. See also G. Royen, *Die nominalen Klassifikations-Systeme in den Sprachen der Erde* (Mödling: Anthropos, 1929), pp. 42–141.

81 Corbett, *Gender*, pp. 32, 318; see also pp. 92–97.

82 *Ibid.*, p. 236.

83 *Kabale und Liebe*, Schiller, *Werke* (National Edition), vol. V, 86; *Intrigue and Love*, tr. Charles E. Passage (New York: Ungar, 1971), p. 97 (act V, sc. 1). See also Ludwig Uhlig, *Der*

Todesgenius in der deutschen Literatur: Von Winckelmann bis Thomas Mann (Tübingen: Niemeyer, 1975); Wilfried Barner, "Der Tod als Bruder des Schlafs: Literarisches zu einem Bewältigungsmodell," Rolf Winau and Hans Peter Rosemeier (eds.), *Tod und Sterben* (Berlin: de Gruyter, 1984), pp. 144–166.

84 See Kurt Heinemann, *Thanatos in Poesie und Kunst der Griechen* (diss., Munich, 1913), pp. 1, 21, 32, 37, 42–48 *and* 52–54, 60, 69, 80; Emily Vermeule, *Aspects of Death in Early Greek Art and Poetry* (Berkeley: University of California Press, 1979), pp. 37–39. On the revival of the theme in Roman times, see Jordan, "Iconography," pp. 12–14.

85 See Vermeule, *Aspects of Death*, pp. 161–162; Jörgen Birkedal Hartmann, "Die Genien des Lebens und des Todes," *Römisches Jahrbuch für Kunstgeschichte* 12 (1969), 11–38.

86 See Philippe Ariès, *Western Attitudes Toward Death: From the Middle Ages to the Present* (Baltimore and London: Johns Hopkins University Press, 1974), pp. 56–59.

87 Wessely, *Gestalten des Todes*, p. 18.

88 Heinemann, *Thanatos*, pp. 26–27, 48–49; Otto Waser, *Charon, Charun, Charos* (Berlin: Weidmann, 1898), pp. 70–84; ill.: Frederick Parkes Weber, *Aspects of Death and Correlated Aspects of Life in Art, Epigram, and Poetry*, 4th edn. (London: T. Fisher Unwin, 1922), p. 698; George Dennis, *The Cities and Cemeteries of Etruria* (London: Murray, 1848), vol. II, frontispiece; see *ibid.*, pp. 206–209, also Brandon, "The Personification," 329–330; Otto J. Brendel, *Etruscan Art* (New York: Penguin, 1978), p. 383, fig. 295.

89 Heinemann, *Thanatos*, pp. 24, 27; Vermeule, *Aspects of Death*, pp. 39–41.

90 See B. C. Dietrich, *Death, Fate and the Gods* (London: Athlone Press, 1965), ch. 3, esp. p. 72.

91 Tenenti, *La Vie et la mort*, p. 33; "Dordrecht in Holland": Schuster (ed.), *Mensch und Tod*, no. 1160; for a similar motif (the skeleton cuts the thread of life), see *ibid.*, no. 767 (1936).

92 See Dietrich, *Death, Fate*, ch. 4, esp. p. 91.

93 See Vermeule, *Aspects of Death*, pp. 162–165.

94 Bernhard Suphan (ed.), Herder, *Sämmtliche Werke*, vol. XXIX (Berlin: Weidmann, 1889), p. 297. An eccentric amalgamization of Christian and classical personifications of death may be found in Karl Wilhelm Ramler's "Dirge on the Death of a Quail" ("Nänie auf den Tod einer Wachtel"). It says about the "spirit" (Geist) of the dead animal: "Let it perch on your shoulder, heavenly reaperess, with sheaves of wheat in your hands and poppies in your basket" (Laß ihn auf deiner Schulter sitzen, / Schnittermädchen des Himmels, die du Weizen / In den Händen und Mohn im Körbchen trägest, *Poetische Werke*, vol. I [Vienna: Pichler, 1801], p. 22). Wheat and poppies are the attributes of Demeter, Mother Earth and Goddess of Death in Greek mythology; see *Der kleine Pauly*, vol. I (Stuttgart: Druckenmüller, 1964), cols. 1459–1464.

95 Jordan, "Iconography," pp. 8–9.

96 Brandon, "The Personification," pp. 333–335.

97 Uhlig, *Der Todesgenius*, pt. 2.

98 Karl Vietor took issue with it as early as 1945 in an article in *Publications of the Modern Language Association of America*, reprinted as *Literaturwissenschaft als Geistesgeschichte* (Berne: Francke, 1967).

99 Eckhard Schinkel, "Gerippe, Hain und Genius," Heppe et al. (eds.), *Bilder und Tänze des Todes*, p. 75.

100 *Markings* (New York: Knopf, 1964), p. 160.

2. THE MIDDLE AGES: THE UNFORTUNATE FALL

1 Larry D. Benson (ed.), *The Riverside Chaucer*, 3rd edn. (Oxford University Press, 1988), p. 199 (675, 699, 700).

2 Johannes Kleinstück, "Zur Auffassung des Todes im Mittelalter," *Deutsche Vierteljahrsschrift für Literaturwissenschaft und Geistesgeschichte* 28 (1954), 40–60; Philippa Tristram, "'Olde Stories Longe Tyme Agoon':

Death and the Audience of Chaucer's
Pardoner," Herman Braet and Werner Verbeke
(eds.), *Death in the Middle Ages* (Leuven
University Press, 1983), pp. 179–190. On the
medieval tradition of the vilification of Death as
uncourtly "villain," see Kleinstück; on Dante's
uncourtly image of Death, see J. Huizinga, *Wege
der Kulturgeschichte* (Munich: Drei Masken,
1930), pp. 165–170.

3 See Philippa Tristram, *Figures of Life and Death
in Medieval English Literature* (London: Elek,
1976), p. 175: "Most medieval literature is agreed
that death is the penalty paid by man for original
sin."

4 *Moralium Libri*, XVI, 19 (*Patrologia Latina*,
vol. LXXV, col. 1049). See Claude Blum, *La
Représentation de la mort dans la littérature
française de la Renaissance*, 2nd edn. (Paris:
Honoré Champion, 1989), p. 35: "La Mort
continue à être figure du Péché et le Péché figure
de la Mort."

5 Alberto Tenenti, *La Vie et la mort à travers l'art
du XVe siècle* (Paris: Armand Colin, 1952), p. 30:
"Dans certains fresques de la danse macabre, la
première scène est constituée par le péché
originel, cause première de la mort." James M.
Clark, *The Dance of Death in the Middle Ages and
the Renaissance* (Glasgow: Jackson, 1950), pp. 34,
37 (date of La Chaise-Dieu), 38, 57, 73, 101–102;
Stephan Cosacchi, *Makabertanz* (Meisenheim:
Hain, 1965), p. 681; Gisela Luther, *Heinrich
Aldegrever*, Bildhefte des Westfälischen
Landesmuseums für Kunst- u.
Kulturgeschichte, no. 15 (n.p., 1982), p. 13.

6 See J. E. Wessely, *Die Gestalten des Todes und des
Teufels in der darstellenden Kunst* (Leipzig:
Hermann Vogel, 1876), pp. 13–14; Louis Edward
Jordan, "The Iconography of Death in Western
Medieval Art to 1350" (diss., University of Notre
Dame, 1980), pp. 95, 43–48, 52 (this study was
helpful in calling my attention to pictorial
material); Cosacchi, *Makabertanz*, p. 658;
Hester L. Williams, "The Personification of
Death in Medieval German Literature
(1150–1300): A Misrepresentation of Christian
Doctrine" (diss., University of Kansas, 1974),
p. 9; Karl Bernd Heppe, "Bemerkungen zu den

Gestalten des Todes in der Dürerzeit," Heppe et
al. (eds.), *Bilder und Tänze des Todes: Eine
Ausstellung des Kreises Unna* (Paderborn:
Bonifatius-Druckerei, 1982), pp. 29–30, where
other cases are mentioned as well. Photo of the
tympanon of Strasbourg Cathedral: *ibid.*,
fig. 2.

7 Rudolf Helm, *Skelett- und Todesdarstellungen bis
zum Auftreten der Totentänze* (Strasbourg:
Heitz, 1928), p. 33. For a photo of the
Copenhagen cross, see Adolph Goldschmidt,
Die Elfenbeinskulpturen, vol. III (Berlin:
Cassirer, 1923), Plate 43, fig. 124a.

8 Joseph Leo Koerner, "The Mortification of the
Image: Death as a Hermeneutic in Hans
Baldung Grien," *Representations* 10 (1985),
52–101, esp. 87–94.

9 Leonard P. Kurtz (ed.), *Le Mors de la pomme*
(New York: Publications of the Institute of
French Studies, 1937), p. 13.

10 Theodor Frimmel, "Beiträge zu einer
Ikonographie des Todes," *Mittheilungen der k. k.
Central-Commission zur Erforschung und
Erhaltung der Kunst- und historischen Denkmale*
10 (1884), XLIII.

11 Williams, "Personification," 7–9; Wessely,
Gestalten des Todes, p. 12.

12 Erich Ausbüttel, *Das persönliche Geschlecht
unpersönlicher Substantiva . . . im Mittel-
Englischen seit dem Aussterben des grammatischen
Geschlechts* (Halle: Niemeyer, 1904), pp. 53, 131;
on the theological reasons for Christian
misogyny, see Neil Forsyth, *The Old Enemy:
Satan and the Combat Myth* (Princeton
University Press, 1987), pp. 212–218; J. M.
Roberts, *A History of Europe* (Oxford: Helicon,
1996), pp. 143–144. On Augustine, see n. 51
below.

13 Jordan, "Iconography," ch. 5; Raimond van
Marle, *Iconographie de l'art profane au Moyen-Age
et à la Renaissance*, vol. II (The Hague: Nijhoff,
1932), p. 363; Helm, *Skelett- und
Todesdarstellungen*, passim. Hellmut Rosenfeld
notes that it was not until the sixteenth century
that death was commonly represented as a

skeleton; see his *Der mittelalterliche Totentanz*, 3rd edn. (Cologne and Vienna: Böhlau, 1974), p. 28.

14 See Liliane Guerry, *Le Thème du "Triomphe de la Mort" dans la peinture italienne* (Paris: Maisonneuve, 1950), pp. 118–119 and fig. 14 (following p. 132); Cosacchi, *Makabertanz*, pp. 560–571.

15 Adele Reuter, *Beiträge zu einer Ikonographie des Todes* (diss., Strasbourg; Leipzig: Dieterich, 1913), pp. 8–9. On the date, see Wilhelm Molsdorf, *Christliche Symbolik der mittelalterlichen Kunst* (Leipzig: Hiersemann, 1926), p. 241. Reuter, p. 10, provides a list of illustrations. See also Eduard Dobbert, "Der Triumph des Todes im Campo Santo zu Pisa," *Repertorium für Kunstwissenschaft* 4 (1880), 21–23.

16 See the list of illustrations in Reuter, *Beiträge*, pp. 20–28; Jordan, "Iconography," ch. 3: "Death Conquered."

17 On the Utrecht psalter, see Jordan, "Iconography," pp. 22–23; on San Marco, see Stephan Kozáky, *Anfänge der Darstellungen des Vergänglichkeitsproblems* (Budapest: Magyar Történeti Múzeum, 1936), p. 158; ill.: plate IV: 7; Jordan, "Iconography," pp. 56–57; Gertrud Schiller, *Ikonographie der christlichen Kunst*, vol. III (Gütersloh: Mohn, 1971), fig. 145.

18 Reuter, *Beiträge*, pp. 32, 35–36; Dobbert, "Triumph," 22.

19 Reuter, *Beiträge*, pp. 33–35; Jordan, "Iconography," pp. 58–59; ill.: Kozáky, *Anfänge*, plate IV: 5; Louisa Twining, *Symbols and Emblems of Early and Medieval Christian Art* (London: Murray, 1885), plate LXVIII: 2.

20 Reuter, *Beiträge*, pp. 38–39; on the ill.: *ibid.*, p. 42. Ill. (detail): Rosenfeld, *Totentanz*, fig. 7; ill. of the entire image: Gertrud Schiller, *Ikonographie der christlichen Kunst*, vol. II (Gütersloh: Mohn, 1968), fig. 385; see *ibid.*, pp. 126–127.

21 Jordan, "Iconography," p. 43; Schiller, *Ikonographie*, vol. II, p. 140, fig. 433 ("animal head").

22 Kozáky, *Anfänge*, p. 159; Reuter, *Beiträge*, pp. 40–41; Jordan, "Iconography," pp. 53–54.

23 Jordan, "Iconography," pp. 65–66; ill.: Alexandre de Laborde, *La Bible moralisée*, vol. IV (Paris: Pour les membres de la Société, 1921), fig. 599.

24 Joseph Stange (ed.), *Dialogus miraculorum* (Cologne: Heberle, 1851), Distinctio XI, ch. 61, II, 312. See Jordan, "Iconography," p. 66. The quotation is preceded by: "Quidam putant mortem esse personam"; it is followed by a reference to the male Old Testament angel of death.

25 See Jordan, "Iconography," pp. 108–110. On the identification with the devil, see Jordan, ch. 2: "Death in the Early Middle-Ages: Mors-Satan"; also Williams, "Personification," pp. 96–101.

26 See Roberts, *A History of Europe*, pp. 139–140.

27 Reprinted in Gerhild Scholz Williams, *The Vision of Death: A Study of the "Memento mori" Expressions in Some Latin, German, and French Didactic Texts of the 11th and 12th Centuries* (Göppingen: Kümmerle, 1976), p. 155 (stanza 3).

28 Williams, *Vision of Death*, p. 73. The text is reprinted in *ibid.*, pp. 140–152. See Cosacchi, *Makabertanz*, pp. 26–28, for a description of the (male) roles of Death. See also Blum, *Représentation*, pp. 32–33, and Gerhild Scholz Williams, "Der Tod als Text und Zeichen in der mittelalterlichen Literatur," Braet and Verbeke (eds.), *Death in the Middle Ages*, pp. 134–149.

29 Tenenti, *La Vie et la mort*, p. 35; on the date, see p. 32. Ms. Bibl. Nat. 594.

30 Williams, "Der Tod als Text," p. 138.

31 See Kleinstück, "Auffassung des Todes."

32 Ill.: *Die Waage* 30: 3 (1991), 115. Death also appears as drummer in the "Mittelrheinischer Totentanz" (*Der doten dantz*, late fifteenth century); ill. in the facsimile edn. by Albert Schramm (Leipzig: Hiersemann, 1922), fig. 11. See also n. 46 below.

33 Gert Kaiser, *Der tanzende Tod: Mittelalterliche Totentänze* (Frankfurt: Insel, 1983), p. 116.

34 Tenenti, *La Vie et la mort*, fig. 8; cp. p. 34.

35 Wessely, *Gestalten des Todes*, pp. 27–28; Rosenfeld, *Totentanz*, p. 17. Ill.: Heinrich Wilhelm Schulz, *Denkmäler der Kunst des Mittelalters in Unteritalien*, vol. III (Dresden: W. K. H. Schulz, 1860), p. 53, fig. 135 (see above, p. 263 n. 69); D. C. Hesseling, *Charos* (Leiden: van Doesburgh, 1897), pp. 37–39.

36 Ill.: Norbert Ohler, *Sterben und Tod im Mittelalter* (Munich and Zurich: Artemis, 1990), p. 23; Tristram, *Figures of Life and Death*, frontispiece; Heppe et al. (eds.), *Bilder und Tänze des Todes*, p. 31, speaks of a tradition of this image of death as nobleman, with references to English and French thirteenth-century manuscripts. Rosenfeld, *Totentanz*, ills. 2 and 3 show Death as a knight riding a cow (!), wielding his lance (Amiens missal, 1323).

37 A. C. Cawley (ed.), *Everyman and Medieval Miracle Plays* (London: Dent, 1974); R. T. Davies (ed.), *Ludus Coventriae: The Corpus Christi Play of the English Middle Ages* (London: Faber, 1972), pp. 198–202, and Stephen Spector (ed.), *The N-Town Play* (Oxford University Press, 1991), vol. I, pp. 193–195. See Walther Rehm, *Der Todesgedanke in der deutschen Dichtung vom Mittelalter bis zur Romantik* (Halle: Niemeyer, 1928), pp. 91–92, on the Alsfeld passion play.

38 Norman Davis (ed.), *The Pride of Life* in *Non-Cycle Plays and Fragments* (Oxford University Press 1970); Mark Eccles (ed.), *The Castle of Perseverance* in *Macro Plays* (Oxford University Press 1969).

39 A. V. C. Schmidt (ed.), *The Vision of Piers Plowman* (London: Dent, 1978), p. 254 (Passus XX, 88–105). Schmidt's text is that of the B version, which is generally considered the authoritative one.

40 See Rehm, *Todesgedanke*, pp. 93–97, 100. "Douce mère": *Regrès de la mort de S. Loys* (thirteenth century); see Claude Thiry, "De la mort marâtre à la mort vaincue: Attitudes devant la mort dans la déploration funèbre française," Braet and Verbeke (eds.), *Death in the Middle Ages*, p. 242. "Sweet Death": Anton

Benedict (ed.), *Das Leben des Heil. Hieronymus* [thirteenth century] (Prague: Tempski, 1880), pp. 62–65 (also "Sister Death"). See also Enite's desperate longing for death as her bridegroom when she believes Erec to be dead, in Hartmann von Aue's *Erec*, 5886–5907. (I owe this reference to Gert Kaiser, *Der Tod und die schönen Frauen* [Frankfurt and New York: Campus, 1995], p. 31.)

41 H. Walther, *Das Streitgedicht in der lateinischen Literatur des Mittelalters* (Munich: Beck, 1920), pp. 80–85; Henri Stegemeier, "The Dance of Death in Folksong, with an Introduction on the History of the Dance of Death" (diss., University of Chicago, 1939), pp. 33–35.

42 See Thiry, "De la mort marâtre," pp. 239–257; Claude Thiry, *La Plainte funèbre*, Typologie des sources du Moyen Age occidental, fasc. 30 (Turnhout: Brepols, 1978), pp. 75–90.

43 Paris MS, as edited by Leonard P. Kurtz (see above, n. 9), p. 13. The *Dictionnaire des lettres françaises* places *Le Mors* in the early fifteenth century; a good case is made for the middle of the century by Pasquale Morabito (who ascribes the work to Jean Miélot) in his *Mors de la pomme* (Messina: Peloritana, 1967), p. 137.

44 Clark, *Dance of Death*, pp. 107–111. Rosenfeld thinks that *originally* the skeleton represented not Death but a dead person (*Totentanz*, p. 199).

45 See the survey in Clark, *Dance of Death*, p. 113.

46 An exception is the sixteenth-century German ivory statuette in the Victoria and Albert Museum; it shows a mummified drummer Death with male sex organs; ill.: Frederick Parkes Weber, *Aspects of Death and Correlated Aspects of Life in Art, Epigram, and Poetry*, 4th edn. (London: T. Fisher Unwin, 1922), p. 68, see also p. 67. For a similar Dance of Death image from a Cassel manuscript (ca. 1470), see Reinhold Hammerstein, *Tanz und Musik des Todes* (Berne and Munich: Francke, 1980), fig. 281.

47 See Sarah Webster Goodwin, *Kitsch and Culture: The Dance of Death in Nineteenth-Century Literature and Graphic Arts* (New York

48 Hartmut Freytag (ed.), *Der Totentanz der Marienkirche in Lübeck und der Nicolaikirche in Reval (Tallinn)* (Cologne: Böhlau, 1993), p. 184. On the Heidelberg blockbook, see Gert Kaiser, *Der tanzende Tod*, fig. 1, and H. F. Massmann, *Atlas zu dem Werke: Die Baseler Todtentänze* (Leipzig: Expedition des Klosters, 1847), fig. 23. See also Theodor Prüfer (ed.), *Der Todtentanz in der Marien-Kirche zu Berlin* (Berlin: Prüfer, 1883), p. 15, where Death is addressed as "Geselle" (117).

49 Florence Warren, *The Dance of Death*, Early English Text Society, Orig. Series, no. 181 (London: Humphrey Milford, 1931), p. xx.

50 See Rosenfeld, *Totentanz*, fig. 12; Clark, *Dance of Death*, pp. 51–52: the skeletons are identified as Death's assistants (p. 52); see also Guido Bonandrini, *Il trionfo della morte e la danza macabra, Clusone 1485/1985* (Clusone: Ferrari, 1985).

51 *Patrologia Latina*, vol. xxxix, col. 2131. I owe this (verified) reference to Jordan, "Iconography," p. 75. For the larger context, see Ernst Guldan, *Eva und Maria: Eine Antithese als Bildmotiv* (Cologne: Böhlau, 1966). On Augustine's incrimination of Adam *and* Eve, see *Civitas Dei*, XIII, 14, also Forsyth, *The Old Enemy*, pp. 434–436.

52 Jordan, "Iconography," p. 79, cites evidence from Augustine and Anselm of Canterbury.

53 See the examples in Jordan, "Iconography," pp. 80–83. On the following sentence, see Max Geisberg, *Heinrich Aldegrever* (Dortmund: Ruhfus, 1939), p. 21.

54 The manuscript is in the Staatsbibliothek Preußischer Kulturbesitz in Berlin. See Jordan, "Iconography," pp. 69–70; Wilhelm Neuß, *Die Apokalypse des Hl. Johannes in der altspanischen und altchristlichen Bibel-Illustration* (Münster: Aschendorff, 1931), pp. 45–47, 247–267 (esp.

pp. 252–253); ill.: fig. clviii: b; John Williams, *The Illustrated Beatus*, vol. I (London: Harvey Miller, 1994).

55 Plate xxvii in Allan Temko, *Notre-Dame of Paris* (London: Secker and Warburg, 1956); Marcel Aubert, *Notre-Dame de Paris* (Paris: Editions Albert Morancé, n.d. [1928]), fig. 44.

56 See Jordan, "Iconography," pp. 77, 88, and 125; Wolfgang Medding, *Die Westportale der Kathedrale von Amiens und ihre Meister* (Augsburg: Filser, 1930), fig. 90; Bernhard Degenhart and Annegrit Schmitt, *Corpus der italienischen Zeichnungen 1300–1450* (Berlin: Mann, 1968), part I, vol. I, p. 41. Ill.: *ibid.*, vol. III, plate xxxvii: b.

57 Ill.: Rosenfeld, *Totentanz*, fig. 5; Kozáky, *Anfänge*, plate vii: 1. But see above, p. 49 and note 28 on Hélinant's genderization of Death.

58 J. J. Stürzinger (ed.), *Pèlerinage de vie humaine* (London: Roxburgh Club, 1893), pp. 418–419 (13420–13426).

59 Ill.: Millard Meiss, "Atropos-Mors," J. W. Rowe and W. H. Stockdale (eds.), *Florilegium historiale* (University of Toronto Press, 1971), fig. 4; see also Michael Camille, *Master of Death: The Lifeless Art of Pierre Remiet* (New Haven and London: Yale University Press, 1996), pp. 130–133.

60 Paris: Armand Colin, 1934, p. 240.

61 Arthur Långfors's edition, *Romania* 47 (1921), 516. See also Marie-Thérèse Lorcin, "Le Thème de la mort dans la littérature médiévale," Danièle Alexandre-Bidon and Cécile Treffort (eds.), *A Réveiller les morts* (Lyon: Presses universitaires, 1993), pp. 46–48; see p. 47 for an illustration from a thirteenth-century manuscript.

62 Kurtz (ed.), *Le Mors de la pomme*, p. 13; on Eve's guilt, see p. 2.

63 F. A. de Icaza (ed.), *La Danza de la muerte* (Madrid: El Arbol, n.d. [1981?]), p. 41. On the date, see Cosacchi, *Makabertanz*, p. 622: second half of the fourteenth century; Florence Whyte, *The Dance of Death in Spain and Catalonia* (1931;

The unmarked skeleton is assumed to be male, since the sexual organs seem invariably to have rotted off the corpse" (on the fourteenth and fifteenth centuries). But see above, n. 46.

repr. New York: Arno, 1977), p. 20: "as late as 1450"; Rosenfeld, *Totentanz*, p. 159: second half of the fifteenth century. According to Joël Saugnieux, *Les Danses macabres de France et d'Espagne et leurs prolongements littéraires* (Lyon: E. Vitte, 1972), p. 47, the date currently favored is "around 1400." Saugnieux and Icaza also print a considerably enlarged version, published in 1520; the passage on Eve is on pp. 188 and 127, respectively.

64 Joseph M. Donatelli (ed.), *Death and Liffe* (Cambridge, Mass.: The Medieval Academy of America, 1989), lines 235 and 271–273. Date: mid-fifteenth century.

65 As printed in Pietro Vigo, *Le Danze macabre in Italia* (Livorno: Vigo, 1878), p. 138. See Cosacchi, *Makabertanz*, p. 726.

66 Sarah Webster Goodwin, *Kitsch and Culture*, p. 44 on Holbein's nun: "Here the macabre visually echoes the Nun's spiritual corruption; Death's body is an emblem of illicit female sexuality." See above, p. 122. On the Basle Dance of Death, see Massmann, *Atlas*, fig. 5 of the first sequence of images; also Kaiser, *Der tanzende Tod*, p. 206; Franz Egger, *Basler Totentanz* (Basle: Buchverlag Basler Zeitung, 1990). In the fifteenth century there is at least one Dance of Death that has a man fetched by a death figure with pendulous breasts: the South German Dance of Death (Oberdeutscher Totentanz) of about 1465 where the nobleman is summoned by this figure; ill.: Massmann, *Atlas*, fig. 16 of the second sequence of images.

67 *Coplas* and *Pelegrí* are quoted as printed in Whyte, *Dance of Death*, pp. 164–165 (Saugnieux, *Danses macabres*, pp. 252–253) and p. 62. For the date of *Pelegrí*, see Whyte, pp. 64–65. R. Foulché-Delbosc (ed.), Manrique, *Coplas* (Madrid: Murillo, n. d. [1902?]), pp. 34–37; on the male personification of death in the *Coplas*, see Stephen Gilman, "Tres retratos de la muerte en las *Coplas* de Jorge Manrique," *Nueva Revista de Filología Hispánica* 13 (1959), 309, 323; also Saugnieux, *Danses macabres*, p. 67.

68 Wolfgang Stammler (ed.), *Mittelniederdeutsches Lesebuch* (Hamburg: Hartung, 1921), pp. 116–118.

For further examples, see Jordan, "Iconography," pp. 52, 73–74, and Donatelli (ed.), *Death and Liffe*, pp. 25–29.

69 Alberto Tenenti, *Il senso della morte e l'amore della vita nel rinascimento (Francia e Italia)* (Turin: Einaudi, 1957), fig. 7. See also Tenenti, *La Vie et la mort*, p. 23.

70 See above, n. 14. Oertel (see below, n. 81) mentions a similar fresco in a church in Lucignano (p. 21).

71 Guido Bezzola (ed.), Petrarch, *Trionfi* (Milan: Rizzoli, 1984), p. 76; *The Triumphs of Petrarch*, tr. Ernest Hatch Wilkins (University of Chicago Press, 1962), p. 54. On the biographical background, see Klaus Bergdolt, "Petrarca und die Pest," *Sudhoffs Archiv* 76 (1992), 63–73.

72 Guerry, *Le Thème*, p. 76; see also ch. 6: "Le Thème pétrarchien du triomphe de la mort" (on the repetitiveness of the iconography of Petrarch illustrations). The older critical literature is summarized in Werner Weisbach's review of Prince Victor E. d'Essling and Eugène Müntz's *Pétrarque* (1902): "Petrarca und die bildende Kunst," *Repertorium für Kunstwissenschaft* 26 (1903), 271–287; see also Weber, *Aspects of Death*, p. 125.

73 See Guerry, *Le Thème*, pp. 81–82.

74 According to Guerry, *Le Thème*, p. 96, who cites *Familiarum rerum libri XXIV*, I, I as the source.

75 Ill.: *ibid.*, fig. 9.

76 Ill.: Meiss, "Atropos-Mors," fig. 11; see also fig. 12 (school of Mantegna).

77 Ill.: Tenenti, *La vie et la mort*, fig. 3.

78 Ill.: *ibid.*, fig. 4; F. W. Wentzlaff-Eggebert, *Der triumphierende und der besiegte Tod in der Wort- und Bildkunst des Barock* (Berlin: de Gruyter, 1975), fig. 1 (Piero della Francesca).

79 Ill.: Tenenti, *Il senso*, fig. 41.

80 Lucia Battaglia Ricci, *Ragionare nel giardino: Boccaccio e i cicli pittorici del "Trionfo della morte"* (Rome: Salerno, 1987), fig. 28.

81 "Similar in many respects," according to Robert

Oertel, *Francesco Traini: Der Triumph des Todes im Campo Santo zu Pisa* (Berlin: Mann, 1948), p. 28; for a similar view, see Jordan, "Iconography," p. 149. Ill. of the entire fresco: Oertel, figs. 8–9; ill. of the left and right half: Guerry, *Le Thème*, figs. 10 and 13; ill. of the death figure alone: Stephan Kozáky, *Geschichte der Totentänze: Danse Macabre, Einleitung: Die Todesdidaktik der Vortotentanzzeit* (Budapest: Magyar Történeti Múzeum, 1944), plate VI. On the earlier ascription to Francesco Traini and his assistants, see Guerry, pp. 128–141; on the influence of Pietro Lorenzetti, *ibid.*, pp. 28–30. Jordan, "Iconography," pp. 141–143, summarizes recent research on the dating of the fresco, which is now assigned to the 1330s or early 1340s, so that it can no longer be said that it took shape under the influence of the plague (as Rosenfeld, *Totentanz*, p. 12, and others claimed). The new dating is confirmed by Ricci, *Ragionare*, pp. 12–13, as is the ascription to Buffalmacco (pp. 52–62). The restored fresco is now in the Pisa Museum. For a most detailed description, see Cosacchi, *Makabertanz*, pp. 571–588.

82 Guerry, *Le Thème*, p. 125. Translation by Dante Della Terza.

83 André Pératé, "Un 'triomphe de la mort' de Pietro Lorenzetti," *Mélanges Paul Fabre* (Paris: Picard, 1902), pp. 435–445; see Guerry, *Le Thème*, p. 115. The painting is in the Siena Accademia.

84 Ill.: Meiss, "Atropos-Mors," fig. 1.

85 Ill.: Tenenti, *La Vie et la mort*, fig. 5 (Florence: Morgiani).

86 Guerry, *Le Thème*, p. 94, n. 1.

87 Cp. the copper engraving of this painting by Silvestre Pomarède, in Guerry, *Le Thème*, fig. 10 (eighteenth century).

88 Guerry, *Le Thème*, pp. 94–95; Meiss, "Atropos-Mors," 157; Dobbert, "Der Triumph," 43, n. 72; Weber, *Aspects of Death*, pp. 128–129; note the sixteenth-century French engraving p. 129 (the Parcae as drivers of a chariot); Cosacchi, *Makabertanz*, pp. 802–803; Prince Victor M. d'Essling and Eugène Müntz, *Pétrarque* (Paris: Gazette des Beaux Arts, 1902), pp. 209–211.

89 Quoted from Meiss, "Atropos-Mors," 153. Atropos is also identified with Death in the *Danse macabre des femmes* (1480s); see Ann Tukey Harrison (ed.), *The Danse macabre of Women* (Kent, Ohio, and London: Kent State University Press, 1994), p. 58.

90 Meiss, "Atropos-Mors," 156 and fig. 13 (Morgan Library); see also fig. 14. Quotation: Sarah Kay (ed.), *The Romance of the Rose* (London: Grant and Cutler), 1995, p. 9.

91 Barbara Folkart (ed.), Michault, *Œuvres poétiques* (Paris: Union générale d'éditions, 1980), pp. 110–113. On a MS illustration, see Leonard P. Kurtz, *The Dance of Death and the Macabre Spirit in European Literature* (1934; repr. New York: Gordon, 1975), p. 222.

92 Tenenti, *La Vie et la mort*, pp. 22–23.

93 See, e.g., Oertel, *F. Traini*, p. 21; Dobbert, "Der Triumph," 24–25 (on the claws, see 24).

94 Horace: "Mors atris circumvolat alis" (Sat., II, 1, 57); Seneca: "Mors / atra avidos oris hiatus pandit et omnis explicat alas" (164). See further citations in Dobbert, "Der Triumph," 26–27.

95 Meiss, "Atropos-Mors," 155; cp. fig. 6; Kozáky, *Anfänge*, p. 165; Cosacchi, *Makabertanz*, pp. 571–588, 782. On the wings of the Furies/Erinyes, see B. C. Dietrich, *Death, Fate and the Gods* (London: Athlone, 1965), p. 144.

96 Guerry, *Le Thème*, p. 30; Dobbert, "Der Triumph," 25; Jordan, "Iconography," pp. 146–148 (I am indebted to Jordan for bibliographical references).

97 Dobbert, "Der Triumph," 25.

98 See Oertel, *F. Traini*, p. 23.

99 On female personifications of the plague, see above, p. 14.

100 See above, p. 259, n. 22.

3. RENAISSANCE AND BAROQUE: THE DEVIL INCARNATE

1 Edward A. Maser (ed.), *Baroque and Rococo Pictorial Imagery: The 1758–60 Hertel Edition of*

Ripa's "Iconologia," with 200 Illustrations (New York: Dover, 1971), Introduction.

2 Quoted from Elvire Freiin Roeder von Diersburg, *Komik und Humor bei Geiler von Kaisersberg* (1921; repr. Nendeln: Kraus Reprint, 1967), p. 47.

3 Walther Rehm, *Der Todesgedanke in der deutschen Dichtung vom Mittelalter bis zur Romantik* (Halle: Niemeyer, 1928), pp. 148–165; quotations: pp. 154, 158. See above, p. 269, n. 68.

4 See the references in Karl Bernd Heppe et al. (eds.), *Bilder und Tänze des Todes: Eine Ausstellung des Kreises Unna* (Paderborn: Bonifatius Druckerei, 1982), pp. 16–19, 29–41; Theodore Spencer, *Death and Elizabethan Tragedy* (Cambridge, Mass.: Harvard University Press, 1936), pp. 72–86; Lucas van Leyden: Eva Schuster (ed.), *Das Bild vom Tod: Graphiksammlung der Heinrich-Heine-Universität Düsseldorf* (Recklinghausen: Bongers, 1992), fig. 24.

5 Ill.: Reinhold Hammerstein, *Tanz und Musik des Todes: Die mittelalterlichen Totentänze und ihr Nachleben* (Berne and Munich: Francke, 1980), p. 239, fig. 253; Franz Egger, *Basler Totentanz* (Basle: Buchverlag Basler Zeitung, 1990).

6 See above, p. 258, n. 12.

7 Ill.: Heppe et al. (eds.), *Bilder und Tänze des Todes*, pp. 36, 37.

8 Joseph Leo Koerner, "The Mortification of the Image: Death as a Hermeneutic in Hans Baldung Grien," *Representations* 10 (1985), 72; ills.: 73, 75. For an ill. of Dürer's painting, see also Karl-Adolf Knappe, *Dürer: The Complete Engravings, Etchings and Woodcuts* (London: Thames and Hudson, 1965), fig. 43; for an ill. of Baldung's drawing, see Carl Koch, *Die Zeichnungen Hans Baldung Griens* (Berlin: Deutscher Verein für Kunstwissenschaft, 1941), fig. 15. Theodor Frimmel, "Beiträge zu einer Ikonographie des Todes," *Mittheilungen der k. k. Central-Commission zur Erforschung und Erhaltung der Kunst- und historischen Denkmale* 11 (1885), LXXXIX, mentions three examples of

death as "muscleman" in sixteenth-century French graphic and sepulchral art as well as one Italian example (Jacopo Ligozzi, d. 1627), *ibid.*, 10 (1884), XLIV.

9 See above, p. 267, n. 46.

10 Ill.: Hammerstein, *Tanz und Musik*, fig. 24. See also Francis Douce, *The Dance of Death* (London: Bell, 1902), pp. 204–205. See above, p. 57. Death is black ("swart") in a Low German Shrovetide play of the late fifteenth or early sixteenth century; see Wilhelm Seelmann (ed.), *Mittelniederdeutsche Fastnachtspiele* (Norden and Leipzig: Soltau, 1885), p. 36. Further examples of Death as a black man: Hammerstein, fig. 23; Frimmel, "Beiträge," 11 (1885), LXXXVII; Georges Kastner, *Les Danses des morts* (Paris: Brandus, 1852), p. 211 and plate V: 35, 36; Karl Bihlmeyer (ed.), Heinrich Seuse, *Deutsche Schriften*, ed. Karl Bihlmeyer (Stuttgart: Kohlhammer, 1907), p. 285. Erwin Koller, *Totentanz* (Innsbruck: Institut für Germanistik, 1980), p. 374, interprets the black color of Death as an approximation to the appearance of the dead body. Stephan Cosacchi, *Makabertanz* (Meisenheim: Hain, 1965), pp. 694–695, sees a connection with the oriental "Devil-Death."

11 Ill.: Roger H. Marijnissen, *Bruegel* (New York: Harrison House, 1984), p. 111. On the miniature in the Duke of Berry's Book of Hours, see above, p. 51. On Death as fool, see Gert Kaiser, "Totentanz und verkehrte Welt," Franz Link (ed.), *Tanz und Tod in Kunst und Literatur* (Berlin: Duncker und Humblot, 1993), pp. 94–97.

12 Ill.: Knappe, *Dürer*, fig. 155; Schuster (ed.), *Das Bild vom Tod*, fig. 18. See Rudolf Chadraba, *Dürers Apokalypse: Eine ikonographische Deutung* (Prague: Tschechische Akademie der Wissenschaften, 1964).

13 Ill.: Knappe, *Dürer*, fig. 72; Heppe et al. (eds.), *Bilder und Tänze des Todes*, p. 35, fig. 9. See Heinrich Theissing, *Dürers "Ritter, Tod und Teufel": Sinnbild und Bildsinn* (Berlin: Mann, 1978).

14 Ill.: Friedrich Winkler, *Die Zeichnungen Albrecht Dürers*, vol. II (Berlin: Deutscher Verein für

Kunstwissenschaft, 1937), fig. 377.

15 Ill.: Heppe et al. (eds.), *Bilder und Tänze des Todes*, p. 32, fig. 5. On N. de Bruyn (in the next sentence), see Frimmel, "Beiträge" 14 (1888), 239.

16 *Don Quixote*, tr. John Ormsby (Mexico City: The Limited Editions Club, 1950), p. 403.

17 On Lope's play as a model, see J. M. Clark, *The Dance of Death in the Middle Ages and the Renaissance* (Glasgow: Jackson, 1950), p. 50, n. 1. For another view, see Florence Whyte, *The Dance of Death in Spain and Catalonia* (1931; repr. New York: Arno, 1977), p. 145; George Irving Dale, "*Las Córtes de la Muerte*," *Modern Language Notes* 40 (1925), 276–281.

18 *Obras de Lope de Vega*, vol. III (Madrid: Sucesores de Rivadeneyra, 1893), p. 599.

19 On these *Cortes de la muerte*, see Leonard P. Kurtz, *The Dance of Death and the Macabre Spirit in European Literature* (1934; repr. New York: Gordon, 1975), p. 166, and Whyte, *Dance of Death*, pp. 114–115. See above, pp. 115–116.

20 Dietrich Briesemeister (ed.), *Bilder des Todes* (Unterschneidheim: W. Uhl, 1970), fig. 186.

21 Angel Valbuena Prat (ed.), Calderón, *Autos sacramentales*, vol. I, Clásicos Castellanos (Madrid: Espasa-Calpe, 1957), pp. 29, 34, 56, 58, 62.

22 Emilio Cotarelo y Mori (ed.), *Colección de entremeses*, vol. I, part 2 (Madrid: Bailly-Baillière, 1911), pp. 506–507.

23 See Spencer, *Death*, pp. 73, 83, 85; W. Meredith Thompson, *Der Tod in der englischen Lyrik des 17. Jahrhunderts* (Breslau: Priebatsch, 1935), p. 85 (Donne, Milton); Caroline E. Spurgeon, *Shakespeare's Imagery and What it Tells us* (1935; repr. Cambridge University Press, 1965), pp. 182, 183, 227 (actor, wrestler, butcher).

24 Anton Dürrwächter, "Die Darstellung des Todes und des Totentanzes auf den Jesuitenbühnen, vorzugsweise in Bayern," *Forschungen zur Kultur- und Literaturgeschichte Bayerns* 5 (1897), 91, 99.

25 See above, p. 267, n. 40.

26 Marian Szyrocki and Hugh Powell (eds.), Gryphius, *Gesamtausgabe der deutschsprachigen Werke*, vol. VI (Tübingen: Niemeyer, 1966), pp. 211, 206–207.

27 *Frauenzimmer-Gesprächsspiele*, vol. VIII (1649), no. ccxcvi: 20. For a similar Harsdörffer text, see Rehm, *Todesgedanke*, p. 217. Another adaptation of Balde's poem, by Johann Christoph von Schönborn, appeared in Gryphius, *Gesamtausgabe*, vol. III (1964), pp. 25–26.

28 See above, pp. 80, 106–108, 136–144.

29 Ill.: Schuster (ed.), *Das Bild vom Tod*, fig. 24.

30 See above, pp. 106–108

31 "Hactenus in eo natura humana vitiata atque mutata est, ut repugnantem pateretur in membris inoboedientiam concupiscendi et obstringeretur necessitate moriendi" (*De Civitate Dei*, XIII, 3; *The Confessions, the City of God, On Christian Doctrine*, 2nd edn. [Chicago: Encyclopaedia Britannica, 1990], p. 416).

32 András Vizkelety and Martin Bircher (eds.), *Sämtliche Werke*, vol. II (Berlin: de Gruyter, 1975), pp. 240–241, 256, 258, 269, 270.

33 Ill.: Eva Schuster (ed.), *Mensch und Tod: Graphiksammlung der Universität Düsseldorf* (Düsseldorf: Triltsch, 1989), fig. 12; Briesemeister (ed.), *Bilder des Todes*, fig. 200.

34 Ill.: Knappe, *Dürer*, fig. 3; Winkler, *Zeichnungen*, vol. III (1938), fig. 629 (Museum Boymans–van Beuningen, Rotterdam).

35 Ill.: Klaus Wolbert (ed.), *Memento mori: Der Tod als Thema der Kunst vom Mittelalter bis zur Gegenwart: Ausstellung im Hessischen Landesmuseum* (Darmstadt: Hessisches Landesmuseum, 1984), p. 24.

36 Ill.: Gert von der Osten, *Hans Baldung Grien: Gemälde und Dokumente* (Berlin: Deutscher Verein für Kunstwissenschaft, 1983), fig. 10 (cp. pp. 58–62); Kunsthistorisches Museum, Vienna. See also Osten, fig. 87 (cp. pp. 237–246) for a painting of two stages of life represented by two women confronted by a bearded Death holding an hourglass.

37 See Koerner, "Mortification," 80–83; ill.: Osten, *Grien*, fig. 48 (cp. pp. 149–152). For thematically similar paintings, with hardly a touch of eroticism, see Osten, figs. 44 and 24.

 Kollwitz: ill.: Schuster (ed.), *Mensch und Tod*, fig. 47; August Klipstein, *Käthe Kollwitz: Verzeichnis des graphischen Werkes* (Berne: Klipstein, 1955), fig. 259.

38 See above, pp. 39–43 and below, n. 51. On Luther, see Koerner, "Mortification," 85. Koerner refers to Ovid's "mors edax."

39 Ill. of the drawing: Philippe Ariès, *Images of Man and Death* (Cambridge, Mass.: Harvard University Press, 1985), p. 178; ill. of the Dance of Death scene: Schuster (ed.), *Das Bild vom Tod*, fig. 20; Paul Zinsli, *Der Berner Totentanz des Niklaus Manuel* (Berne: Haupt, 1953), Plate XVIII.

40 Zinsli, *Berner Tatentanz*, Plate XVIII.

41 Rehm, *Todesgedanke*, p. 166. Raimond van Marle describes the woman as "consentante" (*Iconographie de l'art profane au Moyen-Age et à la Renaissance*, vol. II [The Hague: Nijhoff, 1932], p. 397).

42 Wilhelm Franz, *Die Sprache Shakespeares*, 4th edn. (Halle: Niemeyer, 1939), p. 288.

43 Elsie Vaughan Hitchcock (ed.), Roper, *The Lyfe of Sir Thomas Moore, Knighte* (London: Early English Text Society, 1935), p. 80.

44 See Douce, *Dance of Death*, pp. 99–100.

45 On Alciati, see Erwin Panofsky, *Studies in Iconography* (New York: Oxford University Press, 1939), pp. 124–125; on the graphic works, see Schuster (ed.), *Mensch und Tod*, nos. 935, 1089, and fig. 18.

46 John Manning (ed.), Whitney, *A Choice of Emblemes* (Aldershot, Hants.: Scolar Press, 1989), pp. 132–133.

47 G. C. Moore Smith (ed.), *The Poems, both English and Latin, of Edward, Lord Herbert of Cherbury* (Oxford: Clarendon, 1923), pp. 48–53. See Arnold Stein, *The House of Death: Messages from the English Renaissance* (Baltimore and London: Johns Hopkins University Press, 1986), pp. 170–171.

48 C. A. Mayer (ed.), Marot, *Œuvres lyriques* (London: Athlone Press, 1964), pp. 142–143, 147 (lines 43–46, 159–160). See Claude Blum, *La Représentation de la mort dans la littérature française de la Renaissance*, 2nd edn. (Paris: Champion, 1989), pp. 161–163.

49 See Blum, *Représentation*, pp. 506–507.

50 *Ibid.*, pp. 507–508.

51 Jean Céard et al. (eds.), Ronsard, *Œuvres complètes*, 2 vols. (Paris: Gallimard 1993–94), vol. II, p. 604: "que la Mort soit quelque beste noir / Qui les viendra manger." References in the text are to this edition.

52 Jakob Bächtold (ed.), *Schweizerische Schauspiele des sechszehnten Jahrhunderts*, vol. II (Zurich: Huber, 1891), p. 203.

53 Ferdinand Wolf (ed.), *Ein spanisches Fronleichnamsspiel vom Todtentanz* (Vienna: Braumüller, 1852), p. 33. See Whyte, *Dance of Death*, pp. 98–99; Clark, *Dance of Death*, pp. 48–49.

54 Frida Weber de Kurlat (ed.), Sánchez de Badajoz, *Recopilación en metro* (Buenos Aires: Universidad de Buenos Aires, 1968), p. 509. See Whyte, *Dance of Death*, p. 79.

55 Whyte, *Dance of Death*, p. 115. Justo de Sancha (ed.), *Romancero y cancionero sagrados* (Madrid: Rivadeneyra, 1855), p. 9; quotation in the following sentence: p. 40.

56 Douce, *Dance of Death*, pp. 191–192; on the following sentences, see pp. 190–196.

57 See Schuster (ed.), *Mensch und Tod*, no. 252.

58 Ill.: Hammerstein, *Tanz und Musik*, figs. 182, 192, 196; Zinsli, *Berner Totentanz*, plate v and appendix (the drawing). The entire Dance of Death is reproduced in Zinsli's book.

59 Sarah Webster Goodwin, *Kitsch and Culture: The Dance of Death in Nineteenth Century Literature and Graphic Arts* (New York and London: Garland, 1988), p. 29.

60 Ill.: Alexander Goette, *Hans Holbeins Totentanz und seine Vorbilder* (Strasbourg: Trübner, 1897), plates IV and V; Hammerstein, *Tanz und Musik*, fig. 214 (the nun); Schuster (ed.), *Das Bild vom Tod*, fig. 29 (the nun).

61 Goette, *Holbeins Totentanz*, ch. 15. Distinctions are in order, however. E.g., in *La Danse macabre des femmes* (by Martial d'Auvergne? from the 1480s) a male "La Mort" fetches the women (Ann Tukey Harrison [ed.], *The Danse macabre of Women* [Kent, Ohio, and London: Kent State University Press, 1994], pp. 112, 53); in *La Grande Danse des hommes et des femmes* (Troyes, 1486), "La Morte" summons the women, "Le Mort" the men (*La Grande Danse* . . . [Paris: Baillieu, n.d. 1862?]).

62 Goodwin, *Kitsch and Culture*, pp. 44–45. "Italian influence" (Roeder von Diersburg, *Komik*, p. 48) is, in itself, no satisfactory explanation either.

63 Koller, *Totentanz*, p. 373; see also pp. 365, 371. See above, p. 21 on G. Kaiser.

64 Koller, *Totentanz*, p. 368 ("All deiner dienstmegd darfftu nimmer. Hie ist ein dürres frawenzimmer").

65 Jakob von Wyl, *Todtentanz* (Lucerne: Jenni, 1843), plate 6.

66 Max J. Friedländer and Jakob Rosenberg, *The Paintings of Lucas Cranach* (London: Sotheby Parke Bernet, 1978), nos. 43, 112–114, 193, 195, 198, 357; Karl Bernd Heppe (ed.), *Heinrich Aldegrever, die Kleinmeister und das Kunsthandwerk der Renaissance: Eine Ausstellung des Kreises Unna* (Unna: Kreis Unna, 1986), p. 124. For a similar engraving by Aldegrever, see *ibid.*, pp. 80, 120.

67 See the well-documented analysis in Neil Forsyth, *The Old Enemy: Satan and the Combat Myth* (Princeton University Press, 1987), pp. 399–400, 434–436 (on Augustine), p. 277 (on Paul), pp. 429–434 (on Augustine's difficulties with Manicheism), p. 435 (Augustine on Adam and Eve). See also Peter Stanford, *The Devil* (London: Heinemann, 1996), pp. 86–87, and above, p. 268, n. 51.

68 Ian Watt, *Myths of Modern Individualism* (Cambridge University Press, 1996), pp. 12–13; on the next sentence, see also Stanford, *The Devil*, ch. 8.

69 Goethe, *Werke* (Hamburg Edition), vol. XIV, p. 63.

70 See Rehm, *Todesgedanke*, pp. 170–173.

71 Adelbert von Keller (ed.), Sachs, *Werke*, vol. VI (Tübingen: Laupp, 1872), p. 177: "Dein gwart [gwalt?] und macht hast du von mier."

72 On a sixteenth-century architectural rendering of the idea, see Heppe et al. (eds.), *Bilder und Tänze des Todes*, pp. 29–30. See also Christopher Smart, ca. 1759–63: "The Devil, who is death" (W. H. Bond [ed.], Smart, *Jubilate Agno* [London: Hart-Davis, 1939], fragm. B2, line 722). To the extent that Death and the Devil are merged in medieval iconography (see Jordan, "Iconography," pp. 19–47), not much, if anything, is made of the devil's erotic powers. See above, p. 48 and p. 266, n. 25.

73 Heppe et al. (eds.), *Bilder und Tänze des Todes*, pp. 33 (fig. 6) and 36. For a tenth-century anticipation of "Mors" with horns, in an illustration in Bishop Leofric's missal, see J. O. Westwood, *Fac-Similes of the Miniatures and Ornaments of Anglo-Saxon and Irish Manuscripts* (London: Quaritch, 1868), plate 33; see also pp. 99–100. On the horns as attributes of the devil, see Luther Link, *The Devil: A Mask without a Face* (London: Reaktion Books, 1995), index (but see p. 35 for exceptions). A similar identification of Death and the devil may be suggested by the late fifteenth- and sixteenth-century illustrations that present Death riding an ox or driving an ox-drawn chariot. See above, pp. 50, 68, 77; Alexandre de Laborde, *La Mort chevauchant un bœuf* (Paris: Lefrançois, 1923); Paul de Keyser, "De houtsnijder van Gerard Leeu's *Van den drie blinde danssen* (Gouda, 1482)," *Gentsche Bijdragen tot de kunstgeschiedenis* I (1934), 65; Rosenfeld, *Totentanz*, p. 15.

74 Jeffrey Burton Russell, *Lucifer: The Devil in the Middle Ages* (Ithaca: Cornell University Press, 1984), pp. 42, 71–73, 77, 130, 211; Beat Brenk, *Tradition und Neuerung in der christlichen Kunst*

des ersten Jahrtausends (Vienna: Böhlau, 1966), pp. 178–179.

75 Erwin Panofsky, "Mors vitae testimonium: The Positive Aspect of Death in Renaissance and Baroque Iconography," Wolfgang Lotz and Lise Lotte Möller (eds.), *Studien zur toskanischen Kunst: Festschrift für Ludwig Heinrich Heydenreich* (Munich: Prestel, 1964), pp. 221–236; see *ibid.*, p. 233, n. 33 for further examples. An instance of Death with "female breast and male genitals" is cited in J. E. Wessely, *Die Gestalten des Todes und des Teufels in der darstellenden Kunst* (Leipzig: Hermann Vogel, 1876), p. 108.

76 Fiorentino: Panofsky, "Mors vitae," fig. 7; see also Schuster (ed.), *Mensch und Tod*, no. 649; *Art de bien vivre…*: Michel Vovelle, *La Mort et l'Occident* (Paris: Gallimard, 1983), fig. 17; Dürer: Knappe, *Dürer*, fig. 193.

4. THE ROMANTIC AGE: "HOW WONDERFUL IS DEATH"

1 Schiller, *Werke* (National Edition), vol. XXII, p. 83.

2 Clemens Brentano, *Sämtliche Werke und Briefe* (Frankfurt Edition), vol. VI, pp. 22–26.

3 Schiller, *Werke* (National Edition), vol. V, p. 86; *Intrigue and Love*, tr. Charles E. Passage (New York: Ungar, 1971), p. 97 (act V, sc. 1).

4 *Ibid.*; *Intrigue and Love*, pp. 96–97.

5 Thomas Anz, "Der schöne und der häßliche Tod," Karl Richter (ed.), *Klassik und Moderne* (Stuttgart: Metzler, 1983), pp. 409–432.

6 Goethe, *Werke* (Hamburg Edition), vol. IX, pp. 316–317.

7 Ludwig Uhlig, *Der Todesgenius in der deutschen Literatur von Winckelmann bis Thomas Mann* (Tübingen: Niemeyer, 1975), pp. 19–29. See below, n. 9. See also Hans Kurt Boehlke, "Der Zwillingsbruder des Schlafs," Hans Helmut Jansen (ed.), *Der Tod in Dichtung, Philosophie und Kunst*, 2nd edn. (Darmstadt: Steinkopff, 1989), pp. 337–361.

8 Bernhard Suphan (ed.), Herder, *Sämmtliche Werke* (Berlin: Weidmann, 1877–1913), vol. V, pp. 656–658. References in the text are to this edition by volume and page.

9 On the historical importance of Lessing's view, which signals a turn to enlightened concepts of human nature, see Wilfried Barner, "Der Tod als Bruder des Schlafs: Literarisches zu einem Bewältigungsmodell," Rolf Winau and Hans Peter Rosemeier (eds.), *Tod und Sterben* (Berlin and New York: de Gruyter, 1984), pp. 144–166.

10 "Der Tod," Karl Lachmann and Franz Muncker (eds.), Lessing, *Sämtliche Schriften* (Stuttgart: Göschen, 1886–1923), vol. I, pp. 90–91. References in the text are to this edition by volume and page. Translations from *Wie die Alten* are taken from Edward Bell (ed.), *Selected Prose Works of G. E. Lessing*, tr. E. C. Beasley and Helen Zimmer (London: George Bell, 1879); page references are to this edition, followed by volume and page references to *Sämtliche Schriften*.

11 Schiller, *Werke* (National Edition), vol. I, p. 286.

12 *Ibid.*, vol. I, p. 193. The translation of lines 1–4 is from *The Poems of Schiller*, tr. Edgar A. Bowring, 2nd edn. (London: George Bell, 1874), p. 74; the translation of lines 5–8 is from *The Poems of Schiller*, tr. E. P. Arnold-Forster (London: Heinemann, 1901), p. 74.

13 Herder, *Sämmtliche Werke*, vol. V, pp. 674–675; see also vol. XV, p. 481. See above, pp. 133–134.

14 Gerhart Hauptmann, *Michael Kramer, Sämtliche Werke* (Centenary Edition), vol. I, p. 1172 ("der ewigen Liebe Meisterstück"). Cp. Zacharias Werner, *Die Söhne des Thals, Ausgewählte Schriften* (1840; repr. Berne: Lang, 1970), vol. V, p. 192: "Meisterstück der ew'gen Liebe."

15 See Uhlig, *Der Todesgenius*, pp. 23–26.

16 Jörgen Birkedal Hartmann, "Die Genien des Lebens und des Todes: Zur Sepulkralikonographie des Klassizismus," *Römisches Jahrbuch für Kunstgeschichte* 12 (1969), 10–38, with numerous illustrations. See also Uhlig, *Todesgenius*, pp. 43–47. On the next sentence, see Hartmann, p. 20.

17 Paul Kluckhohn and Richard Samuel (eds.), Novalis, *Schriften*, 3rd edn., vol. I (Stuttgart: Kohlhammer, 1977), p. 143. References in the text are to this edition by volume and page. The translation is James Thomson's, quoted from Simon Reynolds, *Novalis and the Poets of Pessimism* (Norwich: Michael Russell, 1995).

18 "Johannes Ziska," Hermann Engelhard (ed.), Lenau, *Sämtliche Werke, Briefe* (Stuttgart: Cotta, 1959), p. 365.

19 "Wetternacht," Jonas Fränkel (ed.), Keller, *Sämtliche Werke*, vol. I (Berne: Benteli, 1931), p. 24.

20 Johann Georg Jacobi, *Sämtliche Werke*, vol. III (Frankfurt and Leipzig: no publ., 1779), p. 186 ("Musarion"); 2nd edn., vol. IV (Zurich: Orell und Füßli, 1810), p. 137 (*Der Tod des Orpheus*).

21 Uhlig, *Der Todesgenius*, pt. 2, offers a wealth of pertinent quotations to which I am indebted. Examples from Swedish literature: Carl Fehrman, *Liemannen, Thanatos och Dödens Ängel* (Lund: Gleerup, 1957). See also Wendelin Schmidt-Dengler, *Genius: Zur Wirkungsgeschichte antiker Mythologeme in der Goethezeit* (Munich: Beck, 1978), pp. 114–134.

22 Novalis, *Schriften*, vol. I, p. 147.

23 Eichendorff, *Sämtliche Werke* (Historisch-kritische Ausgabe), vol. I, part I, pp. 287–288. The concluding lines of Goethe's "Ganymed" are: "Aufwärts / An deinen Busen, / Alliebender Vater!"

24 On what follows, see Hartmann, "Die Genien," 27–37.

25 Ill.: Hartmann, "Die Genien," 29, fig. 33; 31, fig. 38, and Mario Praz and Giuseppe Pavanello (eds.), *L'Opera completa del Canova* (Milan: Rizzoli, 1976), pp. 123, 127.

26 Ill.: Hartmann, "Die Genien," 26, fig. 28.

27 Ill.: *ibid.*, 31, fig. 37; 32, fig. 40.

28 Ill.: Ekkehard Mai and Anke Repp-Eckert (eds.), *Triumph und Tod des Helden* (Milan: Electa, and Cologne: Museen der Stadt Köln, 1987), p. 195.

29 See above, pp. 55, 94.

30 Urban Roedl (ed.), Claudius, *Werke* (Zurich: Buchclub Ex Libris, n.d.), p. 100.

31 *Ibid.*, pp. 11–12.

32 Ill.: Eva Schuster (ed.), *Das Bild vom Tod: Graphiksammlung der Heinrich-Heine-Universität Düsseldorf* (Recklinghausen: Bongers, 1992), nos. 53–58; Stephan Kozáky, *Der Totentanz von heute* (Budapest: Magyar Történeti Múzeum, 1941), Plates XXV–XXVII.

33 Ill. and description: K. J. Schroer, "Der Erfurter Totentanz," *Mittheilungen des Vereins für die Geschichte und Alterthumskunde von Erfurt* 23 (1902), 12–13, 40–41; ills. follow XX and 48.

34 Johanna Schopenhauer, *Gabriele* (Munich: DTV, 1985), p. 95; Rode: Eva Schuster (ed.), *Mensch und Tod: Graphiksammlung der Universität Düsseldorf* (Düsseldorf: Triltsch, 1989), no. 798.

35 Ill.: Schuster (ed.), *Das Bild vom Tod*, nos. 60–71; Willi Geismeier, *Daniel Chodowiecki* (Leipzig: E. A. Seemann, 1993), p. 207.

36 Kugler, *Skizzenbuch* (Berlin: Reimer, 1830), p. 39: Death as "friend" and playmate of a child. On Schwind, see above, pp. 180–181. (One of his illustrations is called "Freund Hein at the masquerade" [Freund Hein im Mummenschanz].) Rethel: ill.: Schuster (ed.), *Das Bild vom Tod*, fig. 80. Flegel/Merkel: see above, pp. 181–182 (Death is called a "friend" in the verses underneath the image entitled "old man" [Greis]). Meyer: ill.: Friedrich W. Kasten (ed.), *Thema Totentanz* (Mannheim: Mannheimer Kunstverein/Battert, 1987), p. 114. Kollwitz: ill.: August Klipstein, *Käthe Kollwitz: Verzeichnis des graphischen Werkes* (Berne: Klipstein, 1955), fig. 261. An echo of German Romanticism may be heard in Thomas Lovell Beddoes's *Death's Jest Book* (1850), IV, 4, 162: "Friend Death."

37 Schiller, *Intrigue and Love*, p. 97; Herder, *Sämmtliche Werke*, vol. XXVIII, p. 135 (see above, pp. 139–140).

38 *Gesammelte Werke der Brüder Christian und Friedrich Leopold Grafen zu Stolberg*, vol. I (Hamburg: Perthes, 1827), p. 239.

39 Wilhelm Michel (ed.), Hölty, *Sämtliche Werke*, vol. 1 (Weimar: Gesellschaft der Bibliophilen, 1914), p. 88; see also "Der Tod," *ibid.*, p. 80. On Novalis, see below, n. 40, and above, p. 162.

40 Stolberg, *Gesammelte Werke*, vol. 11, p. 241. Cp. Novalis, *Hymnen an die Nacht, Schriften*, vol. 1, p. 153: "Die Lust der Fremde ging uns aus, / Zum Vater wollen wir nach Haus"; and vol. 1, p. 155: "Wir müssen nach der Heymath gehn."

41 Friedrich Creuzer casually refers to "sweet" death in his letter to Caroline von Günderode of October 16, 1804; see Karl Preisendanz (ed.), *Die Liebe der Günderode* (Munich: Piper, 1912), p. 20.

42 Christiaan L. Hart Nibbrig, *Ästhetik der letzten Dinge* (Frankfurt: Suhrkamp, 1989), p. 240. On Romantic death eroticism and the corresponding longing for death, see Philippe Ariès, *Western Attitudes Toward Death: From the Middle Ages to the Present* (Baltimore and London: Johns Hopkins University Press, 1974), pp. 57–58, and Eva Volkmer-Burwitz, *Tod und Transzendenz in der deutschen, englischen und amerikanischen Lyrik der Romantik und Spätromantik* (Frankfurt: Lang, 1987), ch. 4. For further examples of Death the bridegroom, see Erwin Koller, *Totentanz* (Innsbruck: Institut für Germanistik, 1980), p. 369.

43 Brentano, *Sämtliche Werke und Briefe* (Frankfurt Edition), vol. xvi, p. 144.

44 *Ibid.*, p. 366.

45 See Walther Rehm, *Der Todesgedanke in der deutschen Dichtung vom Mittelalter bis zur Romantik* (Halle: Niemeyer, 1928), pp. 410–417, esp. p. 414.

46 Werner, *Ausgewählte Schriften*, vol. 1, pp. 117–118.

47 W. von Wurzbach (ed.), Bürger, *Sämtliche Werke* (Leipzig: Hesse, n.d.), vol. 1, pp. 118–124; *Leonora*, translated from the German of Gottfried August Bürger by W. R. Spencer (London: T. Bensley, 1796); William Taylor's translation is included in Christopher Smith (ed.), *Lenore* (Norwich: Solen Press, 1996).

Neither translation is entirely accurate. See Evelyn B. Jolles, *G. A. Bürgers Ballade "Lenore" in England* (Regensburg: Carl, 1974).

48 See Wm. A. Little, *Gottfried August Bürger* (New York: Twayne, 1974), p. 102.

49 Albrecht Schöne, *Säkularisation als sprachbildende Kraft*, 2nd edn. (Göttingen: Vandenhoeck und Ruprecht, 1968), pp. 214–216; Emil Staiger, *Stilwandel* (Zurich: Atlantis, 1963), p. 77; see also Little, *Bürger*, pp. 102–104, on the controversy over Bürger's blasphemy.

5. FROM DECADENCE TO POSTMODERNITY: THE STRANGER AT THE MASKED BALL

1 Carla Gottlieb, "Modern Art and Death," Herman Feifel (ed.), *The Meaning of Death* (New York: McGraw-Hill, 1959), pp. 159–160.

2 Tschabuschnigg, *Gedichte*, 4th edn. (Leipzig: Brockhaus, 1872), pp. 298–299.

3 Ill.: Gottfried Sello (ed.), Grandville, *Das gesamte Werk* (Munich: Rogner und Bernhard, 1969), vol. 1, pp. 29–38. See also Sello's introduction and Sarah Webster Goodwin, *Kitsch and Culture: The Dance of Death in Nineteenth-Century Literature and Graphic Arts* (New York and London: Garland, 1988), pp. 83–87.

4 London: Ackermann, 1815–16, vol. 11, p. 37. On Grandville's indebtedness to Rowlandson, see, e.g., Goodwin, *Kitsch and Culture*, p. 84.

 The only female personification of death in *Death's Doings in Twenty-Four plates, designed and etched by R. Dagley* (London: J. Andrews, 1826) is that of the nurse (plate preceding p. 99); the text, however, refers to this Death as "he" (p. 101). For similar cases, see below, note 121 (Tobias Weiß); Schellenberg, *Freund Heins Erscheinungen* (see above, p. 152), engraving between pp. 54 and 55, and Merkel/Flegel, *Bilder des Todes* (see above, p. 181), fig. 5. See also below, n. 49.

5 Sello (ed.), Grandville, *Das gesamte Werk*, vol. 1, p. 29.

6 Ill.: Otto Weigmann (ed.), *Schwind: Des*

Meisters Werke (Stuttgart and Leipzig: Deutsche Verlagsanstalt, 1906), pp. 87–89; Stephan Kozáky, *Der Totentanz von heute* (Budapest: Magyar Történeti Múzeum, 1941), plates XXVIII–XXIX, see also p. 257. There is a similar scene in a late eighteenth-century Berne Almanach: "In the dress of an old woman he [Death] seizes a midwife with a newly born child in her arms" (Leonard P. Kurtz, *The Dance of Death and the Macabre Spirit in European Literature* [1934; repr. New York: Gordon, 1975], pp. 238–239).

7 Leipzig: Engelmann und Weigel; ill.: Kozáky, *Totentanz*, plates XXXII–XXXIV.

8 The same motif may be found in a 1902 caricature, "La Marchande de plaisir," by Hermann Vogel, in the journal *Assiette au Beurre*, no. 64; see Eva Schuster (ed.), *Mensch und Tod: Graphiksammlung der Universität Düsseldorf* (Düsseldorf: Triltsch, 1989), p. 384 (no. 1090). See also Bram Dijkstra, *Idols of Perversity* (Oxford University Press, 1986), p. 359.

9 Munich: Fleischmann [1862]. Ill.: Kozáky, *Totentanz*, plates XXXIX–XL. Pocci also published a play entitled *Gevatter Tod* (Munich: Braun und Schneider [1855]).

10 Leopold Hirschberg, "Totentänze neuerer Zeit," *Zeitschrift für Bücherfreunde* 7 (1907), 233; on the "other" Pocci see Eugen Roth's introduction to Marianne Bernhard (ed.), Pocci, *Die gesamte Druckgraphik* (Munich: Rogner und Bernhard, 1974).

11 See Hirschberg, "Totentänze," 233; Kozáky, *Totentanz*, p. 229.

12 Munich: Braun und Schneider, [1867] (25 steel engravings, with couplets); ill.: Kozáky, *Totentanz*, plates XXXV–XXXVII; see also Goodwin, *Kitsch and Culture* pp. 137–139.

13 Ills.: Fritz von Ostini, *Wilhelm von Kaulbach* (Bielefeld and Leipzig: Velhagen und Klasing, 1906), pp. 36, 50, 51, 57, 58, 117, 119.

14 *Songs and Dances of Death for Voice and Piano*, Engl. adaptation by Marion Farquhar (New York: International Music Company, 1951). I am indebted to John E. Malmstad for helping me understand the text by A. A. Golenishtchev Kutusov.

15 Fragment; quoted from Winfried Mennighaus (ed.), Schlegel, *Theorie der Weiblichkeit* (Frankfurt: Insel, 1983), p. 126: "Der Tod ist vielleicht männlich, das Leben ist weiblich."

16 See also Philippe Ariès, *Western Attitudes Toward Death: From the Middle Ages to the Present* (Baltimore: Johns Hopkins University Press, 1974), pp. 56–59.

17 *Poems* (Boston: Roberts, 1870), p. 209.

18 Maria Moog-Grünewald, "Die Frau als Bild des Schicksals: Zur Ikonologie der Femme fatale," *Arcadia* 18 (1983), 241; Patrick Bade, *Femme Fatale: Images of Evil and Fascinating Women* (New York: Mayflower, 1979); Virginia M. Allen, *The Femme Fatale: Erotic Icon* (Troy, NY: Whitston, 1983).

19 See Moog-Grünewald, "Die Frau," 248–257.

20 *Dialektik der Aufklärung* (Amsterdam: Querido, 1947), p. 277; *Dialectics of Enlightenment*, tr. John Cumming (London: Lane, 1973), p. 232; see also pp. 245–255.

21 Renate Berger and Inge Stephan (eds.), *Weiblichkeit und Tod in der Literatur* (Cologne and Vienna: Böhlau, 1987), p. 4: "Die . . . Inszenierung des weiblichen Todes schlägt um in die Angstvision einer Tod bringenden Weiblichkeit" (Berger and Stephan).

22 *Le Deuxième Sexe*, 2 vols. (Paris: Gallimard, 1986), vol. 1, pp. 273–274; *The Second Sex*, tr. Deirdre Bair (New York: Random House, 1989), p. 165.

23 *Herzstück* (Berlin: Rotbuch, 1983), p. 36. See Carlotta von Maltzan, *Zur Bedeutung von Geschichte, Sexualität und Tod im Werk Heiner Müllers* (Frankfurt: Lang, 1988), pp. 108–117.

24 Paris: Minuit, 1957, pt. 1, ch. 4.

25 Hans Albert Peters (ed.), *Alfred Kubin: Das zeichnerische Frühwerk bis 1904* (Baden-Baden: Kunsthalle, 1977), p. 150: ill.: p. 151. On psychological aspects of the identification of

death and the female sex, see above, pp. 209–228. For a death figure similar to Kubin's in that it is focused on an oversized vagina, see Adolf Frohner's drawing (1990) reproduced in Rainer Stöckli, *Zeitlos tanzt der Tod* (Constance: UVK, 1996), p. 47.

26 *The Standard Edition of the Complete Psychological Works*, vol. XII, tr. James Strachey (London: Hogarth Press, 1958), p. 299.

27 John Milner, *Symbolists and Decadents* (London: Studio Vista, 1971).

28 Zurich: Orell Füßli, 1972, figs. 10, 36, 62, 156, 161. These angels, draped in long garments, are similar to Joseph and other male biblical figures (see, e.g., fig. 40). The more female-looking angels are devoid of erotic appeal (see, e.g., fig. 240).

29 Ill.: Weigmann (ed.), *Schwind*, p. 312. On Schwind and Schnorr, see also Karl Bernd Heppe et al. (eds.), *Bilder und Tänze des Todes: Eine Ausstellung des Kreises Unna* (Paderborn: Bonifatius-Druckerei, 1982), pp. 89–90. Helmut Knirim's chapter in this volume, "Vom Todesgenius zum Tod in weiblicher Gestalt – Ein Aspekt der Todesikonographie im 19. Jahrhundert," has useful references to female personifications of death in the visual arts.

30 Ill.: Josef Ponten, *Alfred Rethel: Des Meisters Werke* (Stuttgart and Leipzig: Deutsche Verlagsanstalt, 1911), pp. 31, 32; see Heppe et al. (eds.), *Bilder und Tänze des Todes*, p. 90.

31 Ill.: Heppe et al. (eds.), *Bilder und Tänze des Todes*, p. 88.

32 Ill.: Philippe Jullian, *The Symbolists* (Oxford: Phaidon, 1973), fig. 175; see Heppe et al. (eds.), *Bilder und Tänze des Todes*, p. 92.

33 Ill. of the poster: Jullian, *Symbolists*, fig. 199. On Péladan, see Jennifer Birkett, *The Sins of the Fathers: Decadence in France 1870–1914* (London: Quartet Books, 1986), pt. 2, ch. 3; also Milner, *Symbolists*, pp. 70–78.

34 Ill.: Jullian, *Symbolists*, fig. 197 (in color); *Le Symbolisme en Europe* (Rotterdam: Museum Boymans–van Beuningen, 1975), p. 205. See also

Jean David Jumeau-Lafond, *Carlos Schwabe* (Paris: ACR, 1995).

35 *Le Symbolisme en Europe*, p. 205.

36 "Un svelte adolescent" (*ibid.*, p. 117) is hardly accurate.

37 Ill.: *Malczewski* (Stuttgart: Württembergischer Kunstverein, 1980), p. 50; Agnieszka Lawniczakowa, *Jacek Malczewski* (Warsaw: Krajowa Agencja Wydawnicza, 1976), p. 50.

38 *Malczewski*, p. 50; see also Heppe et al. (eds.), *Bilder und Tänze des Todes*, p. 93.

39 *Malczewski*, p. 51; ill. *ibid.*; see also Heppe et al. (eds.), *Bilder und Tänze des Todes*, p. 92. Quotation: Gerhart Hauptmann, *Michael Kramer*, *Sämtliche Werke* (Centenary Edition), vol. I, p. 1172.

40 Ill.: Dijkstra, *Idols*, p. 359.

41 Ill.: *Malczewski*, pp. 61, 127. See also "Śmierć" (1911–12) in Lawniczakowa, *Malczewski*, p. 51, and in *Malczewski*, p. 129: Death as a naked woman with a scythe, opening the gate of a Polish estate to a wanderer.

42 Heppe et al. (eds.), *Bilder und Tänze des Todes*, p. 93, following *Malczewski*, pp. 60, 126.

43 For the biographical background, see Isabella Zuralski, *Stufen des Welt- und Selbsterlebens bei Jacek Malczewski* (diss., Cologne: HundtDruck, 1984).

44 Quoted from W. K. West and Romualdo Pántini (eds.), *G. F. Watts* (London: Newnes, n.d. [1904]), pp. xxi–xxii.

45 O. von Schleinitz, *George Frederick Watts* (Bielefeld and Leipzig: Velhagen und Klasing, 1904), p. 103.

46 Ill.: Schleinitz, *Watts*, p. 104.

47 Ill.: G. K. Chesterton, *G. F. Watts* (London: Duckworth, n.d. [1904]), p. 61. According to Wilfrid Blunt, "*England's Michelangelo*" (London: Hamish Hamilton, 1975), p. 147, Watts worked on "The Court of Death" as late as 1903.

48 West and Pántini (eds.), *Watts*, p. xxi.

49 See the aluminum print "Tod mit Kind" (1991) by Klaus Drechsler in Eva Schuster (ed.), *Das Bild vom Tod: Graphiksammlung der Heinrich-Heine-Universität Düsseldorf* (Recklinghausen: Bongers, 1992), fig. 158 (in color). See also above, n. 4.

50 Quoted from Blunt, *"England's Michelangelo,"* pp. 204–205.

51 Ill.: Schleinitz, *Watts*, p. 43 (cp. p. 44 and the ill. on p. 45: death as a woman); West and Pántini (eds.), *Watts*, fig. 52.

52 Ill.: Schleinitz, *Watts*, p. 110; West and Pántini (eds.), *Watts*, fig. 34.

53 Schleinitz, *Watts*, p. 112.

54 Schuster (ed.), *Mensch und Tod*, p. 385 (no. 1090).

55 Ill.: Peter Hahlbrock, *Gustave Moreau oder das Unbehagen in der Natur* (Berlin: Rembrandt, 1976), fig. 97; Moreau's comment, p. 160; see also pp. 193–194. Cp. Pierre Louis Mathieu, *Gustave Moreau* (Oxford: Phaidon, 1977), pp. 180–182; fig. 408; Moreau's comment, p. 182.

56 Fogg Museum, Harvard University; ill.: Mathieu, *Moreau*, p. 91; Hahlbrock, *Moreau*, fig. 11; p. 36: "angel of death."

57 Heppe et al. (eds.), *Bilder und Tänze des Todes*, p. 91; Mathieu, *Moreau*, p. 92.

58 Pencil draft: Julius Kaplan, *The Art of Gustave Moreau: Theory, Style, and Content* (Ann Arbor, Mich.: UMI Research Press, 1982), fig. 9; sketches: Mathieu, *Moreau*, p. 271, n. 362; for Moreau's statement, in his letter of December 8, 1856 to Eugène Fromentin, see Kaplan, *Moreau*, p. 32; Mathieu, *Moreau*, p. 90.

59 Goodwin, *Kitsch and Culture*, p. 150.

60 Ostini, *Kaulbach*, p. 110, undated.

61 E. H. Coleridge (ed.), Coleridge, *The Complete Poetical Works* (Oxford: Clarendon, 1912), vol. 1, p. 194.

62 *Poésies* (Paris: Charpentier, 1890), pp. 5, 6, 49.

63 Claude Pichois (ed.), Baudelaire, *Œuvres complètes*, 2 vols. (Paris: Gallimard, Bibliothèque de la Pléiade, 1975–76), vol. 1, p. 1032.

64 *Œuvres complètes*, vol. 1, pp. 96–98; *The Flowers of Evil*, tr. James McGowan (Oxford University Press, 1993), pp. 197–201.

65 Peters (ed.), *Alfred Kubin*, p. 143.

66 Baudelaire, *Œuvres complètes*, vol. 11, p. 978; vol. 1, p. 1029.

67 Ill.: *Le Symbolisme en Europe*, fig. 196; for a similar treatment of the motif, see Jean François Bory (ed.), *Félicien Rops: L'Œuvre graphique complète* (Paris: Hubschmid, 1977), p. 550.

68 Ill.: Bory (ed.), *Rops*, p. 419; Schuster (ed.), *Mensch und Tod*, fig. 32.

69 Ill.: Hans Helmut Jansen (ed.), *Der Tod in Dichtung, Philosophie und Kunst*, 2nd edn. (Darmstadt: Steinkopff, 1989), p. 311; Ottokar Mascha, *Félicien Rops und sein Werk* (Munich: Langen, 1910), between pp. 20 and 21.

70 Ill.: Friedrich W. Kasten (ed.), *Thema Totentanz* (Mannheim: Mannheimer Kunstverein/Battert, 1987), p. 102; see also Schuster (ed.), *Mensch und Tod*, no. 244.

71 Ill.: Bory (ed.), *Rops*, p. 420.

72 Ill.: Kasten (ed.), *Thema Totentanz*, p. 100.

73 For another female personification of death with a scythe, see Hellmut Eichrodt's print reproduced in *Die Jugend* (1898; issue 19, p. 317): wearing a flower-decorated hat and a skirt, a skeleton traverses a hilly landscape on horseback. It is, however, entitled "Ritter Tod." Ill.: Kozáky, *Totentanz*, plate LXVI: 4; see also Kozáky, p. 265.

74 Ill.: Bory (ed.), *Rops*, p. 56; "Kisses of Death" is Bade's translation (*Femme Fatale*, p. 9).

75 Ills.: André Mellerio, *Odilon Redon* (Paris: Secrétariat, 1913), fig. 153; also Heppe et al. (eds.), *Bilder und Tänze des Todes*, p. 91 (the statement on p. 94, that Death addresses these words to St. Anthony, is incorrect); Frank Trapp (ed.), *The Temptation of Saint Anthony by Odilon Redon*, Mead Museum Monograph, no. 2 (Amherst, Mass.: Amherst College, n.d.)

[1980]), p. 9. *La Tentation de St. Antoine*, ch. 7.

76 Ill.: Mellerio, fig. 97. *La Tentation de St. Antoine*, ch. 7.

77 Rachilde, *Théâtre* (Paris: Savine, 1891); see esp. the end of act II. See André David, *Rachilde*, 4th edn. (Paris: NRC, 1924); Birkett, *Sins*, pt. 2, ch. 4. Gauguin's drawing is also reproduced in Richard Brettell et al. (eds.), *The Art of Paul Gauguin* (Washington: National Gallery of Art, 1988), p. 197 (Musée du Louvre). Gauguin's Peruvian-inspired folkloric female personifications of death (*The Art of Paul Gauguin*, pp. 145, 280, 391) are marginal to the focus of the present essay.

78 Ill.: Hans Wolfgang Singer (ed.), Klinger, *Etchings, Engravings, and Lithographs, 1878–1903* (San Francisco: Alan Wofsy, 1991), fig. 238; on p. 265 the male figure is interpreted as John the Baptist, though "originally, and strictly speaking, a representation of Christ" tempted by Satan. See Kozáky, *Totentanz*, pp. 238–242. In Klinger's etching "Ritter Tod" (Singer, fig. 220) Death is unmistakably male, also in his oil painting "Pinkelnder Tod" (ca. 1880; ill.: *Der Künstler und der Tod: Ausstellung Galerie Pels-Leusden* [Berlin: Pels-Leusden, 1981], fig. 64).

79 *Dämonen und Nachtgesichte* (Munich: Piper, 1959), p. 24.

80 Ill.: Peters (ed.), *Alfred Kubin*, p. 127; Schuster (ed.), *Das Bild vom Tod*, fig. 98.

81 "Das Kind," *Ein Totentanz* (= *Die Blätter mit dem Tod*, Berlin: Cassirer, 1918), no. 8; also Kasten (ed.), *Thema Totentanz*, p. 59; see *ibid.* on Kubin's predecessors. In Kubin's *Ein neuer Totentanz* (1947; no. 2: "Athlet") a female death figure dressed like a Dégas ballet-dancer ominously confronts a muscular weight-lifter; ill.: Schuster (ed.), *Das Bild vom Tod*, fig. 134. One might also think of Arnold Böcklin's 1898 painting of the plague as a woman riding a fantastic flying dragon; ill.: Werner Block, *Der Arzt und der Tod* (Stuttgart: Enke, 1966), p. 120; Rolf Andree, *Arnold Böcklin: Die Gemälde* (Munich: Prestel, 1977), color plate 45. On the

lithographs mentioned subsequently, see Schuster (ed.), *Mensch und Tod*, nos. 487, 488.

82 Ill.: Philippe Jullian, *Dreamers of Decadence* (New York: Praeger, 1971), fig. 33; color ill.: Bade, *Femme Fatale*, plate 8. Preliminary study: John Morley, *Death, Heaven and the Victorians* (London: Studio Vista, 1971), fig. 134.

83 *The Tales of Algernon Blackwood* (London: Secker, 1938); written 1906–10, according to the introduction.

84 *A soi-même* (Paris: Corti, 1961), p. 87 (June 12, 1885).

85 On Kubin, see above, n. 81. Drechsler: ill.: Schuster (ed.), *Das Bild vom Tod*, fig. 158.

86 Schuster (ed.), *Mensch und Tod*, no. 501.

87 Ill.: Kasten (ed.), *Thema Totentanz*, p. 170.

88 Ill.: *ibid.*, p. 169.

89 Schuster (ed.), *Mensch und Tod*, no. 817.

90 Büsum: Dithmarschen. Ill.: Kozáky, *Totentanz*, plate LXXVII: 4; see pp. 249, 266 ("Die Mutter") and Kasten (ed.), *Thema Totentanz*, p. 87 ("Tod und junge Frau"). For a less ambiguous return of Death in the shape of the mother, see Wallace Stevens's poem "Sunday Morning" (1923): "Death is the mother of beauty; hence from her, / Alone, shall come fulfilment to our dreams / And our desires" (*The Collected Poems* [London: Faber and Faber, 1955], pp. 68–69).

91 Ill.: Kasten (ed.), *Thema Totentanz*, p. 49.

92 Ill.: *ibid.*

93 Ill.: Günther Nicolin, *A. Paul Weber: Schachspieler* (Hamburg: Christians, 1988), p. 80; cp. the male chess-player Death on p. 44 and the gender-neutral chess-player Death on p. 35. On the tradition of the motif, see above, p. 14 and p. 259 n. 20; also Erwin Koller, *Totentanz* (Innsbruck: Institut für Germanistik, 1980), pp. 353, 612.

Another recent German case of female personification of death is a 1967 pen-and-ink drawing by Gertrude Degenhardt preserved in the Düsseldorf collection of death images; see also her *Vagabondage Ad Mortem* (Mainz:

Edition GD, 1995); it is subtitled *Musicians of Death* (*Musikanten des Todes*), but works like the lithograph on p. 48, featuring a female death figure with a scythe, would suggest Death in person.

94 Edith Södergran, *Love and Solitude: Selected Poems 1916–1923*, tr. Stina Katchadourian (San Francisco: Fjord Press, 1981), pp. 52–53.

95 Celan, *Gesammelte Werke*, vol. II (Frankfurt: Suhrkamp, 1983), p. 167; *Poems of Paul Celan*, tr. Michael Hamburger (London: Anvil Press Poetry, 1988), p. 275.

96 See Stöckli, *Zeitlos*, pp. 69–71, 150–151.

97 *The Park*, tr. Tinch Minter and Anthony Vivis (Sheffield: Academic Press, 1988), p. 99.

98 Hofmannsthal, *Sämtliche Werke* (Kritische Ausgabe), vol. IX, p. 146.

99 Berlin: Bothe u. Bock.

100 Tabori, *Mein Kampf*, German transl. by Ursula Tabori-Grützmacher (Vienna: Burgtheater, Programmbuch no. 17, 1987), pp. 125, 128. Quotations are from Tabori's original English version, *Mein Kampf*, in Carl Weber (ed.), *Drama Contemporary: Germany* (Baltimore: Johns Hopkins University Press, 1996); see Konrad Paul Liessmann, "Die Tragödie als Farce: Anmerkungen zu George Taboris *Mein Kampf*," *Text + Kritik* 133 (1997), 81–89; Sandra Pott, "*Mein Kampf* – Farce oder theologischer Schwank?" Hans-Peter Bayerdörfer (ed.), *Theater gegen das Vergessen: Bühnenarbeit und Drama bei George Tabori* (Tübingen: Niemeyer, 1997), pp. 248–269. The subtitle "Farce" appears only in the (authorized) German version.

101 See the description in Schuster (ed.), *Mensch und Tod*, no. 499.

102 *Ibid.* My quotation is taken from a copy of the original typescript, preserved in the Düsseldorf collection.

103 To cite just one example: Percy Smith, *Sixteen Drypoints and Etchings: A Record of the Great War* (London: Soncino, 1930), figs. 2, 15.

104 For ills. and commentary, see Karin Groll,

Alfred Rethel: "Auch ein Totentanz aus dem Jahre 1848" (Meßkirch: Gmeiner, 1989), and Kasten (ed.), *Thema Totentanz*, pp. 28–29.

105 Schiestl: Klaus Wolbert (ed.), *Memento mori* (Darmstadt: Hessisches Landesmuseum, 1984), fig. 68; Jentzsch: Schuster (ed.), *Das Bild vom Tod*, fig. 100, and A. S. Warthin, *The Physician of the Dance of Death* (New York: Arno, 1977), p. 118; mountain guide: Kasten (ed.), *Thema Totentanz*, pp. 135–142; Bierbaum: *Der neubestellte Irrgarten der Liebe* (Leipzig: Insel, 1913), p. 391: "Des alten Weibleins Lied vom Schwager Tod"; cp. *ibid.*, p. 104: "Maestro Tod"; Dickinson: Thomas H. Johnson (ed.), *The Poems of Emily Dickinson* (Cambridge, Mass.: Harvard University Press, 1955), no. 712 (ca. 1863). A wealth of material may be found in Kozáky, *Totentanz*, and Kasten (ed.), *Thema Totentanz*, pp. 43–229 (from 1871 to 1933).

106 See above, p. 7.

107 Ill.: Wolbert (ed.), *Memento mori*, figs. 14, 17.

108 Schuster (ed.), *Das Bild vom Tod*, no. 115.

109 Alfred Döblin, *Berlin Alexanderplatz* (Olten and Freiburg: Walter, 1961), pp. 488–490: "Der große Opferer, Trommler und Beilschwinger" (chapter heading).

110 See Kozáky, *Totentanz*, plates LXXIII–LXXV and pp. 247–250; Kasten (ed.), *Thema Totentanz*, pp. 167–192; Siegmar Holsten, *Allegorische Darstellungen des Krieges 1870–1918: Ikonologische und ideologiekritische Studien* (Munich: Prestel, 1976), pp. 76–86, 102–112, with ills.

111 Ill.: Kasten (ed.), *Thema Totentanz*, p. 234 (April 14, 1937): "Wo dieser Sämann geht durchs Land, / Erntet er Hunger, Krieg und Brand."

112 *Ibid.*, pp. 234, 246.

113 Ill.: *Der Künstler und der Tod*, p. 49: see also Weber's lithograph "Der Oberkommandierende" (1962) in the Düsseldorf collection. "General Tod" is the title of an etching by Jürgen Brodwolf (1968; see Schuster [ed.], *Mensch und Tod*, no. 64). On earlier occurrences of the motif, see above, p. 12, also index s.v. 'General, Death as'.

114 Ill.: Block, *Arzt und Tod*, p. 164: "Ich behandle Sie völlig kostenlos."

115 *Poems*, no. 1445.

116 See Kasten (ed.), *Thema Totentanz*, pp. 86–89; Kozáky, *Totentanz*, pp. 234–247; Schuster (ed.), *Das Bild vom Tod*, passim (Marcks: fig. 137); Schuster (ed.), *Mensch und Tod*, passim; Wolbert (ed.), *Memento mori*, passim; on Janssen, see *Der Künstler und der Tod*, pp. 54–55; on Fuchs: Rolf Schneider, *Leben in Wien* (Munich: Hanser, 1994), p. 17, and Fuchs, *Fantasia* (Munich: Artograph, 1993); Hofmannsthal, *Sämtliche Werke* (Kritische Ausgabe), vol. III, p. 70; *Poems and Verse Plays*, tr. Michael Hamburger (London: Routledge and Kegan Paul, 1961), p. 113.

117 Schuster (ed.), *Mensch und Tod*, p. 221 (no. 638).

118 Hasemann: ill.: Kasten (ed.), *Thema Totentanz*, p. 90; Schuster (ed.), *Das Bild vom Tod*, fig. 118. Hessel: ill.: Wolbert (ed.), *Memento mori*, fig. 21.

119 Ill.: Kasten (ed.), *Thema Totentanz*, p. 89 and appendix.

120 Ill.: Schuster (ed.), *Mensch und Tod*, fig. 29.

121 Ill.: Kozáky, *Totentanz*, plate XLVIII: 14; see also pp. 262, 230. Tobias Weiß, *Ein moderner Totentanz* (Mönchen-Gladbach: Kühlen, 1895), p. 47. The death figure is, however, dressed the same way in its role as nurse; see Kozáky, plate XLVI: 1.

122 Ill.: Kasten (ed.), *Thema Totentanz*, fig. 64 (between pp. 88 and 89).

123 Ill.: *ibid.*, pp. 90–91; Schuster (ed.), *Das Bild vom Tod*, fig. 118.

124 Schuster (ed.), *Mensch und Tod*, p. 393 (no. 1108); ill.: Schuster (ed.), *Das Bild vom Tod*, fig. 148; Stöckli, *Zeitlos*, p. 111.

125 Goethe, *Collected Works*, vol. IX (New York: Suhrkamp, 1988), p. 191 (pt. 2, ch. 4; tr. Judith Ryan).

126 *Doce maestros latinoamericanos* (Mexico City: Galería López Quiroga, 1992), p. 47. "Una de las figuras más sobresalientes de la plástica latinoamericana" (p. 54).

127 Karl S. Guthke, *Die Entdeckung des Ich* (Tübingen: Francke, 1993).

128 Marie Lenéru, *Les Affranchis* (1911), act III, sc. 4: "La mort c'est encore elle seule, qu'il faut consulter sur la vie."

EPILOGUE: DEATH IMMORTALIZING LIFE

1 London: SCM Press, 1963, p. 24.

2 T. S. Eliot, *Four Quartets*, "East Coker"; also the motto of Mary Stuart (see *Oxford Dictionary of Quotations*, 1992, p. 452).

3 *Patrologia Latina*, vol. XIV, col. 556. I owe this quotation and its translation to Erwin Panofsky, "Mors vitae testimonium: The Positive Aspect of Death in Renaissance and Baroque Iconography," *Studien zur toskanischen Kunst: Festschrift für Ludwig Heinrich Heydenreich* (Munich: Prestel, 1964), p. 231. The theme of Panofsky's essay is essentially the role of Death as historiographer.

4 Karl S. Guthke, *Last Words: Variations on a Theme in Cultural History* (Princeton University Press, 1992), pp. 54–55.

5 See above, p. 69; Otto Gerhard Oexle (ed.), *Memoria als Kultur* (Göttingen: Vandenhoeck und Ruprecht, 1995), pp. 9–78. L. Sterne, *Tristram Shandy*, vol. V, ch. 3 (1762): "Death opens the gate of fame." This is an echo of Francis Bacon's final sentence in his essay "Of Death." See also Schiller, *Die Braut von Messina*, act IV, sc. 9, 2731–2735.

6 Tertullian, *De testimonio animae* (*Patrologia Latina*, vol. I, col. 615).

7 Ill.: Salomon Reinach, *Répertoire de reliefs grecs et romains*, vol. III (Paris: Leroux, 1912), p. 199, fig. 1; Jörgen Birkedal Hartmann, "Die Genien des Lebens und des Todes," *Römisches Jahrbuch für Kunstgeschichte* 12 (1969), 18, fig. 20. On "scribunda," see Pauly/Wissowa, *Realencyclopädie*, s.v. "Fatum"; also A. Baumeister, *Denkmäler des klassischen Altertums*, vol. II (Munich and Leipzig, 1887), p. 926; see also *ibid.*, vol. III (1888), p. 1412 on the Prometheus sarcophagus: Atropos reads "die

Schicksale des Verstorbenen." Panofsky's remark, "Mors vitae," p. 222, n. 4, that Atropos is writing something on the scroll is incorrect, but he is right when he adds, "to keep a record of the life she has terminated."

8 For more documentation, see Erwin Koller, *Totentanz* (Innsbruck: Institut für Germanistik, 1980), pp. 332–334; Philippe Ariès, *Essais sur l'histoire de la mort en Occident* (Paris: du Seuil, 1975), pp. 34–35.

9 Ill.: Panofsky, "Mors vitae," p. 233; Karl Bernd Heppe et al. (eds.), *Bilder und Tänze des Todes: Eine Ausstellung des Kreises Unna* (Paderborn: Bonifatius-Druckerei, 1982), pp. 66–67, figs. 31, 32. Panofsky also treats related motifs.

10 *Vita del Cavaliere Gio. Lorenzo Bernino* (Florence: Vangelisti, 1682), pp. 16–17, according to Panofsky, "Mors vitae," pp. 221–222.

11 Cicero, *Philippicae*, IX, 5: "Vita enim mortuorum in memoriam est posita vivorum"; Seneca, *Epistulae ad Lucilium*, 102, 26: "Dies iste quem tamquam extremum reformidas, aeterni natalis est."

12 See note 3 above. Cp. St. Jerome, *Commentarius in Ecclesiasten*: "Certe quod in morte, quales simus, notum sit" (*Patrologia Latina*, vol. XXIII, col. 1114).

13 Guthke, *Last Words*, pp. 53–56.

14 In the introduction to his *Histoire de la Révolution française* (1847), section 9.

SELECT BIBLIOGRAPHY

A Abrahamsson, Hans. *The Origin of Death: Studies in African Mythology* (Uppsala: Almquist and Wiksell, 1951).

Alexandre-Bidon, Danièle and Cécile Treffort, editors. *A Réveiller les morts: La mort au quotidien dans l'Occident médiéval* (Lyon: Presses Universitaires, 1993).

Anz, Thomas. "Der schöne und der häßliche Tod," in *Klassik und Moderne*, Karl Richter, editor (Stuttgart: Metzler, 1983), pp. 409–432.

Ariès, Philippe. *Western Attitudes Toward Death: From the Middle Ages to the Present* (Baltimore and London: Johns Hopkins University Press, 1974).

— *The Hour of our Death* (New York: Knopf, 1981).

— *Images of Man and Death* (Cambridge, Mass.: Harvard University Press, 1985).

B Barner, Wilfried. "Der Tod als Bruder des Schlafs: Literarisches zu einem Bewältigungsmodell," in *Tod und Sterben*, Rolf Winau and Hans Peter Rosemeier, editors (Berlin and New York: de Gruyter, 1984), pp. 144–166.

Bauer, Johann. "Totentanzadaptationen im modernen Drama und Hörspiel: Hofmannsthal, Horváth, Brecht, Hausmann, Weyrauch und Hochhuth," in *Tanz und Tod in Kunst und Literatur*, Franz Link, editor (Berlin: Duncker und Humblot, 1993), pp. 463–488.

Berger, Renate and Inge Stephan, editors. *Weiblichkeit und Tod* (Cologne and Vienna: Böhlau, 1987).

Birkett, Jennifer. *The Sins of the Fathers: Decadence in France 1870–1914* (London and New York: Quartet Books, 1986).

Block, Werner. *Der Arzt und der Tod in Bildern aus sechs Jahrhunderten* (Stuttgart: Enke, 1966).

Bloomfield, Morton W. "A Grammatical Approach to Personification Allegory," in Morton W. Bloomfield, *Essays and Explorations: Studies in Ideas, Language, and Literature* (Cambridge, Mass.: Harvard University Press, 1970), pp. 243–260.

Blum, Claude. *La Représentation de la mort dans la littérature française de la Renaissance*, second edition (Paris: Honoré Champion, 1989).

Brandon, S. G. F. "The Personification of Death in Some Ancient Religions," *Bulletin of the John Rylands Library, Manchester* 43 (1961), 317–335.

— *Man and his Destiny in the Great Religions* (University of Toronto Press, 1962).

Breede, Ellen. *Studien zu den lateinischen und deutschsprachlichen Totentanztexten des 13. bis 17. Jahrhunderts* (Halle: Niemeyer, 1931).

Briesemeister, Dietrich, editor. *Bilder des Todes* (Unterschneidheim: W. Uhl, 1970).

Bronfen, Elisabeth and Sarah Webster Goodwin, editors. *Death and Representation* (Baltimore: Johns Hopkins University Press, 1993).

C Clark, James M. *The Dance of Death in the Middle Ages and the Renaissance* (Glasgow: Jackson, 1950).

Condrau, Gion. *Der Mensch und sein Tod* (Zurich: Benziger, 1984).

Corbett, Greville. *Gender* (Cambridge University Press, 1991).

Cosacchi, Stephan. *Makabertanz* (Meisenheim: Hain, 1965).

D *Día de los Muertos: A Celebration of this Great Mexican Tradition Featuring Articles, Artwork, and Documentation from Mexico, Across the United States, and Chicago* (Chicago: Mexican Fine Arts Center Museum, 1991).

Dietrich, B. C. *Death, Fate and the Gods* (London: Athlone Press, 1965).

Dijkstra, Bram. *Idols of Perversity* (New York: Oxford University Press, 1986).

F Fehrman, Carl. *Liemannen, Thanatos och Dödens Ängel* (Lund: Gleerup, 1957).

Feifel, Hermann, editor. *The Meaning of Death* (New York: McGraw-Hill, 1959).

Fest, Joachim. *Der tanzende Tod: Über Ursprung und Formen des Totentanzes vom Mittelalter bis zur Gegenwart* (Lübeck: Kunsthaus, 1986).

Frimmel, Theodor. "Beiträge zu einer Ikonographie des Todes," *Mittheilungen der k. k. Central-Commission zur Erforschung und Erhaltung der Kunst- und historischen Denkmale* 10–16 (1884–90), in eleven parts.

G Goodwin, Sarah Webster. *Kitsch and Culture: The Dance of Death in Nineteenth-Century Literature and Graphic Arts* (New York and London: Garland, 1988).

Guerry, Liliane. *Le Thème du "Triomphe de la mort" dans la peinture italienne* (Paris: Maisonneuve, 1950).

Guthke, Karl S. *Last Words: Variations on a Theme in Cultural History* (Princeton University Press, 1992).

H Hammerstein, Reinhold. *Tanz und Musik des Todes: Die mittelalterlichen Totentänze und ihr Nachleben* (Bern and Munich: Francke, 1980).

Hanika, Josef. "Die Tödin: Eine Sagengestalt der Kremnitz-Deutschprobener Sprachinsel," *Bayerisches Jahrbuch für Volkskunde*, 1954, 171–184.

Hartmann, Jörgen Birkedal. "Die Genien des Lebens und des Todes: Zur Sepulkralikonographie des Klassizismus," *Römisches Jahrbuch für Kunstgeschichte* 12 (1969), 10–38.

Heinemann, Kurt. *Thanatos in Poesie und Kunst der Griechen* (dissertation, Munich, 1913).

Helm, Rudolf. *Skelett- und Todesdarstellungen bis zum Auftreten der Totentänze* (Strasbourg: Heitz, 1928).

Heppe, Karl Bernd et al., editors. *Bilder und Tänze des Todes: Gestalten des Todes in der europäischen Kunst seit dem Mittelalter: Eine Ausstellung des Kreises Unna* (Paderborn: Bonifatius-Druckerei, 1982).

Herzog, Edgar. *Psyche und Tod: Wandlungen des Todesbildes im Mythos und in den Träumen heutiger Menschen* (Zurich and Stuttgart: Rascher, 1960).

Hirschberg, Leopold. "Totentänze neuerer Zeit," *Zeitschrift für Bücherfreunde* 7 (1903), 226–243.

Holck, Frederick H. "Sutras and the Mahabharata Epic," in *Death and Eastern Thought*, Frederick H. Holck, editor (Nashville and New York: Abingdon Press, 1974), pp. 53–78.

Hornung, Johann Baptist. *Ein Beitrag zur Ikonographie des Todes* (dissertation, Freiburg im Breisgau, 1902).

J Jansen, Hans Helmut, editor. *Der Tod in Dichtung, Philosophie und Kunst*, second edition (Darmstadt: Steinkopff, 1989).

Jordan, Louis Edward. "The Iconography of Death in Western Medieval Art to 1350" (dissertation, University of Notre Dame, 1980).

Jullian, Philippe. *The Symbolists* (Oxford: Phaidon, 1973).

K Kaiser, Gert. *Der tanzende Tod: Mittelalterliche Totentänze* (Frankfurt: Insel, 1983).

— *Der Tod und die schönen Frauen: Ein elementares Motiv der europäischen Kultur* (Frankfurt and New York: Campus, 1995).

Kasten, Friedrich W., editor. *Thema Totentanz* (Mannheim: Mannheimer Kunstverein/Battert, 1987).

Kastenbaum, Robert and Ruth Aisenberg, *The Psychology of Death* (New York: Springer, 1972).

Kastner, Georges. *Les Danses des morts: Dissertations et recherches* (Paris: Brandus, 1852).

Kleinstück, Johannes. "Zur Auffassung des Todes im Mittelalter," *Deutsche Vierteljahrsschrift für Literaturwissenschaft und Geistesgeschichte* 28 (1954), 40–60.

Koerner, Joseph Leo. "The Mortification of the Image: Death as a Hermeneutic in Hans Baldung Grien," *Representations* 10 (1985), 52–101.

Koller, Erwin. *Totentanz: Versuch einer Textembeschreibung* (Innsbruck: Institut für Germanistik, 1980).

— "Die Entwicklung der Totentanz-Tradition im 20. Jahrhundert," in *Tradition und Entwicklung: Festschrift Eugen Thurnher zum 60. Geburtstag* (Innsbruck: Institut für Germanistik, 1982), pp. 409–427.

Konrad, Karl. "Freund Hein auf der Bühne," *Der neue Weg* 42 (1913), 180–182, 337–340, 423–427.

Kozáky, Stephan. *Geschichte der Totentänze: Anfänge der Darstellungen des Vergänglichkeitsproblems* (Budapest: Magyar Történeti Múzeum, 1936).

— *Geschichte der Totentänze: Der Totentanz von heute* (Budapest: Magyar Történeti Múzeum, 1941).

— *Geschichte der Totentänze: Danse Macabre, Einleitung: Die Todesdidaktik der Vortotentanzzeit* (Budapest: Magyar Történeti Múzeum, 1944).

Der Künstler und der Tod (Berlin: Galerie Pels-Leusden, 1981).

Kurtz, Leonard P. *The Dance of Death and the Macabre Spirit in European Literature* (1934), Reprint (New York: Gordon Press, 1975).

L *Lebende Tote: Totenkult in Mexiko* (Bremen: Überseemuseum Bremen, 1986).

Link, Franz. *Tanz und Tod in Kunst und Literatur* (Berlin: Duncker und Humblot, 1993).

Link, Luther. *The Devil: A Mask without a Face* (London: Reaktion Books, 1995).

M Macho, Thomas H., editor. *Bilder vom Tod: 168. Sonderausstellung des Historischen Museums der Stadt Wien* (Vienna: Eigenverlag der Museen der Stadt Wien, 1993).

Mai, Ekkehard and Anke Repp-Eckert, editors. *Triumph und Tod des Helden: Europäische Historienmalerei von Rubens bis Manet* (Milan: Electa, and Cologne: Museen der Stadt Köln, 1988).

Mâle, Emile. *L'Art religieux de la fin du Moyen Age en France*, third edition (Paris: Colin, 1925), part 2, chapter 2: "La Mort."

L'Art religieux de la fin du XVIe siècle, du XVIIe siècle et du XVIIIe siècle, second edition (Paris: Colin, 1951), chapter 5: "La Mort."

Marle, Raimond van. *Iconographie de l'art profane au Moyen-Age et à la Renaissance*, vol. II (The Hague: Nijhoff, 1932), chapter 5: "La Mort."

Meiss, Millard. "Atropos-Mors," in *Florilegium historiale*, J. W. Rowe and W. H. Stockdale, editors (University of Toronto Press, 1971), pp. 152–159.

Moog-Grünewald, Maria. "Die Frau als Bild des Schicksals: Zur Ikonologie der Femme fatale," *Arcadia* 18 (1983), 239–257.

N Nibbrig, Christiaan L. Hart. *Ästhetik der letzten Dinge* (Frankfurt: Suhrkamp, 1989).

O Ohler, Norbert. *Sterben und Tod im Mittelalter* (Munich and Zurich: Artemis, 1990).

P Panofsky, Erwin. "Iconography and Iconology," in Erwin Panofsky, *Meaning in the Visual Arts* (Garden City, NY: Doubleday, 1957), pp. 26–54.

— "Mors vitae testimonium," in *Studien zur toskanischen Kunst: Festschrift für Ludwig Heinrich Heydenreich*, Wolfgang Lotz and Lise Lotte Möller, editors (Munich: Prestel, 1964), pp. 221–236.

R Rehm, Walther. *Der Todesgedanke in der deutschen Dichtung vom Mittelalter bis zur Romantik* (Halle: Niemeyer, 1928).

Reuter, Adele. *Beiträge zu einer Ikonographie des Todes* (dissertation, Strasbourg; Leipzig: Dieterich, 1913).

Ripa, Cesare. *Baroque and Rococo Pictorial Imagery: The 1758–60 Hertel Edition of Ripa's "Iconologia," with 200 Illustrations*, Edward A. Maser, editor (New York: Dover, 1971).

Rohr, Klaus. *Der Tod in der Nachkriegsdramatik: Analysen an ausgewählten Beispielen* (dissertation, Cologne, 1971).

Röhrich, Lutz. "Der Tod in Sage und Märchen," in *Leben und Tod in den Religionen: Symbol und Wirklichkeit*, Gunther Stephenson, editor (Darmstadt: Wissenschaftliche Buchgesellschaft, 1980).

Rosenfeld, Hellmut. "Tod," *Lexikon der christlichen Ikonographie*, Engelbert Kirschbaum et al., editors (Rome: Herder, 1972), vol. IV, pp. 327–332.

— *Der mittelalterliche Totentanz*, third edition (Cologne and Vienna: Böhlau, 1974).

Russell, Jeffrey Burton. *Lucifer: The Devil in the Middle Ages* (Ithaca: Cornell University Press, 1984).

S Sánchez-Camargo, M. *La Muerte y la pintura española* (Madrid: Editora Nacional, 1954).

Sander-Hansen, C. E. *Der Begriff des Todes bei den Ägyptern* (Copenhagen: Munksgaard, 1942).

Saugnieux, Joël. *Les Danses macabres de France et d'Espagne et leurs prolongements littéraires* (Lyon: E. Vitte, 1972).

Schmidt-Dengler, Wendelin. *Genius: Zur Wirkungsgeschichte antiker Mythologeme in der Goethezeit* (Munich: C. H. Beck, 1978).

Schuster, Eva, editor. *Mensch und Tod: Graphiksammlung der Universität Düsseldorf* (Düsseldorf: Triltsch, 1989).

— *Das Bild vom Tod: Graphiksammlung der Heinrich-Heine-Universität Düsseldorf* (Recklinghausen: Bongers, 1992).

Schwebel, Oskar. *Der Tod in deutscher Sage und Dichtung* (Berlin: Alfred Weile, 1876).

Serrano Martín, Eliseo, editior. *Muerte, religiosidad y cultura popular: Siglos XIII-XVIII*, (Zaragoza: Fernando el Católico, 1994).

Spencer, Theodore. *Death and Elizabethan Tragedy* (Cambridge, Mass.: Harvard University Press, 1936).

Stegemeier, Henri. "The Dance of Death in Folksong, with an Introduction on the History of the Dance of Death" (dissertation, University of Chicago, 1939).

Stewart, Garrett. *Death Sentences: Styles of Dying in British Fiction* (Cambridge, Mass.: Harvard University Press, 1984).

Stöckli, Rainer. *Zeitlos tanzt der Tod: Das Fortleben, Fortschreiben, Fortzeichnen der Totentanztradition im 20. Jahrhundert* (Constance: UVK, 1996).

Le Symbolisme en Europe (Rotterdam: Museum Boymans–van Beuningen, 1975).

T Tenenti, Alberto. *La Vie et la mort à travers l'art du XVe siècle* (Paris: Colin, 1952).

— *Il senso della morte e l'amore della vita nel rinascimento (Francia e Italia)* (Turin: Einaudi, 1957).

Thielicke, Helmut. *Tod und Leben* (Tübingen: Mohr, 1946).

Tristram, Philippa. *Figures of Life and Death in Medieval English Literature* (London: Elek, 1976).

U Uhlig, Ludwig. *Der Todesgenius in der deutschen Literatur: Von Winckelmann bis Thomas Mann* (Tübingen: Niemeyer, 1975).

V Vermeule, Emily. *Aspects of Death in Early Greek Art and Poetry* (Berkeley: University of California Press, 1979).

W Warren, Florence. *The Dance of Death*, Early English Text Society, Original Series, no. 181 (London: Humphrey Milford, 1931).

Weber, Frederick Parkes. *Aspects of Death and Correlated Aspects of Life in Art, Epigram, and Poetry*, fourth edition (London: T. Fisher Unwin, 1922).

Wentzlaff-Eggebert, Friedrich Wilhelm. *Der triumphierende und der besiegte Tod in der Wort- und Bildkunst des Barock* (Berlin: de Gruyter, 1975).

Wessely, J. E. *Die Gestalten des Todes und des Teufels in der darstellenden Kunst* (Leipzig: Hermann Vogel, 1876).

Westheim, Paul. *Der Tod in Mexiko* (Hanau: Müller und Kiepenheuer, n.d. [1948?]).

Wienold, Götz. *Genus und Semantik* (Meisenheim: Hain, 1967).

Williams, Gerhild Scholz. "Der Tod als Text und Zeichen in der mittelalterlichen Literatur," in *Death in the Middle Ages*, Herman Braet and Werner Verbeke, editors (Leuven: Leuven University Press, 1983), pp. 134–149.

Williams, Hester L. "The Personification of Death in Medieval German Literature (1150–1300): A Misrepresentation of Christian Doctrine" (dissertation, University of Kansas, 1974).

Wolbert, Klaus, editor. *Memento mori: Der Tod als Thema der Kunst vom Mittelalter bis zur Gegenwart* (Darmstadt: Hessisches Landesmuseum, 1984).

INDEX

Ackermann aus Böhmen, Der, see Tepl

Adam 4, 40–81, 86, 96, 123–124, 125, 176, 251

Adorno, Theodor W. 189–190, 192

Aisenberg, Ruth 31

Alciati, Andrea 107, 273 n. 45

Aldegrever, Heinrich 40, 59, 96 124, 268 n. 53

Allen, Woody 237

Ambrose, St. 252, 255

Améry, Jean 257 ch. 1, n. 2

Amiens Cathedral 61

Amiens missal 267 n. 36

Amor, *see* Eros

Angel of Death 4, 11, 15, 35, 80, 84, 186, 188,
 193–208, 220, 223, 225–226, 227, 244, 254, 266
 n. 24

Angels 15, 259 n. 25

Anouilh, Jean 2, 27, 237

Anselm of Canterbury 268 n. 52

Anthony, St. 126

Apocalyptic horseman, *see* Horseman

Apollinaire, Guillaume 29, 257 n. 4

Archer, Death as 11, 183

Ariès, Philippe 36

Arnim, Achim von 129

Atropos 34, 44, 76, 78, 80, 95, 106–108, 111, 152,
 159, 206, 252, 270 n. 89, 283 n. 7

Augustine, St. 40, 41, 42, 59, 96, 117, 124, 125, 265
 n. 12, 268 nn. 51, 52

Aunt Sebastiana, *see* Tía Sebastiana

Aurora, *see* Eos

autos sacramentales 89–91, 107, 115–117

Baba Yaga 17, 18

Bacon, Francis 283 n. 5

Bailiff, Death as 11, 29, 56

Bajadoz, *see* Sánchez de Bajadoz

Balanchine, George 15

Balde, Jacob 94, 95, 128, 272, n. 27

Baldinucci, Filippo 254

Baldung, Hans, called Grien 12, 41, 64, 86,
 100–102, *102*, 104

Ballo della morte, Il 63–64

Balzac, Honoré de 178

Barlach, Ernst 24, 242, 243

Barth, Ferdinand 12, 183–184, 222, 230, 244

Bartholomew, apostle, 17, 125

Basle Dance of Death 21, 44, 64, 86, 117–118, 120,
 246

Bataille, Georges 191

Baudelaire, Charles 16, 28, 188, 189, 196, 209,
 210–215, 216, 221, 223, 259 n. 18

Baudouin, Jean 82

Beatus de Liébana 60, *60*

Beauvoir, Simone de 190–191, 201, 239, 257 ch. 1,
 n. 1, 260 n. 37

Bebel(ius), Johann 118

Bechstein, Ludwig 12

Beck, Jakob Samuel 154

Beddoes, Thomas Lovell 263 n. 66, 276 n. 36

Beham, Hans Sebald 12, 22, 64, 99–100, 125,
 220

Bella, Stefano della 2, 257 n. 5

Bellery-Desfontaines, Henri 195–196

Bellori, Giovanni Pietro 137

Berger, Renate 278 n. 21

Bergman, Ingmar 14, 230

Berne Dance of Death, *see* Manuel

Bernegger, Alfred 230

Bernini, Gian Lorenzo 254, 256, *253*

Berry, Jean, Duc de 29, 51–52, 55, 87

Berthélemy, Jean Simon 11, 144

Bible 4, 11, 35, 39–42, 80, 226

Bierbaum, Otto Julius 242

Binck, Jakob 86

Black Death 14–15, 48, 58, 67–68, 69, 80, 129, 232,
 259 n. 22, 270 n. 81

Black Man, Death as 14, 57, 64, 87, 92, 235, 271 n.
 10

Blackwood, Algernon 226–227

Blake, William 15

Block, Werner 258 n. 2

Bloomfield, Morton W. 30

Blum, Claude 265 n. 4

Boccaccio, Giovanni 68, 77

Böcklin, Arnold 15, 281 n. 81

Böhmer, Auguste 144

Boltz, Valentin 114

boneman 12, 19, 22, 35, 99, 133–134, 144, 146,
 147–150, 151, 180

Borchert, Wolfgang 236

Brecht, Bertolt 191

Brentano, Clemens 129, 162–163

Bride, Death as 5, 14, 27, 94, 105, 159, 162–163, 165, 172, 223, 227

Bridegroom, Death as 5, 12, 14, 63, 94, 96, 97, 105, 129, 159–172, 251, 277 n. 42

Brodwolf, Jürgen 282, n. 113

Brother Death 15, 259 n. 26

Browning, Elizabeth Barrett 187

Browning, Robert 258 n. 6

Brueghel, Pieter, the Elder 87

Bruyn, Nicolaes de 88, 272 n. 15

Bürck, Paul 218

Bürger, Gottfried August 12, 14, 96, 100, 129, 161, 165–172

Buffalmacco 71, 270 n. 81

Bunyan, John 115, 156

Buonamico, *see* Buffalmacco

Burgkmair, Hans 50, 88

Burns, Robert 156

Busch, Wilhelm 174

Byron, George Gordon, Lord 15

Caesarius of Heisterbach 46

calaveras 263 n. 73

Calderón de la Barca, Pedro 29, 64, 89, 91, 238

Campbell, Thomas 254

Camus, Albert 16, 237

Canova, Antonio 144

Caravaggio 15, 208

Cardplayer, Death as 181

Carvajal, Micael de 90, 107, 116

Castle of Perseverance, The 54

Celan, Paul 3, 19, 234–235, 237

Cervantes Saavedra, Miguel de 8, 29, 64, 89–91, 230

Champfleury, Jules François 209

Charioteer, female, Death as 68, 69–71, 110

Charon 34

Charun 34

Chassériau, Théodore 206

Chatterton, Thomas 157

Chaucer, Geoffrey 38–39, 50, 54

Chénier, André 159

Chessplayer, Death as 14, 230, 281 n. 93

Chodowiecki, Daniel 22, *148*, 151, 155, 180

Christine de Pisan 75, 77

Chronos 35, 101

Cicero, Marcus Tullius 254

Clark, James M. 56, 268 n. 50

Claudius, Matthias 12, 146–151, 158, 180

Coatlicue 17

Cocteau, Jean 15, 27, 237

Coleridge, Samuel Taylor 156, 158, 161, 188, 209

Colombe, Jean 29, 51, *52*, 55, 87, 109

Condrau, Gion 257 ch. 1, n. 2

Cook, Death as 92

Corbett, Greville 31–32

Corpus Christi plays, *see autos sacramentales*

Cosacchi, *see* Kozáky

Costa, Lorenzo 70

Coventry Cycle 53, 56, 91

Cranach, Lucas the Elder 123

Crashaw, Richard 99

Cratander, Andreas 118

Creuzer, Friedrich 277 n. 41

Croissant-Rust, Anna 19

Cummings, E. E. 7, 242, 250

Cupid, *see* Eros

D., L. S. 83

Dagley, R. 277 n. 4

Dalí, Salvador 2, 29, 64, 244, 257 n. 4

Dança general de la muerte 43, 62–65, 97, 117

Dance of Death 21–22, 40–41, 50, 56–57, 63–64, 85, 97, 114–123, 127, 128–129, 135, 155, 176–186, 209, 229, 241, 243, 247, 249, 254

Danse macabre 50, 87, 270 n. 89, 274 n. 61

Dante Alighieri 38, 50, 55, 79, 265 n. 2

Daumier, Honoré 177, 229

Death and Liffe 43, 62–63, 65–68

Death and the Maiden 2, 12, 14, 21, 41, 64, 85, 95–104, 114, 116, 118, 129, 132, 163, 220, 241, 244–245, 249

Death, Goddess of, *see* Goddess

Death-Woman 3, 19, 234–235

Dégas, Hilaire Germaine Edgard 281 n. 81

Degenhardt, Gertrude 281 n. 93

Deguileville, Guillaume de 61

Della Terza, Dante 270 n. 82

Devil, *see* Satan

Dickinson, Emily 242, 244

Dietrich, Marlene 232

Dilthey, Wilhelm 258 n. 6

Disciplini, Chiesa dei (Clusone) 44, 58

dísir 18, 261 n. 38

Dobbert, Eduard 74, 78, 261 n. 48

Doctor, Death as 177, 243

Döblin, Alfred 242

Doña Sebastiana, *see* Tía Sebastiana

Donne, John 92, 177, 272 n. 23
Douce, Francis 118
Drechsler, Klaus 2, 25, 228, 280 n. 49
Drummer, Death as 50, 87, 236, 242, 266 n. 32, 267 n. 46
Drummond of Hawthornden, William 11, 86
Dürer, Albrecht 11, 21, 85, 86, 87–88, 99, 123, 196
Duller, Eduard 158, 180–181
Dunstan, St. 126

Eagleton, Terry 257 ch. 1, n. 2
Earth Mother 18, 264 n. 94
Eichendorff, Joseph von 142–144, 150, 161, 165, 170, 246
Eichrodt, Hellmut 280 n. 73
Einem, Gottfried von 237–238
Eliot, T. S. 237, 252, 283 n. 2
Emperor Death 24, 248, 260 n. 30
Empress Death 17
Encina, Juan del 64
Enright, D. J. v
Eos 35
Epstein, Jacob 15
Erinyes 34, 78, 80
Eros 13, 33, 34–35, 80, 95, 104, 106–108, 136–141, 158–159, 162
Euripides 14, 34, 69
Eve 4, 40–81, 96, 116, 118, 123–124, 125, 176, 251
Everyman 42, 53, 56
Executioner, Death as 91, 181

Fábiánné, Ilona Bizcó 22
Farquhar, Marion 278 n. 14
Fates 18, 34, 76
Faust(us), Doctor 125
Fehrman, Carl 276 n. 21
femme fatale 188, 208, 221, 228, 278 n. 18
Fiddler, Death as 1, 11, 86, 92, 181, 185, 247
Flaubert, Gustave 189, 220–221, 223
Flegel, Johann Gottfried 158, 181–182, 183, 185
Florio, John 26
folklore, *see* mythology
folksong (folkballad) 7, 11, 12, 13, 14, 18, 129, 136, 259 n. 13
Fool, Death as 21, 22, 87, 100, 155, 222, 271, n. 11
Fowler, Death as 11, 85, 151
Francesco Basilica, San (Assisi) 48
Francis of Assisi 15, 259 n. 26

Franz, Wilhelm 262 n. 53
French, Daniel Chester 15, 205
Freud, Sigmund 192, 198
Freund Hein (Hain) 7, 12, 35, 132, 147–155, *148*, 158, 171, 172, 180–181, 244, 251
Friend, Death as 5, 12, 55, 61, 93, 128, 132, 146–158, 163, 165, 171
Friend Hein (Henry), *see* Freund Hein
Frohner, Adolf 279 n. 25
Fromentin, Eugène 280 n. 58
Fuchs, Ernst 244
Furck, Sebastian 34
Furies 14, 34, 58, 78, 80, 190

Gaiman, Neil 232
Gardener, Death as 11, 183, 237
Gauguin, Paul 16, 221
Gautier, Théophile 209–211
Geiler von Kaisersberg, Johannes 83, 252–253
Geisberg-Wichmann, Renate 218
General, Death as 12, 13, 92, 186, 236, 242, 243, 257 n. 5, 259 n. 13, 263 n. 73, 282 n. 113
Gérard, *see* Grandville
Gheyn II, Jacob de 118
Gilgamesh 14
Giltine 17, 260 n. 33
Gísli saga 18
Glass, Philip 15
Gleim, Johann Wilhelm Ludwig 12
Glissenti, Fabio 106
Goddess, Death as 62, 111–114
Godfather, Death as 12, 150, 237, 242, 278 n. 9
Godmother, Death as 237
Goethe, Johann Wolfgang von 8, 15, 125, 126, 133, 134, 136, 141, 143, 165, 250, 276 n. 23
Golden Legend 17
Golenishtchev-Kutusov, A. A. 278 n. 14
González de la Torre, Juan 91, 123
Goodwin, Sarah Webster 120, 121, 267 n. 47, 269 n. 66
Gotch, Thomas Cooper 27, 223–224, *224*, 227
Gottlieb, Carla 173
Graf, Urs 99
grammatical gender 1–3, 20–21, 22–32, 261 n. 48
Grandville, Jean 28, *28*, 177–180, 181, 209, 218, 230, 243, 262 n. 65
Gravedigger, Death as 11, 44, 61, 85, 196–197
Great Mother 18
Greflinger, Georg 83

Gregory I (the Great), Pope 40
Grien, *see* Baldung
Grim Reaper 4, 7, 11, 18, 39, 48, 55, 135, 181, 188,
 203, 223, 230, 232, 237
Grimm, Jacob 12, 18, 21, 24, 32, 125, 150
Grimm, Wilhelm 12, 125, 150
Groß, Hans 229
Grosz, George 243
Gryphius, Andreas 93

Hades (Pluto) 34, 45
Hahn, Albert Pieter 229
Hammarskjöld, Dag v, 37
Hardenberg, Friedrich von, *see* Novalis
Hare, Augustus 204
Harpies 15, 35, 58, 78–79, 80, 85
Harsdörffer, Georg Philip 94, 272 n. 27
Hartmann von Aue 96, 267 n. 40
Hasemann, Arminius 242, 245, 248
Hauptmann, Gerhart 9, 136, 275 n. 14, 279 n. 39
Hausmann, Manfred 236
Heartfield, John 243
Heidegger, Martin 257 ch. 1, n. 2, 258 nn. 2, 6
Hein 125, 132
Hein, Anton 12, 147
Hein, de magere 12
Heine, Heinrich 247
Heisterbach, *see* Caesarius
Hel (Halja) 14, 18
Hélinant de Froidmont 48, 49–50, 61, 268 n. 57
Helm, Rudolf 41
Hemingway, Ernest 177
Herald, Death as 87
Herbert of Cherbury, Edward, Lord 26,
 108–110, 111
Herbert of Cherbury, George 108
Herder, Johann Gottfried 13, 18, 35, 133, 136, 137,
 138, 139, 141, 146, 159, 162, 163
Hertel, Johann Georg 83
Hesiod 34
Hessel, Christoph 245
Heyne, Christian Gottlob 169
Heyne, Therese 169
Hildesheim Cathedral 46
Hitler, Adolf 2, 3, 238–239, 243
Hochhuth, Rolf 235–236, 262 n. 49
Hocking, William Ernest 258 n. 6
Hölty, Ludwig 160
Hofmannsthal, Hugo von 10, 12, 237, 244

Holbein, Hans, the Younger 11, 21, 25, 40, 64, 87,
 100, 120–122, *121*, 123, 150–152, 269 n. 66
Homer 11, 33, 34, 144
Horace 78, 82, 270 n. 94
Horkheimer, Max 189–190, 192
Horseman (Apocalyptic), Death as 11, 49, 50,
 79, 80, 87, 88, 92, 129, 165–172, 181, 242, 263 n.
 73
Horsewoman, Death as 60–61, 67, 68, 79, 80,
 85
Hübner, Julius 194
Hugo, Victor 202
Humboldt, Wilhelm von 21
Hunter, Death as 11, 49, 51, 86, 92
Hurtado de Toledo, Luis 90, 107, 116
Huysmans, Joris Karl 189
Hyvrard, Jeanne 14

Ibsen, Henrik 218
Ingrisch, Lotte 237–238
Ionesco, Eugène 2, 27–28, 237
Isherwood, Christopher 242
Ishtar 14

Jacobi, Johann Georg 142
Jacobus de Voragine 17
Jahnn, Hans Henny 237
Janssen, Horst 244
Jentzsch, Hans 242, 243
Jerome, St. 284 n. 12
Jesuit drama 92
Joan, Pope 24
Jordan, Louis Edward 261 n. 48
Jünger, Ernst 259 n. 18
Jung, Carl Gustav 9, 31, 258 n. 4

Kaiser, Gert 21, 267 n. 40, 274 n. 63
Kali 18
Kaplan, Edward K. 14
Kastenbaum, Robert 31
Kaulbach, Wilhelm von 178, 184–185, 194, 209
Kauw, Albrecht 86, 101
Kay, Sarah 270 n. 90
Keats, John 159
Keller, Gottfried 142
Kers, the 14, 34, 78, 80
King Death 11, 29, 51, 58, 80, 88–90, 92, 154, 259
 n. 22
Kirchner, Ludwig 229

Klinger, Max 222, 223, 281 n. 78
Klopstock, Friedrich Gottlieb 138
Klotz, Christian Adolph 137
Knight, Death as 21, 49, 50–55, 87, 92, 109, 267 n. 36
Knochenmann, *see* boneman
Koerner, Joseph Leo 41, 86
Koller, Erwin 271 n. 10
Kollwitz, Käthe 101, 158
Kosmas Indikopleustes 44
Kostucha 260 n. 33
Kozáky, Stephan 271 n. 10
Krolow, Karl 22, 261 n. 49
Kubin, Alfred 25, *25*, 192, 222–223, 228
Kühn, Sophie von 162
Kugler, Franz 158
Kurtz, Leonard P. 263 n. 66

La Chaise-Dieu, abbey 40
Lamon, Jean Pierre 239–240
Lang, Fritz 237
Langland, William 54–55, 67
La Rochefoucault, Guy de 8, 10
Larson, Gary 232
Latini, Brunetto 61
Legrand, Louis 228
Lemaire, Jean 77, 95, 106
Lenau, Nikolaus 142
Lendecke, Otto 246
Lenéru, Marie 10, 36, 251, 283 n. 128
Lenin, Vladimir Ilyich 230
Leofric, Bishop 274 n. 73
Leonardo da Vinci 223
Lessing, Gotthold Ephraim 13, 33, 34, 39, 43, 80, 94, 95, 134–144
Leyden, Lucas van 86, 95
Lichnowsky, Mechthilde 236
Ligozzi, Jacopo 271 n. 8
Lincoln, Abraham 26, 201
Loewe, Carl 19
Longfellow, Henry Wadsworth 11, 13
Lope de Vega, Félix de 90 272 n. 17
Lorenzetti, Pietro 75, 270 n. 81
Louis XVIII, King of France 185
Lover, Death as, *see* Seducer, Seductress
Low German Dialogue of Life and Death 65
Ludus Coventriae, see Coventry Cycle
Ludwig I, King of Bavaria 184, 185, 209
Lübeck Dance of Death 57

Lurker, Manfred 261 n. 48
Luther, Martin 85, 87, 101, 125, 135, 273 n. 38
Luxuria 96
Lydgate, John 26, 43

Madame La Mort (Lamort) 3, 7, 16, 35, 212, 221, 250
Maeterlinck, Maurice 10, 36, 196
Mahabharata 17
Malczewski, Jacek 15, 188, 198–201, *199*
Malmstad, John E. 278 n. 14
Malraux, André 10, 20
Mani 124
Mann, Thomas 4, 258 n. 8
Manrique, Jorge 65
Mantegna, Andrea 269 n. 76
Manuel, Niklaus, called Deutsch 12, 21, 40, 64, 86, 100, 101–104, *103*, 118–119, *119*, 120, 128, 262 n. 62
Marcks, Gerhard 244
Marco Cathedral, San (Venice) 45
Marle, Raimond van 273 n. 41
Marlowe, Christopher 88
Marly, *see* Thibaud
Marot, Clément 110–111
Martial d'Auvergne 274 n. 61
Mary Stuart, Queen of Scots 283 n. 2
Masked ball, Death as dancer at 5, 183, 241, 244, 245–249
Maugham, Somerset 26
Mauléon, Michel Pierre 101
Mellerio, Elisabetta, Contessa 144
Melville, Herman 226
Méndez, Leopoldo 30, 263 n. 73
Merian, Matthäus 86
Merkel, Carl Gottlieb 158, 181–182, 183, 185
Meyer, Conrad 123, 151
Meyer, Hans 158
Meyer, Rudolf 123, 151
Michault, Pierre 77
Michelangelo Buonarroti 34
Michelet, Jules 14, 256
Miélot, Jean 267 n. 43
Miller, Johann Martin 146, 164
Milton, John 15, 42, 84, 87, 92, 126, 272 n. 23
Mister Death, *see* Mr. Death
Moira (Moerae) 34, 76, 77, 192
Montaigne, Michel de 10, 26, 113, 255
Montez, Lola 178, 185, 209

Moog-Grünewald, Maria 189
Moore, Thomas 159
Morabito, Pasquale 267 n. 43
Moralities 53, 56, 89
More, Thomas 106
Moreau, Gustave 3–4, 31, 188, 189, 195, 205–208, 207
Mors de la pomme, Le 29, 41, 56–57, 62–63, 267 n. 43
Mother Death 14, 18–19, 26, 55, 61, 111, 172, 190–191, 200–205, 239, 260 n. 37, 281 n. 90
Mountain Guide, Death as 182
Mozart, Wolfgang Amadeus 237
Mr. Death 7, 13, 114, 242, 250
Mr. and Mrs. Death 18–19, 174
Müller, Heiner 191, 239, 260 n. 37
Munch, Edvard 3–4, 12, 85, 101, 163, 244–245
Musäus, Johann Karl August 150, 152
Musorgsky, Modest 185–186, 243
Mysteries 53, 56
mythology (folklore)
 African 13
 Argentinian 260 n. 29
 Classical 32–35
 Colombian 260 n. 29
 Egyptian 11, 35, 258 n. 10
 Etruscan 34, 78
 German(ic) 18–19
 Indian 17–18, 206
 Mexican 7, 12, 16–17, 250, 252, 259 n. 29, 260 nn. 29, 32
 Peruvian 281 n. 77
 Romanian 263 n. 69
 Scandinavian 14, 18, 261 n. 38
 Slavic 17, 186, 260 n. 33
 Spanish 16–17

Nibbrig, Christiaan L. Hart 162
Nicodemus 45, 125
Nicolas II, Tsar 230
Nietzsche, Friedrich 230
Nimrod 11, 35, 86
Norns 18, 261 n. 38
Nossack, Hans Erich 243–244
Notre Dame Cathedral (Paris) 61
Novalis 141–143, 159, 160, 162, 165, 170, 171, 277 n. 40
Nurse, Death as 3, 25, 155, 178, 180, 183, 204, 228, 277 n. 4, 283 n. 121

Occleve, Thomas 26, 43
O'Hara, John 26, 229
Old crone, Death as 118, 120, 183
Omme, Robert de l' 62
Orcagna, Andrea 75
Osborn, Paul 237
Ovid 273 n. 38

Panofsky, Erwin 126, 283 n. 3, 284 n. 9
Parcae 18, 34, 76
Pasti, Matteo de 70
Paul, St. 39–40, 42, 59, 124, 158, 254
Paz, Octavio 16
Pedraza, Juan de 115
Péladan, Joséphin 196, 216
Percy, Thomas 129
Persephone 14, 18, 27, 69, 111, 193, 223
Pesellino, Francesco 70, 70
Peters, Hans Albert 192, 216
Petrarch, Francesco 14, 16, 68, 69–71, 76, 82, 83, 85, 111, 208, 252, 269 n. 71
Piero della Francesca 71, 269 n. 78
Pietro Martire, San, church (Naples) 29, 51
Pisa, Campo Santo, fresco in 7, 20, 34, 72–73, 71–75, 85, 95
Pisan, *see* Christine
plague, *see* Black Death
Plowman from Bohemia, The, see Tepl
Pocci, Franz, Count 25, 182–183, 222, 230, 278 n. 9
Poe, Edgar Allan 246
Pomarède, Silvestre 270 n. 87
Posada, José Guadalupe 30, 263 n. 73
Praz, Mario 126
Pride of Life, The 53
Procuress, Death as 181–182
Proserpina, *see* Persephone
Prostitute, Death as 178–179, 208, 209, 211, 218, 223

Queen Death 17, 154
Quevedo, Francisco Gómez de 117
Quiñones de Benevente, Luis 91

Rachilde (Marguérite Vallette) 7, 16, 212, 221
Ramler, Karl Wilhelm 264 n. 94
Rauwolf, Louis 243
Reaper, *see also* Grim Reaper 7, 8, 13, 27, 35, 46, 83, 85, 87, 90, 113, 183, 224, 225, 237, 242, 244, 257 ch. 1, n. 1

Reaper, female 7, 8, 22, 25, 68, 69–75, 90, 112, 117, 191, 198, 200, 218, 224, 225–226, 230, 257 ch. 1, n. 1, 260 n. 29, 264 n. 94, 279 n. 41, 280 n. 73, 282 n. 93

Redon, Odilon 212, 220–221, 223, 227

Rehm, Walther 36, 104

Rembrandt van Rijn 15

Remiet, Pierre 268 n. 59

Rethel, Alfred 158, 194, 195, 241–242, *241*, 246–247

Reuter, Adele 44–46

Ricci, Lucia Battaglia 270 n. 81

Richardson, George 84

Rilke, Rainer Maria 3, 7, 16, 212, 221, 250

Rimbaud, Arthur 15

Ringhieri, Innocenzio 85

Ripa, Cesare 82–85

Robertet, Florimond 110

Rode, Christian Bernhard 154

Rodríguez-Solís, Eduardo 17

Roeder von Diersburg, Elvire 274 n. 62

Roman de la Rose 77

Ronsard, Pierre de 16, 101, 110–114, 117, 257 ch. 1, n. 1, 273 n. 51

Roper, William 106

Rops, Félicien 3, 7, 64, 178–179, 187, 188, 208, 211, 216–220, *217, 219*, 223

Rosanowski, Klaus 229, *231*

Rosenfeld, Hellmut 265 n. 13, 267 n. 44

Rossetti, Dante Gabriel 187–188

Rosso Fiorentino 126, *126*

Rowlandson, Thomas 178, 262 n. 65

Saarikivi, Sakari 1

Sacher-Masoch, Leopold von 8, 225–226, 227

Sachs, Hans 85, 125

Sacro Speco Monastery (Subiaco) 44, 68

Sammael 35

Sánchez de Bajadoz, Diego 115

Sargent, John Singer 27, 223

Satan 4, 35, 97, 123–127, 176, 251, 274 nn. 72, 73

Sauer, Walter 242

Saugnieux, Joël 269 n. 63

Savonarola, Girolamo 71, 75

Schadow, Wilhelm 194

Scheffauer, Philipp Jakob 144, *145*

Scheit, Kaspar 122

Schellenberg, Johann Rudolf 11, 25, 150–155, *153*, 159, 171

Schiestl, Matthäus 242

Schiller, Friedrich 12, 13, 33, 94, 128, 131–132, 135, 142, 146, 158, 164, 165, 171, 283 n. 5

Schinkel, Eckhard 36

Schlegel, Friedrich 186

Schneider, Robert 15

Schnorr von Carolsfeld, Julius 193–194

Schönborn, Johann Christoph von 272 n. 27

Schopenhauer, Johanna 154

Schubart, Jacoba Elisabeth von 144

Schubert, Franz 12, 85, 96, 100

Schuster, Eva 228, 245, 248–249

Schwabe, Carlos 15, 196–198, *197*, 200

Schwebel, Oskar 194, *195*

Schwind, Moritz von 158, 180–181, 183, 194, 230, 279 n. 28

Scott, Sir Walter 13, 156

Seducer, Death as 5, 12–13, 20, 64, 93, 95–104, 180

Seductress, Death as 5, 20, 63, 85, 93, 96, 105, 106, 152, 186, 188, 204, 208, 209–229 245

Seitz, Otto 222, 242

Seneca 78, 254, 270 n. 94

Set 35

Seuse, Heinrich 271 n. 10

Shakespeare, William 11, 14, 23, 27, 29, 56, 77, 84, 88, 92, 98–99, 105, 128, 156, 204, 223

Shaw, George Bernard 218

Shelley, Percy Bysshe 11, 156, 159

Siciliano, Italo 61

Simberg, Hugo 1, *2*, 22, 257 n. 3

Sister Death 15, 267 n. 40

Skeleton 43–44, 84, 176, 266 n. 13, 267 n. 44, 268 n. 47

Slater, P. E. 20, 261 n. 43

Slevogt, Max 245, 247–248, *247*

Smart, Christopher 274 n. 72

Smith, Percy 282 n. 103

Södergran, Edith 233–234

Soldier, Death as (*see also* Warrior) 12, 243

South German Dance of Death 50, 57, 87, 269 n. 66

Southey, Robert 5, 157–158

Spangenberg, Wolfhart 97

Stammheim missal 46

Stanninow, James 99

Stephan, Inge 278 n. 21

Sterne, Laurence 283 n. 5

Sterner, Albert 200

Stevens, Wallace 281 n. 90
Stolberg, Christian, Count 161
Stolberg, Friedrich Leopold (Fritz), Count 159–160
Strasbourg Cathedral 41
Strauß, Botho 235, 237
Strindberg, August 3
syphilis 218

Tabori, George 3, 238–239, 282 n. 100
Taylor, William 168
Tempest, P. 83
Tenenti, Alberto 265 n. 5
Tepl, Johann von 11, 13, 55, 85, 114
Tertullian 252
Thanatos 4, 11, 13, 15, 33–35, 39, 44, 46, 69, 80, 95, 104, 106, 111, 131–132, 134–144, *138*, *145*, 147–150, 151, 156, 157, 158–159, 161, 162, 163, 170, 171, 172, 189, 198, 206, 225, 236, 244, 251
Thibaud de Montmorency de Marly 42, 48–49
Thielicke, Helmut 257 ch. 1, n. 2
Thomson, James 276 n. 17
Thorvaldsen, Bertel 144
Tía Sebastiana 7, 16–17, 35, 250, 260 n. 29
Tillich, Paul 252, 256
Titian 76
Tlaltecuhtli 17, 18
Tödin (*see also* Death Woman) 3, 19, 174, 234–235, 237
Toledo, Francisco 30, 250
Toller, Ernst 236
Traini, Francesco 71, 270 n. 81
transi 44, 84, 253
Traven, B. 12
Trionfo della morte, *see* Triumph of Death
Tristram, Philippa 265 n. 3
Triumph of Death 14, 20, 34, 44, 57–58, 61, 68–81, 117, 118, 238
Tschabuschnigg, Adolf von 19, 174
Uhlig, Ludwig 276 n. 21
Ungerer, Tomi 16
Urban VIII, Pope 253, 254, 256
Uta, abbess 24, 45–46, 47, 48, 65
Utrecht psalter 45

Vallette, Marguérite, *see* Rachilde
van Gogh, Theo 27

van Gogh, Vincent 27
van Rusting, Salomon 154
Vasari, Giorgio 75
Veneziano, Agostino *126*
Venturos Pelegrí 64
Vérard, Antoine 127
Vérola, Paul 220
Veronese, Bonifacio 76
Viëtor, Karl 264 n. 98
Vigoureuz, Charles le *76*
Villon, François 61–62
Virgil 11, 69, 78–79
Vishnu Narayana 206
Vogel, Hermann 205, 278 n. 8
Vogeler, Heinrich 243

Wagner, Richard 187, 230
Wanderer, Death as 243
Warlord, Death as 50, 58, 181, 186, 263 n. 73
Warrior, Death as (*see also* Soldier *and* Knight) 12, 86
Watt, Ian 124–125
Watts, George Frederick 19, 27, 200, 201, 203–205, 206
Weber, Andreas Paul 230, *232*, 243, 282 n. 113
Weber, Frederick Parkes 77
Weininger, Otto 216
Weismantel, Leo 237
Weiß, Tobias 222, 242, 248
Wenders, Wim 15
Werner, Zacharias 164, 275 n. 14
Weyrauch, Wolfgang 236
White Zombie 14
Whitman, Walt 19, 26, 200, 201–203
Whitney, Geffrey 26, 95, 107–108
Wickram, Jörg 85
Wilde, Oscar 15, 189
Wilder, Thornton 237
Winckelmann, Johann Jakob 95, 137
Winkler, Eduard 243
Wolfhagen, Ernst 15
Worms missal 45
Wyl, Jakob von 122

Yama 260 n. 35
Young, Edward 86, 156, 157

Zapata, Emiliano 30